Art Deco Chrome

Jim Linz

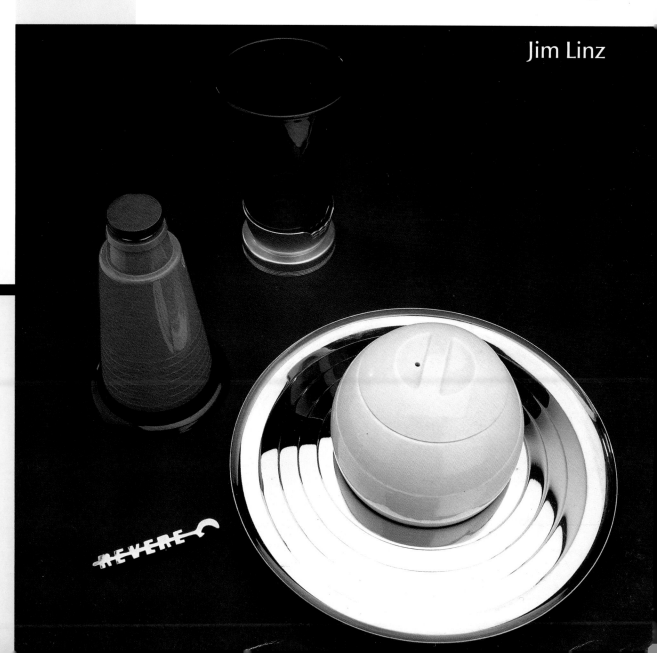

4880 Lower Valley Road, Atglen, PA 19310 USA

Dedication

In memory of my parents, Howard Joseph Linz (1912-1988), who taught me the rewards of public service, and Mary Kathleen Peeples Linz (1910-1996), who instilled in me a respect for the past and the passion to collect.

Design Blair Loughrey
Type set in Zapf Humanist/Korrinna

ISBN: 0-7643-0744-4
Printed in China
1 2 3 4

Published by Schiffer Publishing Ltd.
4880 Lower Valley Road
Atglen, PA 19310
Phone: (610) 593-1777; Fax: (610) 593-2002
E-mail: Schifferbk@aol.com
Please visit our web site catalog at **www.schifferbooks.com**

This book may be purchased from the publisher.
Please include $3.95 for shipping.
Please try your bookstore first.
We are interested in hearing from authors
with book ideas on related subjects.
You may write for a free catalog.

In Europe, Schiffer books are distributed by
Bushwood Books
6 Marksbury Rd.
Kew Gardens
Surrey TW9 4JF England
Phone: 44 (0)181 392-8585; Fax: 44 (0)181 392-9876
E-mail: Bushwd@aol.com

Contents

Part One: Overview

1. Introduction 6
2. Giftware Manufacturers 11
3. Selected Giftware Designers 25
4. The Chase That Might Have Been: Proposals and Prototypes 38
5. Recent Chase Discoveries 42
6. Chase Reincarnated: Emerald Glo, Cavalier 49
7. Identifying Finishes 52
8. Care and Feeding of Chromium and Other Metals 56
9. Factors that Affect Values 58

Part Two: Giftware Gallery

10. Decorative and Floral Items 62
11. Drinkware 76
12. Buffet Service 104
13. Smokers' Articles 129
14 Lighting 151
15 Miscellaneous 162

Part Three: Advertisements and Catalog Reprints

16. Advertisements 171
17. Reprint of a 1934 Chase Modern Fixtures Pamphlet 176
18. Excerpts from the 1941 Chase Lighting Fixtures Catalog 180
19. Reprint of a 1937 Revere Gifts Brochure 185

Selected Bibliography 191
Appendix A: Listing of Chase Giftware
 Designed by Harry Laylon 192

Acknowledgements

I would like to express my appreciation to friends and family who encouraged and assisted my research efforts. While it is not possible to individually recognize each individual and organization, the following made special contributions:

• Olga Laylon allowed me to review and photograph her Chase and Manning Bowman catalogs, advertising flyers, and other memorabilia. She also allowed me to photograph display boards of proposed new giftware items and a prototype cigarette box prepared by Harry Laylon. Olga, who worked for Chase at the time she met her husband of almost 60 years, also provided biographical data on, and a listing of, items designed by Harry Laylon.

• Anne Hoffmann provided biographical data on her late husband, Wolfgang, and his designs for the *Sunlight House* at the 1933 Chicago Century of Progress Exposition.

• Bob Merchant sifted through the hundreds of copies of the *New Yorker, Fortune, House Beautiful,* and *House and Garden* in his collection in search of advertisements and information on giftware companies and their designers. Bob also prepared drawings of the Manning-Bowman, Chase, Landers, Frary & Clark, Kensington, and Park Sherman trademarks.

• Allen Weathers and the Meriden Historical Society gave me access to the society's voluminous data on Manning-Bowman. The Manning-Bowman catalog covers shown in this book were reproduced from Historical Society files.

• Rachael Guest and the Mattatuck Historical Society assisted in my Chase research. The Chase catalog covers and the 1934 Modern Fixtures pamphlet reproduced in this book are from the collections of the Mattatuck Historical Society.

• Martha Smart and the Connecticut Historical Society assisted my research efforts on Connecticut manufacturers. Because so many of the art deco giftware manufacturers were located in Connecticut, the Historical Society proved to be an invaluable source of information.

• Kathleen Hynes-Bouska and staff at the Rome Historical Society provided historical information on Revere and its Rome Manufacturing Company Division.

• Staff from the Frederick (Maryland) Historical Society provided information on the Everedy Company.

• Staff from the public libraries in Meriden, Waterbury, and New Britain, Connecticut, Springfield and Chicago, Illinois, and Frederick, Maryland, assisted in my research.

• Staff from the United States Patent and Trademark Office taught me the "ropes" in researching patents and trademarks.

• Barbara Endter helped identify Chase giftware and lamps and freely shared the results of her research on other giftware manufacturers.

• Sara Hassan, Bob Merchant, and Olga Laylon allowed me to photograph items from their collections.

• Rick Inserra photographed his Chase Coronet Coffee Service for inclusion in the book.

• Mark Kotishion and Mike Stradtner unearthed many of the items in my collection that are pictured in this book.

• Doug Congdon-Martin, Jeffrey Snyder, and the staff at Schiffer guided me through the book building process.

Part One
Overview

Chapter 1
Introduction

The term art deco was coined in the 1960s to describe the modern style exhibited at the 1925 Paris "Exposition Internationale des Arts Décoratifs et Industrial Modernes." Some argue that the 1925 Exposition marked the end of the art deco movement, while others argue that it was the beginning. I believe it should be viewed as the turning point in the movement, marking the birth of machine age design. The Exposition both displayed and celebrated the graphic designs and handcrafted furnishings of the preceding 15 years (the exposition had originally been planned for 1915) and provided a glimpse of the future in its display of tubular chromium furniture and machine-made accessories.

Equally important in the evolution of art deco was the 1933-34 Chicago "A Century of Progress" Exposition, perhaps the single event most responsible for popularizing the new "streamline moderne" style in America. With public acclaim for the tubular chromium furniture and "moderne" furnishings displayed in the model homes and exhibitions, American manufacturers, initially slow to embrace the new style, reacted swiftly. Chase Brass & Copper Co., Incorporated and Manning-Bowman & Company unveiled extensive new lines of "modern" giftware in 1933. Chase relied heavily on freelance designers such as Walter von Nessen and Ruth Gerth to develop its giftware line before expanding its in-house design capabilities under Harry Laylon. Manning-Bowman's line featured designs by Jay Ackerman. Both companies had previously produced art deco giftware, but their lines up to that point had met with limited consumer acceptance.

The Aluminum Company of America quickly followed suit in 1934, displaying an extensive line of Kensington™ giftware designed by Lurelle Guild. Later that year, The Rome Manufacturing Company, a division of Revere Copper and Brass Incorporated, introduced its 1935 giftware line featuring designs by Norman Bel Geddes. Numerous other companies such as Bruce Hunt, Everedy, Park Sherman, and Napier, also created or expanded giftware lines. Bright, gleaming chromium was the metal of choice for most of the giftware although a variety of other finishes, including brass, copper, aluminum, and nickel were used.

During the 1930s, which became known as the "Design Decade," streamlined design was applied to virtually all consumer products. Manufacturers continued to expand their giftware lines until the advent of World War II halted virtually all consumer production. A few manufacturers resumed production of their giftware lines after the war, but by then the art deco period was essentially over.

Art Deco Graphic Design

Although the roots of art deco are generally traced to the 1925 Paris Exposition, the art deco style developed in the graphic arts as early as 1908. That year marked the publication of *Robes de Paul Poiret Racontées par Paul Iribe* (Dresses by Paul Poiret Presented by Paul Iribe). Unlike previous fashion illustrations which depicted women's bodies with their natural curves and proportions, Iribe presented women's bodies in a slightly elongated, tubular form. As such they created a fantasy world. Iribe's new simplified style was reinforced the following year with the arrival of the Ballet Russes in Paris.

The new style quickly caught on in French and American fashion magazines. Among the foremost American proponents of the new style of fashion illustration was Helen Dryden, whose covers for *Vogue* between 1911 and 1923 and later for the *Delineator* showed a steady evolution of art deco graphic styling. Dryden gave up her successful career as a cover artist to become an industrial designer, contributing giftware designs to Revere and the Dura Company. She is best remembered, however, for her design of the interior of the 1937 Studebaker.

The avant-garde art movement began to influence the development of the art deco graphic style following World War I. Among the elements of the avant-garde movement that were incorporated into art deco graphic style were the more radical use of geometric designs and extreme simplification of design.

Widening Gap Between Machine Design and Aesthetics

In the early years of the industrial revolution, the design of machines and machine-made items focused almost entirely on efficiency with little thought to aesthetics. As the industrial revolution took hold during the nineteenth century, the gap between machine design and aesthetics steadily widened. Although the machine created new design possibilities, there was little attempt to bring the arts into machine age design. As a result, both the arts and industrial design languished.

Before the nineteenth century, every generation had developed its own "modern" style that expressed contemporary life. Thus were born such styles as Chippendale, Queen Anne, and Colonial that are now know as period styles. During the nineteenth century, however, the development of new styles largely ended. Spawned

by the industrial revolution, a new group of millionaires sought to gain acceptance in "society" by emulating the styles of the aristocracy. Rather than seeking new designs, they sought to copy the designs long favored by the aristocracy. As Emily Genauer noted in her 1939 book *Modern Interiors: Today and Tomorrow*, "…not having background, they couldn't distinguish between good and bad design, and hand and machine work."

The widening gap between machine-age design and aesthetics fueled the development of the arts and crafts movement in the late nineteenth century. Scottish Architect Charles Rennie Mackintosh is often viewed as having been the inspiration for the modern design consciousness that led to the art deco movement. Mackintosh believed that art should be applied to the design of everyday objects, favoring a return to the handicrafts and away from machine-made items.

Fellow architect Josef Hoffmann, a founding member of the Vienna Secession in 1897 and the Wiener Werkstätte in 1903, shared many of Mackintosh's views, and was an early advocate of the limited use of ornamentation. Hoffmann's son Wolfgang, himself a skilled architect who began his career working with his father, became the leading designer of art moderne tubular chromium furniture and smoking stands during the 1930s.

The contribution of these early movements to the development of art deco was the belief that art should be applied to the design of everyday objects. Although the arts and crafts movement grew out of a rejection of machine-made goods because they lacked an aesthetic quality, it ultimately contributed to a fundamental redirection in machine age design. Slowly the gap between engineering and aesthetics began to narrow in the years immediately following World War I.

World War I Facilitates Machine Age Design

World War I inadvertently facilitated the transformation of art deco from handcrafted to machine made items. When America entered World War I in April 1917, virtually all use of copper and brass for production of consumer goods was halted and, as Watson Davis noted in his 1924 *The Story of Copper*, "the copper industry virtually enlisted along with the youth of the country." Production of copper increased by more than one-half during the war. Most of the copper was used in munitions factories. Nearly all of the metal used in small arms ammunition was composed principally of alloys of copper; the cases for artillery shells were made of brass. Davis noted that a "man cannot be killed in an up to date manner without copper."

When the war ended, both American and European factories were faced with significant excess capacity as the demand for munitions dropped dramatically. Companies such as Chase and Revere needed to find new outlets for their brass and copper if closure of their rolling mills was to be avoided.

1925 Paris Exposition

President Hoover declared in 1923 that the United States would not participate in the Paris Exposition because the United States had no modern art. In her 1939 book *Modern Interiors: Today and Tomorrow*, Emily Genauer noted that in 1925

…new houses were being rapidly filled with the same taupe-mohair, three-piece, overstuffed suites which had packed the face of America for more than a decade. Grand Rapids manufacturers found they could not turn out enough of that cheap, over-elaborate, poorly constructed and even more poorly-designed stuff known to the trade as 'borax,' or Bronx Renaissance, to meet the demand for it. There were many persons not yet aspiring even to this mire of mohair. These were still in the golden-oak era.

Genauer had even harsher words for the decorating tastes of the affluent at that time:

The draperies could be no fresh and colorful modern versions of a traditional English chintz, because dark, red velvet or heavy crewel work were more "correct." A Louis XVI chair must never be seen outside the traditional setting of gilded carving and cornices and rose brocade-lined walls.

The 1925 Paris Exposition is viewed by many as the end rather than the beginning of the art deco movement. Originally planned for 1915 as a way to promote the development of modernism, the Exposition was delayed by 10 years because of World War I. Despite the war, the art deco style developed rapidly between 1915 and 1925. As a result, the 1925 Exposition served mainly as a display of a style that had already become commonplace in Europe, and to a lesser, but still significant, extent in the United States. By the time the Exposition was held, art deco fashion design and avant garde paintings were widely accepted. Thus Exposition pavilions for leading magazines such as *L'Illustration* and *Arts et Décoration* celebrated rather than promoted the new style as originally intended. Similarly, the Exposition served to showcase the works of established avant garde and cubist artists.

Those arguing that the Exposition marked the beginning of the art deco period also have a strong case, for it provided the impetus for the marriage of art and industrial design that characterized the period between 1925 and 1942. The importance of the Exposition rested primarily in the Pavilion de l'Esprit Nouveau, which displayed tubular steel and chromium furniture and industrially designed objects by Le Corbusier and others. What had, up until 1925, been a style characterized by one-of-a-kind hand-crafted decorative items would be quickly transformed into a style characterized by mass production of machine made items.

America Reacts Slowly to the Exposition

Although the seeds of modernism had been planted as early as the late nineteenth century, the effects of the movement were initially limited primarily to the wealthy. Following the 1925 Paris Exhibition, exhibitions of French art deco furniture were held by major "society" department stores—Bloomingdales, Macy's, and Lord and Taylor—to attract wealthy clients. But the big mail order firms—Sears Roebuck, Montgomery Ward, and J. C. Penney—and the rapidly expanding "Five and Dime" stores—F. W. Woolworth, S. S. Kress, H. L. Green, and S. S. Kresge—catering to the tastes of everyday America did little to popularize the new style.

As a result, until the opening of the Chicago "A Century of Progress" Exposition in 1933, the general public had little exposure to modern household decoration. Modern decoration, or art deco, was largely limited to the "artsy" studios in

New York and to "society" folks. The closest the general public came to streamline moderne home furnishings was at the local cinema. It was in this "fantasy" world that art deco design took hold in America. Many of America's foremost industrial designers started their careers designing for the stage and screen. Designers such as Norman Bel Geddes, Russel Wright, Henry Dreyfuss, and Lurelle Guild began their careers as stage and set designers. Guild even enjoyed a brief career as an actor.

Joseph Urban became the first American art director to use modern décor, using modern furnishings in *Enchantment* (1921), starring Marion Davies and *The Young Diana* (1922). Other early American films showing art deco furnishings included *Camille* (1921) and *Salome* (1922) with sets designed by Natacha Rambova.

The first Hollywood film to feature all art deco sets was Metro-Goldwyn-Mayer's 1928 hit *Our Dancing Daughters* starring Joan Crawford. Costarring with Crawford were stunning art moderne sets by Cedric Gibbons. Public reaction to Gibbons' sets was so favorable that other studios immediately began to put art deco sets into their films. The movie palace, itself, was also transformed into an art deco showplace where the public could experience the latest in art deco design. Movie magazines promoted the lavish art deco lifestyles of the Hollywood stars. Many stars attempted to recreate the lavish art deco movie sets in their homes.

Although the movies helped popularize the art deco style, it remained beyond the reach of most Americans. With the opening of the Chicago World's Fair, however, millions of Americans were introduced to mass produced art deco home furnishings as they visited the row of model homes, including the "Sunlight House" designed by Wolfgang Hoffmann. The owner of the W. H. Howell Manufacturing Company was so impressed by Hoffmann's furniture designs that he hired him to design exclusively for Howell. Hoffmann spent the rest of his design career with Howell.

Emily Genauer noted that "…the country-wide popularity of the new style dates from the time they came upon it accidentally in Chicago, admired its simplicity, its directness, its straight simple lines and chunky forms, and, most of all, its patent livableness." In her 1933 pamphlet *How to Give Buffet Suppers*, Emily Post noted that "Another beauty of chromium to most of us is that really lovely things can be had at comparatively small expense."

The "Design Decade"

During the ensuing decade, industrial designers were engaged to redesign virtually all machine made products. Items as mundane as the vacuum cleaner, typewriter, and refrigerator were converted into works of art. For example, Henry Dreyfuss, Norman Bel Geddes, and Lurelle Guild each contributed designs for vacuum cleaners. *Architectural Forum* devoted its entire October 1940 issue to a retrospective of what it termed the "Design Decade." It noted that

> With the emergence of the designer as the conscious exponent of a machine esthetic, design enters a new stage. Not only are the arts influenced by the machine, but the reverse is also now true. It is this interplay of influences that gives the 1930-40 period—"Design Decade"—its peculiar interest and importance.

The *Forum* also noted that "…the decade just closed, nearly two hundred years after the Industrial Revolution, has for the first time shown a substantial accomplishment in relating machine inspired design to a machine inspired way of life."

This marriage was not, however, without problems. Early industrial designers often lacked an understanding of the limitations of machine made goods, producing designs that were either impractical or too costly to mass-produce. One of the companies that successfully addressed this problem was Chase. Its early efforts at developing a giftware line met with limited success and many of the items were quickly discontinued. In 1933, however, they hired Harry Laylon to head their in-house design staff. Laylon, at the time only 22 years old, had convinced Chase management that he could solve this problem by working alongside the engineering staff to get a better idea of production costs and potential production problems. He was apparently right as the Chase giftware line soon eclipsed all others in popularity.

Art Deco Design Elements

Art deco, like all "period" designs, has certain design elements that transcend the work of individual designers and provide the family resemblance that defines the art deco style. Common design elements found in art moderne giftware include the use of:

- Streamlining, tall slender designs with little or no ornamentation.
- Fluting, broad grooves similar to those frequently used to decorate columns in classical architecture.
- Concentric circles, typically embossed on flat surfaces. Chase termed this design element "Quiet Pool," noting that: "A pebble dropped in a still pool of water creates concentric circles."
- Step-down designs, where the base of an object becomes progressively broader through a series of distinct "steps." Stepped designs were also applied to tops and handles.
- Parallel lines, typically enameled or embossed on vertical surfaces. One of the most popular motifs was the use of three equally spaced parallel lines to break up an otherwise undecorated surface.
- Ribbing, a series of ridges machined into metal through use of dies, molded into bakelite trim, or carved into wood trim.
- Stars for decoration of an otherwise unadorned object.
- Laurel branches as a design motif. Lurelle Guild used laurel wreaths in many of his designs for Kensington giftware and Chase lamps.
- Stylized arrows as an ornament. The use of arrows frequently provides the linkage between art deco and more traditional "directoire modern" and "Empire" styling. Lurelle Guild was particularly fond of arrows and he incorporated them in many of his 1934 designs for Chase lamps, including them in his designs of Federal, Empire, and Classic Modern lamps.

Architectural Forum noted that some manufacturers carried art deco design to extremes, citing as an example a coffin manufacturer that asked its designer for the latest in streamlined caskets. Similarly, the *Forum* criticized

the use of three parallel lines as an ornament to break up surfaces, noting that "few objects have escaped the plague of this unholy trinity." Personally, I find the "three little lines" one of the most distinctive and appealing art deco motifs.

In 1940, Grace McCann Morley, Director of the San Francisco Museum of Art, summarized the accomplishments of the "Design Decade:"

> The last ten years have seen a tremendous development in arts, crafts, and industrial design in this country. Influences from abroad, discoveries in techniques and new materials, the creativeness of young designers aware of contemporary living in the U. S., growing penetration of art into industry, combined to make this a period worth noting in the evolution of contemporary styles. Modern design techniques that were at first superficial and decorative have settled into a sincere harmony between form and function, and standards of both execution and of appreciation have noticeably risen. In many fields, a distinctive contemporary style has emerged.

Not all Chromium is Art Deco

Although polished chromium was the predominant finish used on art deco giftware, one should not assume that just because an item is chromium-plated that it is art deco. When the plating process was developed in the mid-1920s, it was initially applied primarily to traditional designs. Similarly, some companies, such as Forman Brothers and S. W. Farber never fully embraced the new style and continued to produce traditional designs with polished chromium finishes.

Above right: Not all chromium-plated giftware is art deco. There is little collector interest in the types of elaborately detailed embossed and cut-out designs—the antithesis of art deco—shown in these serving dishes by Forman Brothers, Brooklyn, New York. Such items usually sell for $25 or less.

Right: Although these unmarked shakers are chromium and have bakelite handles, they have none of the styling elements typical of art deco. Such traditionally styled shakers have limited value, usually selling for $20-30.

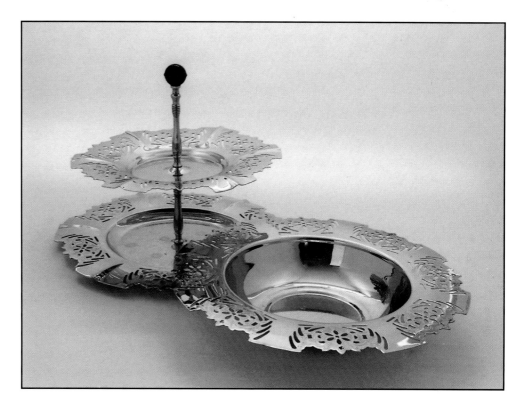

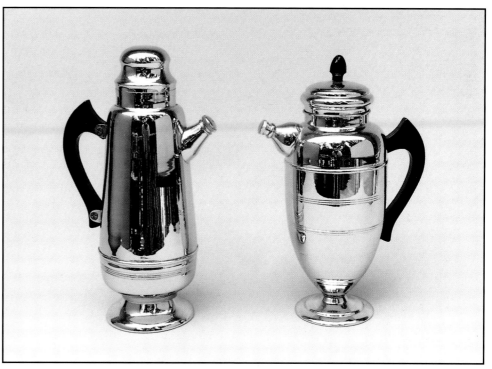

Not all Chase and Manning-Bowman is Art Deco

Just as one should not assume that all chromium-plated giftware is art deco, it should not be assumed that all Chase giftware and lamps or all Manning-Bowman giftware are art deco. Chase produced lamps and lighting fixtures in a wide range of styles, including Colonial, Empire, and Federal, in addition to art deco. Similarly, as the 1930s drew to a close, it added many giftware items with colonial styling. Manning-Bowman produced giftware and appliances in traditional styles for decades before the art deco style became popular in the late 1920s and 1930s. In addition, it, like Chase, began to return to traditional styling as the decade drew to a close. In introducing its new Peacock Plate™ finish in 1941, Manning-Bowman offered the new finish primarily on traditionally styled serving pieces.

Differences Between Manufacturers

Although Chase, Revere, Manning-Bowman, and Kensington all produced giftware during the 1930s, there are significant differences in the range of products they produced. Manning-Bowman produced a wide range of vacuum ware, clocks, and small appliances in addition to its giftware line, producing separate catalogs for each line. Although Chase included several electric buffet service items in its giftware catalogs, it did not produce the full range of small appliances produced by Manning-Bowman and produced neither vacuum ware nor clocks. Revere, like Manning-Bowman, produced a line of electric clocks but produced neither appliances nor vacuum ware. Kensington did not produce clocks, vacuum ware, or small appliances.

Chase was the only one of the four companies to offer a full range of lamps and lighting fixtures, although Revere did produce novelty lamps designed by Norman Bel Geddes and Helen Dryden. In 1934, Chase introduced extensive lines of lamps and lighting fixtures designed by Lurelle Guild, releasing separate catalogs. Other designers, including Ruth Gerth, Walter von Nessen, and Harry Laylon also added lighting designs. Finally, Chase, in 1935, acquired the Steele and Johnson Company and eventually added the Steele and Johnson line of lamps to the Chase Specialties catalog.

The three companies also differed in the finishes offered:
- Manning-Bowman offered most of its art deco giftware items only in polished chromium, occasionally offering pieces in polished copper.
- Chase offered the widest range of finishes. In addition to polished chromium, Chase offered many of its items in brass, copper, nickel, black nickel, or English bronze.
- Revere made extensive use of satin chromium and polished bronze in addition to polished chromium and copper.
- Kensington giftware was produced almost exclusively of Kensington metal, an aluminum alloy. Brass was used extensively for ornamentation.

Chase was a relative late bloomer with respect to the use of chromium plating. Most of Chase's early giftware items were produced in copper or brass and were frequently enameled. While other manufacturers, such as Manning-Bowman, Farber, and Landers, Frary & Clark pioneered the development of chromium plating in the mid-1920s, Chase did not introduce an extensive line of plated articles until 1933.

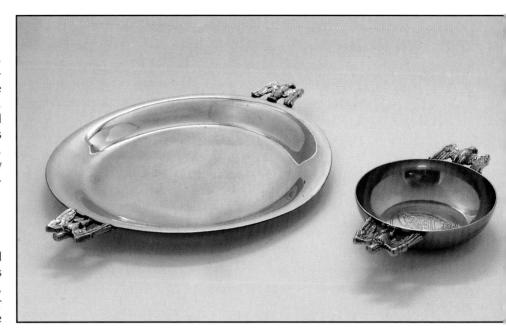

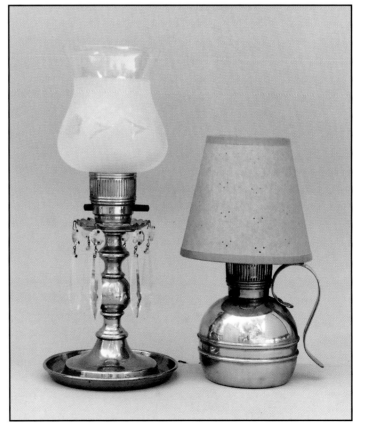

Above: Chase copper and brass accessories in the federal style. There is limited interest in Chase items other than those in the art deco style. Although these items are rare, they do not command high prices. Left: "Federal" Plate (No. 09007), 9" d. $45-55. Right: A 1933 commemorative porringer marking the birth of George Washington, 4" d., excluding handles. $25-35.

Left: Chase colonial lamps do not have a strong following. Left: The "Lexington" (No. 6178), polished brass with a frosted cut glass shade and crystal drops, 12" h. $45-55. Right: The "Chester" (No. 6194), polished brass, 11-3/4" h. The original lamp had both a glass chimney and a parchment shade. $35-50.

Chapter 2
Giftware Manufacturers

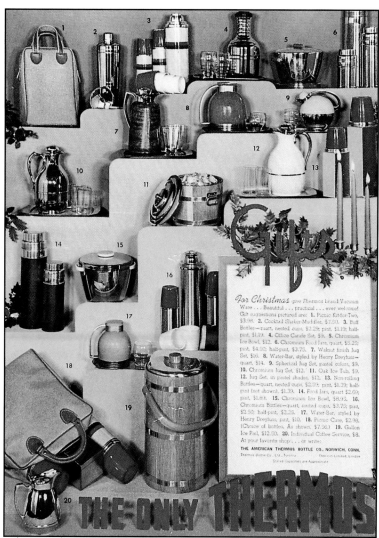

Thermos advertisement (*New Yorker*, December 2, 1939).

American Thermos Bottle Company

The American Thermos Bottle Company was incorporated in Portland, Maine, in 1907. During the next three years it produced vacuum bottles in a rented factory in Brooklyn, New York. The company was an immediate success and its "Thermos™" brand vacuum bottles were soon in use throughout the world. President Taft used Thermos vacuum bottles at the White House, Admiral Peary carried a Thermos with him to the North Pole, the Wright Brothers had a Thermos on their maiden flight from Kitty Hawk, and Teddy Roosevelt used a Thermos on his expedition to Mombasa.

As demand grew, the company purchased more modern equipment from Thermos Gesellschaft, the German firm that developed the original metal casing to protect the fragile vacuum bottle. Thermos Gesellschaft registered the trade name "Thermos" in Germany in 1906; it had used the name on its products since March 1904.

In 1910, the American company moved is offices and plant to a new twelve-story building in Manhattan. The new building proved to be only a temporary solution as sales quickly outpaced the capacity of the new plant and Thermos again relocated, this time to Norwich, Connecticut. Even as construction was underway on the new plant, the American Thermos Bottle Company began what was probably the first industrial school in the country to offer paid training to employees. By December 1912, the fifty employees at the training school were turning out between 1,200 and 1,500 Thermos bottles daily. At about the same time, the American company acquired the Thermos Bottle Co., Ltd. of Canada.

Even in its early years, the American Thermos Bottle Company offered a diversified line including coffeepots, decanters, and "motor restaurants" (picnic sets fitted with Thermos bottles). The company's products earned gold medals at Berlin and Paris expositions, awards from expositions at Antwerp and Madrid, and the Grand Prize at the Alaska-Yukon-Pacific Exposition in Seattle.

With the advent of World War I, the American Thermos Bottle Company found it increasingly difficult to maintain production; experienced employees increasingly left to enter military service and expenditures for raw materials and taxes increased. Despite these problems, the company moved forward with plans for worldwide expansion. In 1919, it negotiated to build a plant in Kokura, Japan. The following year, it began negotiations for the purchase of Thermos Limited of London. In addition, Thermos began construction of a new glass plant in Huntington, West Virginia.

Following the death of founder and president William B. Walker in December 1922, his wife, Mary Marcella Rinn Walker, after briefly taking over as acting president, decided

to sell the family interest in the company. A group of investment brokers and bankers acquired the company and formed a new corporation, the American Thermos Bottle Corporation of Maryland, in November 1923.

Competition in the vacuum bottle business was fierce, however, and during the early 1920s Thermos experienced considerable losses. Among its competitors were Manning-Bowman's "HOTAKOLD™" produced by its Vacuum Specialty Division, Landers, Frary & Clark's "Universal™" brand vacuum bottles, and "Icy Hot™" bottles produced by the Icy-Hot Bottle Company of Cincinnati, Ohio.

As financial conditions began to improve, the company sold the Japanese plant and, in December 1923, completed the acquisition of Thermos Limited of London. In February 1925, an agreement was reached on a merger of Thermos and Icy-Hot with the combined company retaining the American Thermos Bottle Corporation name but temporarily moving its headquarters to Cincinnati. The Icy-Hot manufacturing plant was closed and all production shifted to the Norwich and Huntington plants. After weathering its financial troubles of the early 1920s, Thermos survived the Great Depression virtually untouched, reporting a profit every year until 1957.

Between 1935 and 1939, the company introduced an extensive line of thermal ice buckets, cocktail shakers, carafes, casseroles, and desk sets with art deco styling. Among those holding design patents for Thermos products during the 1930s are George E. Ball and Henry Dreyfuss. There is, however, little information on designers of individual giftware items as Thermos applied for few design patents during the 1930s.

Unlike other giftware manufacturers that ceased all giftware production and retooled to produce war materials, Thermos continued to produce vacuum bottles throughout World War II. Its pint bottle and workmen's lunch kit were granted the highest civilian priority ratings and its factories were taxed to keep up with demand. Over 98 percent of the company's production was either in the form or pint bottles or special bottles designed for military usage and atomic energy laboratories. The company also produced precision military parts. Because of the military demands, however, it discontinued the specialty and luxury items of vacuum ware.

After the war ended, Thermos reconverted its vacuum bottle line to civilian and peacetime uses. The demand was so great, however, that the company was unable to immediately resume production of the specialty line.

In 1955, the American Thermos Bottle Corporation acquired control of Hemp and Company, Inc. of Macomb, Illinois, makers of the "Little Brown™" line of insulated picnic jugs, ice chests, and barbecue grills, further expanding its product line. Shortly thereafter, in 1957, Thermos began marketing a wide range of school lunch kits in varied styles, colors, and decorations. Such lunch boxes are among today's hottest collectibles.

Household International, Inc., purchased the American Thermos Bottle Corporation in 1969. Household is best known for the consumer loans made by another of its subsidiaries, the Household Finance Company (HFC). The Thermos headquarters were moved from Norwich to Freeport, Illinois, in 1987 and the Norwich plant was closed the following year. In June 1989, Household International announced the sale of the American Thermos Bottle Company to the Japanese firm Nippon Sanso K.K. Nippon Sanso continues to use the Thermos trademark.

Trademark of the American Thermos Bottle Company.

Thermos is Lured to Norwich—William B. Walker, President of the American Thermos Bottle Company, began looking at potential locations for a new plant and offices in 1912. The New York, New Haven, and Hartford Railroad suggested a site along the Thames River in Norwich, Connecticut. When he visited Norwich, Walker identified 7 acres of a 27-acre parcel of land that would meet the company's needs. He asked the city to provide both the land and a 75,000 square foot factory building. In exchange, he promised that Thermos would pay five times the cost of the site and building for labor employed in Norwich and for national advertising mentioning the city.

The whole community participated in efforts to attract the American Thermos Bottle Company to Norwich. The Norwich Industrial Improvement Corporation was established to raise the money to buy the land and construct the factory building. Shares in the corporation were sold for $25. In less than a month, the city raised the necessary funds to lure Thermos to Norwich. Among the fund raising activities taking place during the month were:

•Sale of building lots in the portion of the 27-acre tract not needed for the factory. Every time someone donated $750 to the cause they would be deeded a building lot. The City Hall bell sounded 10 times every time someone donated $750.

• Sale of $1 "boomer badges" by a group of 100 citizens, known as the "Norwich Boomers."

• A citywide ball that raised $2,900 for the cause. The musicians conducted an auction at the ball to raise another $544.

All told, the city raised about $78,000 to attract Thermos and on February 14, 1912, the company announced its move to Norwich. The city agreed to use the funds raised by the Norwich Industrial Development Corporation to build a semi-fireproof factory building that would be deeded, along with the land and existing house, to Thermos when the company had paid out $375,000 for labor and $375,000 in national advertising mentioning Norwich.

Chase Brass & Copper Co., Incorporated

Chase Brass & Copper Co., Incorporated of Waterbury, Connecticut, was the most successful of the metal giftware manufacturers of the 1930s. It combined exceptional designs by some of the leading freelance industrial designers such as Walter von Nessen, Lurelle Guild, and Russel Wright with a strong in-house design capability headed by Harry Laylon. Part of Chase's success, however, can also be traced to its marketing efforts. The development of "Chase Shops" in leading department and giftware stores made Chase a household name. Harry Laylon designed most of the shops, one of the extra services Chase offered its wholesale customers.

Augustus S. Chase moved to Waterbury in 1850, to work for the Waterbury Bank; fourteen years later he became the president. In December 1875, Chase and several other businessmen bought the former United States Button Company plant at auction. Shortly thereafter, they organized the Waterbury Manufacturing Company. The new company, incorporated in 1876, continued to make brass buttons, but expanded its product line to include articles such as umbrella fittings, upholstery trimmings, saddlery goods, and brass castings. The new company was

Cover to the 1942 Chase Specialties and Lamps catalog.

1942

Chase

SPECIALTIES & LAMPS

Immigrants Helped Run Brass Mills—Immigrants played an important part in the growth of Chase and other Brass mills. As early as 1890, over 70 percent of Waterbury residents were either immigrants or the children of immigrants. Initially, the immigrants were primarily of French Canadian or Irish descent, but after 1890, most of the immigrants were of Southern or Eastern European descent including Italian, Russian, and Lithuanian. Chase built 12 separate barracks near its Waterville plant to house single men. Each nationality was housed separately.

started with an initial investment of $25,000 in capital. Chase was the treasurer of the new concern. Within a few years, however, he became president and his son, Henry Sabin Chase, secretary-treasurer.

The new company was successful and an 1887 summary of Waterbury industries noted that the Waterbury Manufacturing Company had "...a deservedly high reputation for honorable dealing and intelligent treatment of brass work—which it makes in great variety." At one point the company produced 33,000 different articles. Augustus Chase developed financial interests in a number of firms in addition to the Waterbury Manufacturing Company. Other firms in which he had an interest included the Waterbury Watch Company, Benedict and Burnham, and the Waterbury Buckle Company.

Upon the death of his father in 1898, Henry Chase became president of the Waterbury Manufacturing Company. Among his first actions as president was the construction, in 1900, of a rolling mill to supply the brass needed by the Waterbury Manufacturing Company. A new company, the Chase Rolling Mill Company, was established to operate the Waterbury mill. Henry Chase soon acquired other manufacturing plants, including the 1909 acquisition of the Noera Manufacturing Company, producers of automobile oilers and oil pumps. Noera continued to operate independently until the death of its founder, Frank D. Noera in 1924. In 1910, Henry Chase ordered construction of a mile long rolling mill in Waterville, Connecticut, known as the Chase Metal Works. Within a ten-year period, Chase had become one of Waterbury's largest brass mills.

In preparation for and during the first World War, the Chase rolling mills became major suppliers of brass for the war effort. The end of the war, however, created a serious problem for Chase. Fueled by the war effort, Chase had developed a tremendous capacity to produce brass in all forms. Its principal customer, the military, no longer had a need for the large quantities of brass it had been purchasing. Frederick Chase, who became president of the Chase Companies upon his brother's death in 1919, began an aggressive sales campaign to develop new customers for its brass, opening warehouses on the east and west coasts. Its efforts to expand its warehouse network gained momentum with the 1927 acquisition of the U. T. Hungerford Brass Company and its warehouses. Chase contin-

ued expanding its capacity to produce brass and other metals, building a rolling mill in Cleveland, Ohio, in 1929. That same year, however, family ownership of Chase ended as Kennecott Copper acquired the company.

From its origins, Chase was involved in the manufacture of consumer products, but mainly by supplying parts to other manufacturers. It produced oil lamps and gas jets before the invention of electricity and obtained a patent in 1914 for a battery operated candle. Initially, however, its involvement in electric lighting was limited to production of parts, such as sockets, for use by other companies, such as the American Brass & Copper Company. That changed in 1925, when Chase purchased the American Brass & Copper Company. Suddenly, Chase found itself manufacturing completely assembled lighting fixtures. It is not clear, however, whether the products were marketed under the Chase name or under an American Brass & Copper Company trademark.

In 1934, Chase introduced new lines of lamps and lighting fixtures designed by Lurelle Guild. The collections included Early American, Empire, Federal, Georgian, and Classic Modern styles. In addition to the Guild-designed collection, Chase offered lamps by other designers under the "American Adaptations" line. Chase again revised and expanded its line of lamps following the acquisition of the Steele & Johnson Company.

In a 1953 article tracing the industrial history of Waterbury, the *Waterbury Sunday Republican* reported that

> In 1935, one of Waterbury's old industries ceased corporate existence when the Steele & Johnson Co. was absorbed by the Chase companies, the machinery being moved to the Chase plant. The Steele & Johnson Co. was established as a corporation in 1858, having been founded by Elisha Steele. Screw machine products, eyelets, plumbing, electrical supplies, and numerous novelties were manufactured. The Waterbury Mfg. Co. of the Chase Companies largely duplicated the production of S & J.

It appears that Chase operated Steele & Johnson as a separate division for several years before integrating the Steele & Johnson lamps into Chase catalogs sometime after 1938.

Chase established its Specialty Sales Department in 1931 and began to market giftware items based primarily on designs by Albert Reimann, Walter von Nessen, and Ruth Gerth. Many of the early designs by Reimann, Gerth, and von Nessen, however, were quickly dropped. Because they were produced for only a few years during the worst part of the depression, these early pieces are among the hardest to find and consequently the most valuable. The giftware line was greatly expanded in 1933 and the first known catalog was produced.

Chase continued to expand its giftware line, hiring Harry Laylon as an in-house designer in 1933: At the same time, new designs by freelance designers including Russel Wright, Lurelle Guild, and Walter von Nessen continued to be added. As the 1930s came to a close, an increasing number of the new products introduced had colonial rather than moderne styling, as the country moved toward another colonial revival period.

Soon after introducing its 1942 catalog, Chase ceased consumer production and once again turned its factories toward wartime production. It appears Chase briefly resumed consumer production following the war, but magazines from the period generally have no ads for Chase giftware. I did find, however, a picture of a bar caddy in the December 1945 *House Beautiful* that appears to be the Chase bar caddy with a blunt end. The copy accompanying the picture reads "[t]his is the outstanding bar accessory of all time, and once more its back on the market in an improved model."

Any reappearance of Chase giftware was brief, however, as by 1948, the National Silver Company had begun to market giftware items under the Cavalier trademark based on Chase designs. Although I was unable to identify any agreement between Chase and National Silver, the large number of Chase designs introduced by National Silver through its Cavalier™ and Emerald Glo™ lines suggests that Chase likely sold its dies to National Silver after stopping production of Chase giftware.

Soon after the end of World War II, the brass industry in the Naugatuck valley began a sharp decline that led to closure of most of the rolling mills. Although many factors contributed to the decline, outside ownership is viewed by some as the beginning of the end. Local ownership of Chase had ended in 1929 with the sale to Kennecott Copper; Anaconda had previously taken over American Brass

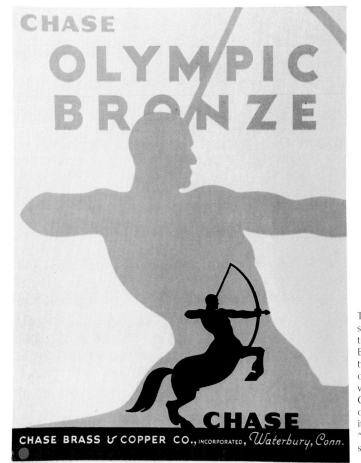

The Chase trademark as shown on the cover of the trade catalog for "Olympic Bronze." Chase giftware typically bears the likeness of the Centaur and the word "CHASE." Early Chase giftware items are often unmarked. Later items are typically marked "CHASE USA" rather than simply "CHASE."

(not related to the American Brass & Copper Company acquired by Chase). Some workers believed that the conglomerates came in and ran the plants into the ground. According to some former Chase workers interviewed as part of the brass workers history project, conditions at the Chase plant became so bad that workers had to wear hard hats to protect them from bricks falling out of the ceiling.

Other factors also contributed to the demise of the rolling mills. After the war, there was an increased interest in aluminum and plastics and a corresponding decrease in demand for brass. In addition, foreign companies had invested in more modern equipment and had lower wages, enabling them to produce brass at a fraction of the cost of U.S. companies. The big conglomerates that owned the brass mills were generally unwilling to put a lot of money into modernization with an uncertain future facing the industry. The final Chase plant in Waterbury was closed in early 1976 after a nine-month strike.

Everedy Company

In 1920, two brothers, Harry J. and Robert W. Lebherz started the Everedy Company in Frederick, Maryland, to manufacture home bottling and preserving equipment. A third brother, William B. Lebherz, joined the firm in 1922.

Although their home bottling business, believed to be the first in the nation, was successful, it proved to be seasonal, leaving the brothers with considerable slack periods. In 1928, they expanded their business to add screen door hardware. Advertising in the *Saturday Evening Post* and *Colliers*, the new line was immediately successful.

Everedy was among the first companies in the nation to install equipment for chromium plating, initially using the equipment to produce home bottling supplies. They devoted their excess capacity to handling work from nearby factories in Baltimore and Hagerstown including plating automobile radiators, bumpers, and decorative hardware.

The Lebherz brothers again expanded their product line in 1933 when they introduced the Everedy chrome plated steel skillet. Within a few years, the skillet line, nicknamed "beauty in a skillet," grew into a full line of chromium-plated cooking utensils under the name "Speedy-Clean™." During the same time period, the brothers introduced an extensive giftware line under the name "Evercraft™ Modern Gift Ware." The giftware line included a variety of chromium-plated trays, cocktail sets, coffee sets, vases, smoking accessories, and serving pieces. The items were distributed nationally as well as in Canada, Mexico, and several countries in South America.

Everedy advertised in the *Saturday Evening Post, Liberty, Good Housekeeping, American Home,* and in a variety of fiction weeklies. The Speedy Clean line enjoyed such success that most of Everedy's production capability between 1935 and 1940 was turned to meeting demand for cooking utensils. Although the Evercraft line continued, production was limited and such items are rare.

With the advent of World War II, the Lebherz brothers repeatedly offered their services to the government only to be told their concern was too small to play an active role in defense production. In 1941, the company succeeded in receiving its first defense contract. To fulfill the contract, however, the company needed specialized welding equipment. Unable to obtain the equipment from welding apparatus manufacturers, Everedy president Harry Lebherz designed, and Everedy machinists built, the welding equipment needed to fulfill the contract on schedule. The company went on to earn the Army-Navy "E" for its efforts.

The company resumed consumer production after the war and prospered into the 1970s. In June 1977, the Everedy Company was sold and the Frederick plant closed.

> Everedy Develops a "Recipe" for Success—Many of Everedy's defense contracts required that Army ordnance items be finished in lacquer. Told that it would take 4 or 5 months to obtain the needed lacquering equipment, Everedy engineers developed their own equipment and submitted the following "recipe" for a lacquering machine to the Philadelphia Ordnance District:
>
> Take one manure spreader from junk yard and remove wheels. Mix with 72 pairs of roller skates; add lumber, an old blower fan, and steam pipe. Stir with electrical energy. Serves millions of Army Ordnance parts with satisfying helpings of lacquer or paint.
>
> The makeshift lacquering equipment enabled Everedy to fulfill its defense contracts on time.

Farber Brothers

Farber Brothers, established in New York City in 1915 by brothers Louis and Harry Farber, is remembered primarily for it collaboration with the Cambridge Glass Company on a line of chromium giftware items with removable colored glass inserts. The two brothers, who prior to 1915 had worked for their brother Simon at the S. W. Farber Co., initially produced silver- and nickel-plated hollowware but began producing chromium-plated hollowware under the trademark "Krome-Kraft™" in the early 1930s.

In 1932, the company patented a cocktail cup with a removable glass insert. The inserts, made principally by Cambridge Glass Co., were available in a range of colors including yellow, green, red, and purple. In addition to the cocktail glasses, Farber Brothers produced a number of other giftware items combining chromium frames with colorful glass inserts. Neither the cocktail cups nor the other items with glass inserts demonstrate the art deco styling typical of other giftware manufacturers of the period. Similarly, their cocktail shakers, while utilizing the same materials characteristic of art deco pieces, seldom achieved the purity of design characteristic of Chase, Manning-Bowman, and Revere. Most of the company's cocktail shakers were introduced in the early or late 1940s. Nevertheless, there is strong collector interest in Farber Brothers products, principally from cocktail memorabilia and Cambridge glass collectors.

Howell Chromsteel™ furniture advertisement (*House & Garden*, October 1938).

Like other giftware manufacturers, Farber Brothers halted consumer production during World War II, turning instead to production of military items. Unlike Chase and Revere, however, the Farber Brothers resumed consumer production after the War. By that time, consumer tastes had changed and there was demand for new designs. Unwilling or unable to introduce new designs, Farber Brothers sales steadily declined and, in 1965, the company closed.

S. W. Farber Co.

At the time of its establishment in 1900, the S. W. Farber Co. was primarily a manufacturer of copper and brass kitchenware. In 1910, the New York City company expanded into giftware, introducing a line of serving pieces under the trademark "Farberware™." With the advent of chromium plating around 1925, Farber expanded its giftware line to include more serving items such as casserole frames and serving platters. And, with the end of Prohibition in 1933, Farber began making a range of cocktail shakers and other drinking accessories. The company's products, for the most part, however, were either blandly or garishly designed, and are not in great demand by art deco collectors. That is not to say, however, that they produced no admirable designs.

By returning to its roots as a kitchenware manufacturer, S. W. Farber was able to avoid the decline that affected so many other giftware manufacturers. Its line of pots and pans, together with percolators and other small appliances, continue to be produced under the Farberware name. Sadly, all goods are now produced overseas.

W. H. Howell Co.

The W. H. Howell Co., established in 1860 in Geneva, Illinois, initially produced "sad irons," now commonly referred to as flatirons. At the time "sad" was used to describe a heavy object in addition to its current use to describe a somber or downcast mood. However, I cannot imagine anyone who had to use one of the old flatirons being anything other than sad. The company prospered and, in 1910, produced half of the sad irons in the United States. The company's 1910 catalog boasted that the

> ...most skilled and highly paid experts in this particular line of manufacture are employed by us and years of attention to one article, the Howell Sad-Iron (ninety-five percent of our product) have enabled us to produce an iron unequaled in style, finish, utility, or durability.

The company's other cast iron products included a variety of doorstops.

In 1924, Howell was purchased by Edward E. Ekvall and William McCredie. Initially, they continued to focus on production of cast iron

objects, including drapery hardware, smoking stands, and plant stands. The items were lacquered black and gold, apple green, or Chinese red to go with 1920s interiors. Ekvall and McCredie soon expanded the product line to include brass-plated and lacquered wrought iron tables with tops of marbelite or glass, and piano and radio benches with upholstered seats.

Howell became one of the first American furniture manufacturers to embrace the styles of the European modernists. By 1927, its showrooms in Chicago and New York were displaying iron furniture with distinctive zigzag, ziggurat, hexagonal, and fluted shapes inspired by European designs. In addition, Howell reproduced many hand-carved European furniture designs in wrought iron, claiming to be able to reproduce the beauty of handcarved wood in metal at a fraction of the price. The company also introduced a line of colorful wrought iron and steel garden furniture, including chairs with octagonal backs and seats of spring steel.

In 1929, Howell became the first American company to introduce tubular chromium furniture. Howell employees adapted designs by Mies van de Rohe and Marcel Breuer and began manufacturing chairs, armchairs, and settees with tubular steel frames chromium plated for indoor use or enameled for outdoor use. Based on the initial success of its adaptations of European designs, the company employed free-lance designers to expand its product line. Most notable of these designers were Abel Faidy and Leland Atwood. The company's product line was expanded to include tubular steel tables, sofas, and smoking stands.

A major boost in the company's fortunes came with the 1933-34 Chicago "A Century of Progress" Exposition. Howell's "Chromsteel" furniture was used to furnish several of the model houses and exhibition buildings. For example, Howell built the Leyland Atwood-designed furniture in the twelve-sided "House of Tomorrow". Tubular steel furniture was used in eighty-seven percent of the fair's exhibition buildings, thus facilitating the public's acceptance of "moderne" furnishings.

So impressed was Howell president William McCredie with the furniture and accessories of the "Sunlight House" that he asked the designer, Wolfgang Hoffmann, to design exclusively for Howell. Hoffmann accepted, and from 1934 to 1942 designed Howell's complete lines of steel furniture. His designs combined flat bars or round tubing with wood, leather, or fabric to produce chairs and sofas or plate glass or glossy black bakelite to produce tables and desks. The company targeted sales primarily toward offices, showrooms, and shops. In addition to furniture, Hoffman designed a wide range of streamlined smoking stands.

The Company further expanded its product line in 1935, introducing a line of "Summer Furniture" using newly acquired equipment for applying synthetic enamel finishes. The line included colorful lounge

chairs, folding chairs, and chaises of tubular or spring steel. The company also introduced a simplified version of the tubular steel "S" chair, the cantilevered form initially popularized by Mies van de Rohe. The simplified version was paired with tubular chromium tables to form "dinette sets." The new dinette sets proved so popular that they became the company's primary products when consumer production resumed after World War II. As consumer interest in tubular chromium dinette sets waned in the 1960s, Howell shifted to production of metal furniture for cafeterias, auditoriums, and waiting rooms. The company was sold to Acme Steel around 1954 and subsequently to Burd, Inc.; both continued use of the Howell trademark. Following a strike, the company was closed in 1979.

Kensington, Inc.

In 1888, Charles Martin Hall, who perfected the process used to separate aluminum from bauxite ore, founded the Pittsburgh Reduction Company. Three years later the plant was relocated to nearby New Kensington, Pennsylvania. Since 1907, the company has been known as the Aluminum Company of America (Alcoa™). Alcoa was established primarily as a producer of raw materials to be sold to other manufacturers for use in a wide range of products. The biggest problem Alcoa faced was convincing other companies of the potential uses of aluminum.

Alcoa's first attempt at marketing consumer products came in 1901 with the establishment of the Aluminum Cooking Utensil Company, Inc., to market aluminum cooking utensils. Two years later, the subsidiary was renamed Wear-Ever Aluminum. Products bearing the "Wear-Ever™" trademark were initially distributed through direct marketing, with sales personnel peddling their wares door-to-door. The company remained in New Kensington until 1967 at which time cookware manufacture was transferred to Chillicothe, Ohio.

In 1934, Alcoa established a new division—Kensington, Inc.—to produce a decorative giftware line under the "Kensington™" trademark. The new line of Kensington giftware, designed by Lurelle Guild, was first shown at a July 1934 trade show in Chicago and went on sale in the fall. Unlike Wear-Ever, Kensington was not made of pure aluminum. Rather it was made from an aluminum alloy that produced a whiter color than pure aluminum. While aluminum does not rust like iron or tarnish like brass or copper, its surface oxidizes, creating a chalky feel. In creating the aluminum alloy used in Kensington, Alcoa overcame this problem for the alloy does not rust, tarnish, or oxidize. As Kensington noted in its promotional literature, the aluminum alloy used in Kensington retains its original lustre with only soap and water.

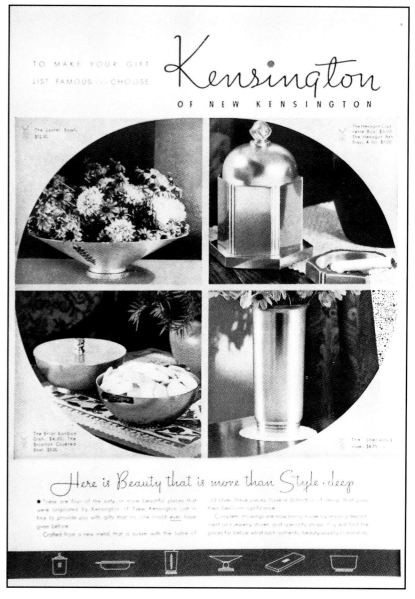

Above: Kensington advertisement (*House Beautiful*, December 1934)

Left: Kensington trademarks.

In introducing the new giftware line, Alcoa noted that Lurelle Guild's designs are not tied to any one period. Although Guild designed the entire Kensington line introduced in 1934, giftware created by other industrial designers was subsequently added. Guild, however, continued to contribute most of the new designs, and Guild designed the overwhelming majority of the Kensington line. This book contains a sampling of Kensington giftware. *Art Deco Aluminum: Kensington* by Paula Ockner and Leslie Piña presents a comprehensive history of the company and its products.

Landers, Frary & Clark

In 1842, George M. Landers and Josiah Dewey established a hardware manufacturing business under the name Dewey and Landers, producing furniture casters, coat and hat hooks, and other hardware items. After Dewey's death in 1847, Levi O. Smith joined the firm and, in 1853, the company was incorporated as the Landers and Smith Manufacturing Company. About that same time, James Frary joined the firm after the Frary and Carey Company of Meriden, Connecticut, was acquired.

The firm became known as Landers, Frary & Clark in 1866 and the manufacture of cutlery was added to the hardware items. Although a successful company, Landers, Frary & Clark's "Universal™" trademark did not become a "universally" recognized name until 1898 when the company took out a patent on a hand-cranked food grinder, the first such product produced in this country. The enormous success of the meat grinder led to the development of additional kitchen appliances, such as the bread maker and cake mixer. Cooking appliances heated by alcohol were also added to the line. With the introduction of electricity, Landers, Frary & Clark further expanded its line, introducing an electric flatiron around 1912. Other electric appliances such as percolators, toasters, and food mixers were soon introduced. With its line of small appliances a success, Landers, Frary & Clark expanded into the production of major appliances including vacuum cleaners, washing machines, and electric ranges, all marketed under the "Universal" trademark.

The "Universal" trademark of Landers, Frary & Clark.

During World War I, Landers, Frary & Clark turned to the manufacture of trench knives, producing over 113,000. Following the war, the company resumed consumer production and, in the early 1920s, was producing a wide range of aluminum cookware including coffeepots, muffin tins, and pots and pans in addition to its electric household appliances. It had offices in New York, Chicago, London, and Paris.

With the advent of chromium plating, Landers, Frary & Clark began producing a wide range of chromium plated ware with a "blue diamond finish," including percolators, waffle irons, toasters, irons, and ornamental tableware. The company also began manufacturing vacuum bottles. Its 1927 vacuum specialties catalog identified company offices in New York, Chicago, Montreal, San Francisco, London, and Paris. The company continued expanding throughout the 1930s.

When the United States was drawn into World War II, Landers, Frary & Clark once again turned to wartime production, producing commando knives, fuses, and gun mounts. Although the company resumed production of consumer products following the war, its fortunes soon took a turn for the worse. Between 1950 and 1960, employment dropped by about a third.

Faced with imminent closure, Landers, Frary & Clark was sold to General Electric in May 1965 in a last ditch effort to preserve one of the nation's most innovative manufacturers. Sadly, General Electric was unable to reverse the company's fortunes and, in May 1969, General Electric closed the company.

Manning-Bowman & Company

Unlike Chase and Revere, whose primary business by the mid-1920s was the operation of rolling mills to produce copper and brass sheets and rods, Manning-Bowman was, from its founding in 1832, a producer of consumer products, purchasing the raw materials from other manufacturers. The types and variety of products it produced, however, changed and expanded significantly over the life of the company. Manning-Bowman was the Cadillac of giftware manufacturers when being compared to a Cadillac was still considered a compliment.

Manning-Bowman initially manufactured tin ware, including pots, pans, and ladles from a plant located in Middletown, Connecticut. The company hired a sales force to sell its wares off the back of horse-drawn wagons. Salesmen would travel to nearby towns once or twice a month, sleeping in the wagon and displaying the tin ware on hooks on the outside of the wagon. The salesmen would stay on their routes until the tin ware had all been sold.

In 1872, the company was purchased by a group of prominent Meriden, Connecticut, citizens. They reorganized the company, naming Edward Manning, President, and Robert Bowman, Secretary-Treasurer, respectively. The business was moved to Meriden and its product line expanded. Within 10 years after moving to Meriden, the company had changed from producing only tin ware to large volume production of mounted enamel ware, Britannia, planished tin, and copper goods.

The company exhibited several of its new line of products at the 1876 Worlds Fair in Philadelphia, marking the nation's centennial. Among the products displayed were enameled tea and coffee pots decorated with fancy flowers and white metal mountings. The company's products were awarded several prizes.

Under the leadership of George Savage, former president of the Meriden Britannia Company, Manning-Bowman continued to expand its product line. Savage was elected president, treasurer, and general manager of Manning-Bowman in 1898. By the early 1900s, the products the company produced consisted mainly of chafing dishes, coffee percolators, prize trophies, solid copper tableware with

English pewter mountings, plated tableware, and a full line of bathroom furnishings. During this period, Manning-Bowman introduced its patented "Ivory" enameled food pan that could be used interchangeably in a number of its chafing dishes. As a result, Manning-Bowman became a leader in the production of chafing dishes. As sales expanded, the company added showrooms in New York and Chicago and established sales agencies in San Francisco and London.

Another major Manning-Bowman innovation, the "Ellipse" mechanical bread kneader, was introduced in 1912. The "Ellipse," the predecessor of today's electric bread making machines, was one of nation's most up-to-date and economical laborsaving devices at the time.

Around 1915, Manning-Bowman began to develop and manufacture electrical appliances, including percolators, coffee urns, toasters, and irons. It continued to produce a wide range of alcohol chafing dishes and stoneware teapots. The company's ability to develop high quality electric appliances was strengthened when, in 1919, Manning-Bowman lured Reginald P. Tracy away from the Graybar Electric Company, at the time the leading producer of electrical appliances. Tracy was subsequently elected president of Manning-Bowman in 1925.

Under Tracy, Manning-Bowman assumed a leading role in the production of electrical appliances. Among his innovations were the Manning-Bowman electric cigar and tobacco lighter, the automatic iron with the Westinghouse "Clicker" control, the waffle iron with the bake oven indicator, and a complete line of electric clocks with Hammond synchronous motors. Tracy was also a member of a group of manufacturers responsible for enactment of legislation to control the 60-cycle frequency of electric power to homes throughout the country. Without such legislation, electric clocks and timers were not practical because they would run faster or slower in different parts of the country and even within states because of differences in the frequency of electric power.

By the late 1920s, Manning-Bowman had perfected the chromium-plating process and was producing stunning art deco coffee and cocktail sets in chromium and catalin. Most of its giftware line, however, continued to display traditional lines. The early art deco giftware items were not, however, aimed at the general public but rather at the wealthy who could afford to pay $60 for a coffee service or $95 for a "mixer" set. Prohibition was in full swing and Manning-Bowman sold "shakers" and "mixers," but not "cocktail shakers."

During the late 1920s, Manning-Bowman experienced financial difficulties and International Silver acquired a controlling interest in the company. International operated Manning-Bowman as a separate division. Prior to International's acquisition of a controlling interest in Manning-Bowman, another International division, the Meriden Brittania Co. owned a large interest in Manning-Bowman.

In 1932, Benjamin J. Tassie was elected president and general manager of Manning-Bowman. Before joining Manning-Bowman as sales manager in 1926, Tassie had worked for General Electric. During his tenure at Manning-Bowman, many new appliances were developed including toasters, waffle irons, and percolators. Manning-Bowman continued to develop innovative electrical devices, such as the automatic percolator with thermostatic controls and safety devices to prevent appliances from overheating. Manning-Bowman was the first company—or among the first companies—to develop electric table cookers, coffee urns, food mixers, drink blenders, and heating pads. Manning-Bowman also introduced the steep method of brewing coffee and was, for many years, the leading percolator manufacturer in the United States. Under Tassie's leadership, Manning-Bowman became the first company to introduce matched sets of kitchen appliances including coffeepots, toasters, waffle irons, and chafing dishes.

In 1933, Manning-Bowman introduced a new line of giftware items designed by Jay Ackerman, including many art deco designs. Although the 1933 catalog still contained many traditional designs, by 1934 the catalog offered further expansion of Manning-Bowman's art deco giftware line. Manning-Bowman produced separate catalogs for its giftware, appliances, and vacuum ware. In addition, for a brief period Manning-Bowman produced some stunning art deco clocks. Such clocks are rare and often command prices in the range of $600-$700.

In 1937, Manning-Bowman introduced a new line of giftware under the Lustralite™ trademark. The line represented another important innovation developed by Manning-Bowman—anodized aluminum giftware. The development allowed aluminum to be produced in many colors with a hard glossy finish free from the chalky oxidation typical of aluminum products. Manning-Bowman also developed a color plating process introduced in its 1941 catalog as Peacock Plate™. Both new finishes met with limited consumer acceptance.

Around 1938, International Silver began selling portions of its Manning-Bowman division. For example, in 1941, the electrical appliance division of Manning-Bowman was purchased by a

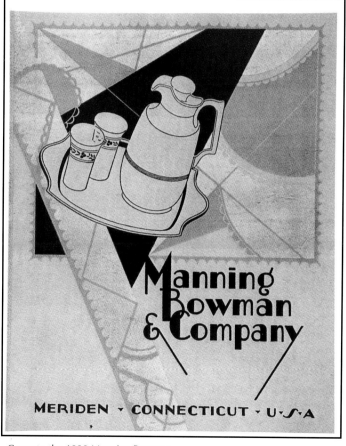

Cover to the 1930 Manning-Bowman catalog for HotaKold™ vacuum containers.

newly formed subsidiary of the Bersted Manufacturing Company of Fostoria, Ohio. A former long-time employee noted that manufacture of the company's best products was soon transferred to Ohio and Manning-Bowman as it existed in Meriden was dismantled. It is not clear whether or when Bersted acquired the giftware and vacuum ware lines.

Manning-Bowman, like most other manufacturers, turned from consumer production to wartime production with the advent of World War II. Production of Manning-Bowman giftware, appliances, and thermal ware was halted.

Bersted resumed production of electrical appliances after the end of the war, continuing to use the Manning-Bowman name. Many of the later Manning-Bowman appliances are marked to show that Manning-Bowman was a division of Bersted and that the appliance was produced in Fostoria, Ohio, rather than Meriden, Connecticut. The products produced by Bersted and its successor, McGraw Edison, never achieved the same reputation for quality that had been a Manning-Bowman hallmark. Production of Manning-Bowman vacuum ware was also resumed after the war. It is not clear whether the Vacuum Specialties Division was owned by Bersted or remained a part of International Silver until its closure in 1951. I found no indication that the production of giftware was resumed after the war.

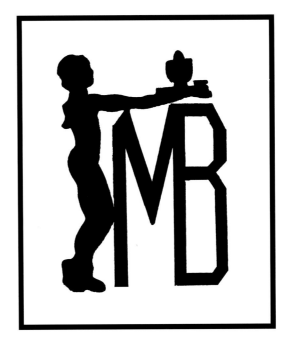

Above & above right: Trademarks used by Manning-Bowman during the 1920s-1930s. The "Means Best" trademark is from the 1920s; the "Server" from the 1930s. After 1935, giftware was generally stamped "Manning-Bowman & Co., Inc. Meriden, Connecticut" without the trademark. Electric appliances produced after the war are often marked "Fostoria, Ohio" rather than "Meriden, Connecticut."

"'MB Means Best' was the Manning-Bowman boast, and we did our best to live up to it. The trouble was that we built so well that our goods lasted a long time. We were proud of this, but when Ben Tassie became sales manager, and later president, he had a different idea. He got us all together and told us that Manning-Bowman products lasted 25 to 30 years. That was too long he said; it was bad for business. What he wanted was a product that could be sold at a reasonable price and would last for only five or six years. In other words, what he wanted was built-in obsolescence." (Former Manning-Bowman inventor/designer Allan Young in an October 1980 interview with the *Meriden Record Journal*.)

Nagel-Chase Manufacturing Co.

The Nagel-Chase Manufacturing Company was established in 1908. Although little is known about the company's early history, the 1917 Chicago *City Directory* shows the company as a producer of lighting systems. The company's officers were Theodore Nagel (President) and Guy M. Chase (Secretary/Treasurer). By 1929, Edward Schulz had been named president of the company and the company was listed as a manufacturer of metal goods rather than lighting systems. The 1951 and 1983 editions of the *Illinois Manufacturers' Directory* listed Nagel-Chase as a manufacturer of casters, pulleys, and metal stampings. Between 1951 and 1983, employment dropped from 250 to 110. The company is no longer listed in Chicago phone directories, but I was unable to determine whether the company was closed, relocated, or sold.

Napier

Like Manning-Bowman, the Napier Co. has always manufactured consumer goods, although its primary focus has been on ladies jewelry. The firm began in North Attleboro, Massachusetts, in 1875 as Whitney and Rice. The name was soon changed to Carpenter & Bliss and was incorporated in 1882 as the E. A. Bliss Company.

The E. A. Bliss Company moved to Meriden, Connecticut, in 1890 and was incorporated under Connecticut law the following year. At that time the company specialized in producing watch chains and silver-plated boxes for carrying wooden matches.

In 1914, James H. Napier joined the firm, following stints with General Electric (1910-1911) and International Silver (1911-1914). He was elected president and general manager of the company in 1920 at which time the company became known as Napier & Bliss. Two years later, the name was shortened to The Napier Company. Mr. Napier remained with the firm until his death in 1960, serving as president and general manager for 40 years.

During the 1930s, Napier introduced a line of silver-plated giftware items, including the famous Penguin cocktail shaker. Many of its designs, including the Penguin, have also been found in chromium but almost always without a manufacturer's mark. It is not clear whether such items were produced by or authorized by Napier.

National Silver Co.

The National Silver Co., producers of the Cavalier™, Emerald Glo™, Perma-Brite™, and Wise Buys™ giftware lines, was established in 1890 by Samuel E. Bernstein. Initially a manufacturer of sterling and plated silverware, the company became known as the National Silver Company sometime before 1904.

In the late 1930s, the company began to expand its product lines, adding a line of plated and unplated base metal tableware (1938), Royal™ electric shavers (1939), field glasses and cameras (1940), a line of pottery cooking and tableware (1941), and ceramic dinnerware and vases (1942). The company continued to expand after World War II, adding new lines of compacts (1944), wallets, toilet cases, and overnight bags (1945), glassware (1946), hair and clothes brushes (1947), Perma-Brite™ chromium-plated hollowware (1947), Cavalier™ copper and chromium giftware (1948-49), pottery (1950), Wise Buys™ chromium plated hollowware, percolators, electric snack servers (1950), and Emerald Glo™ hollowware (1950).

National acquired Cheltenham & Company, Ltd. of Sheffield, England, in the late 1940s, the F. B. Rogers Silver Company in 1955, and the Ontario Manufacturing Company of Muncie, Indiana, in 1956. It appears National Silver also reached some agreement with Kennecott Copper to acquire Chase giftware designs in the late 1940s as many of the items in its new Cavalier, Wise Buys, and Emerald Glo lines bear a striking resemblance to Chase giftware items from the 1930s.

It is not clear how long the National Silver giftware lines were in production, but Emerald Glo items are fairly common, suggesting that the company had moderate success with that line.

Park Sherman

The origins of the Park Sherman Company are somewhat of a mystery. Around 1922, Jacob S. Sherman of Chicago established the Universal Lamp Company at 1018 South Wabash Street. Other than listings in business directories, little is known about the Universal Lamp Company. For example, was it a retail establishment, a manufacturer, or both? The company sold desk lamps, miner's lamps, and smoking articles designed specifically for the Universal Lamp Company by either Jacob Sherman or James H. Horsley. During the mid-1920s to early-1930s, both Sherman and Horsley assigned design patents to Universal.

Among the patents Jacob Sherman assigned to the Universal Lamp Company was a design for a humidor which appears to be the basic design for the Chase Cigar Humidor (No. 533) and Tobacco Humidor (No. 857) as well as the humidor sold under the Park Sherman trademark. Similarly, a design patent for what appears to be the Chase "Slide-Top" ashtray (No. 804A) was awarded to Sherman in 1932 and assigned to the Universal Lamp Company. I have never seen a smoking article marked Universal Lamp Company and believe that Park Sherman may have originated as a tradename for Universal's smoking articles.

The Park Sherman Company appears to be a 1932 spin off of the Universal Lamp Company rather than merely a new name for an old company. Park Sherman first appeared in Chicago business directories in 1932. Although the Universal Lamp Company was not included in the 1932 business directory, it reappeared in the 1936/37 and 1940/41 directories. In addition, although Jacob Sherman no longer assigned his patents to Universal, James Horsley continued to assign patents to Universal through at least 1939.

In a 1956 article, the *Illinois State Register* indicated that Park Sherman had been in business since 1914, moving to Springfield in 1932 with the purchase of the Shanklin Manufacturing Company. I was able to find no confirming evidence to suggest that the Park Sherman Company existed before 1932; 1914 was the date its Shanklin subsidiary was established.

The *Illinois State Register* article also indicated that Park Sherman moved to Springfield from Waterbury, Connecticut, following its acquisition of Shanklin. I found no record of either the Universal Lamp Company or Park Sherman having manufacturing facilities in Waterbury. As many early Universal/Park Sherman articles are stamped "Made of Chase Brass," I believe it is likely that Chase, or one of its subsidiaries, manufactured the products to Jacob Sherman's specifications. One possibility is that the American Brass & Copper Company, a Waterbury consumer products manufacturer that Chase acquired in 1925, had been producing lamps for Universal and that such arrangements continued after American was sold to Chase. This appears plausible because Chase did not manufacture fully assembled lamps until after its acquisition of the American Brass & Copper Company and therefore could not have produced Universal's early lamps.

The link between Chase and Park Sherman was apparently broken in 1932 following Jacob Sherman's acquisition of the Shanklin Manufacturing Company. Following the acquisition, production of Park Sherman products was shifted to the Shanklin plant in Springfield, Illinois. Several of Jacob Sherman's designs continued to be included in Chase catalogs after 1932. Presumably, some arrangement was reached between Chase and Jacob Sherman to permit Chase to continue producing and marketing Sherman's designs under the Chase trademark.

After purchasing the Shanklin plant at a bankruptcy sale, Jacob Sherman rebuilt the company, expanding the plant from 30,000 square feet to over 120,000 square feet. The plant produced products for Shanklin, Park Sherman, and Universal. At its peak, the plant employed about 350. I found no record of either Universal or Shanklin after World War II, but Park Sherman continued to expand into the 1950s with Jacob Sherman continuing to design most of the products. In February 1960, Park Sherman announced that it would close its Springfield plant and go out of business. Jacob Sherman apparently remained as company president until the end.

Company vice presidents William P. and Robert J. Sherman cited three reasons for the company's closure:
• Cigarette lighter imports from Japan and Austria had captured more than 80 percent of the market. Japanese workers earned about $.10-$.15 per hour compared to Park Sherman workers' $2.05 per hour plus fringe benefits.
• Direct competition from giftware manufacturers in the East and South where prevailing wage rates were $.40 to $.50 an hour lower and fewer fringe benefits were offered.
• A price "straight jacket" in the giftware industry caused by the tremendous increase in imports and competition from domestic manufacturers. They noted that the company had not raised retail prices on three-fourths of its giftware line during the past 10 years despite increased production costs.

Although company officials said that they had no plans for the future and that the company was "definitely" not opening somewhere else, the company briefly resurfaced in the mid-1960s as Park-Sherman, Incorporated of Roseland, New Jersey. The company did not appear in the Roseland City Directory and is believed to have been established as a division of Ketchen McDougal, a local office supply company. The company applied for several trademarks and received a patent for a pipe rack during the mid-1960s, but soon disappeared again.

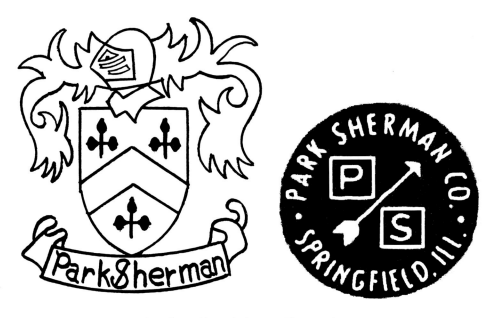

Trademarks used by Park Sherman. The coat of arms mark is from the early 1930s. Some Park Sherman items are marked only with the company name; still others (possibly those to be sold by Chase) bear no markings.

Revere Copper and Brass Incorporated

Revere Copper and Brass Incorporated traces its roots to Paul Revere, hero of the "Midnight Ride." Following the Revolutionary War, Paul Revere, in 1783, began selling copper "slay" bells and brass hinges through his store on Essex Street in Boston. Shortly thereafter, in 1788, he established an iron foundry and, in 1792, began working with copper, casting more than 200 bronze bells, some of which are reportedly still in use in New England churches.

With the nation again facing the prospect of war with England, there was a desperate need for a domestic source of rolled copper. The British had developed a method for making copper so malleable that it could be hammered hot. After many trials, Revere, in 1800, developed the method for rolling copper that is the foundation of the American copper industry. With a $10,000 loan from the Government, Revere purchased land in Canton, Massachusetts, and built the first American mill for rolling copper. The first sheets rolled off the mill in 1801, and a new company was formed—Paul Revere and Son.

In the ensuing years, Revere obtained orders to:
• recopper the frigate "Constitution," enabling it to subdue the Barbary pirates in 1803 and a number of frigates during the War of 1812,
• supply Robert Fulton with copper boiler sheets for all of his early steam-powered craft, with the exception of the "Clermont,"
• produce three tons of copper sheathing, spikes, and nails a week for naval vessels during the War of 1812, and
• cast brass cannon, creating a new American munitions industry.

Perhaps most remarkable was the age at which Paul Revere achieved these accomplishments. He was 67 when he rolled his first copper sheet and 78 at the start of the War of 1812. He died in 1818 at the age of 84.

Although his company made critical contributions to national defense, Paul Revere was better known for his expertise in shaping decorative pieces in wrought silver. Pieces designed by Paul Revere have been displayed in the Metropolitan Museum of Art (New York) and the Boston Fine Arts Museum. Pieces designed and crafted by Paul Revere included a variety of teapots, urns, and vases.

Revere & Son was renamed the Revere Copper Company in 1828 following its merger with James Davis & Son of Boston, a foundry that produced many of the composition castings for ships that Revere & Son had been recoppering. Under the leadership of Joseph Warren Revere, the company continued to flourish. During the Civil War, the Revere Copper Company stepped up its production to a gun a day, including bronze 12-pound cannon for the Army and howitzers for the Navy.

In 1900, the Revere Copper Company merged with the Taunton Copper Manufacturing Company and the New Bedford Copper Company. The new company assumed the name Taunton-New Bedford Copper Company and the name Revere temporarily disappeared. Descendents of Paul Revere, however, continued to play important roles in the new company.

The Rome Manufacturing Company, which later became a part of Revere, was established in 1892 by Jonathan S. Haselton to produce copper teakettles and wash boilers. From its beginnings as a "teakettle factory," the Rome Manufacturing Company soon expanded into the production of a wide range of parts for brass beds. During World War I, the company produced nearly 47 million copper driving bands for large caliber projectiles. Before 1917, the bands were sold to the Allied Governments. Upon entry of the United States into the war, the United States government became the primary customer.

The Rome Manufacturing Company continued to expand the types of products it produced and, by 1927, is said to have produced nearly 10,000 different articles. The articles ranged from tiny button fasteners weighing 61 ten-thousandths of an ounce to rebuilding of a 165 ton locomotive.

On December 31, 1927, the Rome Manufacturing Company became a part of the Rome Brass and Copper Company, temporarily losing its separate identity. Less than a year later, however, the Rome Brass and Copper Company joined forces with the Michigan Brass and Copper Company, the Baltimore Copper Mills, the Dallas Brass & Copper Company, the Taunton-New Bedford Copper Company, and the Higgins Brass & Manufacturing Company to form the General Brass Corporation. Four days later, the name was changed to the Republic Brass Company. On November 12, 1929, the name was again changed, this time to Revere Copper and Brass Incorporated to perpetuate the name Revere in the industry that Paul Revere had founded. The Rome Manufacturing Company regained its separate identity as a division of Revere.

In 1933, the company acquired an interest in the Warren McArthur Corporation and manufacture of McArthur's line of anodized aluminum furniture was moved to Rome from 1933 to 1937. The following year, the Rome Manufacturing Company retained Norman Bel Geddes to design its entire 1934 line of beds.

Shortly thereafter, Revere announced a major giftware line to be produced by its Rome Manufacturing Company Division also based on designs by Bel Geddes. In the introduction to the 1935 Gifts catalog, the President (C. Donald Dallas) stated

> We are proud…to present for the first time in this catalog seventeen items which form the nucleus of a full line of metal Giftwares to be designed by Norman Bel Geddes for Revere. In these items, Mr. Geddes has caught skillfully the tempo of our times. His designs are conservative in their simplicity and yet sophisticated in their smart individuality. We feel very strongly that they reflect a happy and popular balance between progressiveness and traditional beauty.

Although the 1935 giftware line was designed primarily by Norman Bel Geddes, the catalog also introduced designs by William Lescaze, Elsie Wilkins, Leslie Beaton, and Fred Farr. The 1936 catalog added designs by Peter Müller-Munk, Frederick Priess, and Ted Mehrer, while the 1937 catalog introduced designs by Helen Dryden and W. Archibald Welden. The company continued to add new designs for the rest of the decade.

An important turning point in the history of the Rome Manufacturing Company Division occurred in January 1939 with the introduction of the Revere Ware™ line of copper clad cookware. Although sales started slowly, by the end of the year, demand was exceeding production capacity.

With the onset of World War II, Revere again turned its attention to munitions. Each of the company's six divisions won Army-Navy "E"s. The company built and managed three complete plants for the Government and installed and operated government-owned machinery in each of its plants.

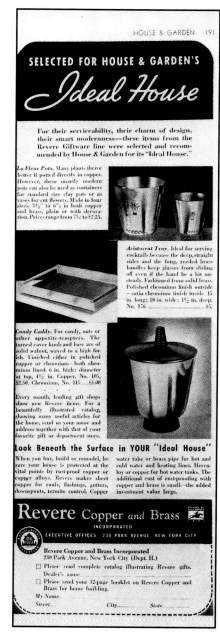

Revere advertisement (*House & Garden*, May 1937). Revere generally marked its giftware "Revere Rome, N.Y." with no other trademark. Many Revere products, however, are unmarked and can be identified only through examination of catalogs and advertisements.

The Birth of Revere Ware™—As manager of the Highway Transportation Department of the Goodyear Rubber Company, Chester M. McCreery helped invent the six-wheel vehicle that revolutionized truck transportation. He organized the Six Wheel Company and marketed the first six-wheel vehicles for commercial and military use. McCreery subsequently sold his interest in the company and decided to take an extended vacation to Europe.

While touring France, McCreery noticed that all French cooking utensils were made of copper. Upon his return to the United States, McCreery, in 1932, presented his idea for a new line of chromium-plated copper cooking utensils to the head of Revere's research department, Dr. R. A. Wilkins, and subsequently to the President, C. Donald Dallas, and Chairman of the Board, Barton Haselton. McCreery was hired and a line of chromium plated copper utensils was soon on the market. The chromium lining, however, failed to hold up. Tests showed that chromium plating was affected by the actions of vegetable acids and would not hold up regardless of the thickness of the plating. Revere returned to the drawing boards.

After extensive testing, Revere found that stainless steel had most of the qualities needed in a good cooking utensil—it was impervious to most food acids, was durable, and resisted corrosion. One major drawback remained, however. Stainless steel does not conduct heat. James Kennedy, the head of the Rome Manufacturing Company Division, suggested that copper be deposited on the outside bottom of the stainless steel utensils to improve heat conductivity.

Kennedy put the full resources of the Revere laboratories to work developing the technology that would permit a thick plating of copper, one and a half times the thickness of the stainless steel, to be deposited on the bottom of a pot. By February 1937, the process had been developed. After further testing and refinement, machinery for the production of Revere Ware was ordered in early 1938. W. Archibald Welden, Revere's Director of Design, was tasked with developing the design for the new cookware. He exceeded expectations, presenting a design that eliminated rivets and other dirt catchers.

Revere Ware premiered at the Chicago Housewares show in 1939 and was an immediate hit. Additional manufacturing plants were soon added but Revere was always in the enviable position of being unable to meet increasing demand. Archibald Welden's cookware design has been in continuous production (except during the Second World War) for nearly 60 years. His design is seen as a major catalyst in the transformation of the kitchen from a stark utilitarian room into a colorful attractive room where the pots and pans are openly displayed.

After the war, the Rome Manufacturing Division returned to production of Revere Ware and, in short order, two new plants—Riverside, California, and Clinton, Illinois—were added to increase production. Sales and profits reached record levels in 1950. By 1957, over fifty million Revere Ware utensils had been produced.

Revere Ware continues to be produced essentially unchanged from W. Archibald Welden's original design.

Shanklin Manufacturing Company

The Shanklin Manufacturing Company was established in 1914 to produce acetylene miners lamps. A Springfield, Illinois, resident, Frank Guy, had invented an improved lamp but lacked the ability to manufacture his new design. George Shanklin set up a workshop on his back porch to produce the lamp. As demand for the lamp increased, Shanklin and his brother Edgar pooled their resources and established a manufacturing center. A third brother, William, soon joined them in the enterprise.

As the company continued to grow, it expanded production to include sheet metal products, miners' dinner pails, smokers' articles, battery charging clips, and metal novelties. In 1929, the company launched production of awning hardware and fabricated awnings of all types under the trade name Shady-Way™.

In 1927, the Shanklin brothers decided to relinquish their interests in the company and retire. "Eastern interests" purchased the company but William Shanklin remained in control of the company for some time after the sale. The Springfield *State Journal* reported in June 1930 that Theodore Hoffacker of New York was the company president, but that operation of the plant was in the hands of employees who had been with the company since its early years. The company, however, did not survive the depression and, by 1932, had been placed in receivership.

Jacob S. Sherman of Chicago purchased the Shanklin company and its manufacturing plant at a bankruptcy sale in 1932. Sherman was president of the Universal Lamp Company/Park Sherman at the time he acquired Shanklin. Sherman continued to operate Shanklin as a separate business for several years even as he moved production of Park Sherman products from Waterbury, Connecticut, to the Shanklin plant. The last record of the Shanklin Manufacturing Company I was able to locate was a January 1937 article in the *State Journal* announcing an addition to the Shanklin plant.

James Horsley designed most of Shanklin's smoking articles, including a variety of roll-top cigarette boxes. The boxes can be found with both Shanklin and Park Sherman markings.

Chapter 3
Selected Giftware Designers

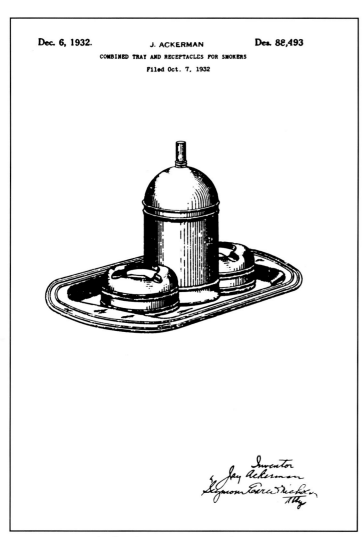

Design patent for the Chase "Four-Piece Smokers' Set" awarded to Jay Ackerman on December 6, 1932.

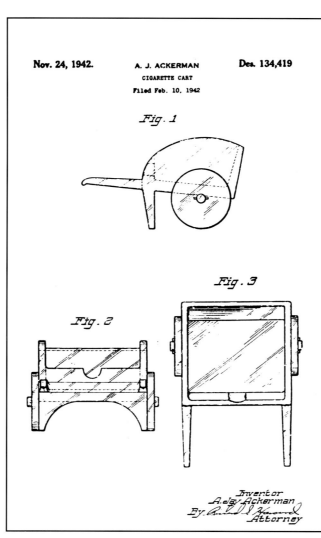

Design patent for a cigarette cart awarded to Jay Ackerman on November 24, 1942. The patent was assigned to the New Martinsville Glass Company.

Charles duBuisson Arcularius

Charles duBuisson Arcularius (1904-1983) is credited with the design of the Chase "Electric Buffet Warming Oven" but it is not clear whether he invented the mechanics of the oven or designed the exterior, or both. The W. L. Maxon Corporation of New York employed him in the early 1940s. Little is known about his other design work.

Arban "Jay" Ackerman

Arban "Jay" Ackerman is best known for his designs for Manning-Bowman although his early work included two designs for Chase, the "Four Piece Smoker's Set" (No. 823) and the "Assembly Smokers Set" (No. 850).

The June 1933 issue of the *Gift and Art Shop*, a trade publication, credits Ackerman with design of a new line of chromium decorative items for Manning-Bowman including

> …many new and unusual beverage accessories, some very good looking containers for sweets, useful little dining table accessories, smart new smokers' items, and many other decorative pieces that will enhance the appearance of the modern home.

Ackerman continued to design for Manning-Bowman through at least 1935 and many of his later designs were pat-

ented, including a number of designs for coffee services, waffle irons, and cocktail shakers. His last Manning-Bowman patent was issued in January 1936.

In the early 1940s, Ackerman designed smoking accessories for the Martinsville Glass Company of Martinsville, West Virginia. Among his designs for Martinsville was a "cigarette cart" shaped like a wheelbarrow. Ackerman's last patent was awarded in December 1942 and little is known about Ackerman's life after 1942.

Oscar Bruno Bach

Oscar Bruno Bach, a German-born and trained industrial designer, specialized in architectural metalwork, winning gold medals for his designs from the Architectural League of New York in 1928 and from Temple Emmanuel in 1929. Among his most notable works are plaques for Rockefeller Center, the Payne Whitney Gymnasium in New York, the Empire State Building, the New York Department of Health, and the S. S. Washington. He also designed the metalwork for such buildings as the city hall in Berlin, Germany, and the Christ Church in Cranbrook, Illinois.

Bach also operated the Oscar Bach Studio, Inc., providing designs to both Revere and Manning-Bowman. Among his employees was Ted Mehrer who designed floral accessories for Revere. Bach himself is credited with design of the line of anodized aluminum giftware Manning-Bowman introduced in 1937 under the tradename "Lustralite."

George E. Ball

George E. Ball (1875-1966), an industrial designer in metal, plastics, and glass, was born in Birmingham, England, on September 6, 1875. According to his entry in the 1940-1941 edition of *Who's Who in American Art*, Ball served as the director of design for several large corporations. Among his designs were several for the American Thermos Bottle Co. In addition to his design work, Ball was a noted lecturer on "Silver Since the 16th Century" and the author of critical and historical articles in numerous publications. His office was located at 250 Park Avenue in New York. He maintained a summer residence in Edgewood, Rhode Island, but while in New York lived at the Hotel Shelton.

Leslie Beaton

British-born Leslie Beaton (1905-1967) designed a number of Revere ashtrays, including the "Stadium" and "Streamline." He also designed the "Fireside Wood Basket." None of Beaton's designs appear to have been patented by Revere or other companies and it is not clear whether he worked directly for Revere or was a freelance designer with one of the design firms.

Helen Bishop Denis

Helen Bishop Denis has been credited with the design of 7 Chase items, most of which incorporate porpoises as decorative accents: the "Dolphin Box" (No. 856),

"Porpoise Candlesticks" (No. 24008), "Ivy or Fish Bowl" (No. 90098), the "Brigantine Cigarette Server" (No. 887) and the "Tarpon Fish Bowl" (No. 90125). Her only Chase designs not incorporating dolphins were the "Marmalade and Jam Globes" (No. 90068) and the "Drum Light" (No. 1010).

Henry Dreyfuss

Henry Dreyfuss (1904-1972) began his career as a stage designer for the theatre after studying at the Ethical Culture School in New York. In that capacity, he worked with Norman Bel Geddes on designs for several hit shows. After working briefly as a design consultant for Macy's, Dreyfuss, in 1929, opened his own Madison Avenue office in New York. He later opened a second office in Pasadena, California.

Dreyfuss was a founding member of the Society of Industrial Design and the first president of the Industrial Designers Society of America. Among his designs were the General Electric flat top refrigerator, the "Big Ben" alarm clock for Westclox, the "Toperator" washing machine for Sears, Roebuck, Crane bathroom fixtures, thermalware for the American Thermos Bottle Company, Bell telephones, Hoover vacuum cleaners, and John Deere tractors. On a larger scale, he designed the New York Central Railroad's *Mercury* and *Twentieth Century Limited*, the Cities Service Douglas airplane, the first modern Western Union office, and the oceanliners *Constitution* and *Independence*.

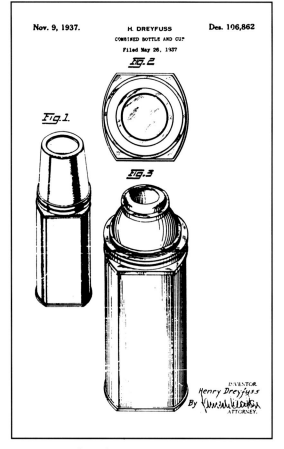

Design patent for a Thermos™ bottle awarded to Henry Dreyfuss on November 9, 1937.

Dreyfuss also lectured, contributed articles, and authored two books on industrial design, *Designing for People* (1955), and *The Measure of Man* (1960). After retiring from his design firm in 1968, Dreyfuss continued to do consulting work. He died in 1972.

Helen Dryden

Helen Dryden (1887-1981) was a graphic artist, posterist, painter, and set designer. A native of Baltimore, Maryland, Dryden graduated from the Pennsylvania Academy of Fine Arts. She was the leading female cover illustrator of the international editions of *Vogue* in the teens and twenties. She also worked for the *Delineator* and other American publications. During the early 1930s, she was the art director for the Dura Co. of Toledo, Ohio. In addition, she is credited with the design of two giftware items for Revere, the "Candlesphere", and the "Masque" lamp, both added to the giftware line in 1937. Ms. Dryden considered her most important work to be her automotive designs, which included the stunning interior of the 1937 Studebaker. Ms. Dryden's work also included fabric designs, design of stage sets, packaging, and portrait painting.

Charles W. Elsenheimer

Charles W. Elsenheimer (1904-1995) worked for Manning-Bowman from 1922 to 1940 and is credited with design both of consumer products and machinery. Elsenheimer was a skilled sculptor and designed the ornamentation on a number of Manning-Bowman products. To commemorate the end of Prohibition, he sculpted a small figure of Uncle Sam seated with a beer in his hand. Although he received at least one offer to mass-produce the statue, he decided against commercial production. Among the sculpturing he did for Manning-Bowman was a stylized seal balancing a chromium-plated ball on its nose. The seal was developed as an accessory for an ashtray designed by E. A. "Bert" Farr. In introducing the "Juggler" ashtray in its 1934 catalog, Manning-Bowman noted that

Adroitly fastened but appearing to balance on the seal's nose is a chromium plated ball containing water; simply touch a burning cigarette to the small hole in the under side of this balanced ball and a drop of water extinguishes the cigarette immediately.

Elsenheimer also made significant contributions to the use of chromium plating. As one of the pioneers in the use of chromium, Manning-Bowman developed many of the production methods. Among those methods was a special rack de-

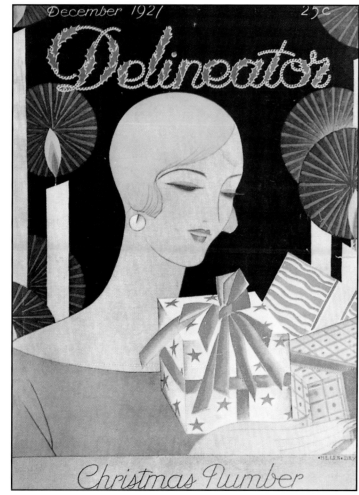

The Helen Dryden cover of the 1927 Christmas issue of the *Delineator*. Dryden's covers for Vogue and the Delineator during the 1910s and 1920s were early examples of art deco graphics.

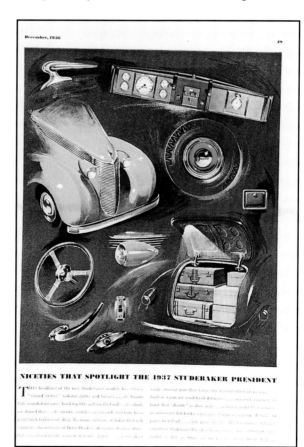

Advertisement for the 1937 Studebaker highlighting the design work of Helen Dryden. The ad copy reads "Its roomy interior, styled in that rich simplicity characteristic of Helen Dryden's designing..." The top of the line Studebaker President 8 sold for $965. (*Esquire*, December 1936)

signed by Elsenheimer that enabled the chromium plating to fully cover all of the "nooks and crannies" in the piece.

During the Depression, Elsenheimer, who had been making $45 a week, was temporarily laid off by Manning-Bowman. He was out of work for several weeks before Bert Farr was able to bring him back at a salary of $.60 an hour.

After he left Manning-Bowman in 1940, Elsenheimer worked for about 14 years with the Charles Parker Company. Among the products he developed and patented for Parker was the "no fog" mirror and a number of other bathroom accessories. Elsenheimer next worked for the Prentice Company, designing the assembly used in "Keytainer" cases made by its subsidiary, the Buxton Company.

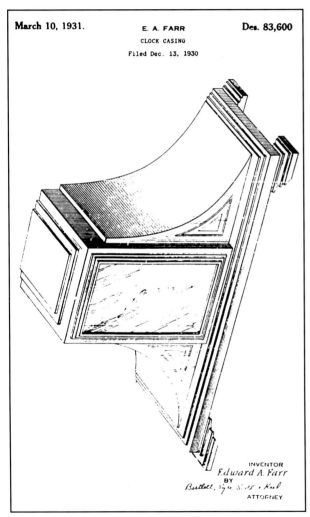

Design patent for a Manning-Bowman clock casing awarded to E. A. (Bert) Farr on March 10, 1931.

Edward A. "Bert" Farr

Edward A. "Bert" Farr, Manning-Bowman's plant superintendent during most of the 1930s, was awarded ten design or mechanical patents for Manning-Bowman products between 1923 and 1936. Among his most notable designs were the "Baker's Man" covered casserole and the "Stowaway" tray, both introduced in 1934. Between 1923 and 1925, he was awarded six patents for his designs of coffeepots, urns, and trays. His next patent, for design of a clock casing, was not awarded until 1931.

Fred D. Farr

Fred D. Farr (1894-1969) designed the entire line of "Scroll" bookends and magazine racks that Revere touted "as the modern successor to bulky bookends." The scroll holds books and magazines in place through spring action. In its 1937 Gifts catalog, Revere notes that the basic scroll with unadorned hemi-sphere was the largest selling bookend ever designed. Farr also designed the simple but elegant "Service Cup," a chromium bowl with a red or blue tumbler for serving fruit, sherbet, shrimp cocktails, or fruit juice and the "Smokette" a unique smoking set composed of a satin chromium base with removable glass containers to hold cigarettes and ashes.

All of Farr's patents are for Revere giftware.

Norman Bel Geddes

Norman Bel Geddes (1893-1958) was arguably the preeminent American industrial designer of the 1930s and certainly one of the top five as cited by Forbes magazine in 1936. Born in Adrian, Michigan, on April 27, 1893, Geddes described himself as generally self-educated, but he attended the Cleveland School of Art.

After completing his education, Geddes worked briefly as an advertising draftsman in Detroit. He became active in the theatre, writing his own play and then designing sets for six theatrical productions in Los Angeles. Geddes designed sets for over 200 plays and operas and, in 1918, became the stage designer for the Metropolitan Opera. Upon returning to California seven years later, he designed film sets for Cecil B. De Mille and D. W. Griffith.

Eric Mendelsohn, a German Expressionist architect, was an early influence on Geddes. In 1924, Mendelsohn gave Bel Geddes a book of his designs and a drawing of his Einstein tower, an early example of streamlining. Geddes became one of the strongest advocates of streamline styling.

Influenced by Mendelsohn, in 1927 Geddes gave up a successful career as a stage designer to become an industrial designer. Geddes designed interiors for J. Walter Thompson (1932), the Manhattan Room at the Hotel Pennsylvania in New York, New York's Theatre Guild Theatre (with Howard Crane), Philco radios (1931), a Graham Paige automobile, radio cabinets for RCA, metal bedroom furniture for Simmons (1929), and a giftware line for Revere. He designed Revere's entire 1934 line of bed frames and most of the items included in Revere's 1935 giftware catalog. His skyscraper cocktail shaker is generally viewed as the ultimate example of streamline styling.

Only three years after deciding to become an industrial designer, Geddes became the first consultant designer to gain public recognition when he was profiled in Fortune. His 1932 book Horizons detailed his technologically oriented philosophy of industrial design. He also wrote Magic Motorways and contributed to the theatre section of the Encyclopedia Britannica.

Geddes was on the planning board for both the 1933 Chicago "A Century of Progress" Exposition and the 1939 New York "World of Tomorrow" Fair. At the 1939 New York Fair, Geddes designed the Futurama "City of Tomorrow" exhibit for General Motors, one of the most popular exhibits at the Fair. Sometimes referred to as the "P. T. Barnum of industrial design," many of Bel Geddes designs were visionary but not particularly practical. For example, his designs for an oceanliner and airliner were never commercially produced. His oceanliners did, however, exist in the movies and it is not clear whether they were ever intended for commercial production. Geddes' designs that found their way into production, including the Graham Paige automobile, often became among the preeminent designs in their field.

Gerth and Gerth

Gerth and Gerth was a design team composed of Ruth L. and William H. Gerth. Little is known, however, about the design firm and its years of operation. For example, the Gerths are described as husband and wife or brother and sister depending on the source. William Henry Gerth was born in Chicago, Illinois, on November 22, 1892. In his 1936 application for a Social Security number, Gerth identified his employer as Oneida, Ltd. He was awarded a number of design patents in the 1930s, all of which were assigned to Oneida.

Ruth Gerth was one of the earliest and most prolific Chase designers, being credited with design of about thirty giftware items. Among her most notable products were those designed using toilet floats—the "Glow Lamp" (No. 1001), the "Ball Lamp" (No. 11235), the "Rain Beau Watering Can" (No. 05002), and the "Watering Can" (No. 11173). Three of her designs, the "Four-Tube Bud Vase" (No. 11230), the "Mint and Nut Dish" (No. 29003) and the "Candy Dish" (No. 90011) were among the best selling Chase items. Some of her early designs, such as the "Ice Servidor" (No. 90001) and "Disc Candlestick" (No. 24005) did not sell as well because the nation was still in the throes of the Depression. As a result, such items generally command significantly higher prices.

In addition to her designs for Chase, Ruth Gerth did design work for the McGraw Electric Company of Chicago (lap trays) and the R. E. Dietz Company (lanterns).

Lurelle Van Arsdale Guild

Lurelle Van Arsdale Guild (1898-1985) was one of the most prolific industrial designers of the 1930s. After studying painting at Syracuse University's College of Fine Arts, Guild initially made a living designing for the theatre and selling cover artwork to *House and Garden* and *Ladies Home Journal*. He later collaborated with his wife on drawings for *Women's Home Companion*, *McCall's*, *House Beautiful*, *Country Life*, and *Designer*. In addition to his drawings, Guild wrote prolifically about antique furniture.

Guild did not turn his talents toward industrial design until 1927. He sometimes executed 1,000 or more designs a year. For example, he designed the entire line of Kensington giftware introduced in 1934 as well as the extensive lines of lamps and lighting fixtures introduced by Chase that same year. Many of the design elements Guild employed in his collection of giftware for Kensington, such as the use of laurel leaves and arrows, were carried forward into his collections of lamps and light fixtures for Chase, particularly the collection of Empire-styled lamps. In addition to lamps and light fixtures, Guild designed numerous other Chase giftware items. Similarly, he continued to contribute new designs for Kensington giftware throughout the 1930s. Guild's collections for Kensington and Chase demonstrated an ability to offer fresh interpretations of period designs, designs that could be used either with period or modern furnishings. He also designed smoking articles for the American Pullmatch Corporation.

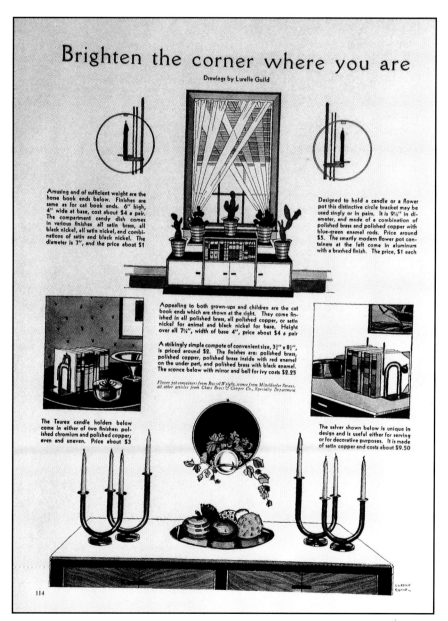

A Lurelle Guild drawing for *The American Home* featuring Chase and Revere giftware (February 1933).

In addition to his giftware and lighting designs, Guild was active in the design of other consumer products, including the 1937 Electrolux™ Model 30 vacuum cleaner, a Norge™ refrigerator, pots and pans for Wear-Ever™ aluminum, and washing machines for General Electric and Montgomery Ward.

Guild lived in Darien, Connecticut, in an Early American village that he moved from New Hampshire and restored. The offices of his design firm, Lurelle Guild Associates, Inc. were located in New York at 545 Fifth Ave.

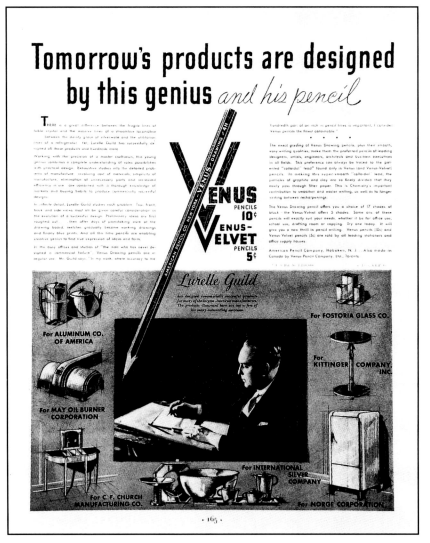

Advertisement for Venus Velvet™ pencils showing some of the products designed by Lurelle Guild (*Fortune,* July 1934).

Wolfgang Hoffmann

Wolfgang Hoffmann (1900-1969), son of secessionist architect Josef Hoffmann, was the resident designer for the W. H. Howell Company during the second half of the 1930s. After studying architecture in Vienna under Oskar Strnad and Josef Frank, Hoffmann worked for 2 years as an architect in his father's office, designing a number of estates in Europe including the Stocklet Palais in Brussels. He and his first wife, Polish designer Pola Hoffmann, moved to the United States in 1925. Settling initially in New York, Hoffmann worked with Joseph Urban, who had formed the American branch of the Wiener Werkstatte, and Elly Jacques Kahn designing stores, theatres, and apartments. Hoffmann and his wife subsequently opened their own Madison Avenue studio where they created furniture, textiles, and decorative accessories. Wolfgang and Pola Hoffmann joined Donald Deskey, Paul Frankl, Bruno Paul, and other well-known modernists in organizing the American Designers Gallery to promote contemporary industrial design.

In 1933, Wolfgang Hoffmann was commissioned to design the interiors of the "Sunlight House" at the Chicago "A Century of Progress" World's Fair. Hoffmann also worked with Joseph Urban in developing the dramatic color scheme used at the fair. So impressed was W. H. Howell Company president William McCredie with Hoffmann's work at the World's Fair that he hired him to design exclusively for Howell. Between 1934 and 1942, Wolfgang Hoffmann designed virtually all of the tubular chromium furniture and smoking stands produced by Howell. Among his accomplishments was the development of the "dinette set."

Hoffmann left the Howell Company in 1942 when consumer production was halted because of the war effort. He never returned to industrial design, devoting the remainder of his life to a successful career in commercial photography.

James H. Horsley

James H. Horsley (1896-1979) is best remembered for his design of a collection of roll top cigarette boxes. Design of the boxes has sometimes been incorrectly attributed to Walter von Nessen. Although his patents were most often assigned to Shanklin of Springfield, Illinois, he also assigned patents to the Universal Lamp Company and Park Sherman. His roll top cigarette boxes have been found with both Shanklin and Park Sherman markings.

Ray Rice Hutcheson

Ray Rice Hutcheson is best known for his designs of figural cigarette lighters for Wm. DeMuth & Co. and cigarette boxes for the Everedy Company of Frederick, Maryland. Hutcheson's design patents assigned to Wm. DeMuth in the early 1930s include a knight in armor whose helmet lifts to reveal a cigarette lighter and a young caddy with a golf bag that opens to reveal a lighter. In the mid-1930s, he assigned patents for pen holders to Diecasters, Inc. of New York.

By 1936, Hutcheson had moved to Frederick, Maryland, and was designing for Everedy. In addition to cigarette boxes and ashtrays, his Everedy designs included trays and other giftware items. Among Hutcheson's best selling (but not

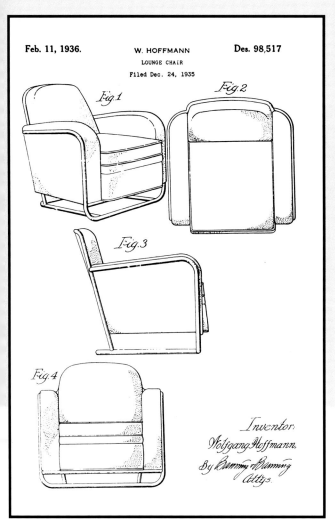

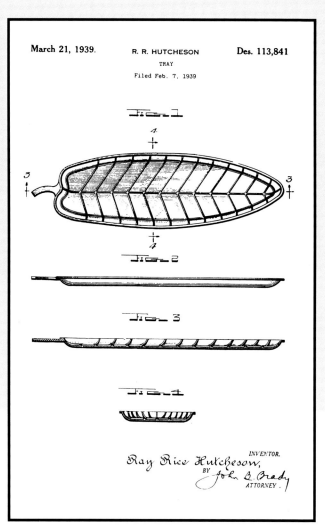

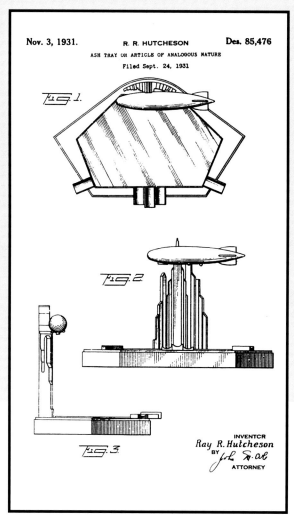

An example of a lounge chair designed by Wolfgang Hoffmann for the Howell Manufacturing Company.

Design patent for a tray awarded to Ray Rice Hutcheson on March 21, 1939. The patent was assigned to the Everedy Company.

Design patent for an ashtray awarded to Ray Rice Hutcheson on November 3, 1931.

necessarily his best) designs was a simple round ashtray with two donkeys in the middle whose exaggerated ears serve as cigarette holders. A similar ashtray features two pelicans whose beaks form cigarette holders.

Alphonso Iannelli

Born in Andretta, Italy, on February 17, 1888, Alphonso Iannelli is known primarily as a sculptor. Among his most notable commissions were sculptures in the Sioux City, Iowa, courthouse, the St. Thomas Aquinas High School and St. Patrick's church in Racine, Wisconsin, and the Adler Planetarium in Chicago. As an architect, he is known for his design of the Immaculata High School in Midway Gardens, the Goodyear Building at the Century of Progress Exposition in Chicago, and the Winnebago County Court House in Oshkosh, Wisconsin.

Iannelli also worked as an industrial designer, most notably for the Chicago Flexible Shaft Company, later known as the Sunbeam Corporation. Perhaps his most memorable design is the 1938 hourglass shaped Sunbeam Coffeemaster™.

Rockwell Kent

Rockwell Kent (1882-1971) was a painter, graphic artist, architect, and book illustrator. He graduated from Columbia University with a degree in architecture. Best known as the foremost American book illustrator, Kent also designed book jackets, bookplates, and national advertising campaigns. Among his larger works were murals commissioned for the U.S. Post Office in Washington, D.C. Kent also wrote three autobiographical works, including *It's Me, O Lord*, published in 1955.

Kent was not an industrial designer, but created a design depicting Bacchus for Chase that was placed on three Chase giftware items, the "Rockwell Kent Cigarette Box" (No. 847), the "Bacchus Wine Cooler" (No. 27015) and the "Bacchus Wine Bottle Holder" (No. 27016). It is not clear who designed the actual items, among the most sought after by Chase collectors.

Harry Laylon

Harry Laylon (1911-1997) was the Resident Designer and later the Director of Design for Chase. In a listing prepared in 1997, Laylon identified Chase giftware items that he designed or redesigned. A listing of those items is included in Appendix I. While Russel Wright is frequently considered the "boy wonder" of industrial design, Laylon completed all of his Chase designs while still in his twenties.

Laylon studied architectural design at New York University and industrial design at the Pratt Institute. In addition, he studied product design and interior design at Gilbert Rhode's New York studio. Following completion of his studies, Laylon, in July 1933, joined Chase. Chase's initial efforts to develop a giftware line had met with mixed success with many of the designs submitted by freelance designers proving too costly or impractical to produce. Only 22 years old at the time, Laylon convinced Chase management that working directly in the engineering department would enable him to learn all facets of the manufacturing process, resulting in development of designs that would be cost effective. Laylon was hired as resident designer and given workspace adjacent to the engineering department. His close working relationship with the engineering staff enabled him to design the types of low cost items that became the staples of the Chase line, items such as the bar tool, cocktail tray, and tea caddy. Of course, he also designed many higher cost giftware items such as the Clipper bowl.

In September 1937, Laylon was appointed Director of Design and transferred to Chase's New York offices. In that capacity, he continued to design new giftware but also purchased services from outside designers and directed design work for all Chase divisions. In addition to designing items bearing the Chase trademark, Laylon designed items as a service for Chase customers. For example, he designed plumbing fixtures and bathroom accessories that Chase produced for Sears, Roebuck, and Co. and lipstick tubes and mascara boxes that Chase produced for such cosmetic firms as Prince Matchabelli and Harriet Hubbard Ayers.

Another important role Laylon played at Chase was the design of "Chase Shops" established in hundreds of gift shops and department stores nationwide. Laylon's marketing expertise propelled Chase to the leadership position in chromium giftware despite its late start in giftware manufacture. So successful were Chase shops that they even appeared in the movies. The 1936 Metro-Goldwyn-Mayer film *The Longest Night*, starring Robert Young and Florence Rice, takes place in a fictional department store. Clearly visible in the background of several scenes is a Chase shop.

Kennecott Copper, which had purchased a controlling interest in Chase in 1929, decided in the late 1930s to discontinue some manufacturing divisions including the giftware line. Mr. Laylon's position was abolished at the end of 1939 and, as Mr. Laylon recalled in 1992, efforts to develop new items for the giftware line essentially ended. Although some new items were added to the catalog between 1940 and 1942, they had, for the most part, been designed prior to Laylon's departure. Laylon did, however, continue to submit designs to Chase as a freelance designer after his departure.

After a brief stint as a freelance industrial designer with clients such as Kodak, Laylon, in August 1940, joined the Samson United Corporation, an electrical appliance manufacturer. In addition to being in charge of all product design, Laylon continued his freelance work. With the outbreak of World War II, Laylon was made Assistant Plant Superintendent and oversaw the manufacture of war materials such as power gun turrets for the Grumman "Avenger" bomber. He was also in complete charge of plant facilities including redesigning the plant for wartime production and design and engineering of all construction projects.

After the war, Laylon returned to his role in the design of electrical appliances, but expanded his design work to include both the exterior design and the design of internal mechanisms. Among his most unusual designs for Samson was the first "tandem" toaster. Laylon's freelance work also flourished in the

postwar years. His designs included photographic equipment, fire extinguishers, vending machines, lamps, and housewares. Building on his experience in designing Chase shops, he also turned his design talents toward retail store layouts.

In 1948, Laylon joined the Syracuse Ornamental Company, better known as Syroco, as Director of Design. Laylon remained at Syroco for the rest of his career, rising to the position of Senior Vice-President of Design and Engineering. At Syroco, Laylon essentially turned a company with a limited product line into a major manufacturer of wall decorations, injection molded plastic furniture, and giftware. In recognition of these contributions, he received the "Man of the Year" award from Dart Industries, Syroco's parent company. He retired in 1976.

William Lescaze

William Lescaze (1896-1969) was a Swiss-born architect and designer active in both the United States and France. Following World War I, he spent two years working on projects for the Committee for the Reconstruction of Devastated France before immigrating to the United States in 1920. After initially working as a draftsman in Cleveland, he set up his own architectural design practice in New York in 1923. His best known architectural design is probably the 1929-32 Philadelphia Savings Fund Society (PSFS) building, an early international style building on which he collaborated with George Howe. Other notable projects included the 1938 studios for the Columbia Broadcasting System, the 1942 Longfellow House Office Building in Washington, D.C., and the 1930-31 Frederick Vanderbilt House (New Hartford, Connecticut), one of the first International Style houses built in the United States.

Although best known as an architect, Lescaze was also active in the decorative arts and metalwork, particularly after the Second World War. For example, he designed a clock, desk set, coat rack, desks, chairs, and ceiling lights for the PSFS building and microphones for CBS. His works were included in many exhibitions during the late 1920s and 1930s. For example, he designed a room setting for the 1928 "Exposition of Art in Industry" at Macy's department store in New York City.

Lescaze is credited with design of the "Duet" salt and pepper shakers introduced in Revere's 1935 catalog.

Ted Mehrer

Ted Mehrer (1900-1995) designed two plant accessories for Revere, the "Jefferson" (Nos. 7052 and 17052) and the "Hamilton" (Nos. 7051 and 17051). Both featured pots suspended from arrow wall brackets. I was able to identify no design patents awarded to Mehrer for his work with Revere or other companies. At the time his designs were added to the Revere catalog, Mehrer appears to have been working for Oscar Bach Studios in New York. Bach was credited with design of the Manning "Lustralite" line of aluminum giftware introduced in 1937.

August J. Mitchell

August J. Mitchell (1891-1970) of New York, New York, designed both the cases and the mechanics for the Chase "Bomb" and "Airalite" flashlights. Although little is known about his other design work, he was employed by the American Machine and Foundry Co. in Brooklyn in the mid-1930s.

Peter Müller-Munk

Peter Müller-Munk (1904-1967) was born and trained in Germany and was already an accomplished craftsman when he showed his work in an independent display at the 1925 Paris exposition. In 1926, he moved to New York, initially working as a designer for Tiffany's. Shortly thereafter, he established his own studio to create works on private commission.

Müller-Munk played an important role in establishing industrial design training courses at Pittsburgh's Carnegie Institute of Technology (now Carnegie-Mellon University). He was an associate professor at Carnegie between 1934 and 1945, establishing the first degree-granting program in industrial design in the United States.

Müller-Munk's 1936 Normandie pitcher for Revere is regarded as among his boldest designs. Another of his more famous designs was the casing for the Waring "beehive" blender. Bandleader Fred Waring invented the mechanics of the blender. Müller-Munk's other designs include clocks, bath brushes, and casings for vending machines. Clients included Texaco, U. S. Steel, and Westinghouse.

Frederick Priess

Frederick Priess designed a number of giftware items introduced in Revere's 1937 catalog, including the "Cocktail Hour" tray (No. 185), the "Sugar and Creamer" (No. 788), the "Cordiality" tray (No. 789), the "Condiment Set" (No. 804), the "Manhattan" candlesticks (No. 159) and the "Candy Caddy" (Nos. 105 and 115). Priess was not awarded patents for any of his designs and it is not clear whether he was employed by Revere, had his own design firm, or worked for a design firm.

Adolph J. Recker

Adolph J. Recker was awarded a number of design and mechanical patents for battery operated candles and flashlights. He was awarded a patent for a "portable electric lamp" on October 13, 1914, which he assigned to the Waterbury Manufacturing Company (Chase). His most notable design was the "Binnacle" Lamp (Nos. 25001 and 25002).

Howard F. Reichenbach

Howard F. Reichenbach (1902-1959) designed a number of Chase giftware items, most notably both the "Gaiety" and "Blue Moon" cocktail shakers. His other

Chase designs included the "Comet" lamp, the "Electric Snack Server," the "Riviera," "Golfer's," and "Whirligig" ashtrays, and the "Hi-Lo" smoke stand. He was awarded both design and mechanical patents.

As a Chase employee, Reichenbach held positions as an industrial designer, development engineer, product engineer, and manager of sales planning. After leaving Chase, he became president of Creosole, Inc. (1950) and his own company, Connecticut Products (1955). He died January 26, 1959.

Albert Reimann

Albert Reimann (1874-1971) was a German metalworker and teacher active in Berlin and London who designed three of the rarest Chase candlesticks, the "Dee Handle" (No. 21006), the "Curl" (No. 21007), and the "Crescent." (No. 21008). Inspired by the British Arts and Crafts movement, Reimann founded the School for Small Sculpture (Schülerwerkstätten für Kleinplastik) in Berlin in 1902. The school soon expanded and by the 1920s had upwards of 1,000 students studying a wide range of decorative arts.

Around 1932, Reimann produced designs for Chase in the Vienna Secession style. In 1935, when Hitler introduced the anti-Semitic Nuremberg Laws, Reimann was forced to sell his school to architect Hugo Haring. Reimann moved to London where, in 1936, he established a new Reimann School. Both his original school in Berlin and the new school in London were damaged during bombing raids in World War II.

Jacob S. Sherman

Jacob S. Sherman was the president and chief designer for both the Universal Lamp Company and Park Sherman. In addition, he purchased the Shanklin Company in 1932. During most of the 1920s and 1930s, virtually all design patents awarded to Universal and Park Sherman were for Jacob Sherman designs. The only other designer holding patents for Park Sherman or Universal articles is James Horsley. Many early "Chase" smoking accessories were actually Park Sherman or Universal designs that were distributed by Chase. As such, Jacob Sherman likely designed them. For example, Sherman's 1930 design patent for a tobacco humidor, which he

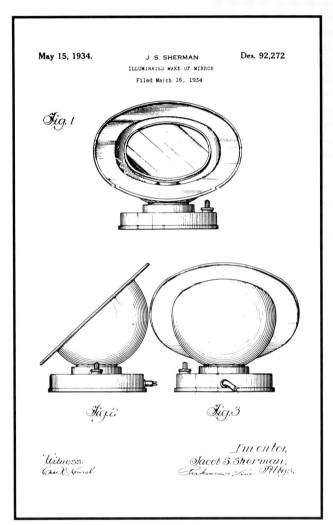

Design patent for an illuminated make-up mirror awarded to Jacob S. Sherman on May 15, 1934. The patent was assigned to the Park Sherman Company.

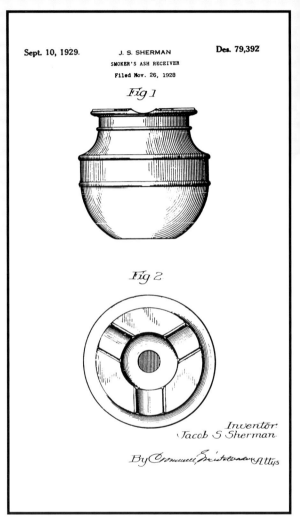

Design patent for an ashtray awarded to Jacob S. Sherman on September 10, 1929. The patent was assigned to the Universal Lamp Company, the predecessor to Park Sherman.

assigned to the Universal Lamp Company, bears a strong resemblance to the Chase "Tobacco Humidor" (No. 857). Similarly, his 1932 design for an ash receiver appears to be the Chase "Slide Top" ash receiver (No. 804).

Among the Park Sherman smoking accessories distributed by Chase were the "Eclipse Ash Tray" (No. 809), the "Humpty Dump Ash Tray" (No. 500), the "Ball Ash Tray" (No. 805), the "Cigarette Container" (No. 541), the "Marionette Ash Tray" (No. 304), the "De Luxe Cigarette Set" (No. 815), the "Cigarette Server and Ash Tray" (No. 806), the "Smoker Set" (No. 560), the "Cigarette Server and Ash Tray" (No. 812), the "Tripod Ash Tray" (No. 301), the "Brocaded Table Lighter" (No. 522), and the "Stayright Set" (No. 302). The principal decorative touch on most of the ash trays and cigarette servers is the use of raised parallel bands of polished brass. This design element is typical of the work of Jacob Sherman.

Sherman continued to design for Park Sherman until the company closed in Springfield, Illinois, in 1960. His last patent was awarded July 19, 1960, 5 months after plans to close the company were announced.

Benjamin M. Tassie

Benjamin M. Tassie joined Manning-Bowman in 1926 as sales manager and six years later was elevated to president and general manager. Although not principally a designer, Tassie holds a design patent for a vacuum jug and is credited with the idea of developing complete matched sets of kitchen appliances including percolators, urn sets, waffle irons, and table roasters. At the same time Tassie is praised for his marketing and innovations, he is criticized for his efforts to cut costs. In an October 1980 interview, former Manning-Bowman engineer Allan Young recalled Tassie getting the staff together and telling them that Manning-Bowman products lasted too long—25 to 30 years—which was bad for business. He suggested that products be designed to last for only 5 or 6 years so that customers would buy products more often.

Walter von Nessen

Walter von Nessen (1889-1943), a German-born industrial designer, studied in Berlin under Bruno Paul. His early work included redesigning the interiors of Berlin subway stations and designing furniture in Stockholm. In 1923, he moved to New York where he initially focused on designing furniture and interiors for Manhattan homes and apartments. Four years later, he founded his own firm, the Nessen Studio, to design and manufacture lamps and other accessories. His studio flourished and in 1930, when many other businesses were failing, the Nessen Studio announced an expansion and released a catalog containing 30 lamps, mirrors, and tables. In addition to designing and manufacturing lamps and accessories under its own name, the Nessen Studio designed prolifically for other companies, most notably Chase, the Efcolite Corporation, and A. H. Heisey.

Von Nessen, along with Ruth Gerth, was among the designers called on to develop the initial Chase giftware line. Von Nessen is reported to have contributed 10 designs to Chase in 1930. Among his most notable designs for Chase

are stylized bookends and coffee services. Von Nessen was particularly adept at taking preexisting metal parts from Chase's inventory and turning them into decorative items.

Another of von Nessen's customers during the early 1930s was the Efcolite Corporation. His designs for Efcolite included coffee urns, pitchers, and lighting fixtures. Although much of his work was in metal, he also designed some wooden furniture.

Von Nessen's designs were widely shown in exhibits in the United States and abroad. For example, his work was shown alongside that of Mies van der Rohe at the influential 1929 "Modern American Design in Metal" exhibition held by the Newark Museum in New Jersey. Similarly, he won a gold metal at the 1937 Paris "Exposition Internationale des Arts et Techniques dans le Vie Moderne."

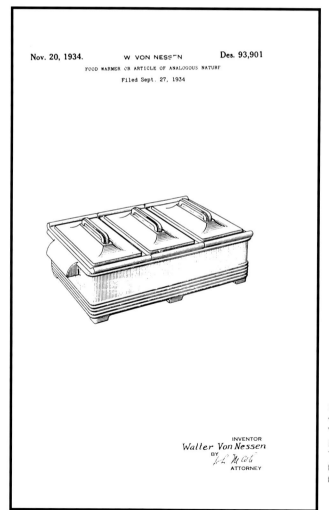

Design patent for a food warmer awarded to Walter von Nessen on November 20, 1934. The patent was assigned to the Efcolite Corporation of New Jersey.

William Archibald Welden

William Archibald Welden (1900-1970), a native of Newmilns, Ayrshire, Scotland, was Director of Design for Revere. Despite his significant contributions to Revere, I was able to identify little biographical information. In 1934, he was living in Boston and was awarded a mechanical patent that was assigned to the Kantuck Company.

His first design credits for Revere appeared in the 1937 giftware catalog. In that year alone, he was credited with the design of the "Pool" centerpiece and candlesticks, "Coronation" bowl, candlesticks, and nut dishes, "Claridge" ice bucket, the "Casserole Tray," the "Stationary Holder," the "Pick-Me-Up" ash receiver, the "Pipe Smokers' Tray," and the "La Fleur" collection of flower pots. He remained with Revere until at least 1954, living for much of that time at the Stanwix Hall Hotel in Rome, New York.

Welden continued to design new items for the Revere giftware line, including two exceptional cocktail shakers introduced in 1938, the "Zephyr" and the "Empire." But he is perhaps best remembered for his designs for cookware. His 1938 design for Revere Ware is nearing 60 years of production virtually unchanged from the initial design. Not even Homer Laughlin's Fiesta™ has been in production as long, having been discontinued from 1969 to 1986. Revere stopped production of Revere Ware only during World War II when its factories were converted to wartime production. Welden also designed Revere's 1954 range of institutional cookware with heat resistant metal handles. His institutional cookware designs were included in the Philadelphia Museum of Art's 1983-4 exhibit "Design Since 1945."

July 11, 1950 W. A. WELDEN Des. 159,307
TEAKETTLE
Filed July 31, 1948

Fig.1

Fig.2

Inventor:
William A. Welden
by Emery Booth Townsend Miller & Bimsell Attys

Design patent for a teakettle awarded to W. Archibald Welden on July 11, 1950. The patent was assigned to Revere.

In addition to his work in designing consumer products, Welden designed architectural ornaments and decorative metalwork.

Elsie Wilkins

Elsie Wilkins (1895-1983) of Rochester, New York, designed at least two floral accessories for Revere, the "Reflector Wall Bracket" and the "Venetian Wall Piece," although neither design was patented. The only patent I identified for Elsie Wilkins was a 1934 design patent for a bottle cap remover in the shape of a pretzel.

Russel Wright

Russel Wright (1904-1976) was the youngest of the big name industrial designers of the art deco period and the first to have his name mentioned in advertisements for giftware items. A friend of playwright Thornton Wilder, Wright began his career in 1924 working for Norman Bel Geddes as a set designer. His entry into decorative arts followed in 1927 when he began casting miniature versions of his stage sets.

By 1930, Wright had moved away from the theatre, designing and producing household accessories in spun aluminum. He established his own workshop in New York in 1930 and began producing metalwork including sterling

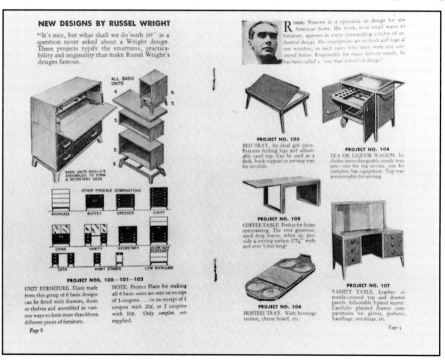

Do-it-yourself furniture designs by Russel Wright for Casco™, the Casein Company of America (1940).

36

silver flatware that drew on the designs of Jean Puiforcat and Josef Hoffman. Russel Wright became one of a number of independent industrial designers contributing designs to Chase. A total of 13 Chase designs have been attributed to Wright, including the Pancake and Corn Set (No. 28003), with its spherical pitcher and salt and pepper shakers and blue glass-bottomed tray. Wright-designed pieces are among the most collectible and valuable Chase pieces, exceeded only by pieces designed by Walter von Nessen.

Among Russel Wright's other designs are a 60-piece collection of furniture for Heywood Wakefield (1934), a *Modern Living* furniture line for Conant-Ball (1935), *American Modern* dinnerware produced by Steubenville Pottery (1939), *Casual China* for Iroquois (1946), glassware for Century Metalcraft and other companies, the *Easier Living* furniture collection for Stratton (1950), a range of metal furniture for Samsonite (1950s), and *Melmac* dinnerware (1945).

In his later years, Wright turned his design talents to public service, working with both the U.S. State Department and the National Park Service. As a consultant for the State Department, he developed ideas for cottage industries in Southeast Asia (1955) and designed over 100 products to be manufactured in Japan (1965). He abandoned most of his design activities in 1967 and began work as a consultant to the National Park Service on programming and planning.

Allan Young

Allan Young (1894-1985) was a mechanical engineer employed by a variety of household appliance manufacturers during his 60-year career. A native of Meriden, Connecticut, Young served in the Navy during World War I. Following his 1919 discharge, he went to work for Landers, Frary & Clark in New Britain, Connecticut, first as an assistant shop director and then as superintendent of the hollowware and range divisions. His innovations while at Landers, Frary & Clark included introduction of an assembly line—patterned after Henry Ford's—for the production of kitchen ranges.

After leaving Landers, Frary & Clark, Young worked for Manning-Bowman for 17 years as chief engineer, designing the inner mechanics for percolators and other appliances. Manning-Bowman and Landers, Frary & Clark introduced the steep method of brewing coffee under which coffee is placed in a basket and a pump is used to force the water through it. Young and Manning-Bowman developed a vacuum type pump that depended on differences in water temperature to draw hot water up through a tube where it would be distributed over the coffee. The water would "percolate" through the coffee, returning to the pot to be heated again.

Young's work at Manning-Bowman also centered on development of the thermal control devices essential to the efficient operation of percolators, waffle irons, toasters, and similar appliances. He received about 20 patents for his work at Manning-Bowman.

After leaving Manning-Bowman, Young briefly developed hydraulic controls for Allied Control in nearby Plantville, Connecticut, before becoming associated with General Electric. He was the division design engineer for General Electric's small appliance plant in Bridgeport, Connecticut, from 1941 to 1956, receiving about 50 patents for his designs.

Young completed his career as chief engineer for AGC in South Meriden, retiring in 1974 at the age of 80.

Chapter 4
The Chase That Might Have Been:
Proposals and Prototypes

For every new giftware item that reached production there were likely many others that were considered and rejected. Sadly, little is known about those items that did not reach production. Fortunately, Harry Laylon preserved records of some of his proposed designs that failed to reach production.

The process of adding new products to the Chase giftware line began with ideas and designs submitted by Harry Laylon and other designers. Proposals were presented to a product committee consisting of Rodney Chase, the advertising manager, the factory manager, the sales manager of the gift and lamp division, a representative from the engineering and manufacturing department, and the Director of Design (Laylon from 1937 to 1940).

In addition to the basic design proposal, the product committee would be provided data on the potential costs of production and retooling. Factors considered in deciding whether to add a new product to the Chase giftware line included the likely sales revenues, options for promoting the item should it be produced, amortization of the retooling costs, and the potential to realize profits.

On the following pages are published some of Harry Laylon's proposed designs for Chase giftware items that were not accepted for production. The photographs are of the original display boards Laylon painted in 1937 for use in presenting the proposals to Rodney Chase and other company executives. As seen in the photographs, had the proposed designs been put into production, they would have been among the most moderne items in the Chase catalog.

Even products that advance beyond the proposal stage are not assured of entering production. The cigarette server pictured below survived the first cut and a hand-made prototype was prepared. The box is unusual in that what appears to be a handle to lift the top is actually a lever. Pressing down on the lever opens the box. Unfortunately, Rodney Chase decided that there were already enough cigarette boxes in the giftware line and decided against production.

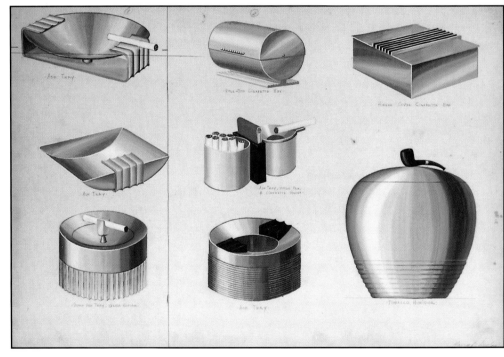

Display board painted by Harry Laylon in 1937 with proposed new designs for Chase smoking accessories.

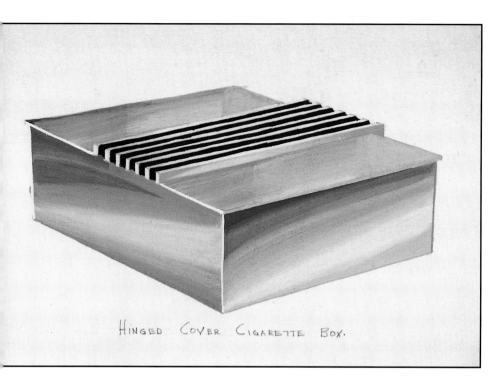

HINGED COVER CIGARETTE BOX.

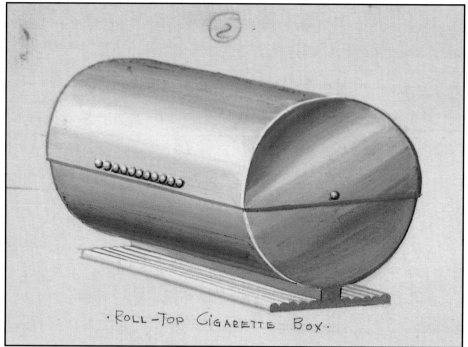

ROLL-TOP CIGARETTE BOX.

Above left: Close-up of proposed "Hinged Cover Cigarette Box" designed by Harry Laylon in 1937.

Above right: Close-up of proposed "Roll-Top Cigarette Box" designed by Harry Laylon in 1937.

Right: Close-up of proposed ashtray designed by Harry Laylon in 1937.

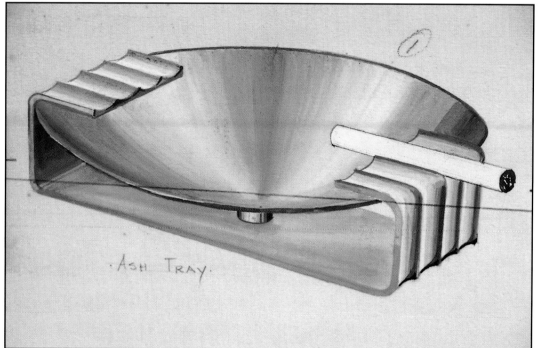

ASH TRAY.

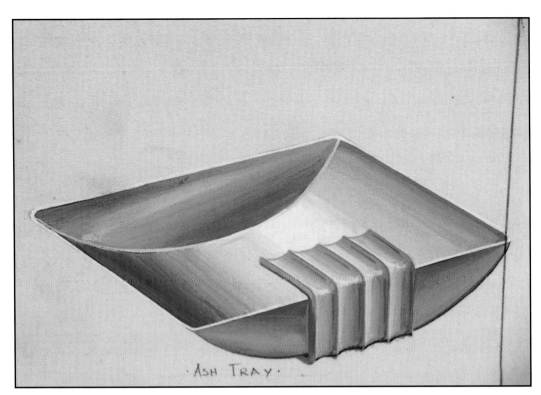

·ASH TRAY·

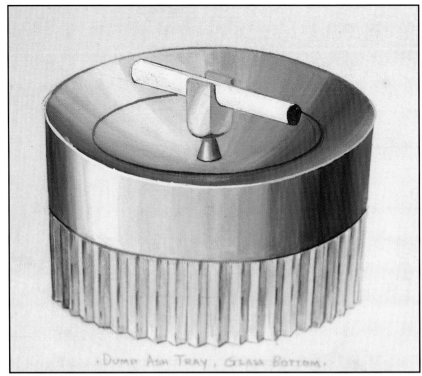

·DUMP ASH TRAY, GLASS BOTTOM·

Above: Close-up of proposed ashtray designed by Harry Laylon in 1937

Above right: Close-up of a proposed dump ashtray with glass bottom designed by Harry Laylon in 1937.

Right: Close-up of a proposed ashtray, match holder, and cigarette holder designed by Harry Laylon in 1937.

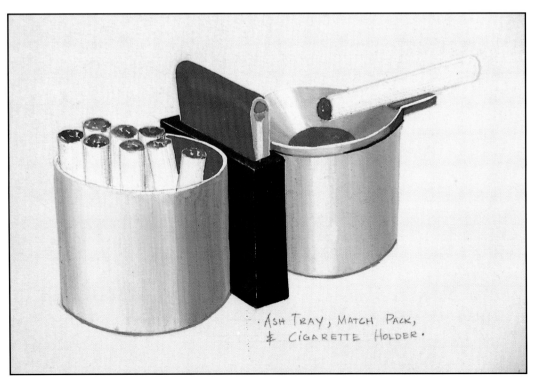

·ASH TRAY, MATCH PACK, & CIGARETTE HOLDER·

40

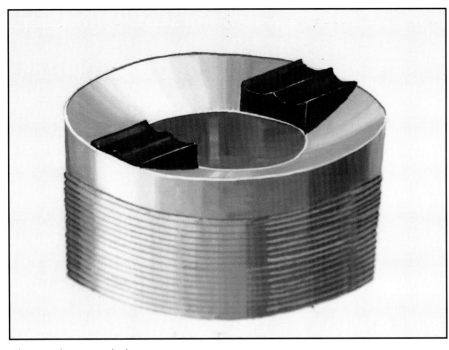

Close-up of a proposed ashtray
design by Harry Laylon.

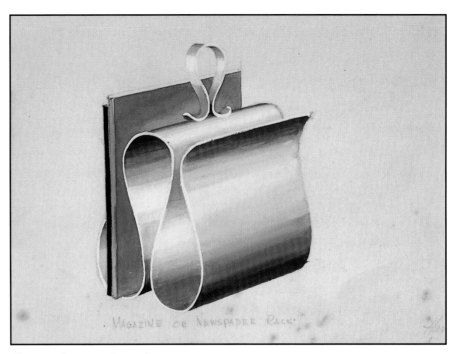

Close-up of a proposed magazine or newspaper
rack designed by Harry Laylon for Chase in 1937.

Prototype for a new Chase cigarette box designed by Harry Laylon. The prototype was
given to Harry Laylon after Rodney Chase decided against production. Because it was a
prototype, the box does not have the normal Chase polished chromium finish.

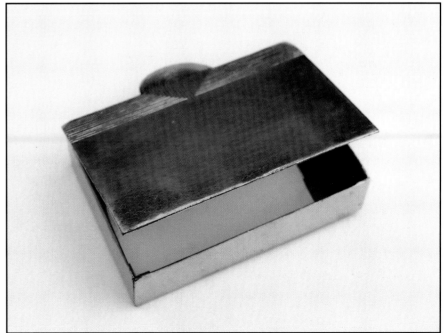

The prototype had a uniquely designed hinged lid/
handle that make it easy to offer a cigarette to a guest.

41

Chapter 5
Recent Chase Discoveries

One of the joys of collecting is discovering the existence of a previously "un-known" piece, or the model number or designer of a piece that has been in your collection for years. Each time a new book about Chase is released, additional Chase pieces are documented. This book is no different in that regard. On the next several pages are pictures of a number of Chase items not included in prior catalog reprints. Others are shown throughout Part 2. Finally, a portion of the 1941 Chase Residential Lighting Fixtures catalog is reprinted in Part 3.

Chase Sold Park Sherman Smoking Articles

For years, collectors have found smoking articles marked "Made of Chase Brass" and "Park Sherman" that look exactly like "Chase" items included in Kilbride's *Art Deco Chrome Book Z.* Kilbride suggested that products marked "Made of Chase Brass" had been produced after World War II using Chase brass but had not been manufactured by Chase. It now appears, however, that giftware stamped "Made of Chase Brass" tends to be from the late 1920s and early 1930s rather than post war. Many early "Chase" smoking articles were, as identified in a Chase advertising flyer, actually part of the "Park Sherman line of smoking articles sold through Chase." Park Sherman articles sold by Chase include: the "Ball Ash Tray" (No. 805), the "Cigarette Server and Ashtray" (No. 806), the "De Luxe Cigarette Set" (No. 815), the "Eclipse Ash Tray" (No. 809), the "Smoker Set" (No. 560), the "Tripod Ash Tray" (No. 301), and the "Cigarette Server and Ashtray" (No. 812). Two other Park Sherman smoking articles distributed by Chase before 1933 are pictured below as they appeared in the Chase flyer.

Park Sherman president Jacob S. Sherman designed most of his company's products. Of design patents assigned to the company or its predecessor, the Universal Lamp Company, almost all were awarded to Jacob Sherman. My research at the Patent Office identified two design patents awarded to Sherman, and assigned to Universal, that suggest that the Chase "Tobacco Humidor" (No. 857), "Cigar Humidor" (No. 533), and the Slide-Top Ash Trays (No. 804A) may also be Park Sherman/Universal products designed by Sherman.

It appears likely that Chase, or one of its subsidiaries, such as American Brass & Copper, manufactured the smoking articles for Park Sherman, although I found

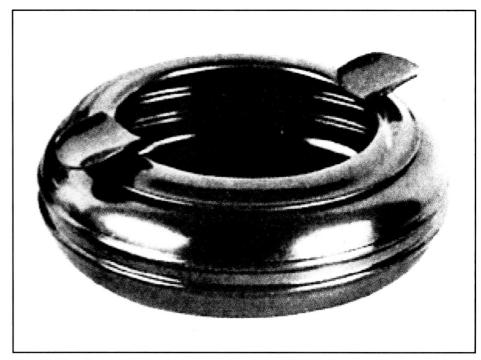

Pre-1933 Park Sherman "Marionette Ash Tray" (No. 304) sold through Chase. The ashtray was finished in red, green, or black enamel. $25-35.

no clear evidence to that effect. Park Sherman purchased the Shanklin Company and its manufacturing plant in Springfield, Illinois, in 1932. A 1956 article in the Illinois *State Register* said that Park Sherman moved from Waterbury, Connecticut, to Springfield in 1932 when it acquired Shanklin. However, I could find no record of Park Sherman or Universal at the Connecticut Historical Society, the Mattatuck Historical Society, or the local history collection at the Silas Bronson Library in Waterbury. The company's headquarters appear to have been located in Chicago from its inception.

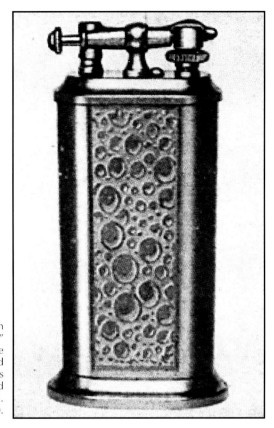

Pre-1933 Park Sherman "Brocaded Table Lighter" sold through Chase. The lighter came in satin gold and satin silver finishes with assorted brocaded designs cut into the metal. $35-50.

I found records of Park Sherman's predecessor, the Universal Lamp Company, in Chicago business directories as far back as 1922. It is not clear, however, whether Universal had a manufacturing plant or had its designs produced by another company, such as Chase. Around 1932, Jacob Sherman stopped assigning his patents to Universal and began assigning them to Park Sherman. Universal may have initially used Park Sherman as a trademark for its smoking accessories before spinning it off as a separate company.

Unfortunately, the Chicago and Illinois historical societies have little information on Park Sherman and the Universal Lamp Company. Nor did the extensive Chase records at the Mattatuck Museum in Waterbury shed light on the business relationship between Chase and Park Sherman.

Clearvue Bank Not Originally a Chase Product

Another recent "discovery" was that the "Clearvue Registering Bank" was not initially a Chase product. It was patented by Donald F. Earl of Melrose, Massachusetts, in March 1929, and sold to banks by his company, Earl Service for Banks. Like the Park Sherman items discussed above, it is marked "Made of Chase Brass." It is not clear whether the bank was manufactured

by Earl Service "of" Chase brass as stated or "for" Earl Service by Chase. I believe it is likely that Chase manufactured the Clearvue for Earl Service before reaching agreement to add it to the Chase giftware line. I found no record of the Clearvue in Chase catalogs until 1936.

"Pohlson" Candle Identified

In his 1992 *Art Deco Chrome Book Z*, Richard Kilbride described the "Pohlson Candle," a hand decorated battery-operated candle so named because it was offered for sale by the Pohlson Galleries. Kilbride speculated at the time that Chase made the base but that another manufacturer had subsequently added the candle. In the absence of documentation that the entire item was produced by Chase, Kilbride assigned it an arbitrary model number (No. 6999-DK).

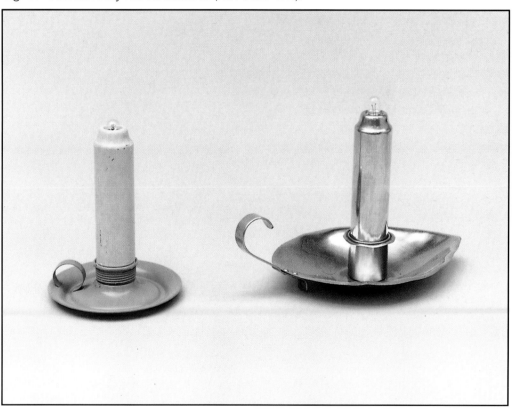

Early Chase battery-operated candles. Although rare, demand for Chase items that are not art deco has been limited.
Left: the "Candle Light" (No. 11150), blue and ivory enamel over brass, 5-1/2" h. The original had one long battery, but it will operate with two "C" cell batteries. The May 1930 House Beautiful describes the "Candle Light" as "…such a cunning and convenient little bedside light to use when you haven't a lamp close at hand. And can't you imagine that a child of six or seven, just beginning to go about the house in the dark, would simply love it? Going up to bed alone in the dark would lose all its terrors if this were at hand." The candle was always white, but the base was also available in brass or rose, green, yellow, or orchid enamel $50-70. An original "Pohlson" decorated candle recently sold at auction on eBay for over $130.
Right: the "Pilgrim Light" (No. 11255) in nickel silver with a brass candle, 8" l. x 5" w. x 5-1/2" h. A wired version, known as the "Priscilla" lamp was also available. $55-75.

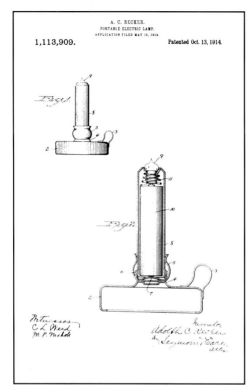

A mechanical patent for battery operated candles was awarded to Adolph C. Recker on October 14, 1914.

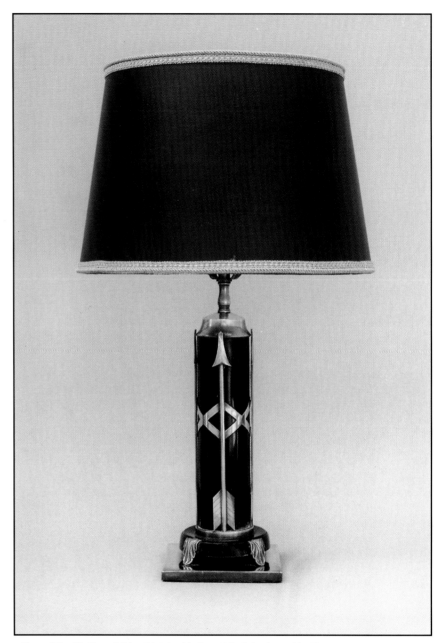

Chase "The Chalfonte" (No. E 300) with the original shade, 21" h. The 1934 catalog notes that a "...black Claire de Lune shade with gold cord binding tops a toned black column against which banded arrows in empire brass form the main decorative motif." The "Chalfonte" was included in the Empire style lamps introduced by Chase in the 1934 collection of lamps designed by Lurelle Guild. $500-700 with the original shade; $300-500 without the shade.

My research suggests that Kilbride's speculation was partially correct. The Pohlson Galleries probably added the hand decoration on the candle, but the candle itself is a Chase product. I recently purchased an undecorated candle that included a patent number. The patent was awarded to Adolph C. Recker in 1914 and assigned to the Waterbury Manufacturing Company (Chase). I found a description of the candle in the May 1930 *House Beautiful* which indicates that the candle was normally undecorated white enamel. Barbara Endter provided names and catalog numbers for both the former "Pohlson" Candle and a second previously unidentified battery-operated candle.

Identifying Lamps and Lighting Fixtures

Identifying lamps and lighting fixtures is particularly difficult because they frequently lack manufacturers' marks and can be identified only through comparison to advertisements and catalogs. For example, I recently saw a picture of a Chase lamp in a 1934 *House & Garden* article and remembered having admired the same lamp at an antique mall the prior week. Although the lamp was unmarked, it was clearly the same lamp featured in the article. Needless to say, I returned to the antique mall and purchased the lamp. When I subsequently obtained a full copy of the 1934 Chase Lamps catalog (only the section on Classic Modern lamps had been reprinted in Kilbride), I was able to identify the model number. Although the lamp is part of the "Empire" collection, it blends well with art deco.

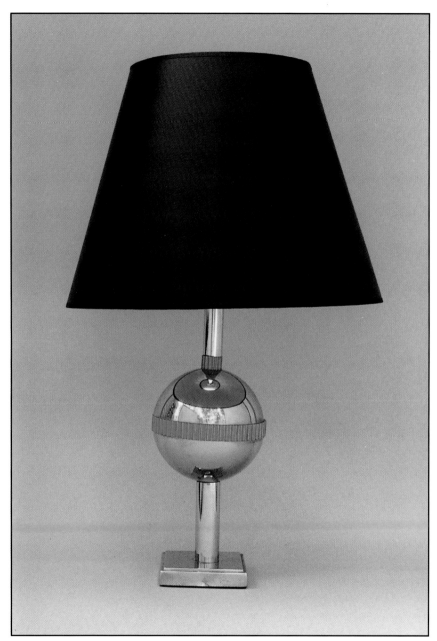

Chase polished chromium and white bakelite table lamp, 25-1/2" h. This signed lamp is a taller version of the Walter von Nessen-designed "Planet Lamp" (No. 01015). The lamp, which I believe to be original, has not been found in any Chase catalogs or advertisements. It appears to be identical to the Planet lamp except for the chromium tubes above and below the ball. In the Planet lamp, there are short pieces of fluted bakelite separating the base from the ball and separating the ball from the socket. These pieces are also present on the pictured lamp, but appear at the opposite ends of the upper chrome tube. Because the authenticity of this lamp has not been documented, I would limit its value to the same as the "Planet Lamp." $700-900. If confirmed as a Chase production lamp, its value will increase.

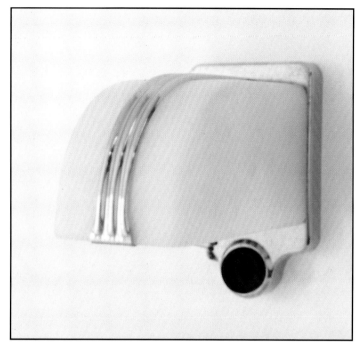

Chase polished chromium and satin finish opal glass bathroom light fixture (No. 1204), 6" x 3-1/2" x 7-3/8". $125-150.

I have not had the same luck in identifying another Chase lamp in my collection. The lamp, pictured below, was purchased in the early-1980s and appears to be original (the cloth cord is badly frayed). It is similar to the von Nessen "Planet" lamp (No. 01015) added to the Chase catalog in 1938, but is taller. It has not been found in any Chase catalog or advertisement. Although the possibility exists that the lamp was altered sometime between production and the time I bought it, I do not believe that to be the case. I believe it is more likely that Chase produced the lamp for a short time without including it in the catalog or produced it as a special order. I would be interested in hearing from anyone that has one of the lamps or can help identify its model number.

Chase Acquired Steele & Johnson

Another area of speculation in Kilbride's *Art Deco Chrome Book Z* was the relationship between Steele & Johnson and Chase. According to a 1953 article in the *Waterbury Sunday Republican*, Chase purchased Steele & Johnson in 1935 and moved all of its production equipment to the Chase plant. It appears that Chase operated Steele & Johnson as an independent division for about three years before incorporating the remainder of the Steele & Johnson line into the Chase Specialties line. Several of the Steele & Johnson lamps are pictured in Chapter 14.

Pre-1933 Chase Items Identified

Pictured below are a number of Chase giftware items included in pre-1933 advertising flyers. Either Walter von Nessen or Ruth Gerth designed most of the items.

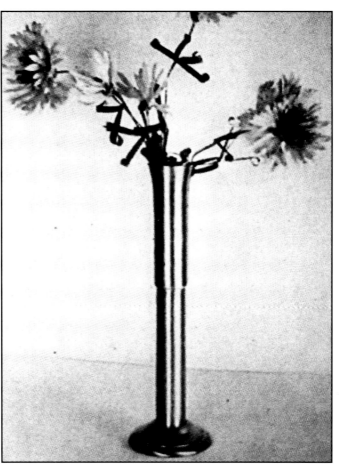

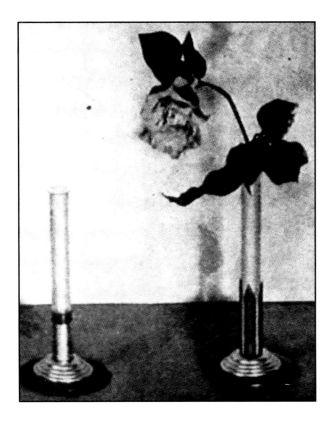

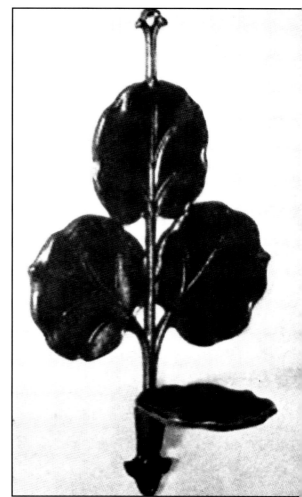

Left: Two early Chase "Bud Holders" designed by Gerth and Gerth. Both bud holders were available in black enamel and nickel, polished brass and green enamel, polished copper, and polished brass and copper. Left: No. 11145, 6-1/2" h., 3-1/4" d. Right: No. 11146, 6-3/4" h., 3-3/8" d. $75-90.

Above: Pre-1933 Chase "Flower Vase" (No. 03003), 9-1/2" h., 3" d. (base). Available finishes were polished brass and polished copper. $65-80.

Right: Pre-1933 Chase "Wall Flower Pot Holder" (No. 11147), designed by Gerth and Gerth, 12" h. Available finishes were polished nickel, brass, burnt orange, verdi green, and black. $75-90.

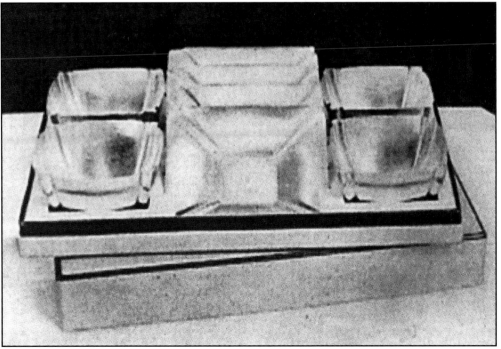

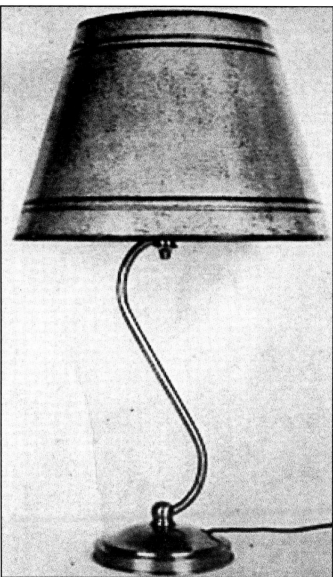

Above left: Chase "Bridge Pencil Set" (No. 11229) with brass pencil holders in the shape of the suits enameled red and black. $75-90.

Above right: Chase "Sigma Lamp" (No. 11244), designed by Gerth and Gerth, 20" h. A similar design, the "Delta Lamp" (No. 11243), that is straight rather than curved at the base, was also offered, 17" h. Both lamps were available in satin copper, English bronze, and satin brass. Shades (No. 11274) were sold separately. $75-90.

Left: The Chase "Frozen Dessert Set" (No. 11231) consists of four silver-plated dishes and plates. $85-105.

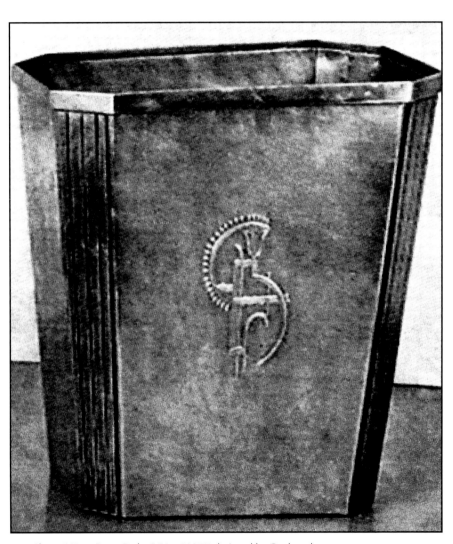

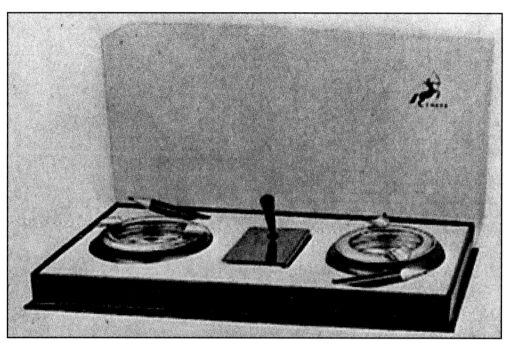

Chase "Bridge Hostess Set" (No. 303), consisting of two ashtrays, a match box and pencil holder, and two bridge pencils in a gift box. Available finishes were red enamel and brass, green enamel and brass, and black enamel and nickel. Rare. $175-250.

Chase "Waste Paper Basket" (No. 11171) designed by Gerth and Gerth, 11" h. Available finishes were polished brass and copper, English bronze and English copper or Verdi green. Rare. $225-300.

Chapter 6
Chase Reincarnated: Cavalier™, Emerald Glo™, Perma-Brite™, and Wise Buys™

Most Chase collectors have doubtless encountered giftware items that appear nearly identical to Chase designs but bear trademarks identifying them as Cavalier or Emerald Glo. The two trademarks, as well as two others—Perma-Brite and Wise Buys—were used by the National Silver Company on giftware lines introduced after World War II. National Silver appears to have obtained the rights to Chase designs, and likely the actual dies, after Chase decided against continued production.

In August 1947 National Silver applied for a trademark for a new line of chromium-plated hollowware marketed under the name Perma-Brite. The trademark, registered February 27, 1951 (No. 538,429), was to be applied to water pitchers, cocktail shakers, cocktail cups, sugar bowls, cream pitchers, trays, casserole servers, candy dishes, coffee pots, vegetable dishes, gravy boats, compotes, and tea sets. I have not found any Perma-Brite items and do not know whether they were original designs or copies of Chase designs.

National Silver applied for a trademark for "Cavalier Copperware" in December 1948, followed in June 1949, with a trademark application for "Cavalier Chromeware." I was unable to determine whether the Cavalier trademarks were actually registered. I have found only two pieces of "Cavalier." Both of the items found have a strong resemblance to items previously produced by Chase.

On June 21, 1950, the National Silver Company filed an application with the U. S. Patent and Trademark Office for the Emerald-Glo trademark, indicating that it had been using the trademark in interstate commerce since April 28, 1950. It amended its application on October 28, 1952 to indicate that it had been using the trademark in interstate commerce for the year preceding the application. The registration (No. 569,789) was granted on January 27, 1953. The Emerald Glo giftware line included serving trays, cake trays, relish dishes, hors d'oeuvres servers, syrup jars, mint dishes, fruit bowls, service plates, bon bon dishes, candy dishes, candy boxes, water pitchers, celery dishes, serving dishes, mayonnaise sets, sugar and creamer sets, cocktail sets, jam sets, relish sets, breakfast sets, liqueur sets, oil and vinegar sets, and salad sets.

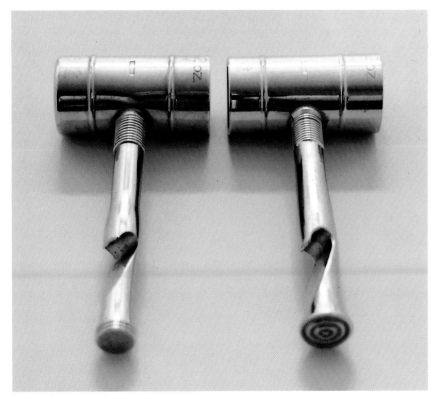

Polished chromium bar tools marked "Chase" (left) and "Cavalier by National Silver" (right). The jiggers on the two bar tools are identical down to the lettering used for the measurements. National Silver did, however, redesign the tip of the handle.

National Silver indicated that Emerald Glo items were made primarily of base metal with glass and plastic fittings. Although the exact composition of the base metal is unknown, in appearance it most closely resembles the reddish-gold polished bronze frequently used in Revere products. Accordingly, I have chosen to describe the metal in Emerald Glo products as bronze although it could just as easily be a type of brass. The glass and plastic in Emerald Glo products are invariably emerald green. There are typically stars cut into the surface of the glass.

Continuing to add new lines, National Silver, in April 1951, applied for a trademark for a new Wise Buys™ line of hollowware, electric percolators, and snack servers. In its application, the company noted that the trade name was printed on tags affixed to the goods and to the boxes. The trademark was registered on March 25, 1952 (No. 556,736). I have seen several electric snack servers that appear identical to the Chase Electric Snack Server (No. 90093) except that they have ceramic rather than glass dishes. I have not seen a manufacturer's mark on these items, but believe that they may be Wise Buys.

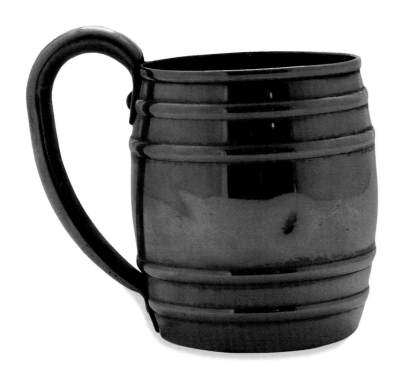

Above: The "Beer Barrel™," stamped "Cavalier by National Silver." The mug appears identical to the Chase "Beer Mug" (No. 90042) shown in the 1934 catalog. $15-25.

Right: The Chase "Beer Mug" (No. 90042) as shown in the 1934 catalog. The mug, available in polished copper or chromium, measures 4" h., 4-3/4" d., the same as the Cavalier "Beer Barrel" by National Silver. $25-35.

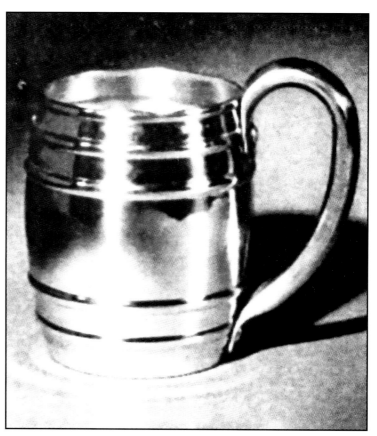

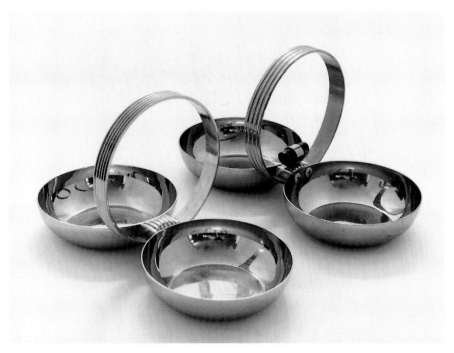

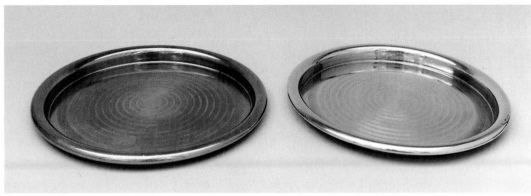

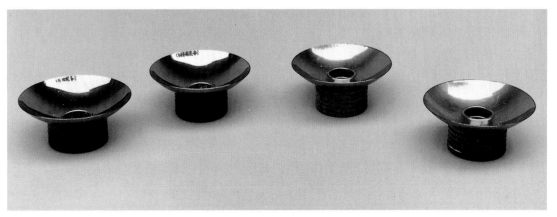

Top: Mint and nut dishes by Chase (left) and National Silver's Emerald Glo (right). The primary difference between the two is the placement of the translucent green plastic rod between the bowls on the Emerald Glo dish. Even the ribbed piece joining the dishes is the same. The Emerald Glo dishes, however, are riveted rather than soldered to the frame. $25-35. Although Chase is more collectable than Emerald Glo, the values of the mint and nut dishes are about the same because the Chase dish sold so well that it is readily available.

Center: The Chase "Ring Tray" (No. 90058) in polished chromium (right) and its 1950s reincarnation in polished bronze by Emerald Glo. The two 12" d. trays are identical down to Harry Laylon's original etched design. The Chase tray has a current value of $75-90. The Emerald Glo tray is worth only $35-45.

Bottom: National Silver's Emerald Glo Candlesticks (left) and Chase's "Diana" candlesticks (right). The Emerald Glo version has a translucent green plastic base rather than the walnut bases used by Chase. $30-40 (Emerald Glo), $45-60 (Chase).

Chapter 7
Identifying Finishes

It is often difficult to identify the specific finishes used in the production of metal giftware. Many of the alloys, such as Brittania and nickel silver, were developed specifically to look like other more expensive metals, such as silver. The following descriptions are intended to help in the process, but the differentiation between many alloys, such as brass and polished bronze, is largely a matter of guesswork without chemical analysis. Similarly, it is difficult to differentiate between satin nickel, satin chromium, and pewter and between aluminum alloys and white metal.

Aluminum is a lightweight malleable metal with a bluish, silver-white color. Although the most abundant metallic element, aluminum is found in nature only in combination with bauxite. Aluminum is often used because of its resistance to corrosion, but drawbacks to its use in consumer products include its tendency to form chalky white surface oxidation and its softness, which often results in extensive scratching.

Aluminum was widely used in the 1920s and 1930s for the manufacture of cooking utensils, household objects, and furniture, not withstanding the above drawbacks. For example, aluminum was extensively used in the 1936 design and layout of the *Hindenburg* and, in 1930, American designer/manufacturer Warren McArthur patented the use of aluminum in furniture. Among those incorporating aluminum into their furniture designs during the 1930s was Donald Deskey.

With the late 1930s discovery of anodizing, one of the principal drawbacks to the use of aluminum—surface oxidation—was overcome. In addition, anodizing can be used to produce colored finishes. Such finishes became popular in beverage sets produced in the 1950s.

Aluminum bronze refers to an alloy of copper and aluminum that has a pale gold color. It is used primarily in costume jewelry and in small ornamental objects.

Bakelite was the trade name for the first totally synthetic plastic. It was invented in 1907 by Belgian-born chemist Dr. Leo Baekeland. The term "bakelite" is often used generically to indicate "plastic" but is properly used only to describe phenolic and other plastic materials produced by the Bakelite Corporation and later by Union Carbide under the trade name *Catalin*.

Phenol and formaldehyde, together with a catalyst and small amounts of other chemicals, are heated until they combine to form a resinous substance with the consistency of molasses. Pigment is then added to provide color; filler, such as wood flour, asbestos, or mica, is added to create the proper molding qualities. Unlike earlier celluloid plastics, bakelite is formed under heat, but once hardened cannot be reformed. Bakelite was initially molded under high heat and pressure. This process allowed a limited range of colors and was used primarily by electrical companies.

Soon, however, a myriad of other commercial uses for bakelite were developed. With these new uses came the development of casting resins. Unlike the original molding process, casting resins are poured into lead molds and allowed to harden slowly. By slightly varying the base mixture and adding coloring agents, it was found that bakelite could be produced in every color, including white. In addition, depending on the additives, it could be transparent, translucent, or opaque. Similarly, by pouring special liquids into the mixture just before it was poured into molds, mottled effects similar to marble and tortoiseshell could be obtained.

Bakelite was extensively used to form handles and knobs for cocktail shakers, ashtrays, and other giftware items. In addition to bakelite and catalin, giftware manufacturers sometimes described their handles as plastic (Chase) or composition (Chase) or coined their own term "Arinite" (Manning-Bowman).

In this book, I have chosen to use the widely accepted term bakelite, except where the manufacturer specifically refers to the trade name catalin.

Aluminum Worth More Than its Weight in Gold—In 1852, aluminum sold for $852 a pound and was worth more than its weight in gold. Napoleon had forks and spoons of the new lightweight metal used at royal banquets and presented an aluminum watch charm to the King of Siam. Although the price of aluminum had dropped by 1879, Paris jewelers quoted aluminum and platinum settings at the same price. By the 1890s, however, manufacturing processes for separating aluminum from bauxite ore had been perfected to the point that the Scovill Manufacturing Company, one of Waterbury's major brass mills, was offering aluminum ingots, sheets, rods, and wire for $2.00 pound. Continued improvements led to a further decline in aluminum prices to where Scovill offered aluminum in 1936 for about $.25 pound.

Black nickel plating is used primarily for decorative effect and to produce nonreflecting surfaces. Among its primary uses is for typewriter and camera parts, military instruments, and costume jewelry. The exact composition of black nickel plating is not known, but the deposits typically contain 50 percent nickel, 7 percent zinc, and 15 percent sulfur. Black nickel plating can generally be applied directly over brass or copper, although an undercoating of nickel is usually applied where greater resistance to abrasion is desired. Because black nickel surfaces are brittle, a protective layer of lacquer usually covers them.

Brass is an alloy of copper and zinc which yields a wide range of color depending on the amount of zinc used and the presence of other metals. The 1940 *Chase Dictionary of Brass and Copper Terms* identifies 26 different types of brass. In general, brasses with less than 5 percent zinc have a salmon-red appearance largely indistinguishable from pure copper. Brass alloys with a content of 5 percent to 10 percent zinc have the reddish-yellow coloring of polished bronze, while brasses begin taking on a golden color at 15 percent zinc. The typical brass yellow found in consumer products is achieved when the zinc content is between 25 percent and 38 percent. Once the zinc content exceeds 38 percent, however, the brass again takes on a reddish appearance.

Brass can be traced with certainty to late Roman times and there are references in the Old Testament to the possible use of brass in making trumpets. Use of brass was first documented in England during Medieval and Renaissance times for the memorial brasses in churches. Brass tarnishes rather readily, taking on a darker, brownish appearance.

Other metals may be alloyed with copper and zinc to form special brasses. Principal among these is tin, added to improve corrosion resistance, increase strength and hardness, and lighten the color and aluminum, to improve corrosion resistance and increase strength. Some of these special brasses are also referred to as bronzes.

Britannia is an alloy containing tin, copper, and antimony. Although related to pewter, it contains a higher proportion of tin and substitutes antimony for lead. These changes result in a more silver-like appearance and Britannia was used extensively in the manufacture of hollowware prior to the development of electroplating. At one time, much of Manning-Bowman's product line was made of Britannia.

Bronze is an alloy of copper, zinc, and tin, with tin as the principal alloying metal. The term bronze, however, is also used to refer to some of the special brasses and the differentiation between brass and bronze is often of academic interest only. The origin of bronze in the arts rests in antiquity. Bronze was widely used in the manufacture of tools, weapons, ornaments, and hollowware until the discovery of iron. Since the discovery of iron, bronze has been used primarily for the fabrication of works of art. It is well suited for casting because it has a melting point below that of iron and copper.

Modern statuary bronze typically contains 75 percent copper, 3 percent tin, 20 percent zinc, and 2 percent lead. Ancient bronze typically contains a higher proportion of tin—from 5 to 15 percent.

Bronze varies in color from dark brown, often referred to as antique or English bronze, to a light golden color barely discernible from brass. The polished bronze typically used by Revere and other giftware manufacturers has a color somewhat more reddish than brass but more golden than copper.

Like brass, bronze tends to tarnish over time. For most statuary, the patina of aged bronze gives the piece great beauty. As it tarnishes bronze takes on a varied appearance. The surface can take on a green or blue patina through the formation of copper carbonates, a red or black patina from the formation of copper oxides, or an unusual shade of green through formation of copper oxychloride.

Bronzing refers to the process used to make objects look like bronze. Typically, this occurs through the application of chemicals to produce the bronze color or the deposit of real bronze on the surface of a base metal through electrotyping. Through the application of various chemicals, the object can be made to appear like ancient bronze. For example a brown patina can be obtained by heating the object and then brushing it with graphite or by immersing the object in a boiling solution of copper acetate, ammonium chloride, and water.

Chromium is a naturally occurring grayish white metal favored as a plating material because of it hardness. Chromium plating refers to the electrolytic deposit of a thin coating of chromium on another metal. Although chromium can be applied to a wide range of metals, it was most commonly applied over brass or copper, often with an intermediate layer of nickel. The 1935 Revere catalog explained the plating process as follows:

> The word "chromium" has been used in such general terms that many people are inclined to think of it as the metal from which articles are made instead of as a finish. It is, however, a plating, and like all platings its durability and appearance are in large measure dependent on the metal underneath.
>
> Experience has proved copper and brass to be the best metals for chromium plating. A solid bond is formed over an intermediate coating of nickel with the result that the hard chromium plating lasts indefinitely. Of equal importance is the fact that copper and brass cannot rust. Thus the danger of rust forming underneath the plating, which in turn causes the chromium to chip and peel or become rust-spotted is eliminated. Where rustable base metals are used, this possibility always exists.

It was previously reported (Kilbride, 1992) that Chase, but not most other companies, used an intermediate coating of nickel over brass or copper resulting is a more durable finish. Both Revere and Manning-Bowman used an intermediate coating of nickel; unlike Chase, they described the plating process in their catalogs. Little is known about the actual plating processes used by other manufacturers.

Although most commonly found in polished form, some manufacturers, most notably Revere, marketed items in satin chromium. Satin chromium was a favorite medium for items designed for Revere by Norman Bel Geddes. In its 1935 *Gifts* catalog, Revere notes that satin chromium, "[p]ossessing unusual warmth and richness,…harmonizes with practically all materials and colors." In appearance, satin chromium resembles nickel, but, unlike nickel plating, will not tarnish.

> "No metal, it seems to me, is quite so complete an answer to the housewife's prayer as chromium—appealing not only to the eye, but to practical requirements, because…it stays brilliantly polished to the end of time."
> Emily Post in *How to Give Buffet Suppers*, 1933.

Copper is a common metal with a salmon-red color. Copper has high electrical and thermal conductivity and was the first metal to be used to make tools and vessels. Copper is easy to work with but has only moderate strength. Consequently, tin, zinc, and other metals are often alloyed with copper to make harder and more durable metals such as brass and bronze. Copper has high corrosion resistance but tarnishes rapidly, taking on a brown or greenish color.

Ebenew is a plated finish with a "rich black tone" introduced by Revere in 1935. Like copper and brass items, it was coated with clear lacquer. The only products identified in the 1935 Revere catalog as being available in Ebenew were two floral accessories. It is not clear whether Ebenew differed from the black nickel used in a variety of other Revere giftware other than in the application of clear lacquer to give it a shiny rather than satin appearance. Ebenew was dropped from Revere catalogs after 1935.

Kensington metal is an alloy of aluminum developed by Alcoa and used exclusively in the production of its line of giftware. It is heavier, has more of a lustre, and has a more subdued silvery color than pure aluminum. In appearance, it looks more like nickel or satin finish chromium than aluminum. In introducing Kensington, Alcoa notes that Kensington metal will not tarnish or stain and retains its soft, silvery, original lustre through cleaning with soap and water. The development of the alloy also appears to have eliminated the chalkiness typical of pure aluminum.

The alloying metal(s) used in the production of Kensington metal are a mystery. Although Kensington metal is sometimes referred to as aluminum, I prefer to use the more accurate terminology "aluminum alloy" or simply "Kensington metal." Referring to Kensington metal as aluminum is the same as referring to brass or bronze as copper because they are alloys of copper.

Nickel is a hard metal typically of silver, white or reddish white color. Nickel plate is one of the oldest protective and decorative electrodeposited metallic coatings. Initially, nickel plating was used for stove and bicycle components. Nickel plate will tarnish unless it is periodically polished, taking on a yellowish color following long exposure to mildly corrosive atmospheres and a greenish color on severe exposure. Use of nickel plating as a final finish declined following the introduction of chromium plating in the mid-1920s, but overall use of nickel plating increased because it was found to be an important intermediate step in chromium plating.

Nickel silver, sometimes referred to as German silver, is an alloy composed of varying amounts of nickel, zinc, and copper. Typically, nickel silver contains between 45 and 75 percent copper, 5 to 25 percent nickel, with the remainder zinc. The color of nickel silver depends primarily on the amount of nickel. At 5 percent nickel, the alloy has a distinctly yellow color. As more nickel is added, the alloy becomes lighter and, at 25 percent nickel, is nickel white.

Germany was the first European country to produce nickel silver, but the Chinese produced nickel silver long before it was introduced in Europe. Benedict and Burnham, an early Waterbury brass mill, first produced nickel silver in the United States in 1834. Augustus S. Chase, founder of the Waterbury Manufacturing Company, would later become president of Benedict and Burnham.

Nickel silver is a white metal that can be made to so closely resemble real silver that it was put to many uses soon after it was introduced in Europe in the early 1800s. For example, the cabin hardware on the luxury liner *Queen Mary* is made of nickel silver. Similarly, nickel silver was, for many years, the metal of choice for zippers. The greatest use of nickel silver, however, proved to be as an intermediate plating material. Shortly after the 1837 discovery of the electroplating process by the British, Waterbury brass mills expanded their production of nickel silver in order to supply the extensive silverware industries in nearby Meriden and Wallingford.

Nickel silver was found to be an ideal base metal for electroplating because it is easy to work with and effectively resists corrosion. Nickel silver can be polished to look like silver, or can be given a smooth satiny finish, which resists fingerprinting.

Peacock Plate™ refers to a patented finish introduced by Manning-Bowman in its 1941 catalog. According to Manning-Bowman: "Peacock Plate, like silver, copper, or chromium plating, is a metallic surface, yet, unlike any one of these, it has a third dimensional quality which reflects light in glittering pools of changing color." Manning-Bowman offered the finish in 10 colors—rose, green with copper relief, silver, copper-tone, bronze, bright copper, canary yellow, dew-drop brown, blue, and ruby. The finish was available on a variety of gift items, including vacuum jugs, ice buckets, buffet and serving trays, bowls, candlesticks, relish trays, bon-bon dishes, ash trays, and incidental serving accessories. Like chromium, Peacock Plate does not fade or tarnish.

Pewter is an alloy composed of a mixture of tin and lead (copper or brass are sometimes used) that takes on a mouse-gray color as it ages. Tin is the predominant metal in all pewter; the more tin the lighter the gray color.

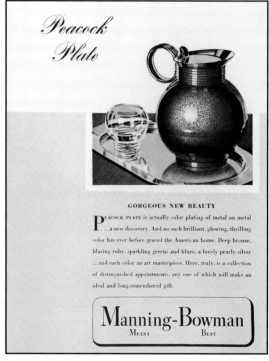

Page from the 1941 Manning-Bowman catalog introducing its new color plating "Peacock Plate™".

Polished refers to a metal surface that has been buffed to a high lustre. When applied to chromium, the terms brilliant and bright are also used to describe polished finishes.

Satin finish refers to a matte or flat as opposed to a polished finish.

Sheffield (Rolled) Plate refers to silver-plate produced before the advent of electroplating in England in 1840. To produce the original Sheffield plate a thin sheet of silver was fused on one or both sides of a sheet of copper. The composite metal was then rolled to the desired thickness and fabricated into hollowware. Sheffield plate was popular until 1840, when electroplating made it possible to

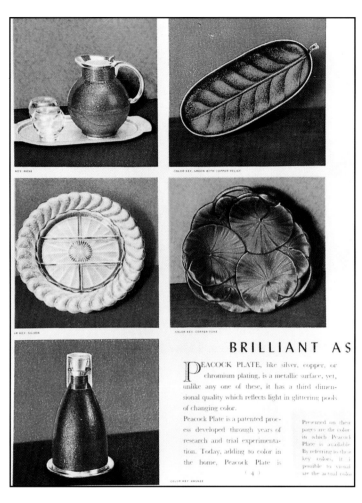

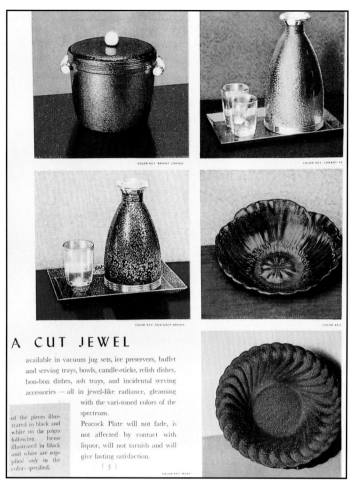

Far left & left: Pages from the 1941 Manning-Bowman catalog showing the available Peacock Plate finishes.

produce products that look like silver but cost much less than rolled Sheffield plate.

Silver is a naturally occurring element, but, as found in nature is too soft for practical fabrication. As a result, it is almost always combined with one or more other metal, typically copper, to give it strength and stiffness. The purest silver—Sterling—typically used for hollowware (coffeepots, candy dishes, etc.) and flatware (knives, forks, spoons, etc.) is 925/1000 silver with 75/1000 copper or other metal. The U.S. Government, in the Stamping Act of 1906, set the standard for Sterling. Foreign silver, other than English sterling, which follows the U.S. standard, generally has a significantly lower silver content than Sterling, typically falling below 900 parts per 1,000. In Scandinavian countries and Germany, solid silver tableware typically contains 830 parts silver per 1,000 and the stamp "830/1000" signifies the silver content.

Triangle metal was used by Chase to describe a golden finish applied over a base metal. I have been unable to identify an exact definition of triangle metal, but believe the descriptions used by Kilbride (an item that was finished and then pol-ished to a golden hue) and at least one advanced collector (an opaque or translu-cent finish applied over brass) are misleading. Triangle metal is clearly an applied finish that can be removed through heavy polishing. It should not, however, be confused with the coat of clear lacquer Chase applied to virtually all of its brass and copper giftware. After 60 years, much of that lacquer has turned a yellow or golden color, giving the items a darker appearance. This translucent finish should not be confused with Triangle metal. The finish on Triangle metal appears to be a precur-sor to modern gold spray enamels. It is a surface finish that can be removed with a commercial metal polish. Doing so, however, decreases the value of the item be-cause Triangle metal is one of the rarest Chase finishes.

White metal refers to any of a group of alloys formed through combinations of tin, copper, lead, antimony, and bismuth. There is no single definition of white metal; it can be used to define any alloy containing two or more of the above elements. Tin, however, is typically one of the elements. The more tin included, the "whiter" the metal.

Chapter 8
Care and Feeding of Chromium and Other Metals

One advantage of collecting art deco chromium is that it virtually never needs to be polished. The cleaning instructions included with Chase chromium giftware tell how simple it is to restore the showroom lustre:

Chromium Finished Articles are easily kept bright and new looking by washing in lukewarm soapy water, rinsing in clear water, and drying with a soft cloth. Those with composition handles or knobs should not be subjected to boiling or very hot water.

The cleaning instructions did not anticipate, however, that items might gather dust and grime for 60 years between cleanings. If you have an item that is so filthy that soap and water will not adequately restore the original shine, try a little Brasso™ or other **nonabrasive** chrome polish. Care should be taken, however, to avoid grinding the dirt into the surface, thus ruining both the appearance and value of a piece that has survived for over 60 years. **Never use any type of steel wool**, including soap pads such as Brillo™. No matter how fine the steel wool, it will permanently scratch chromium and other metals. If you must use a scrubbing pad, use a nylon dishwashing pad such as Dobie™, but not the more abrasive nylon scrubbing pads intended for cleaning floors or pots and pans.

The only metal as easy to care for as chromium is Kensington metal. Like chromium, it cleans with soap and water. Because it is softer than chrome, use of any abrasive cleaner will permanently scratch the item, significantly reducing its value. The only part of Kensington giftware that is improved by the application of a little polish is the brass ornamentation added to most pieces. But don't worry about getting in all the little nooks and crannies. A little shine to the flat surfaces is all that is needed.

Brass and copper are easily the most frustrating metals to keep looking new. Because they readily tarnish in normal use and would require frequent polishing,

most giftware manufacturers applied a coat of clear lacquer over brass and copper items to prevent tarnishing. For example, the Chase care instructions read:

Copper Articles have their finish protected with a coating of clear lacquer to keep them bright. To preserve this coating, they should not be placed in very hot water—lukewarm water and soap will clean them. After continued use, the lacquer may begin to wear off. When it does, remove it entirely with alcohol. Then polish occasionally with any good metal polish bought from a reliable department or hardware store.

If an item does not appear tarnished, but has a dull, yellowish appearance, it probably has a 60-year-old coat of lacquer covering its surface. Although lacquer prevents copper and brass from tarnishing, what started out as a clear finish turns yellow with age. Another indication that a brass or copper piece is lacquered is the presence of dark spots. The spots normally form where the lacquer has worn off and the metal has tarnished. Surprisingly, application of metal polish to such an item will often result in the dark spot being restored to its original color without much change in the surrounding metal.

A quick test with Brasso™ or Tarn-X™ will tell you whether there is still a coat of "protective" lacquer. If Tarn-X does not result in a significant brightening of the finish, then there is a layer of lacquer preventing it from working. Repeated applications of Tarn-X will have little affect on the appearance of the item. Similarly, if moderate polishing with Brasso does not result in significant improvement in the appearance of brass and copper, then the item is lacquered. Although prolonged polishing with a brass and copper cleaner will eventually wear off the lacquer through its slight abrasive action, such an approach is slow and arduous.

There are several ways to remove lacquer. **—Under no circumstances should you use steel wool to remove the lacquer as it will permanently scratch the**

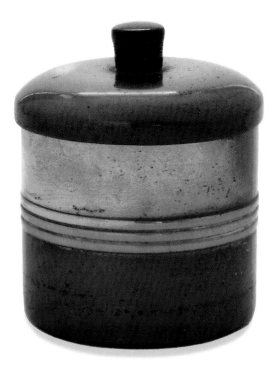

The dangers of polishing antique or English bronze finishes. Originally, only the three bands around the middle of this cigarette box were polished bronze. Use of Brasso™ on the antique bronze finish on the top half of the container, however, has removed the original patina.

metal.— The first approach to try is that recommended in the Chase cleaning instructions. Apply ordinary rubbing alcohol to the surface. **(Care should be taken to keep alcohol from coming in contact with bakelite trim as it can permanently stain the bakelite.)** This method is not totally effective in removing 60-year old lacquer. I have found, however, that if I apply alcohol liberally to the surface and follow immediately with application of a good metal polish applied with a rag soaked in alcohol, the combination seems to work better. A second option is to use an acetone-based remover, such as the original finger nail polish remover. Such removers are increasingly hard to find. If all else fails, commercial paint remover should remove old lacquer. When using either acetone-based removers or commercial paint remover, be sure to follow the label directions and cautions. Wait to light up that cigarette until the lacquer is completely removed and the work area cleaned up. In addition, extreme caution should be used when applying either alcohol or other products to remove lacquer to insure that the removers do not come in contact with bakelite parts. Finally, it is a good idea **to test the remover on an inconspicuous spot before applying it to the whole surface**.

If you don't have the time and patience to restore the finish to brass and copper giftware items, check the yellow pages under metal cleaning or plating for businesses that specialize in cleaning and restoring metal parts.

Deciding whether to polish bronze poses difficult choices. Bronze is often treated to create an antique or English bronze finish, typically a dark brown color. Polishing such items can destroy the natural patina of the piece and significantly reduce its value. Chase offered many of its items in English bronze but not in polished bronze. Revere, on the other hand, made extensive use of polished bronze. Such items, in my opinion, should be polished to restore them to their original high lustre.

Nickel-plated items can be polished with any good nonabrasive metal polish but black nickel finishes should not be extensively polished because the finish is typically thin and excessive polishing can remove the plating.

Many early plastics, such as catalin and bakelite, tend to change colors as they age. For example, much of the plastic used in Chase pieces is referred to as white plastic or ivory composition. While some pieces retain their original color, others have turned a rich butterscotch color with age. Similarly, many Blue Moon shakers and Sentinel Bookends are found with what appear to be brown plastic tops and bodies, respectively. What started out as blue tops slowly changed color after prolonged exposure to sunlight and environmental contaminants. The original color can often be found by looking at areas not routinely exposed to light and air, such as the inside of a cigarette box. As noted in the Chase cleaning instructions, bakelite handles should not be subjected to very hot water. Like the metals, they can be cleaned with soapy water.

Care should be taken not to apply alcohol or acetone to bakelite as they will discolor the plastic. Turpentine, an oil, can be used to clean bakelite and is particularly effective in removing price stickers. Bakelite, like other plastics, is not indestructible and will scratch fairly easily. I would recommend against more extensive cleaning of bakelite unless there is noticeable variation in color caused by a price sticker or other foreign object that "protected" a portion of the surface from exposure to light and air. Bakelite that has darkened through the years can be lightened through application of a little automotive polishing compound on a soft, wet cloth.

Chapter 9
Factors That Affect Values

Many factors affect what dealers can expect to charge and what buyers can expect to pay for giftware items. These include the location where the item is offered for sale, the condition of the item and how it is displayed, who designed and produced the item, and the purity of the design. In setting prices, dealers also need to consider such factors as what they paid for the item and how long they are willing to keep it in inventory to obtain the "best" price. The values cited in this book should be used only as a general guide to retail prices. If you are selling an item to a dealer or offering it for sale at a garage sale, expect to get no more than 30 to 50 percent of the value. Neither the author nor the publisher accepts any responsibility for any losses that might occur through use of this guide.

Location, Location, Location

Prices for art deco giftware vary significantly by region, and even within an individual city. Not surprisingly, prices tend to be higher in big cities and in "trendy" and "touristy" areas such as Melrose Avenue in Los Angeles and Portobello Road in London. Although prices in general are higher in Los Angeles, New York, and San Francisco, geographical variation in prices seems to be declining, in part because of price guides and antique shows that draw dealers from around the country.

In addition to geographical location, prices vary considerably depending on where an item is offered for sale. At the low end of the scale is the thrift store or Church bazaar, where it is still possible to find rare pieces of Chase for mere dollars and cents. The down side of the thrift shop, however, is that it may take 50 or 100 visits before that "bargain" is located.

Another place to find bargains is the garage sale. Garage sales are generally a better source of bargains than estate sales for one important reason. Garage sales are generally run by an individual or family intent on getting rid of "junk" that they no longer want. The homeowner rarely does the research needed to determine that the cocktail shaker that had been gathering dust in the attic for the last 60 years was designed by Norman Bel Geddes and worth several hundred dollars. Estate sales, on the other hand, are increasingly run by professional estate agents having a better idea of the true value of the items in the estate. Still, they have only a couple of days to dispose of the contents of the estate and have ample cause to bargain, particularly on the last day of the sale.

Auctions are another option for finding bargains, but they are somewhat unpredictable. It is important to have a good idea of what an item is worth before you start bidding, otherwise you may get caught up in the excitement and pay too much. Then again, is it possible to pay too much for a "must have" item? On-line auctions such as eBay™ and Auction Universe™, make it relatively easy to find and bid on art deco giftware. One of the methods used in setting the values in this guide was to monitor eBay sales.

Among the highest antique prices in the country are those at large malls located in close proximity to an interstate highway. Dealers have to charge a premium for their merchandise at such malls because of high booth rental fees. The malls offer customers the advantage of a wide selection and convenient access. Shops specializing in art deco are also likely to have higher prices, but provide the best selection and generally have cleaned and polished the items before putting them on sale. As the saying goes, "you get what you pay for."

Many flea markets are no longer the ready source of low cost items they once were. Most of the vendors at the large regional flea markets like Renningers, Brimfield, and Metrolina (Charlotte) are full time antique dealers who travel from show to show. While they avoid the high monthly rental of an antique mall, they incur significant expenses for travel and lodging. There are, however, still some flea markets that function more like community garage sales.

Condition, Condition, Condition

Values reflected in this book, unless otherwise stated, are for items in excellent used condition with no missing parts. Such items should have no dents or dings, but may have a minimal amount of surface scratching. Many price guides quote prices for items in mint or even mint-in-box condition. Although few items actually meet the definition of mint, there is a tendency to set prices based on "book value" without factoring in condition. Buyers should expect to pay a premium for mint-in-box items, sometimes as much as twice the price for the same item in excellent used condition. On the other hand, they should expect to pay significantly less than "book value" for used items that have dents and dings, missing pieces, or major scratching. Few collectors want to display pieces that do not show well. They will tolerate minor dings on the base or backside of an item that is in otherwise excellent condition. Similarly, a degree of surface scratching is found on most trays, particularly those produced by Kensington. Although the aluminum-alloy used by Kensington is less prone to scratching than aluminum, it is still much softer than chromium, brass, and copper. Kensington trays and serving pieces that are badly scratched have only minimal value.

Some metal giftware, particularly items made by Chase with embossed ribbing on the sides, is prone to stress cracks. Among the Chase items where problems are most likely to occur are the "Lazy Boy" Smokers' Stand, the "Butter Dish," the "Sparta Water Pitcher," and the "Electric Table Chef." I watched in horror as my "Butter Dish" and "Sparta Water Pitcher" developed cracks while just sitting on the shelf. Once a stress crack has started, I am aware of no way to keep it from expanding. Buyers would be well advised to examine giftware items carefully for any signs of stress cracks, particularly for items such as the "Lazy Boy" that may cost $500 or more.

Appearance

Closely related to condition is the appearance of the item. Dealers should expect to keep a cocktail shaker covered with a heavy coat of dirt and grime for a long time unless it is priced to sell. Many times, I pass up a piece of chromium because of uncertainty about whether the surface is pitted or just filthy. If an item is so dirty that I am unable to determine its condition, I will not pay more than a few dollars for it. Similarly, brass and copper items are likely to fetch higher prices if they are polished to their original appearance. With the exception of items finished in antique bronze, polishing enhances the beauty of the art deco shape.

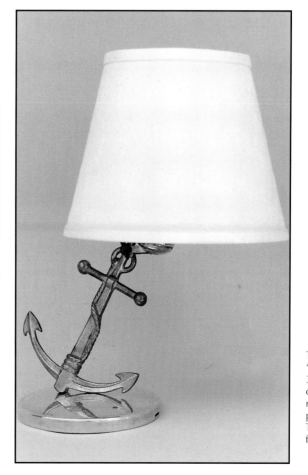

A Chase "Farragut" Lamp as found. The poor appearance of the lamp significantly limits its resale value. Expect to get no more than $20-25 for a lamp in such condition.

The same Chase polished brass "Farragut" lamp (No. 6308), 13-3/8" h., after restoration. The only major expense in the restoration was purchase of a parchment shade for about $10. The restored lamp should sell for $75-90.

Designer

Items by big name designers, such as Norman Bel Geddes, Russel Wright, and Walter von Nessen, invariably bring higher prices than anonymous pieces. Avid collectors are more likely to pay a few extra dollars for a piece if they know something about its history. In addition, many collectors are looking for items by particular designers. For example, there is a large contingent of Russel Wright collectors who seek the full range of aluminum ware, ceramics, and chromium giftware he designed.

Purity of Design

Many manufacturers gave their old designs a more modern look by adding a bakelite handle or top to an otherwise traditional design. For example, many traditionally styled cocktail shakers were given chromium plating and a catalin handle. That's like the 1970s trend of "modernizing" early art deco shopping centers and other buildings by covering them in aluminum siding and adding a mansard roof, perhaps the defining elements of 1970s "architecture." In so doing, they destroyed much of the classic architecture of the 1930s. Perhaps the best example of such "modernization" was the Greyhound Bus Terminal in Washington, D.C. Fortunately, through the efforts of Richard Striner and the Art Deco Society of Washington, the building was saved and restored to its former glory.

Manufacturer

Chase is currently the most collectable of all chromium giftware manufacturers and its giftware commands premium prices. This is due, in large part, to the reproduction of Chase giftware catalogs in 1978, 1988, and 1992. Other manufacturers, such as Revere and Manning-Bowman, are beginning to attract a strong following and their giftware items are likely to show the strongest growth in value over the next 5 to 10 years. Because the Manning-Bowman and Revere lines, in general, were priced higher than Chase and therefore did not sell as well, many of their giftware items are hard to find. As demand for such items increases, prices are likely to accelerate. Kensington giftware has generally not attracted the same attention and high prices generated by chromium giftware. *Art Deco Aluminum: Kensington* by Paula Ockner and Leslie Piña is increasing collector interest in Kensington and is likely to drive prices higher over then next few years. Other giftware manufacturers to watch are Park Sherman, Everedy, and Bruce Hunt.

Penquin Guide to Art Deco Prices

As a buyer, it is impossible to remember the "values" of all giftware items in order to identify a bargain. An easy way to gauge an antique dealer's overall pricing is to look at the price of the most common item in inventory, normally a West Bend "Penguin™" ice bucket. The Penguin was a nice design that sold extremely well. As a result, they are everywhere. It is not unusual to find 4 or 5 in a single antique mall or flea market. If the Penguin is priced above $20, it's a good bet other prices are inflated as well. Incidentally, you should have at least one Penguin in your art deco collection. Just don't pay too much for it.

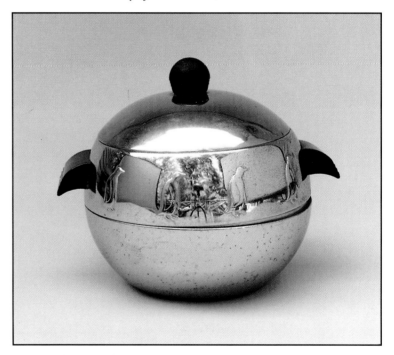

"Penguin" hot and cold server by West Bend Aluminum Co., West Bend, Wisconsin, 8" h., 8"d. The Penguin was available in polished chromium (shown), aluminum, and satin copper and with either bakelite or wood trim. Typical of post-war chromium, the Penguin is often plated over a magnetic metal and subject to pitting and rusting. $10-20.

Part Two

Giftware Gallery

Chapter 10
Decorative and Floral Items

The ideal formal dinner table of yesterday was invariably white, lighted by many but softly shaded candles. Color was confined to that of the roses, with candle shades and iced cakes to match. The ideal formal dinner table, remember, was in harmony with ritualistic calm, its appeal was to the mathematical sense of balance, and the enjoyment of food was Epicurean. The modern buffet supper table, on the other hand, can hardly have color or light too bright, since its object is to fill the senses with the gaiety of color, stimulate conviviality and whet the appetite. (Emily Post in *How to Give Buffet Suppers*, 1933)

Emily Post provides a number of decorating tips in the 1933 pamphlet *How to Give Buffet Suppers* that she developed for Chase. Such tips are interspersed throughout this chapter. Her advice on setting up a buffet service is included in Chapter 12.

Centerpieces

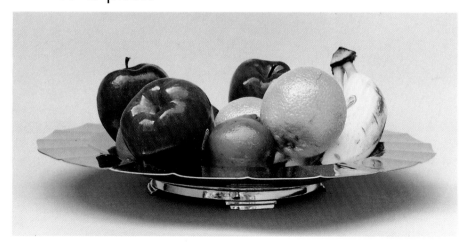

Manning-Bowman polished chromium centerpiece bowl, 14-1/4" d. and 1-3/4" h. This early example of Manning-Bowman art deco giftware has the server trademark. $140-200.

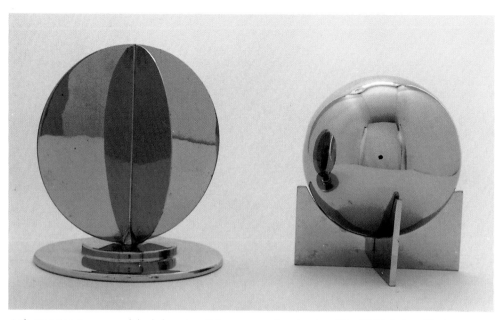

Left: Manning-Bowman polished chromium "Glamouresque" centerpiece (No. K178) designed by Jay Ackerman, 7-1/2" h., 6" d. Not pictured are the matching candlesticks (No. K177), 4-3/4" h., 3-1/2" d., and tray (No. K982), 18" d. Prices in 1934 were $6 for the centerpiece and tray and $7.50 for a pair of candlesticks. Current values are $100-125 for the centerpiece and candlesticks and $50-75 for the tray. Right: Unmarked polished chromium sphere 5" d., on display stand, 5-1/4" x 5-1/4" x 2". $65-85.

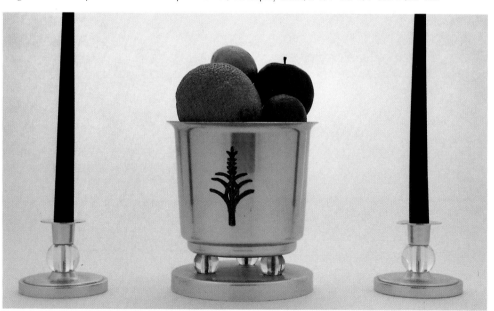

Kensington "Folkestone" bowl (No. 7413), designed by Lurelle Guild in 1934, 7 3/8" h., and 7" d., and "Stratford" candleholders (No. 7405), 3-1/4" h., designed by Samuel C. Brickley in 1939. $70-80 (bowl); $55-65 (candleholders).

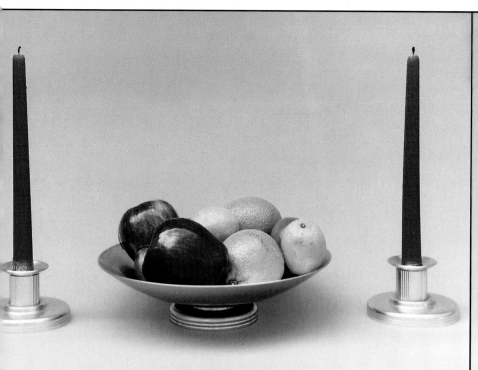

Above left: Kensington aluminum alloy "Sherwood" Compote (No. 9415), 10-1/2" d. x 2-3/4" h., and Candleholders (No. 7402), 4-1/8" d., 2-1/4" h. Lurelle Guild was awarded a design patent in 1937. Compote, $30-40, candle holders, $25-30.

Above right: Chase "Fiesta Flower Bowl," (No. 29002) designed by Gerth and Gerth, 6" h., 8" d. (top), polished copper with walnut base. Introduced in 1935, and produced through 1940, the "Fiesta Flower Bowl" was also available in polished chromium with a white enameled base and polished copper with a white enameled base. $90-115. Shown with the "Diana" candlesticks (No. 24009), 3-1/2" d., 1-1/2" h., also in polished copper and walnut. $45-60.

Left: Chase polished copper and walnut "Diana" Flower Bowl (No. 15005), 10" d., 3-3/8" h., and Candlesticks (No. 24009), 3-1/2" d. x 1-1/2" h. Designed by Harry Laylon, the "Diana" flower bowl and candlesticks were produced from 1936 through 1942, but were twice redesigned. Initially, the base featured horizontal ribbing (as pictured) and was either walnut or white-enameled wood. In the first redesign, the wooden bases were replaced with white plastic bases and the horizontal ribbing replaced with vertical ribbing. The height of the candlesticks also increased to 1-7/8". In 1942, the "Diana" Flower Bowl was replaced by the "New Diana" Bowl (No. 15008), 2" wider and almost 1/2" shorter than the original. The "Diana" candlesticks were also redesigned and given a new catalog number (No. 17116). The redesigned candlesticks added a broad heavy base of polished chromium, copper, or brass (3-5/8" d.) and decreased the size of the upper metal rim. The Diana bowl and candlesticks were produced in both polished copper and polished chromium from 1936-42. As Harry Laylon had left Chase before the 1942 redesign, it is not clear who designed the 1942 versions. Flower bowl, $90-125. Candlesticks, $45-60.

"...if the table is crowded and candles are not needed to see by, they would better be left off." (Emily Post in *How to Give Buffet Suppers*, 1933)

Manning-Bowman polished chromium "Nocturne" console set designed by Jay Ackerman. The set consists of the "Decorative Bowl" (No. 162), 3-3/4" h., 9" d. and "Candlesticks" (No. 207), 3-1/2" h. Available as either a set ($8), or separately ($4 each) in 1936. $50-70 (bowl); $60-75 (candlesticks).

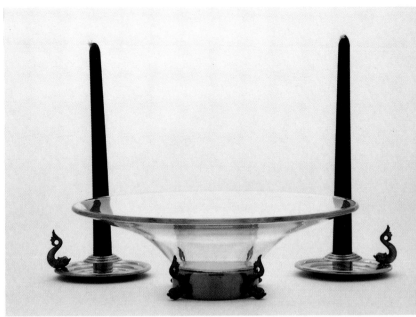

Chase polished brass "Clipper Bowl" (No. 15006), designed by Harry Laylon, 11-3/8" d., 3-1/2" h. $95-110. Chase "Porpoise" candlesticks (No. 24008), designed by Helen Bishop Dennis, shown in polished chromium and polished brass, 4-1/4" d. $35-45 a pair.

Kensington aluminum alloy "Stratford" compote (No. 7411), 13-5/8" d., 6" h., and candlesticks (No. 7405), 3-1/4" h. The compote was designed by Lurelle Guild in 1934, the candlesticks by Samuel C. Brickley in 1939. $120-130 (compote), $35-45 (candleholders).

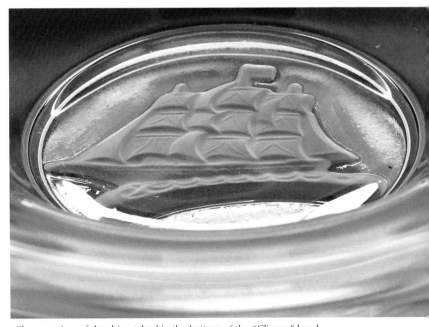

Close up view of the ship etched in the bottom of the "Clipper" bowl.

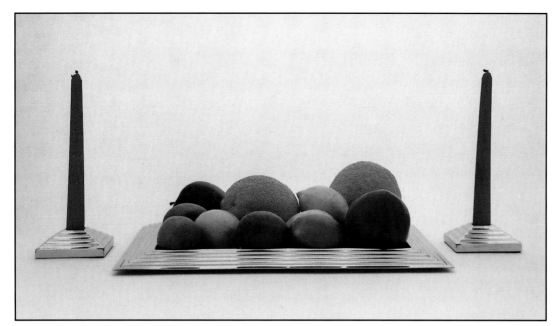

"Color plays an enormous part in the beauty of a modern buffet table…With copper keep all of the autumn tints in mind: green, red, russet and yellow….Very smart colors at the moment are eggplant, russet brown, lobster red, leaf green, dark blue, or, if you are setting your table with chromium, additional colors to choose from include turquoise blue, emerald green, and magenta." (Emily Post in *How to Give Buffet Suppers*, 1933)

Revere polished chromium "Manhattan Centerpiece" (No. 1740), 14-1/2" x 11-1/2" x 7/8". This centerpiece consists of the Manhattan tray designed by Norman Bel Geddes and a white enameled wire grid (missing from this example). The 1936 catalog claims that "…the Manhattan is a decided improvement over the usual centerpieces that obstruct views across the table." $100-125. The Frederick Priess-designed Manhattan Candlesticks (No. 1590), 3-1/3" x 3-1/3", were added to the catalog in 1937 and match the fluted design of the tray. $75-90 a pair.

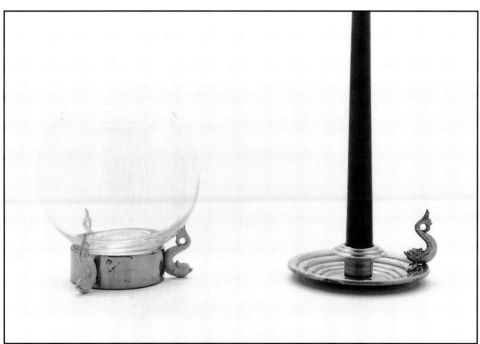

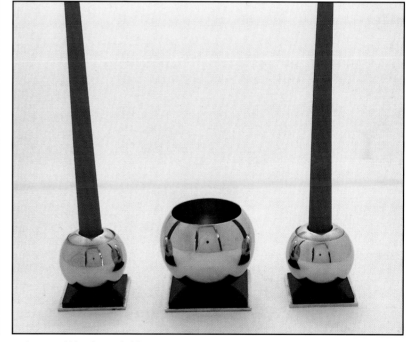

Chase "Ivy or Fish Bowl" (No. 90098), designed by Helen Bishop Dennis, shown in polished copper with white enameled porpoises. Introduced in 1937, the stand is rarely found with its original 5" glass bowl. Replacement bowls, such as that shown, are readily available. There is nothing distinct about the glass bowls to help authenticate the originals so be wary of claims that the bowls are original. $50-60. Shown with the bowl is the "Porpoise" candlestick (No. 24008) in polished copper, 4-1/4" d. $35-45 a pair.

Chase "Bubble" flower holder (No. 17065), 3-1/8" x 3-1/8" x 3-1/4", and candlesticks (No. 17063), 2-1/2" x 2-1/2" x 2-1/2", in polished chromium with "deep midnight blue glass." $75-85 (vase) $90-110 (candlesticks).

Candleholders

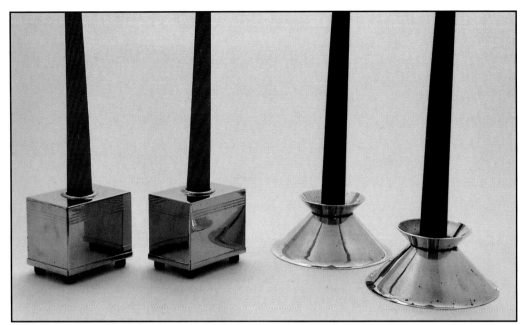

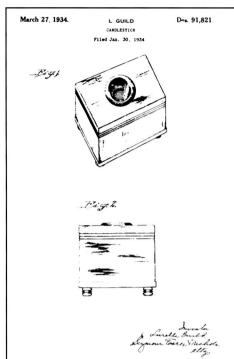

March 27, 1934. L GUILD D-2. 91,821
CANDLESTICK
Filed Jan. 30, 1934

Far left: Left: Chase polished chromium "Architex" candlesticks (No. 27007) with black enameled feet, 3" x 2" x 2-1/2". Designed by Lurelle Guild, the candlesticks are also part of an entire "Architex" centerpiece (No.27012). Rare $130-160 per pair. The full centerpiece has a value of $450-600.
Right: Chase satin brass "Diabolo" candlesticks (No. NS-635), 2" h. x 4-1/4" d. Rare $125-155 per pair.

Left: A design patent for the "Architex" candlestick was awarded to Lurelle Guild on March 27, 1934. A second design patent (D91,874) covering the full "Architex" centerpiece was awarded to Guild on April 3, 1934.

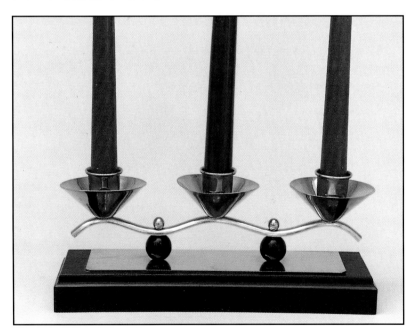

Exceptional candleholder of European design, made of polished chromium, black bakelite spheres, and black lacquered wood, 10" x 4" x 2-3/4". $175-200.

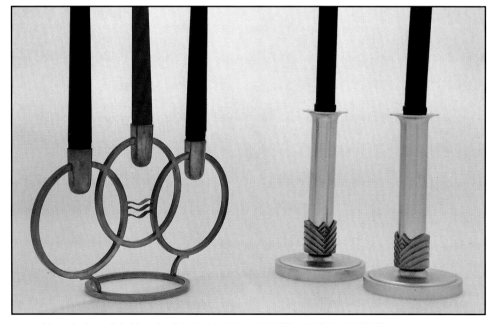

Left: Unmarked candleholder of polished nickel silver, 10-1/4" x 4-1/4" x 6-5/8". The exceptional design makes this a valuable addition to any art deco collection. $125-150.
Right: Lurelle Guild designed Kensington "Vanity Fair" candleholders (No. 7401), aluminum alloy with brass adornment, 7" h. $50-60.

Chase "Fiesta Candlesticks," (No. 29001) designed by Gerth and Gerth, in polished copper with walnut base and collars, 8" x 8" x 3-7/8". Introduced in 1935, and produced through 1940, the "Fiesta Candlesticks" were also available in polished chromium with a black enameled base and collars and polished copper with a white base and collars. $95-120.

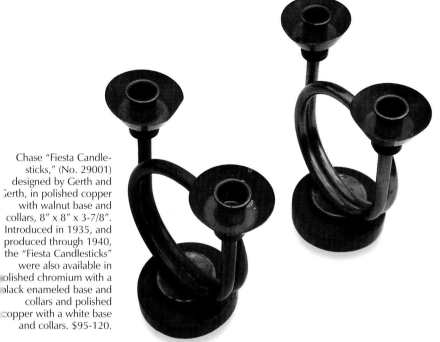

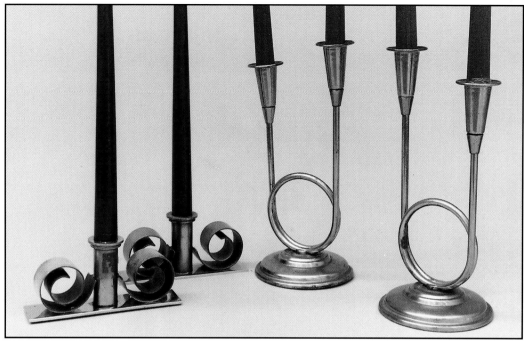

Left: Unmarked candlesticks of polished copper with a polished chromium base, 5-7/8" x 2-3/4" x 1-1/2". $35-$45.
Right: Polished copper and brass candlesticks by Coppercraft Guild, Staunton, Massachusetts, 9-7/8" h., 4-3/8" d. (base). $40-50.

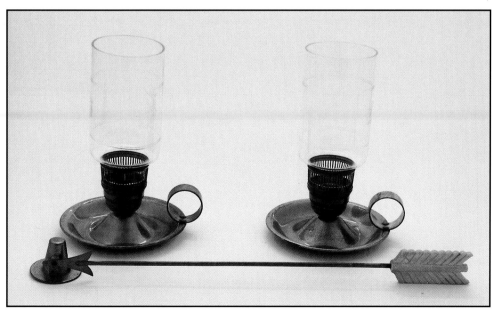

By 1940, Chase was increasingly abandoning "moderne" styling in favor of colonial. In the rear are "Settler's Hurricane Lamps" (No. 16006), polished brass with etched glass shade, 5" d. (base), 7-1/4" h. Also available in a wired version (No. 6307). $65-75 per pair. In the foreground is another design attributed to Harry Laylon, the "Puritan Candle Snuffer" (No. 90151), polished brass and white plastic, 15-1/2" l. $90-110.

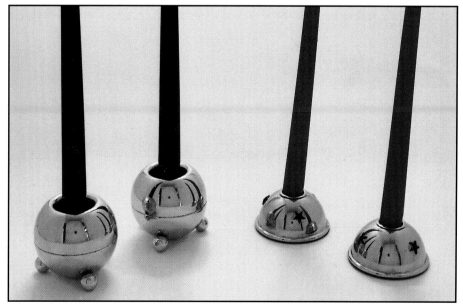

Left: Polished chromium spherical candlesticks marked "Nelson, Cranston, R.I.," 3" d. Produced after the "official" end of the art deco period, these candlesticks feature a spring action mechanism that holds the candle in place. The mechanism was patented in 1954. $30-35. Right: Unmarked polished chromium hemisphere candlesticks with polished brass stars, 3" d. $40-50.

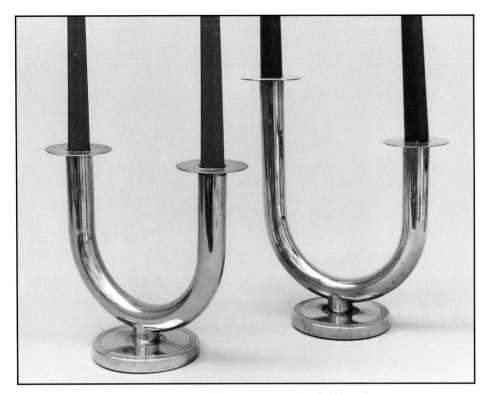

Chase "Taurex" candlesticks designed by Walter von Nessen and included in Chase catalogs for 1933-1937. Left: The even candlestick (No. 24003), polished chromium, 7-1/8" h., dropped after 1936. Right: Uneven (No. 24004), polished copper, 9-3/4" h. Taurex candlesticks were also produced in satin copper. $175-225 each.

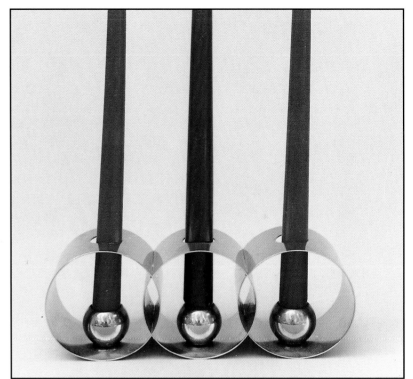

Helen Dryden designed Revere "Candlesphere" (No. 162) of polished chromium with brass holders. One of only two pieces Helen Dryden designed for Revere, the Candlesphere is, in my opinion, undervalued at $75-90.

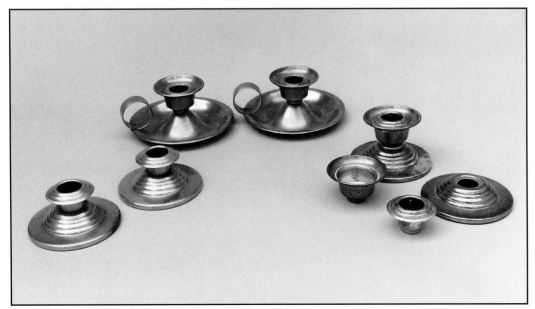

"If candles are needed, candelabra are better than candlesticks for two reasons: first, they give better light; second, they contribute height, which is important because a buffet is always more heavily laden than the ordinary table and therefore looks best when there are many, and dominantly high." (Emily Post in *How to Give Buffet Suppers*, 1933)

Left front: Chase "Sunday Supper" Candlesticks (No. 24002) in satin nickel, 3-3/8" d., 1-3/4" h. $35-45. Center rear: Chase polished brass "Salem" Candlesticks (No. 16008), attributed to Harry Laylon, 5" d. x 2-1/4" h. $35-45. Right: Unmarked polished brass candlesticks made in part of "Sunday Supper" and "Salem" components, 3-3/8" d., 1-3/4" h. One candlestick has been disassembled to show the component parts. It is not clear whether Chase made the candlesticks either for itself or another giftware company or whether another manufacturer made them using Chase components. $35-45.

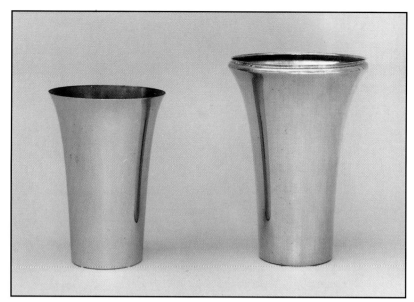

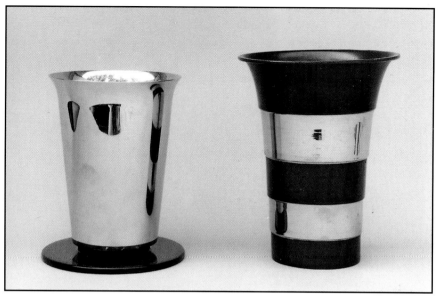

Chase "Calyx" vases. Left: The original design (No. 03007), introduced in the 1933 catalog in polished chromium or copper (not shown), 6-1/2" h. A larger version (No. 03008), 7-1/2" h., was also available in both finishes. $50-60. Right: The redesigned "Calyx" vase (No. 03011) in polished copper or polished chromium (not shown), 7-7/8" h. The new design, introduced after 1938, features a sharp vertical lip. $60-70.

Left: Manning-Bowman "Penthouse" vase (No. K184), polished chromium with black "reflecting" base, 7-1/2" h., 6" d. The "Penthouse" sold in 1934 for $3.50, and was also available in polished chromium with a white, copper, or red base and in polished copper with a white base. $80-95. Right: Manning-Bowman vase from the late 1920s or early 1930s with alternating bands of antique bronze and polished chromium, 8" h. Has the "Means Best" trademark. Rare. $95-115.

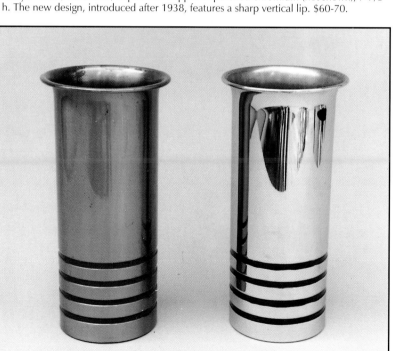

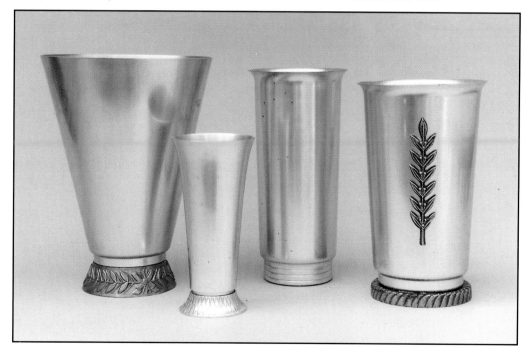

Von Nessen designed Chase "Ring" vases (No. 17039) in golden triangle metal with "lapis blue" rings (left) and in polished chromium with black rings (right), 9-1/2" h. $100-125.

Four aluminum alloy vases by Kensington. Left to right: "Marlborough" (No. 7031), with brass base, 10" h., 7-1/2" d. $90-110. "Kingston" (No. 7032), 6-1/4" h. $25-35. "Sherwood" (No. 7030), 9-1/2" h. $35-45. "Laurel" (No. 7028), 9" h. $80-95. Lurelle Guild designed all but the "Kingston."

"A 'partial' buffet means that in addition to the buffet table on which the dishes of food are arrayed, there is seating place for everyone at numerous small card tables…Each table is covered with a small tablecloth and is set with knives, forks, spoons, napkins, salt and pepper-pots, and perhaps flowers for decoration…" (Emily Post in *How to Give Buffet Suppers*, 1933)

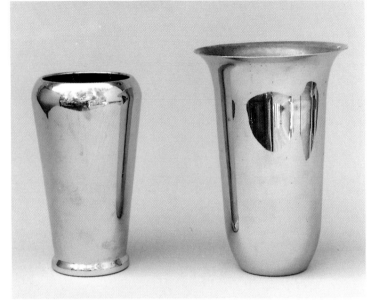

Left: Revere polished chromium vase from the late 1930s, 8" h. $60-70. Right: Chase polished chromium "Trophy" vase (No. 03005), 9" h. Included in Chase catalogs in 1933-35, the "Trophy" vase also came in triangle metal (golden) and black nickel. $100-120.

Left: Kensington "Gainsborough" vase (No. 7029), aluminum alloy base with cobalt blue glass vase, 9" h. Probably the most "moderne" design by Kensington. $135-150.

Below: Two popular designs by Chase. Left: Polished chromium "Minerva" vase (No. 03012), with white bakelite ring at base, 6-3/8" h. Also available in polished copper. $35-50. Right: One of the most popular designs by Gerth and Gerth, the "Four-Tube Bud Holder" (No. 11230), 8-1/4" h., was included in Chase catalogs from 1933-38 in both polished chromium and copper. A redesigned "Four-Tube Bud Holder" (No. 03010), slightly higher (9") and with plastic collars supporting the smaller tubes remained in Chase catalogs through 1942. $35-45.

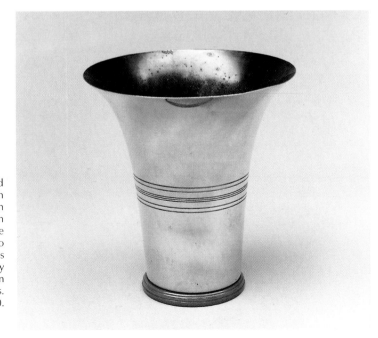

Unmarked polished bronze vase with step-down butterscotch catalin base, 6" h. The design is similar to that of cocktail cups produced by Manning-Bowman in the late 1920s. $80-90.

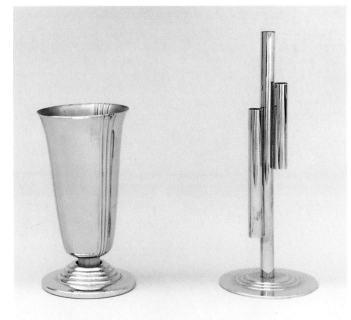

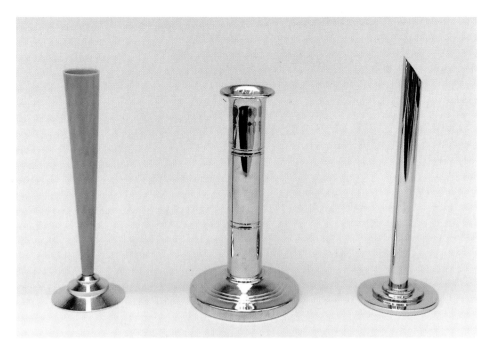

Left: "Dura-Vase" (No. R-4374), produced by the Dura Co., Toledo, Ohio, step-down chromium base with green plastic, 8-7/8" h. $20-30. Center: Polished chromium vase stamped "Hellem" and "France," 8-1/4" h. $35-45. Right: "Evercraft" polished chromium bud vase with step-down base produced by the Everedy Company of Frederick, Maryland, 9-1/4" h. $25-40.

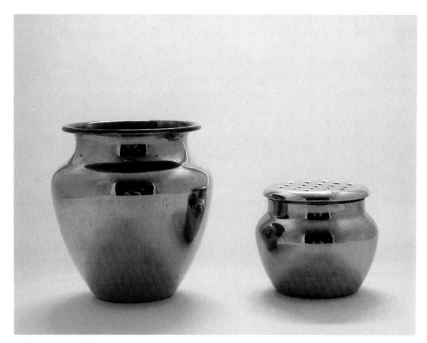

Left: Revere polished copper "Grecian Vase" (No. N-5), 5-1/2" h. A number of other heights (7-1/2", 8") and finishes (polished chromium, and Ebenew) were also available in the 1935 catalog. In addition, the vases were offered in polished copper with brass ring handles. $55-75. Right: Chase "Flower Jar" (No. 11151), polished copper with brass top, 3" d., 3-1/2" h. Available only before 1933, the "Flower Jar" also came with a polished brass bottom and copper top and polished nickel bottom and black enamel top Rare. $120-150.

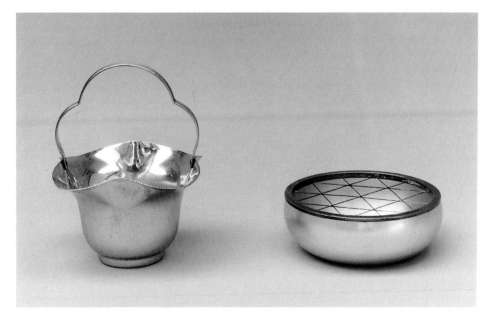

Left: Farberware polished chromium flower basket, 6-1/2" h. $10-20.
Right: Kensington aluminum alloy and brass flower bowl, 5" d. $35-45.

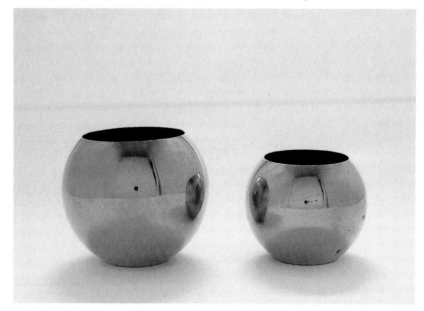

Revere polished copper "Bubble Bowls," 4-1/2" d. (No. F-17), 3-1/2" d. (No. F-18). The bowls were also available in polished chromium (Nos. F-717 and F-718) and Ebenew (Nos. F-17-EB and F-18-EB). Similar bowls were made by a number of other domestic and Japanese manufacturers, limiting their value. $25-35.

Flower Pots and Watering Cans

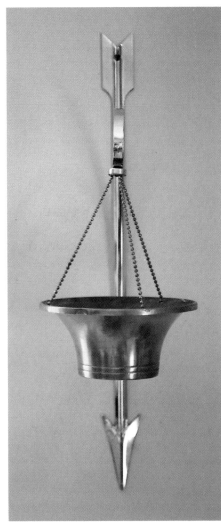

Revere "Hamilton" hanging plant basket (No. 7051), designed by Ted Mehrer, with polished chromium bracket, 18-7/8" l., and satin copper basket, 5-3/4" d. The 1937 catalog copy notes that the Hamilton is "[s]lightly reminiscent of Federal Period Design, yet it combines the modern feeling with a happy result." $35-50.

Revere polished chromium "Reflector Wall Bracket" (No. F-716), 11-1/4" d. (reflector), 4-1/2" d. (bowl). Also available with the ring on the left (No. F-726), and in polished copper with a brass ring on the left (No. F-26) or right (No. F-16). $55-60.

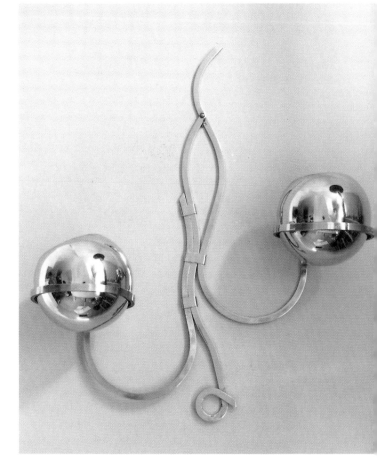

Above: Revere polished chromium "Venetian Wall bracket" (No. F-722), designed by Elsie Wilkins, 12" w., 14-1/4" h., 4" d. (bowls). $55-65.

Left: Chase polished copper flowerpots. Left: "Flower Pot Holder" (No. 11155), 4-1/2" h., 5-3/4" d. $25-35. Center: "Tom Thumb Plant Pot" (No. 04010), designed by Harry Laylon, 2-9/16" h., 2-7/8" d. $15-20. Right: The "Pendant Plant Bowl" (No. 04004), designed by Harry Laylon, 5-1/4" h., 6-1/4" d. The "Pendant," a hanging pot, was also available in polished brass and English bronze. $25-35.

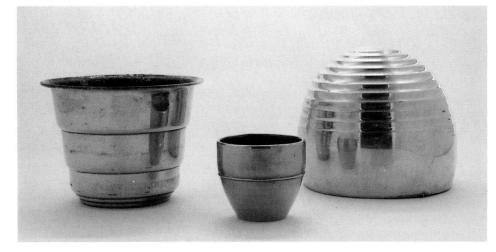

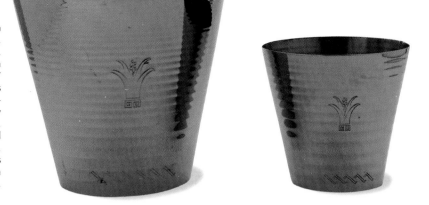

Revere polished chromium "La Fleur" jardinieres, 7" h. and 5" h. Designed by W. Archibald Welden. When introduced in the 1937 catalog, the "La Fleur" was available in two finishes (red-copper and golden-yellow brass), in four sizes (3-1/2", 4", 5", and 6") and with and without the motif decoration. Separate catalog numbers were assigned to each variation. $55-65.

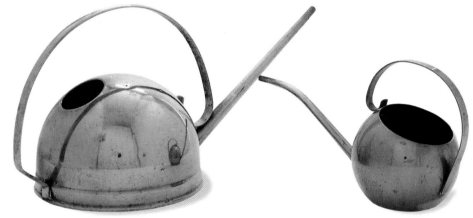

Revere polished copper watering pots with brass handles.
Left: The "Large Watering Pot" (No. WP-42), 17" l. x 7-3/4" h. $65-80.
Right: The "Junior Watering Pot" (No. WP-41), 12-3/4" l., 5" h. $55-70.

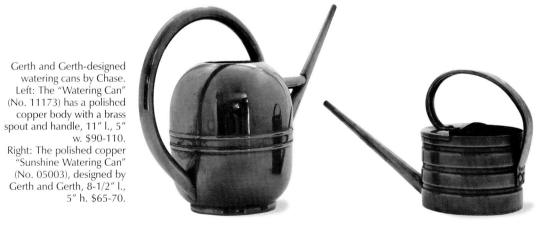

Gerth and Gerth-designed watering cans by Chase.
Left: The "Watering Can" (No. 11173) has a polished copper body with a brass spout and handle, 11" l., 5" w. $90-110.
Right: The polished copper "Sunshine Watering Can" (No. 05003), designed by Gerth and Gerth, 8-1/2" l., 5" h. $65-70.

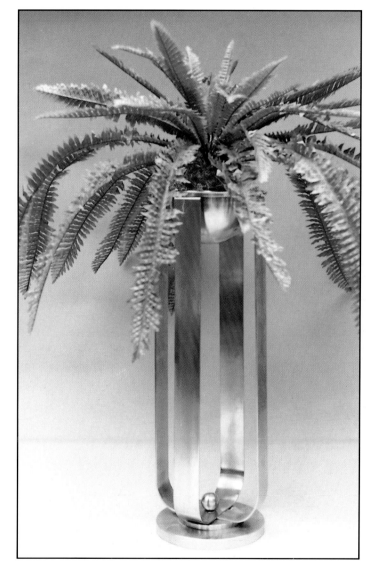

Unmarked white metal fern stand, 36" h., 12" d. $750-900.

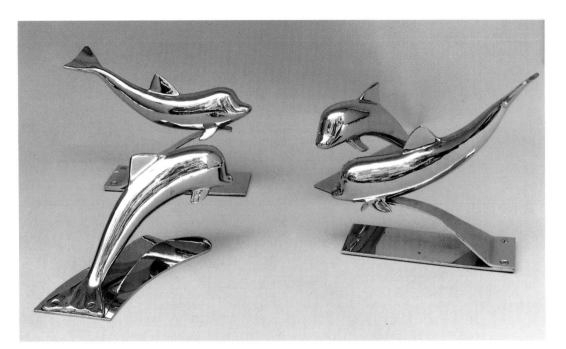

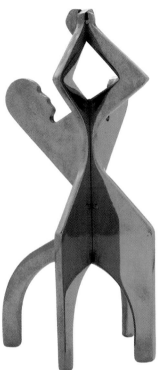

Miscellaneous

> In setting a buffet table, "...objects of utility are of first importance, and unless there is ample space for both, objects that are solely for ornament are omitted." (Emily Post in *How to Give Buffet Suppers*, 1933)

Far left: Set of four unmarked dolphins in polished chromium over solid brass, ranging from 5-1/4" to 9" h. and 9-1/2" to 11-1/4" l. $500-750.

Left: Unmarked nickel silver sculpture, 11-1/4" h. $200-225.

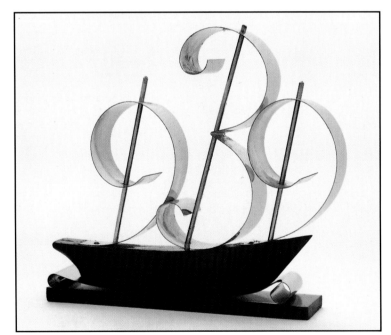

Unmarked ship ornament with polished chromium sails and wave, 6" x 1-3/4" x 5-5/8". Although the ship is unmarked, a design patent awarded to Abraham Solomon of New York and Eugene Volynkine of Paris in 1938 was assigned to the National Silver Deposit Ware Co., New York, New York. $30-45.

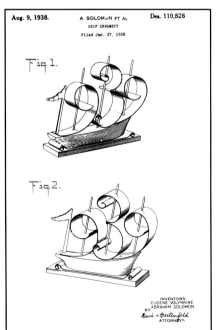

Design patent for a ship ornament awarded to Eugene Volynkine and Abraham Solomon on August 9, 1938.

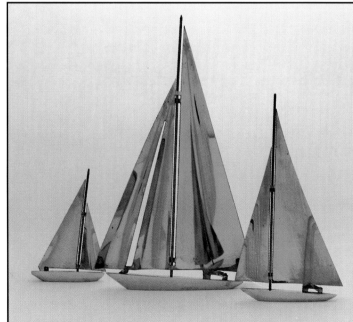

Set of unmarked chromium-plated sailing ships, 5" to 11-5/8" h. $75-100 for the set of three; $15-25 individually.

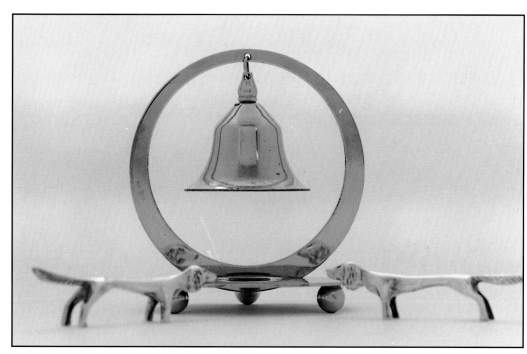

Back: Bradley and Hubbard polished chromium dinner bell; 3-5/8" d.; 4-3/4" h. $75-80. Front: Unmarked silver-plated knife rests, 3-3/4" l. $100-125.

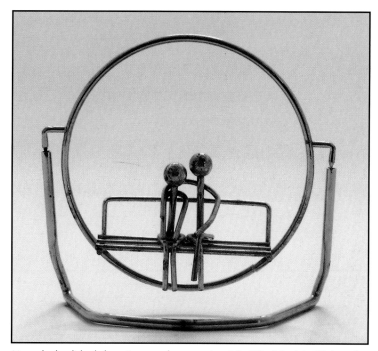

Unmarked polished chromium couple on a swing. It is difficult to date this item, but I believe it to be from the 1930s based on the style and pose of the couple. $25-30.

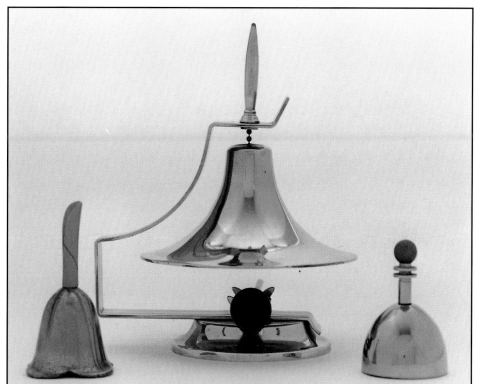

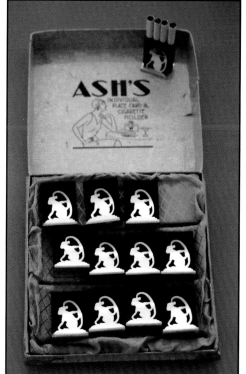

Far left: Three bells (by Chase). Left: "Canterbury" bell (No. 13008) in polished brass with white bakelite handle; 3-3/4" h., 2-1/4" d. Designed by Harry Laylon, this bell was also available in polished brass with a green handle and in polished chromium and polished copper with a white handle. $75-80. Center: "Dinner Gong" (No. 11251), designed by Gerth and Gerth, polished chromium with walnut knob, 8-1/4" h. Rare $175-200. Right: "Ming" table bell (No. 13007), polished chromium with white bakelite knob, 3" h. Produced from 1935-37, the Ming bell was also available in polished chromium with a green or black knob and in polished copper with a white knob. $75-90.

Left: Boxed set of 12 "Ash's Individual Place Card and Cigarette Holder," each 1-1/5" h. They appear to be made of satin and black nickel. $75-90.

Chapter 11
Drinkware

Cocktail Sets

Shake all cocktails that contain fruit juices. Others should be stirred.

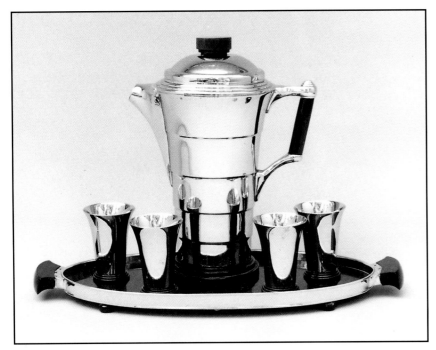

Left: Revere polished chromium "Manhattan Cocktail Ensemble" (No. 7044), designed by Norman Bel Geddes. Tray (No. 174), 14-1/2" l., 11-1/4" w. $100-125. Shaker (No. 7028), 12-3/4" h. $300-375. Cups (No. 7032), 4-1/4" h. $100-125 each. Set: $1,200-1,500.

Lower left: Manning-Bowman cocktail components from the late 1920s. The shaker is the K128 52-oz. mixer, 11" h., of polished chromium with jade catalin base, handle, knob, and cap (missing). This shaker is the ultimate in use of the stepped motif, using it on the catalin base, the top of the handle, the rim of the top, and the body of the shaker. $150-200 (as shown); $250-300 complete. The cups (No. K26) are polished chromium with stepped jade catalin bases, 3-1/2" h., 2-1/2" d. $15-20, each. The tray shown (No. K5615) is polished chromium with ebony catalin handles and bottom, 17" l. x 7-1/8" w. x 1-1/2" h. $80-100. A set would have matching catalin trim on the tray, shaker, and cups. $500-$600 for the set.

Below: Kensington aluminum alloy cocktail items: "Coldchester" cocktail shaker (No. 7152-1), designed by Lurelle Guild, 13-1/2" h., 3-5/8" d. $85-105. "Coldchester" cocktail cups (No. 7253), 2" h., 2-1/4" d. $7-10 each. "Clipper Ship" tray (No.7152), patented in 1936 by Lurelle Guild, 22-3/4" l., 14-1/2" w. $55-65. The tray was also available with a cheese board and dividers. Shown with the set are unmarked aluminum alloy cocktail muddlers, 4-1/4" l. The finish on these muddlers resembles Kensington, but there are no markings. $4-6 each.

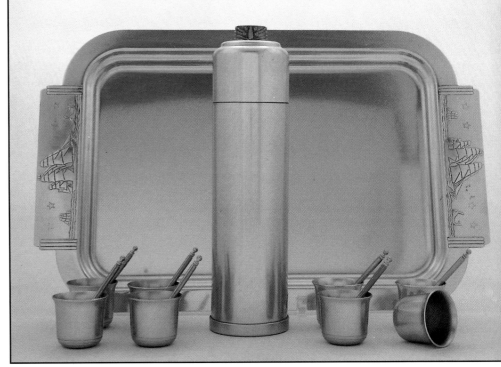

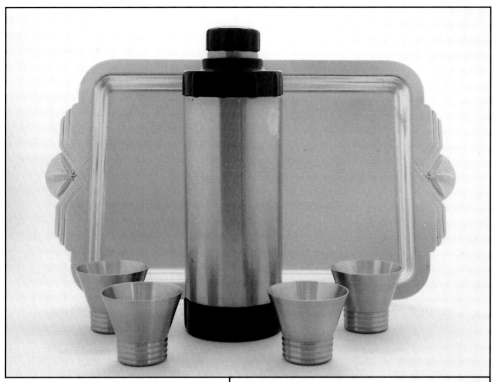

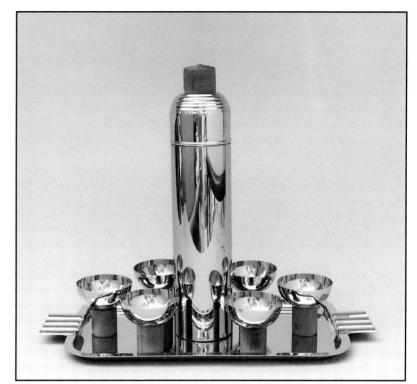

Above: Polished aluminum "Tipple Tumbler" cocktail shaker, designed by Ralph N. Kirchner, and four cups by West Bend Aluminum Co., West Bend, Wisconsin. Shaker: 11-1/4" h., 3-5/8" d., with black bakelite top and bottom and red bakelite cap. $50-60. Cups: 2-1/4" h., 2-3/4" d. $8-10 each. Tray: The Kensington "Chelsea" serving tray (No. 7157), 20-1/2" l., 11-3/4" w. $35-40.

Right: Advertisement for the "Tipple Tumbler" and other West Bend Aluminum Company giftware (*Esquire*, December 1936).

"If people are not sitting beside those they like, women as well as men are free to move elsewhere." (Emily Post in *How to Give Buffet Suppers*, 1933)

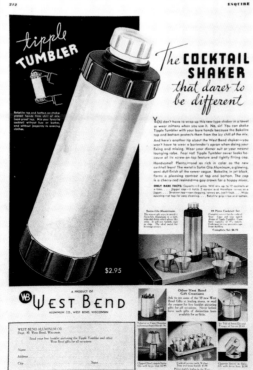

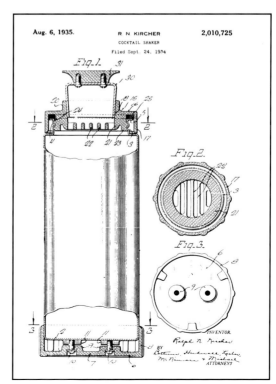

Above: Unmarked skyscraper cocktail shaker and cups, polished chromium with walnut bases and cap. Shaker: 14-1/2" h., 3-1/4" d. $85-95. Cups: 3-3/4" h., 3" d. $10-15 each. Set with six cups, $150-$175. Unmarked polished chromium tray with fluted handles, 18" l., 8-7/8" w. $55-65.

Left: Design patent for a cocktail shaker awarded to Ralph N. Kirchner on August 6, 1935.

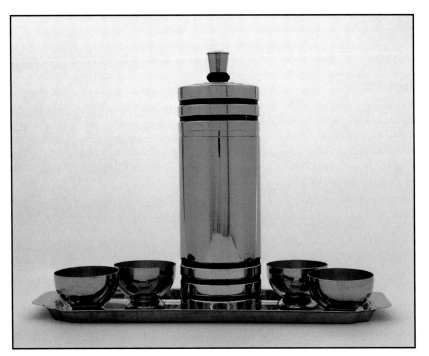

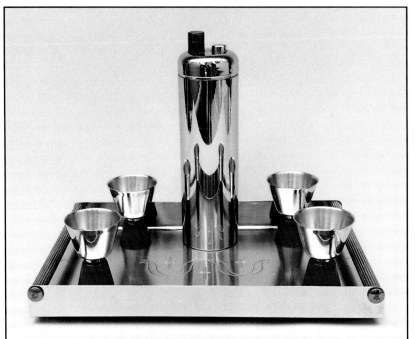

Cocktail components by Revere. "Zephyr" polished chromium cocktail shaker, designed by W. Archibald Welden, 10-3/4" h., 3" d. $150-200. "Empire" cocktail cups, designed by W. Archibald Welden, polished chromium with red catalin bases, 3-3/8" h., 2-5/8" d. $25-35 each. "Aristocrat" tray (No. 176), 15" l. x 10" w. Designed by Charles Harmann, and introduced in 1937, the tray featured polished chromium on the outside with a satin chromium interior and handles of reeded brass tubing. $125-150.

Above left: Chase polished chromium "Holiday Cocktail Set," (No. 90064). The set consists of the "Gaiety" cocktail shaker (No. 90034), 11-1/2" h., 3-3/4" d. ($50-70), four "Cocktail Cups" (No. 26002), 2" h., 2-3/4" d. ($5-10 each), and the "Cocktail Tray" (No. 09013), 15-7/8" l., 5-3/8" w. ($25-35). Howard Reichenbach designed the shaker; Harry Laylon the tray. This set was featured in ads for Kool™ cigarettes as one of the premiums available to smokers. The popularity of this set and its individual components makes it readily available, limiting its value. Set: $125-175.

Right: Once on a Blue Moon. Variations in the Chase "Blue Moon" polished chromium cocktail shaker (No. 90066), designed by Howard Reichenbach, 12-1/4" h., 3-1/2" d. Left: shaker with spherical cobalt blue glass stopper. Center: spherical catalin stopper. Right: serrated chromium and blue catalin cap. All three shakers are marked "patent applied for." The 1936 Chase catalog—the only catalog to picture the Blue Moon with a spherical top—does not describe the composition of the top, unusual for Chase. When I discussed the glass top with cocktail shaker expert Stephen Visakay, he suggested that Chase may have replaced the glass stopper with catalin because of the high cost of producing the glass stopper. After 1936, the shaker was always shown with the serrated top. Both the blue and white versions of the serrated top were initially known as "Blue Moon" cocktail shakers. Because it did not sell nearly as well as the Gaiety shaker, the Blue Moon has a higher current value. With the more common serrated top, it has a current value of $85-100. With the spherical catalin top, $110-140, and with the rare spherical glass top, $250-300.

Far right: Advertisement for Kool™ cigarettes showing Chase and Revere giftware items available as premiums.

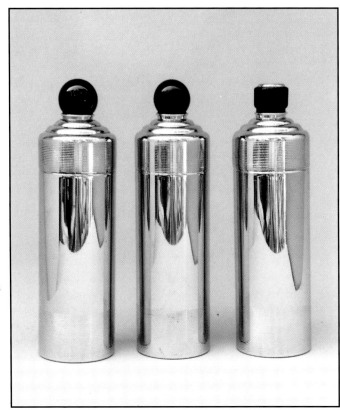

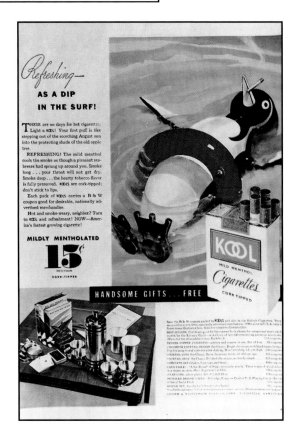

Orange Blossom—
Pour equal parts orange
juice and Gin in a shaker
containing cracked ice.
Shake well and strain into
cocktail glasses.

Close up showing the glass and
catalin "Blue Moon" stoppers.
The glass stopper is the one
with the shorter stem.

Bottom left: Chase polished chromium "Blue Moon Cocktail Set" (No. 90077). The set consists of the "Blue Moon" shaker (No. 90066), 12-1/4" h., the "Ring Tray" (No. 90058), 12" d., and six 3-1/2" h. "Blue Moon Cocktail Cups" (No. 90067) with cobalt blue glass. The shaker was designed by Howard Reichenbach, the tray and glasses by Harry Laylon. The value of the set depends on which shaker is included. As pictured with the glass stopper, the set is valued at $450-500. With the spherical blue catalin stopper (many of the stoppers have turned brown with age) the set has a value of $300-350; with the serrated chrome and catalin stopper, $280-330.

Bottom center: Chase "Doric Cocktail Set" (No. 90114), consisting of the "Blue Moon" shaker, the "Ring" tray, and six "Doric Cocktail Cups" (No. 90101), polished chromium with blue plastic bases, 3" h., 2-3/8" d. The set was also available with white trim under the same catalog number. Doric cups, $10-15 each; complete set $160-200.

Bottom right: Design patent for the Blue Moon cocktail shaker. The patent does not describe the composition of the stopper.

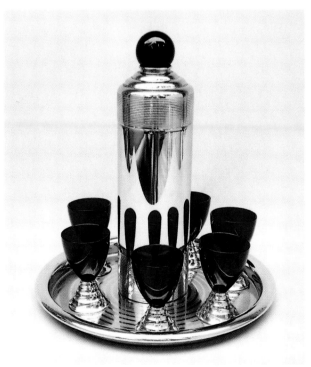

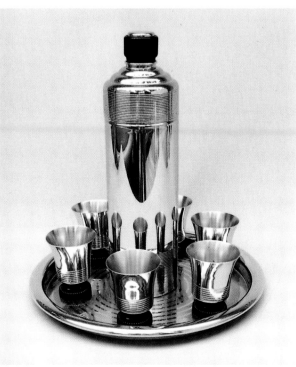

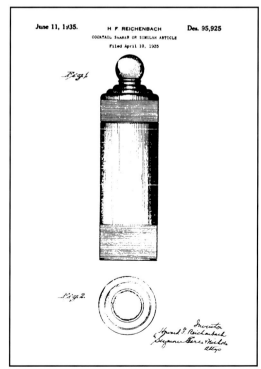

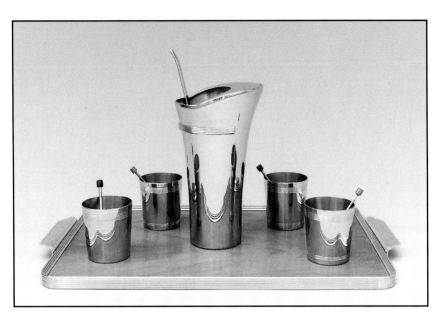

Polished chromium cocktail components by Chase. Walter von Nessen designed "Stirring Cocktail Mixer" (No. 17049), 8-3/4" h., 3" d. (base). $125-150. "Long Handled Spoon" (No. 17055), 11-1/2" l. $25-30. The Stirring Cocktail Mixer, including a long-handled spoon, sold for $5.00 in 1937. "Old Fashioned Cocktail Cups" (No. 90063), 3" h., 2-5/8" d. (top). $25-30 each. Included with every cup was an "Old Fashioned Cocktail Muddler" (No. 90065), with green, red, black, or yellow bakelite handle. A set of four muddlers which sold for $.75 in 1937 is now worth about $75-95 per set. Although the cocktail glasses are generally found with a satin chromium finish on the inside, the May 1935 House Beautiful pictures the cups with a gold wash on the inside of the cups. "Festivity Tray" (No. 09018), designed by Harry Laylon, 17-3/4" l., 12-1/4" w. with polished walnut base. The tray was also offered in polished chromium with a white or black bakelite base and in polished copper with a walnut or white base. The original "Festivity Tray" pictured featured a "stepped" handle. Later versions of the tray have a redesigned arched handle. $150-175.

Although Manning-Bowman offered the widest variety of cocktail shakers and sets, complete sets are extremely rare. Unlike most manufacturers, Manning-Bowman supplied crystal glasses with their cocktail sets during the 1930s, making the sets hard to identify. Pictured are four sets from the 1941 catalog.

Cocktail Sets

THE "CONNOISSEUR" No. 3730

For added zest at "cocktail hour." The three pint shaker handles easily while the flared base is mighty practical. An ivory Arinite cover knob harmonizes beautifully with the lustrous chromium finish; the shaker is also chromium lined. The 19" by 6¾" tray matches the shaker in chromium and ivory Arinite. Six beautiful crystal glasses. Packed one set in a carton. Also sold separately: 373 Shaker, $6.50; 40G Glasses (set of 6), $5.00; 374 Tray, $3.00.

PRICE $13.50 SET

"GROG" SET No. 550

Scotch and brandy, or any other preferred combination . . . and all the accoutrements are right at hand in the Grog Set. The two crystal decanters of generous 1½ pint capacities . . . the "Long-Short" Jiggers for measuring either standard or one-half size jiggers . . . the "Barmaid" spoon, a bottle opener, corkscrew, muddler and mixing spoon all in one . . . and the ample 19 by 6¾ inch chromium tray with solid walnut handles for competent serving. Packed one set in a carton.

PRICE $10.00 SET

THE "GRENADIER" No. 3240

Correctly designed for those who enjoy fine living, the stately combination of beautiful three pint shaker, six stem-based crystal glasses, and liquor-proof tray, makes an incomparable value. Finished outside with non-tarnishing chromium plate; inside with satin chromium. Loop handles and cover knobs of solid maple. Height 11½ inches; diameter 13⅛ inches. Packed one set in a carton. Also sold separately: 324 Shaker, $5.50; 35G Glasses (set of 6), $3.00; 325 Tray, $2.50.

PRICE $11.00 SET

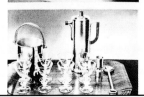

THE "LONGWOOD" No. 952

. . . answers every demand for a complete drink service for its smart eye appeal and competency, and is the pride of every host or hostess. On the large walnut tray which measures 25 by 13 inches is (1) a three-pint chromium shaker; (2) a large ice bucket; (3) eight cocktail glasses; (4) a pair of ice tongs; (5) a "Barmaid" spoon, which is a mixing spoon, bottle opener, muddler, and corkscrew all in one; (6) a Long-Short Jigger for measuring standard jiggers or half jiggers. Patented. Packed one set in a carton.

PRICE $25.00 SET

(38)

Drinking Services

THE "GENIALITY" No. 3750

Cocktails with a flourish! Three-pint shaker with handle and knobs of rich solid maple is most distinguished. It is finished in lustrous chromium and has a chromium lining as well. The large 20" by 9¾" tray is also chromium with generous, natural grip maple handles. Eight-stemmed cocktail glasses are of clear crystal. One set in a carton. Also sold separately: 375 Shaker, $8.50; 40G Glasses (set of 8), $6.75; 376 Tray, $6.00.

PRICE $18.50 SET

"HAPPY DAYS" No. 2880

A cocktail set whose appearance indicates the quality of its contents. The side handle has the white Cordex trim as does the cover handle. Of three-pint capacity the shaker has a neat dripless spout. The tray with its full width barred handles is 20 inches long. Equipped with eight beautiful crystal glasses. Chromium-plated; packed one set in a carton. Also sold separately: 288 Shaker, $10.00; 24G Glasses (set of 8), $6.00; 289 Tray, $6.00.

PRICE $20.00 SET

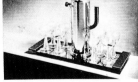

"TOWN HOUSE" No. 2520

Light tall-stemmed crystal glasses reflect against the all-over lustrous chromium finish. The three-pint shaker has a smart spout and convenient pouring handle. It stands 12 inches high. Tray dimensions: 19 inches by 6¾ inches. Handles and knobs are solid walnut. Packed one set in a carton or may be purchased separately. Shaker: 252 $8.50 Each. Tray: 221 $2.50 Each. 22G Glasses (set of 8), $6.00. Patented.

PRICE $16.00 SET

THE "FOURSOME" No. 3570

Cocktails for four. The Foursome Cocktail mixing and serving set caters to the smaller parties. Tray and shaker are chromium-plated while 3½ ounce glasses are clear crystal with white circular design. Shaker is 7½" high; Tray is 7½" by 11¾". Packed one set in a carton or may be purchased separately. Shaker: 357 $4.00 Each. Tray: 94 $1.50 Each. 35G Glasses (set of 4), $1.50.

PRICE $6.50 SET

(39)

Four more Manning-Bowman cocktail sets from the 1941 catalog.

Cocktail Shakers

Right: Left: Manning-Bowman "Esquire" cocktail shaker (No. 252), designed by Jay Ackerman, in polished chromium with walnut "trimmings," 12-1/2" h. By 1941, the shaker had been renamed the "Sportsman." The 1941 catalog notes that "even a teetotaler could not help admiring the beauty inherent in the design of this shaker." Selling for $8.50 in 1941, the "Sportsman" was over twice the price of the shakers offered by Chase. $90-120. Right: Shaker stamped "LB Chromium Plated," 12-1/4" h., 4-1/2" d. This shaker bears a strong resemblance to the Manning-Bowman "Esquire" shaker. $65-80.

Far right: Design patent awarded to Jay Ackerman on December 31, 1935, for the "Esquire" and "Sportsman" cocktail shakers.

Below left: Two Canadian cocktail shakers. Left: Polished chromium and brown catalin cocktail shaker and matching jigger stamped "Modavanti," 9-3/4" h. (shaker), 3-3/4" h. (jigger). The top fits inside the shaker so that it is not visible when viewed in profile. $75-90. Right: Individual cocktail shaker of polished chromium and burgundy catalin, stamped "gh," 7-1/8" h. $45-55.

Below right: Stars in stripes. Left: Chase "Gaiety" cocktail shaker (No. 90034), 11-1/2" h. One of the easiest cocktail shakers to find because of its immense popularity, the "Gaiety" is usually found with black stripes. The harder to find stripes in red, green, white, and blue command higher prices. $50-70. Center: Manning-Bowman "Diana" cocktail shaker (No. 286), available with either black or red stripes, 12-1/4" h., 4-3/8" d. at base. $65-80. Right: Unmarked cocktail shaker with black stripes on the top, 10-1/2" h., 3" d. A strainer is built into the top $60-75.

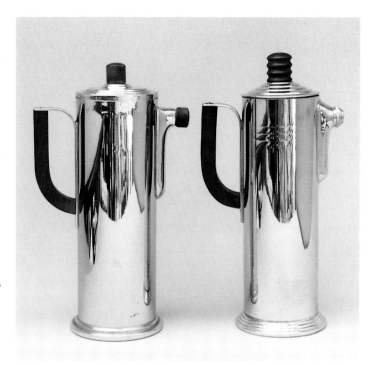

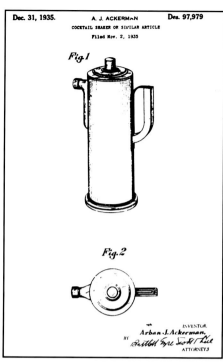

Dec. 31, 1935. A. J. ACKERMAN Des. 97,979
COCKTAIL SHAKER OR SIMILAR ARTICLE
Filed Nov. 2, 1935

Fig.1

Fig.2

INVENTOR
Arban J. Ackerman,
BY
ATTORNEYS

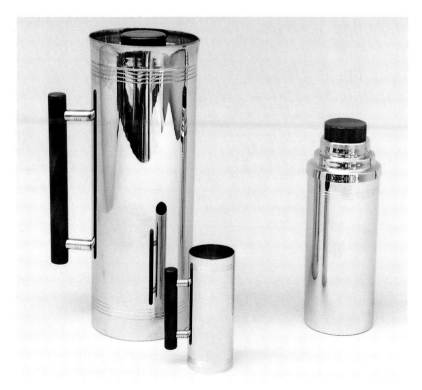

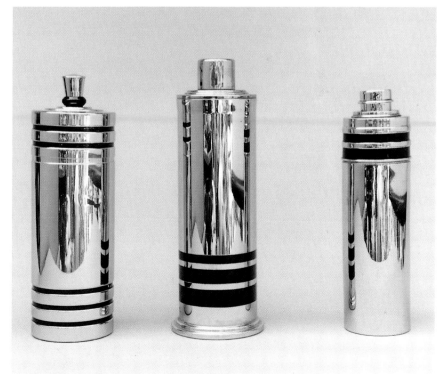

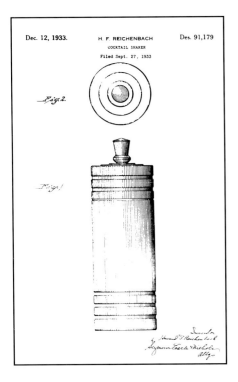

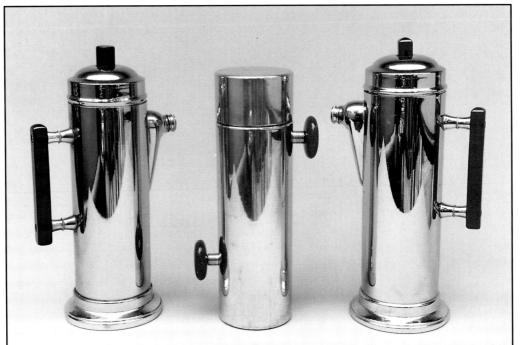

Far left: A design patent for the "Gaiety" cocktail shaker was awarded to Howard F. Reichenbach on December 12, 1933.

Left: A study in red. Left and right: Unmarked polished chromium shakers with translucent red plastic handles and knobs, 12" h. The only discernible difference between the shakers is the design of the knobs. $30-40. Center: Rotating cocktail shaker of highly polished aluminum and red plastic, 11-1/4" h. x 3-1/2" d. The handles on this unique shaker rotate. The screw on lid prevents leaks as the shaker is rotated. $140-165.

Right: Something conical. Left: Unmarked polished chromium cone-shaped shaker with black enamel bands, 12-7/8" h. You can tell from its light weight and overly gimmicky styling that this was not an expensive shaker. $35-45. Right: Kraftware aluminum cone-shaped "Coldseal" shaker (No. 250), 12-1/2" h. $45-55.

Far right: A striking lineup in polished chromium with embossed lines up the sides. Left: An exceptional streamlined design in a vacuum cocktail shaker by American Thermos Bottle Co., Norwich, Connecticut, 11-3/4". Thermos ad copy for 1937 reads: "Cocktail Stays Cooked 12 Hours. An ingenious cocktail shaker and muddler…actually keeps cocktails cold, fresh and undiluted for many hours after mixing. It is superseding ordinary shakers." $125-150. Center: Manning-Bowman "Grenadier" (No. 324), 11-1/2" h., 3-1/4" d. The shaker, which features a black enameled wooden cap, is stamped with the design patent number 97,979 held by Jay Ackerman, but the patent drawing is of the "Sportsman" shaker. It is not clear whether Jay Ackerman also designed the "Grenadier." $100-130. Right: Manning-Bowman's "Foursome" (No. 357), advertised in the 1941 catalog as "…just the thing for all kinds of 'foursome' parties: bridge, golf, tennis, or theater," 7-1/2" h. $40-50.

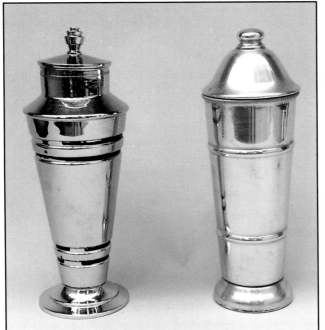

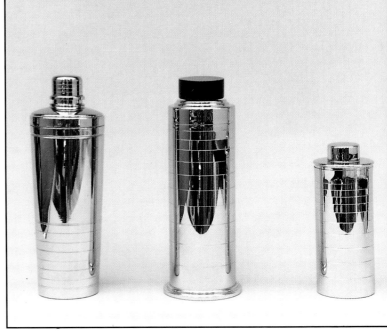

The "Grenadier" Goes to War—Manning-Bowman, like many other manufacturers, ceased consumer goods production during the Second World War, retooling its facilities to support the war effort. Unlike Chase and Revere, whose primary business was the production of raw materials—copper and brass, Manning Bowman found it difficult to obtain the raw materials it needed to fulfill its contracts.

In 1942, the company received a contract to produce "Venturi" tubes, spun metal tubes about 10 inches long and 4 inches in diameter to be attached to the wings of troop carrying gliders. Despite the priority placed on delivery of the Venturi tubes, Manning Bowman was unable to obtain the aluminum specified in the contract. With the Air Technical Service Command pressing for delivery of the tubes, Manning-Bowman suggested using an alternate metal. The metal in the Venturi tubes, however, had to be capable of withstanding 200 pounds of pressure for five minutes to the flaring side of the tubes and then springing back to within ten one-thousandths of their original shape.

Manning Bowman initially tried to use copper, but found that it flattened under the required pressure and did not spring back. Tests with brass were successful but Manning-Bowman, which, prior to the war used tons of brass in the production of toasters, waffle irons, and other consumer products, no longer had any unused brass.

The plant superintendent, however, remembered that there were 3,000 brass bodies to "Grenadier" cocktail shakers in the stockroom that were left unfinished when consumer production was halted to preserve chromium. The bodies were 11 inches long and slightly larger than the specifications for the Venturi tubes, but Manning Bowman was able to remanufacture the tubes to meet the contract specifications. Manning Bowman completed its contract, delivering the tubes in time for them to play an important part in Allied landings in Europe and around the world.

In 1944, the secretary-treasurer and general manager of Manning-Bowman noted that "We feel that very probably our cocktail shaker was the only one to take part in the European invasion, certainly the only one to serve as a glider part. Before the war, we marketed this particular shaker under the name 'Grenadier.' After the war when we start peacetime production again, we may call it the 'Invader.'"

Sadly, Manning-Bowman did not return to production of cocktail shakers after the war.

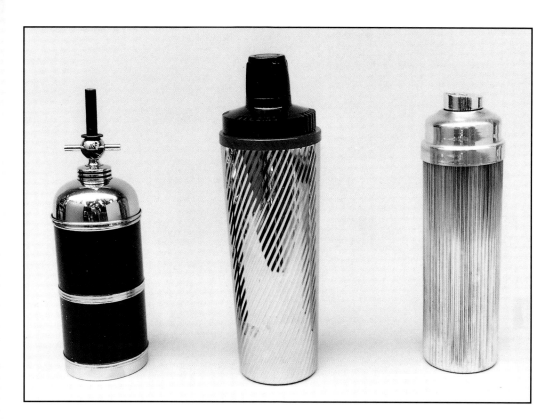

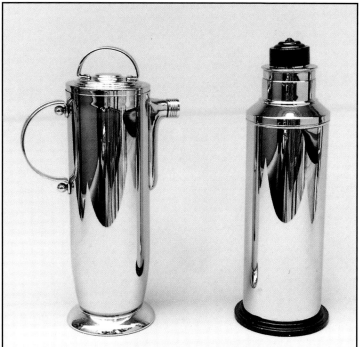

Above: Left: Unmarked cocktail shaker of polished chromium and navy blue leatherette-finish enamel, 11-3/4" h., 3-1/2" d. The screw off cap hides a corkscrew under the whimsical top hat. $90-120. Center: Glass-lined "Ritz" cocktail shaker by Monarch Aluminum Co., polished chromium with black plastic top and red enamel trim, 12-7/8" h., 4-1/2" d. $65-85. Right: Post-war aluminum cocktail shaker by Emson Products, Bridgeport, Connecticut, 11" h. The top of this shaker rotates to allow pouring and prevent spilling. $40-50.

Left: Two more polished chromium shakers by Manning-Bowman.
Left: The most expensive of the Manning-Bowman shakers, the "Good Fellowship" (No. 288) sold for $10.00 in 1941. The 1941 version of this shaker (not shown) featured white "cordex" coverings on the handles. $100-125. Right: This skyscraper shaker, featuring a step-down black enameled base and cap, stands 12-3/4" h. $50-70.

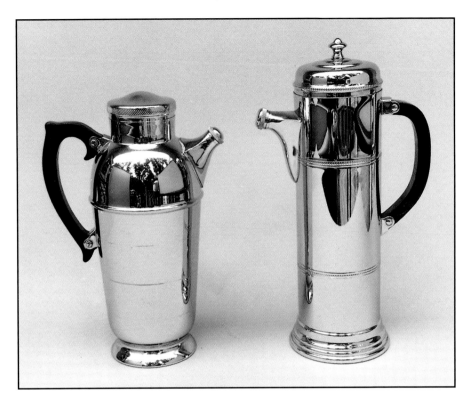

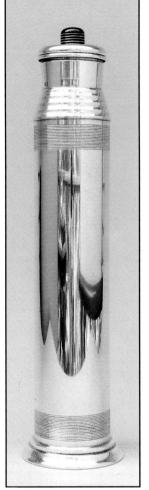

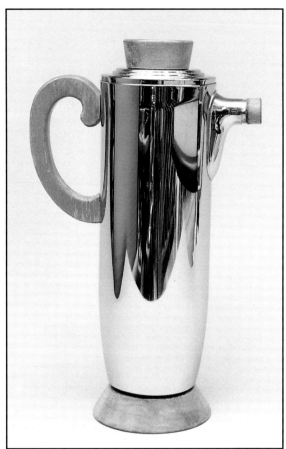

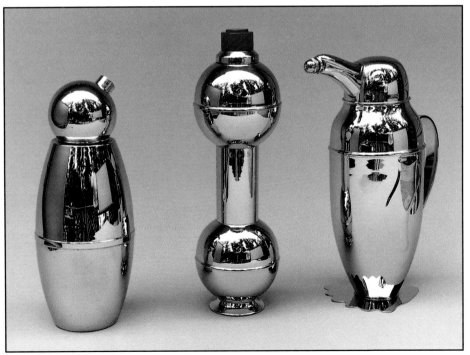

Above left: Krome-Kraft shakers by Farber Brothers, New York.
Left: Traditionally styled shaker with black bakelite handle, 11" h. $20-30. Right: A more modern style, but still lacking the flair of shakers by other manufacturers, 12-1/2" h. Although it utilizes a brown catalin handle, the styling is fairly bland. $25-35.

Above center: Silverplated skyscraper cocktail shaker stamped "Benedict 1195." Among the best in sleek skyscraper design, this shaker stands 16" tall, and features stepped designs on the top and bottom and a black catalin knob with white enameled bands. $375-450.

Above right: Manning-Bowman "Geniality" cocktail shaker (No. 375), polished chromium with solid maple trimmings, 12-1/4" h. Selling for $8.50 in 1941, more than twice the price of Chase shakers, Manning-Bowman's catalog claimed that "Here is a shaker worthy of the finest traditions." $110-125.

Left: Three shakers in polished chromium. Left: Unmarked shaker with a spherical top and elliptical body, 11" h. $45-65. Center: Dumbbell cocktail shaker with red plastic cap, stamped "Stainless Chrome," 13" h. $90-120. Right: Penguin cocktail shaker patterned after the Napier silver-plated shaker. These shakers are much in demand and recent sales at auction have been in the $300 range. $300-325.

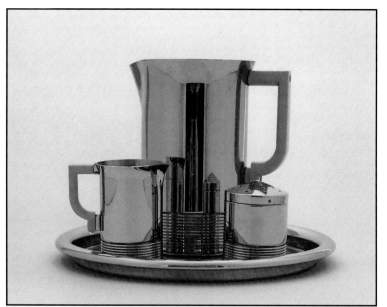

Unmarked polished chromium water pitcher with walnut handle, 7" h. x 6-1/2" d. A nice design that sold well making it relatively easy to find. $35-45. West Bend polished chromium cocktail glasses, 4-1/8" h. x 2-3/4" d. $10-15 each.

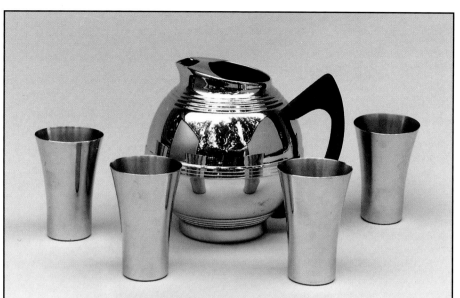

Chase polished chromium and ivory bakelite "Sunday Morning Waffle Set" (No. 90059) . The set consists of the "Sparta Water Pitcher" (No. 90055), 8" h. x 4-1/2" d.; the "Sugar Shaker" (No. 90057), 3-3/8" h. x 2-3/8" d.; the "Syrup Pitcher" (No. 90056), 4" h. x 2-1/2" d.; and the "Ring Tray" (No. 90058), 12" d. Water pitcher: $75-95. Sugar shaker: $45-55. Syrup pitcher: $45-55. Tray: $75-90. As a set, expect to pay $250-300. The Sparta Water Pitcher is prone to stress cracks and should be carefully examined prior to purchase.

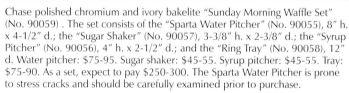

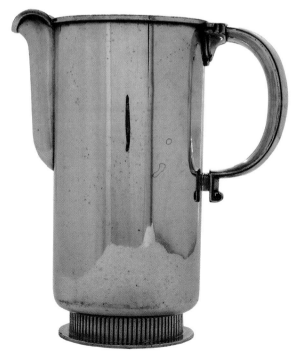

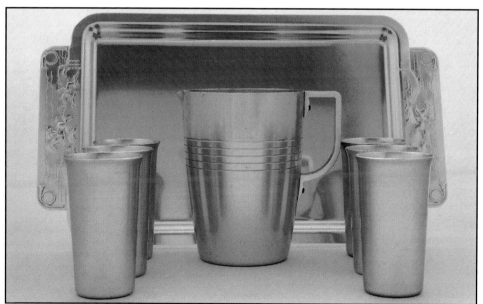

Above: Kensington "Riviera" pitcher (No. 7232), 7-1/2" h. x 5-1/2" d., $45-55; "Coldchester Tumblers" (No. 7252), 5-1/4" h., $5-10; and "Hunt Tray" (No. 7154), 20-1/2" l. x 11-3/4" w., $45-60. Lurelle Guild was awarded design patents for the pitcher and tray in 1938 and 1937, respectively.

Left: Silver-plated water pitcher (No. 5189) by the Meriden Silver Plate Co., a division of International Silver, 9-1/8" h. x 4-3/4" d. $125-150.

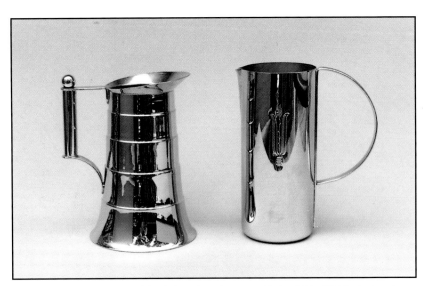

Left: Manning-Bowman polished chromium "Beverage Pitcher" (No. K966), designed by Jay Ackerman, 8-7/8" h. x 6" d. The 1936 catalog shows a slightly taller (by 1-1/8") pitcher with the ball relocated to the top of the handle. $95-115. Right: The Revere polished chromium "Chatham" Water Pitcher (No. 142), 9" h. x 4" d. $85-105.

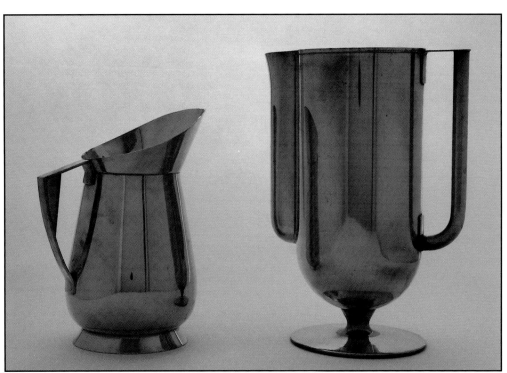

Left: Chase polished copper "Salem Water Pitcher" (No. 90004), designed by Gerth and Gerth, 9-3/4" h. x 7-3/8" w. $105-125. Right: Unmarked polished copper pitcher, 12-1/8" h. This pitcher appears identical to the pitcher in Revere's "Baron" beverage set (No. 7631) except for the finish. The 1935 and 1936 catalogs list the Baron as being available only in polished chromium over solid copper. Although I have seen the design of this pitcher attributed to both Walter von Nessen and Peter Müller-Munk, I was not able to document either claim. Revere catalogs, which typically identify designers, are silent on the Baron. Von Nessen is not known to have submitted any designs to Revere and Müller-Munk is known to have designed only the "Normandie" pitcher for Revere. The "Baron" was not included in the 1937 catalog and it is not clear whether Revere ever formally offered it in copper. Adding to the confusion is the fact that the pitcher and matching goblets are easier to find in copper than in chromium and the knowledge that Revere was not particularly good about stamping their products. In any event, it is a smart design that should be included in any art deco collection. $85-105 (copper) $150-175 (chromium).

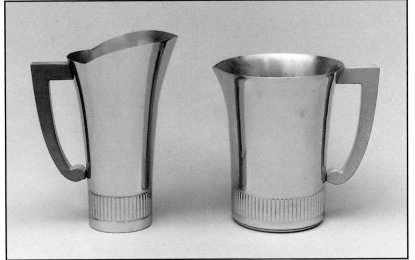

Above: Two Walter von Nessen-designed Chase polished chromium pitchers with white bakelite handles. Left: "Stir-It Pitcher" (No. 17091), with built in strainer, 8-5/8" h. x 2-7/8" d. (at base). $95-115. Right: "Arcadia Water Pitcher" (No. 90123), 7-1/4" h. x 6" d. (at top). $ 85-105.

Right: Chase polished chromium "Devonshire" pitcher (No. 90025), 6-1/8" h. x 6" d., and "Cheshire" mugs (No. 90031), 4" h., and 3-1/4" d. The pitcher, designed by Russel Wright, has a current value of $75-100; the mugs, $25-30 each.

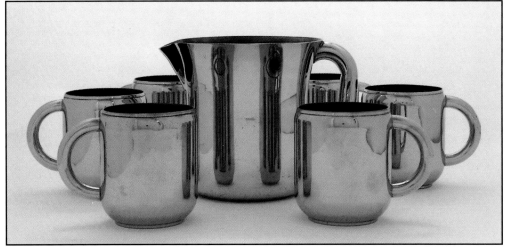

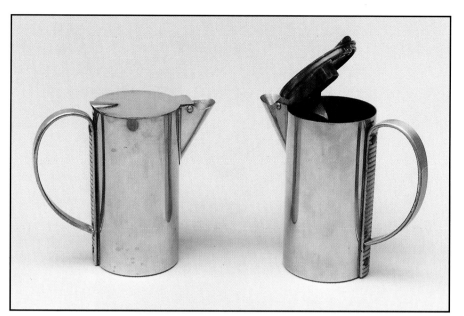

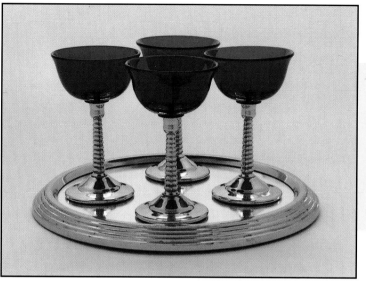

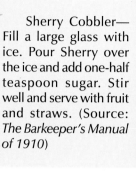
The Revere "Tapster" (No. 101) has a body of nickel silver and top and handle of brass. The 1937 catalog notes that "Tapster adds distinction to any table, ceremonial grace to the serving of noble brews in modern packages." To use the Tapster, simply slip in a 12-oz. beer can, press down on the lid with its stainless steel opener blade, and pour. 5-1/2" h. x 2-3/4" d. $35-45.

Cups: Stamped "LB Chromium Plated" with cobalt blue glass, 5" h. $8-10 each. Tray: unmarked polished chromium tray with step-down rim and mirror base, 10-1/2" d. $35-50.

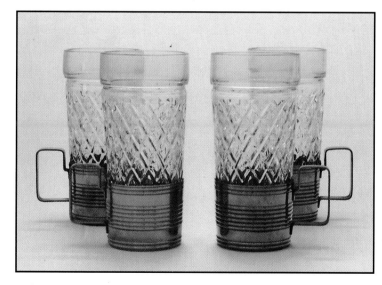

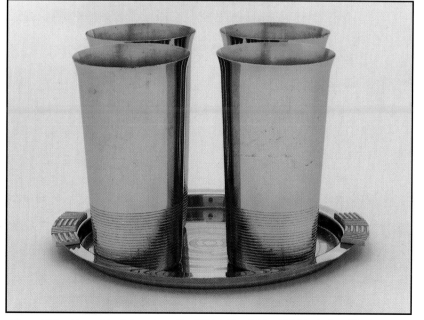

Early Chase "Refreshment Set" (No. 11118), designed by Gerth and Gerth, in polished copper. The glass holders are 2" h. x 2-1/2" d. and 6" h. with the glasses. The glasses resemble the design of the glasses in the Chase catalog but are not believed to be original. Missing from this set is the 8" tray. Holders, $25-35 each. Complete set with original glasses, $175-225.

Chase drink set in polished chromium. "Iced Drink Cups" (No. 90085), designed by Harry Laylon, 5-3/8" h. $15-25 each. "Meridian Tray" (No. 17078), with ivory enameled handles, 7-3/8" d. The 1937 catalog notes that the Meridian tray "...will conveniently hold tea-biscuits, sandwiches, crackers, Hor d'oeuvres, fudge, a small smokers' set, or four drink glasses." $75-85.

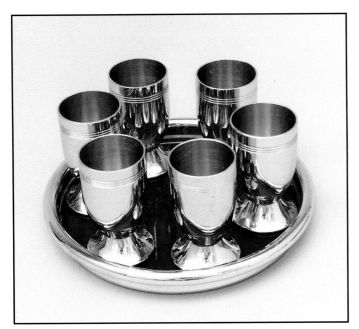

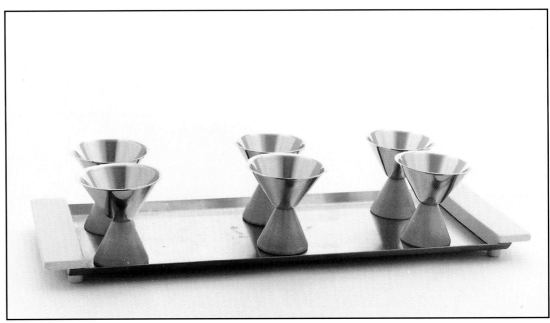

Chase polished chromium "Liqueur Set" (No. 90046) consisting of six "Liqueur Cups" (No. 90047), 2-7/8" h., and the "Coaster Tray" (No. 09014), 6" d., with "deep English blue glass" bottom. Lurelle Guild designed the cups while Russel Wright designed the tray. Cups ($.60 each in 1937) now sell for $25-35 each; the tray ($1.00 in 1937) $100-$125; the set ($4.00 in 1937) $275-350.

Unmarked polished chromium cocktail cups with solid bakelite bases, 3-1/4" h. x 3-1/2" d. (top). Among the best pure streamline moderne designs, the cups are valued at $35-45 each. Shown with the cups is an unmarked satin chromium tray with ivory bakelite handles, 19" l. x 6-3/4" w. The tray bears a strong design resemblance to the Manning-Bowman "Precedence" tray. $75-90.

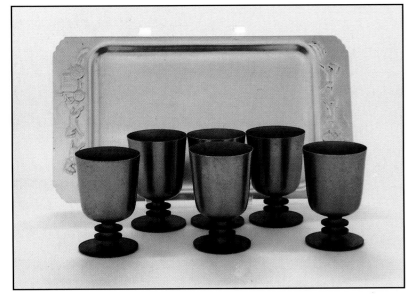

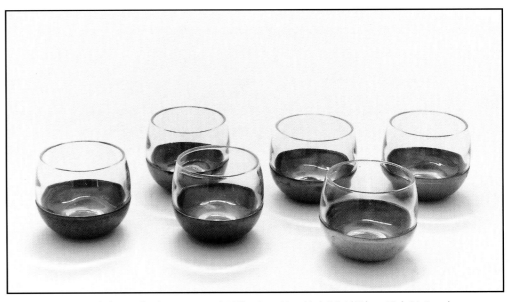

Unmarked cocktail cups of exceptional design in satin and black nickel, 3" h. x 2" d. $20-25 each. Shown with aluminum alloy "Coach 'N Four" tray (No. 7149) by Kensington, 11" l. x 6" w. $35-45.

Polished copper and glass cocktail cups stamped "Gilley, Inc., New York," 2-1/4" h. x 4" d. $6-9 each.

Two for the road. Left: The "Baldwin Tumbler Carrier" by the Baldwin Manufacturing Co., Boston, Massachusetts, consists of four spring loaded glass tumblers in a nickel silver case, 8-3/4" h. x 2-1/2" d. $55-65. Right: Stamped "Germany" and bearing a decal from the 1933 Chicago World's Fair, the "Take-a-Shot," polished chromium and copper, 3-1/4" h., contains four shot glasses. $45-60

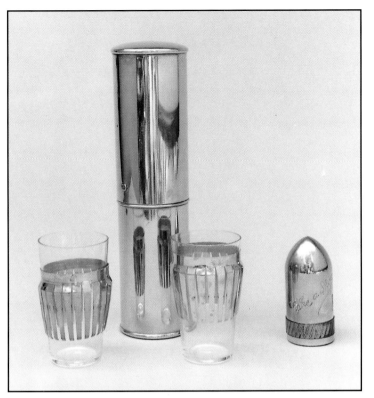

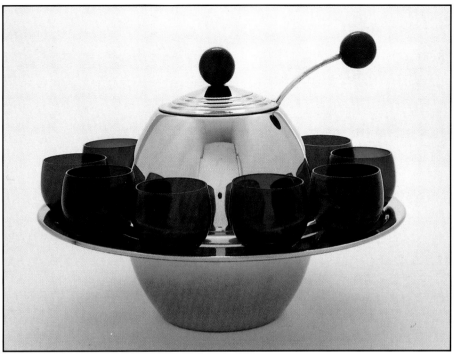

Polished chromium punch bowl set marked "LB Chromium Plated," 10-3/4" h. A removable tray, 14-3/4" d., holds glass punch cups. The lid on the punch bowl and knob on the ladle are red catalin. $85-105.

Unmarked polished chromium rotating cocktail table, c. 1936, 13" x 24" x 27". The table will lock in any position from horizontal to vertical and the cobalt blue glasses and shaker pivot to remain upright. $500-700.

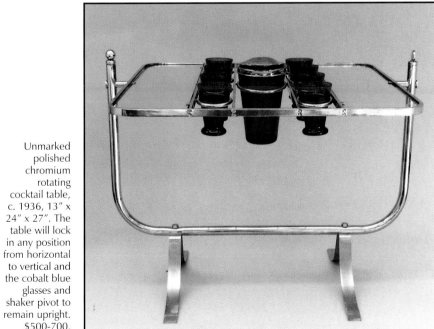

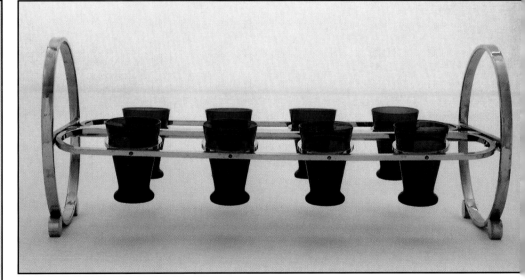

Unmarked polished chromium rotating serving rack, c. 1936, with cobalt blue glasses, 20-3/4" l. x 10-1/4" w. x 8-1/2" h. Both the rings holding the glasses and the oval frames themselves rotate so that the glasses remain upright at all times. $175-225.

89

Ice Buckets

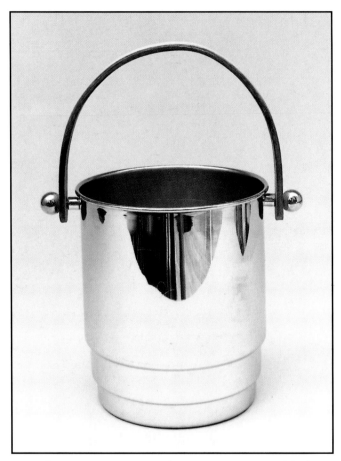

Manning-Bowman Lustralite™ ice tongs of anodized aluminum, 7" l. The Lustralite line designed by Oscar Bach was introduced in 1937. Rare. $35-45.

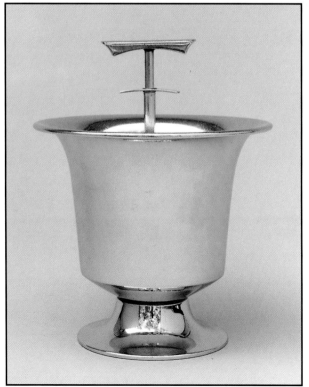

Above: Manning-Bowman "The Ice Man" (No. 196), polished chromium with walnut handle, 9-3/4" h., 5-1/2" d. The 1936 catalog notes that "The simplicity of design is attractive while the solid walnut handle adds a note of smartness." Selling for $4.00 in 1936, the current value is $65-75.

Right: Chase polished chromium "Ice Servidor" (No. 90001) designed by Gerth and Gerth, 7" h. (9-3/4" with handle) x 8-1/4" d. The clever handle allows water to be drained away from the ice. Rare. $150-175.

Revere "Claridge" ice bucket (No. 725) finished in polished chromium and brass., 12" h. x 5-3/4" d. (tongs, 8-3/16" l.). The 1937 catalog notes that "A convenient feature is the depression in the handle on which the tongs can be hung." $65-75 with tongs; $45-55 without tongs.

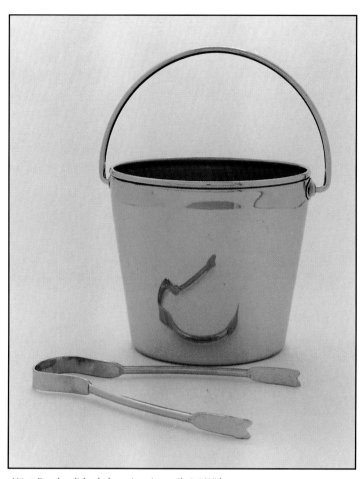

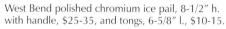

West Bend polished chromium ice pail, 8-1/2" h. with handle, $25-35, and tongs, 6-5/8" l., $10-15.

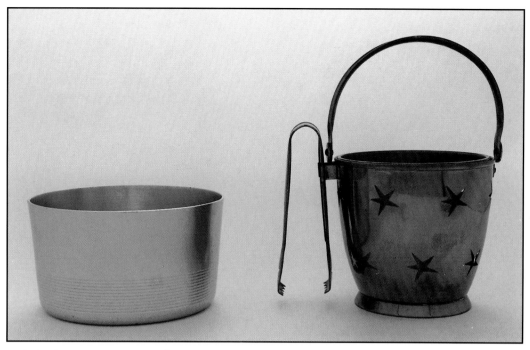

Left: Kensington "Newport Ice Bowl" (No. 7245) designed by Lurelle Guild, 3-1/4" h., 6" d. $35-45. Right: Unmarked polished copper ice bucket with brass base, handle, and tongs, 8" h., 5" d. A nice design with clear glass liner and holder for the tongs. $55-70.

Right: : Two Russel Wright designed ice buckets in polished chromium by Chase. Left: The "Antarctic Ice Bowl" (No. 17108) with a white (now butterscotch) bakelite handle, 7" h. (including handle) x 7" d. $125-145. Right: "Ice Bowl" (No. 28002), 6-1/2" h. x 7" d. $75-90.

Far right: Design patent for an ice bowl awarded to Russel Wright on December 4, 1934.

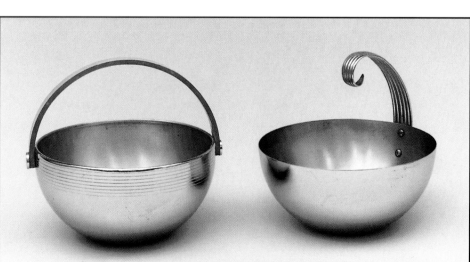

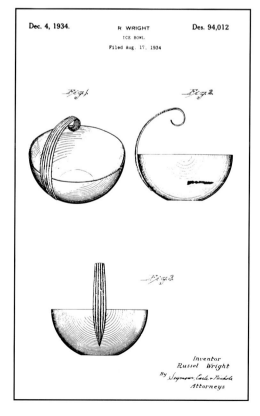

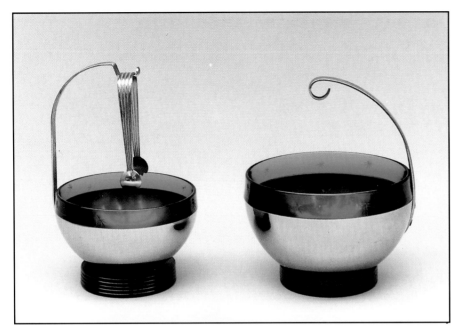

Two 1950s Emerald Glo ice buckets by National Silver. Drawing heavily on the Russel Wright design for Chase, these polished bronze ice buckets have emerald green glass liners and translucent green plastic bases. Left: 9-1/2" h. x 6" d., with tongs, $35-45. Right: 9" h. x 7" d., $35-45.

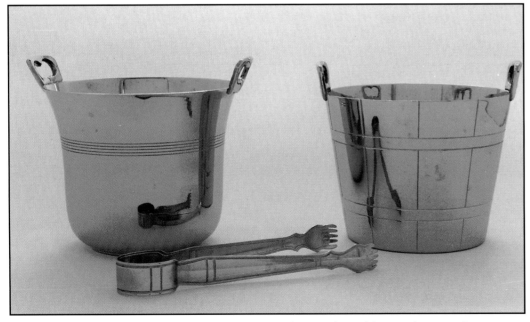

Farberware ice buckets and tongs in polished chromium. Left: An uncluttered design with a series of etched lines near the middle, 5-1/2" h. x 5-3/4" d. $15-25. Right: A more moderne design with angular sides and nice pattern of etched lines, 5-1/4" h. x 5-9/16" d. $20-30. Both ice buckets have inserts to drain water away from the ice as it melts. Center: ice tongs with the ends shaped like hands, 7" l. $5-10.

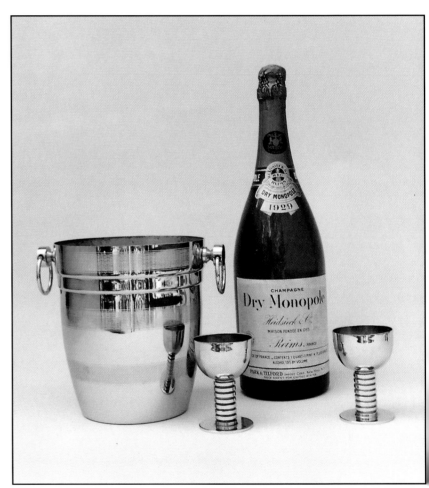

French polished chromium champagne bucket and glasses. The bucket, stamped "Andre Leroy T.L. Made in France," is 7-7/8" high. $125-150. The glasses, stamped "La Cremaillere France," are 3-3/4" tall. $50-60 each. The 1929 "Dry Monopole" store display has a current value of $75-125.

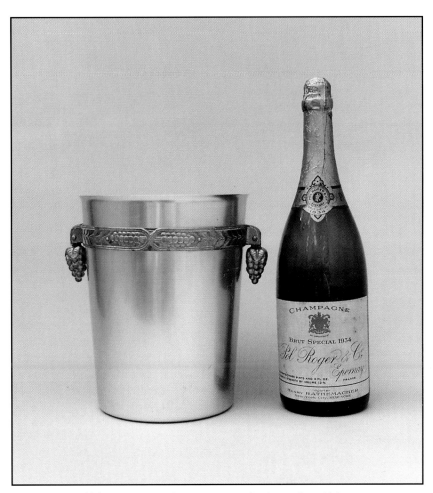

Kensington "Coldchester Wine Cooler" (No. 7250), aluminum alloy with brass handles in the shape of grape clusters, 10-1/4" h. x 8-3/8" d. A design patent was awarded to Lurelle Guild in 1936. Rare. $275-300. The 1934 store display champagne bottle has a current value of $75-125.

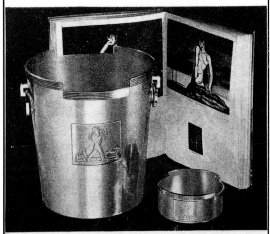

Chase advertisement for the Rockwell Kent "Wine Cooler" (No. 27015), 9-1/4" h., 8-1/2" d. (*New Yorker*, May 19, 1934). One of the most collectible Chase pieces, expect to pay $450-550.

Vacuum Ware

Although the vacuum was discovered in 1643, the ability of a vacuum to keep hot things hot and cold things cold was not discovered until 250 years later. Evangelista Torricelli, an Italian physicist, and philosopher created a vacuum in a tube of mercury while experimenting with a barometer in 1643. Eleven years later, in 1654, Otto von Guericke provided an amazing demonstration to Emperor Ferdinand III. To demonstrate the vacuum pumps he had invented, von Guericke started with two 22-inch copper hemispheres. He joined them to make a sphere by making an airtight joint at the center with a ring of oil soaked leather. He then attached his pump to a small hole in the sphere and exhausted the air from within the sphere, creating a vacuum. Two teams, each of eight horses, were said to have tried unsuccessfully to pull the hemispheres apart.

The importance of the vacuum in temperature retention, however, went unnoticed until 1892 when English scientist Sir James Dewar invented a special flask with one glass bottle inside another and the air pumped out from between the two. The glass bottles have the appearance of metal because there is a coating of pure silver placed on the surface of the vacuum chamber to prevent rays of light, which radiate heat, from affecting the contents of the bottle.

Dewar's early flasks were extremely fragile and he sought the help of German glass blower Reinhold Burger to develop a stronger bottle. Burger recognized the commercial potential of the Dewar flask and designed a protective metal casing. After a German patent was awarded for the casing in 1903, Burger and two associates formed a company known as Thermos Gesellschaft M. B. H. in Berlin to manufacture the vacuum flasks. The Thermos name was selected in a national competition conducted through German newspapers. A Munich resident suggested the word "Thermos" derived from the Greek "Therme," meaning heat.

Dewar never patented his vacuum bottle, giving it to science without consideration of the monetary benefits he could reap.

CARAFON SETS

by

CRAFTSMEN IN METAL SINCE 1864 &

MANNING BOWMAN

Left: Cover to 1933 Manning-Bowman catalog for Carafon Sets.

Below: Manning-Bowman "HOTAKOLD" thermal water carafes, c. 1930. Left: The "Waterboy" (No. 140/25) in polished chromium with ivory enameled sides, black enameled wood stopper, 10-3/4" h., 4" d. at base. The Waterboy was also available in all chromium and combinations of peach and white (No. 140/23), maroon and white (No. 140/28), coral and white (No. 140/29), and willow green and white (No. 140/39). $75-90. Right: The "Lido" (No. 131) in polished chromium with black enameled bands and clear glass stopper, 7" h. $55-65.

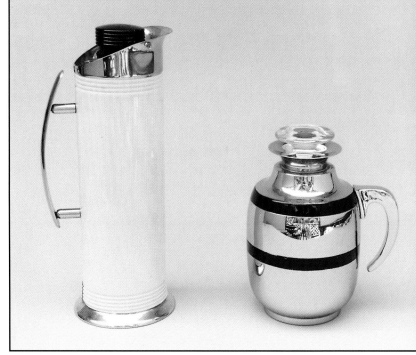

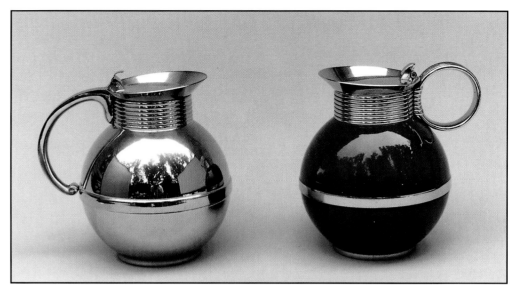

Variations of a Manning-Bowman classic. Left: The "Cascade" jug (No. 1429), spherical polished chromium body, 7-1/2" h. x 6" d. A pint size (No. 1428), 6-3/4" h. was also available. The "Cascade" was available in light blue, white, walnut, rust, peach, and willow green enamel when purchased as part of beverage sets including a matching tray and glasses. The 1941 catalog notes that the "…vacuum filler maintains temperature of cold drinks 72 hours, hot drinks 24 hours." $80-$95 Right: The same jug finished in rust-colored enamel, but with a round handle. $75-85.

Thermal water jugs produced by the American Thermos Bottle Co., Norwich, Connecticut. Left: Vacuum bottle (No. 758F) in polished chromium with fluted neck and black bakelite stopper, 10" h. $65-75. Right: The "Spherical Miracle" (No. 3750) in polished chromium with a black enameled base and black bakelite stopper, 6" d. This water jug, also available in pastel tones of old rose, green, blue, and ivory, is on display throughout the Frank Lloyd Wright-designed "Fallingwater," near Pittsburgh. In 1937, the jug with tray and glass tumbler sold for $9.00. Design of the "Spherical Miracle" is often attributed to Raymond Loewy. Neither Patent Office records nor Thermos advertisements could be located to link Loewy to this design. $95-115.

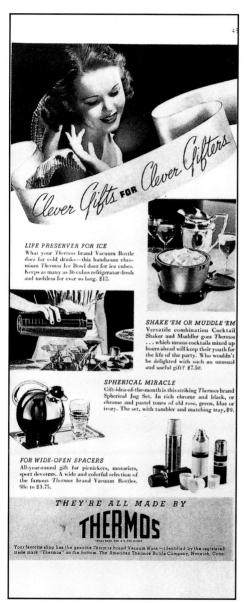

Thermos advertisement for the "Spherical Miracle" (*New Yorker*, November 5, 1938).

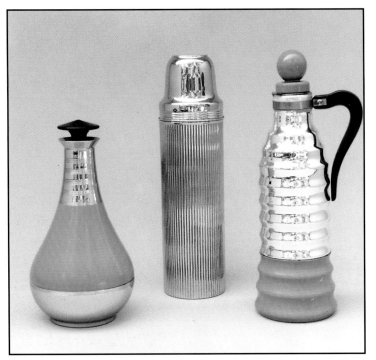

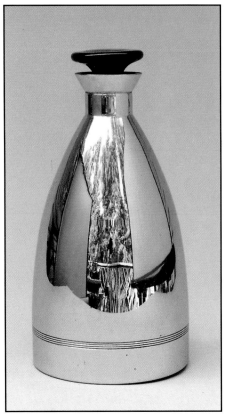

Above: Left: "Universal" brand thermal water jug produced by Landers, Frary, & Clark, New Britain, Connecticut, polished chromium with green enamel and black glass stopper, 10-1/2" h. $45-55. Center: "Universal" polished chromium vacuum bottle by Landers, Frary, & Clark, 13-1/2" h. $35-45. Right: Lusotermo (Portugal) thermal water jug with green enameled base and stopper, silvered glass top, and green plastic handle, 13-3/4" h. x 4-1/4" d. The upper body of this jug is essentially the insulated silvered glass lining. $45-55.

Above center: Manning-Bowman polished chromium thermal jug with black glass stopper, designed by Benjamin M. Tassie, 10" h., 5-1/2" d. Tassie later became President of Manning-Bowman. $50-60.

Right: Design patent for a thermal water bottle awarded to Benjamin M. Tassie on July 28, 1931.

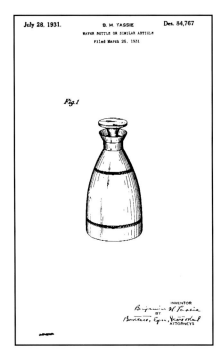

American Thermos Bottle Co. "Hollywood Set" thermal water jug (Model 525F), c. 1938. The rose enameled jug comes with a separate black glass saucer and black bakelite stopper, 8-3/4" h. Missing from this example is the black bakelite cup that fits over the top of the jug. $95-115.

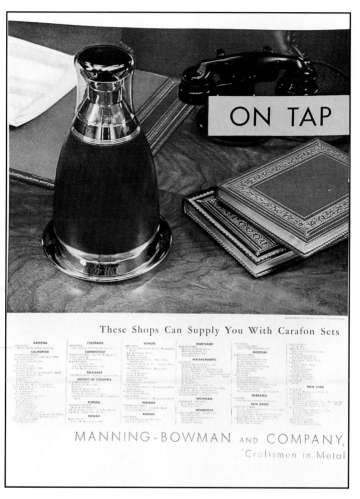

ON TAP

These Shops Can Supply You With Carafon Sets

MANNING-BOWMAN AND COMPANY,
"Craftsmen in Metal"

Advertisement for Manning-Bowman
Carafon Sets (*Fortune*, July 1934).

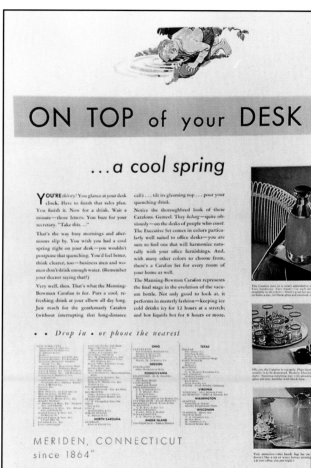

ON TOP of your DESK

...a cool spring

YOU'RE *thirsty!* You glance at your desk clock. Have to finish that sales plan. You finish it. Now for a drink. Wait a minute—those letters. You buzz for your secretary. "Take this. . ."

That's the way busy mornings and afternoons slip by. You wish you had a cool spring right on your desk—you wouldn't postpone that quenching. You'd feel better, think clearer, too—business men and women don't drink enough water. (Remember your doctor saying that?)

Very well, then. That's what the Manning-Bowman Carafon is for. Puts a cool, refreshing drink at your elbow all day long. Just reach for the gentlemanly Carafon (without interrupting that long-distance

call) . . . tilt its gleaming top . . . pour your quenching drink.

Notice the thoroughbred look of these Carafons. Genteel. They *belong*—quite obviously—on the desks of people who count. The Executive Set comes in colors particularly well suited to office desks—you are sure to find one that will harmonize naturally with your office furnishings. And, with many other colors to choose from, there's a Carafon Set for every room of your home as well.

The Manning-Bowman Carafon represents the final stage in the evolution of the vacuum bottle. Not only good to look at, it performs in masterly fashion—keeping ice cold drinks icy for 12 hours at a stretch; and hot liquids hot for 8 hours or more.

• • *Drop in* • or phone the nearest

MERIDEN, CONNECTICUT
since 1864"

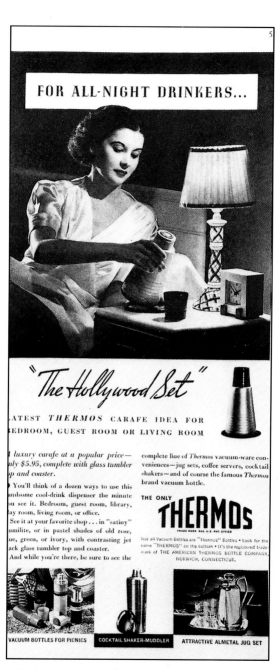

FOR ALL-NIGHT DRINKERS...

"The Hollywood Set"

LATEST *THERMOS* CARAFE IDEA FOR BEDROOM, GUEST ROOM OR LIVING ROOM

A luxury carafe at a popular price—only $5.95, complete with glass tumbler top and coaster.

You'll think of a dozen ways to use this handsome cool-drink dispenser the minute you see it. Bedroom, guest room, library, play room, living room, or office.

See it at your favorite shop . . . in "satiny" gunmetal, or in pastel shades of old rose, blue, green, or ivory, with contrasting jet black glass tumbler top and coaster. And while you're there, be sure to see the

complete line of *Thermos* vacuum-ware conveniences—jug sets, coffee servers, cocktail shakers—and of course the famous *Thermos* brand vacuum bottle.

THE ONLY THERMOS

Not all Vacuum Bottles are "Thermos" Bottles • Look for the name "THERMOS" on the bottom • It's the registered trademark of THE AMERICAN THERMOS BOTTLE COMPANY, NORWICH, CONNECTICUT.

VACUUM BOTTLES FOR PICNICS | COCKTAIL SHAKER-MUDDLER | ATTRACTIVE ALMETAL JUG SET

Thermos advertisement featuring the "Hollywood
Set" (*New Yorker*, March 19, 1938).

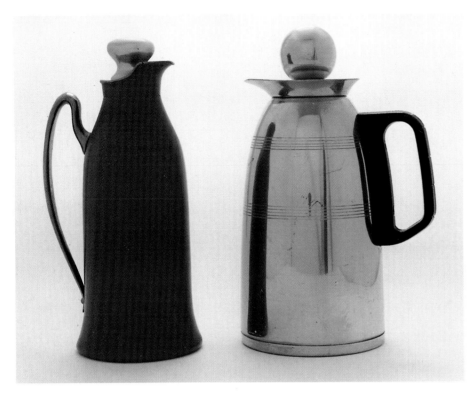

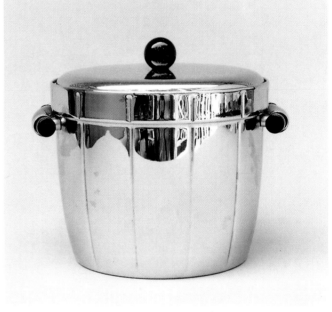

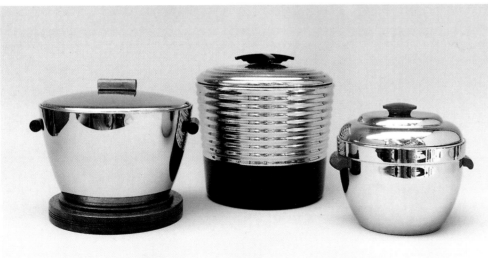

Above left: Something old(er) and something new(er).
Left: An early design in thermal water jugs from the Metalcraft Co., Inc., Taunton, Massachusetts. The jug has a rose-colored enameled body with a pewter handle and aluminum stopper, 10-1/2" h. $35-45
Right: An early 1950s style thermal carafe marked "Kromex," 10-3/4" h. The seam on the plastic handle and rather bland styling gives this away as a later jug. $20-30.

Above right: Manning-Bowman insulated ice bucket, polished chromium with black bakelite handles and knob, 7-1/2" h. x 7-1/4" d. $65-75.

Left: Three polished chromium "Thermos" insulated ice buckets.
Left: Model 1979-26 from the American Thermos Bottle Co., Norwich, Connecticut, with walnut trimmings, 7-1/2" h. x 9-1/2" d. $65-75.
Center: American Thermos Bottle Co. Model 1939, with black enamel trimmings, 8-1/2" h. x 8-1/2" d. A great deco design with a step-down lid and fluted chromium sides. $85-100.
Right: Stamped "Made in England," the Thermos Model No. 923 has red plastic trimmings and a gently stepped lid, 6" h. x 6-1/4" d. $55-65.

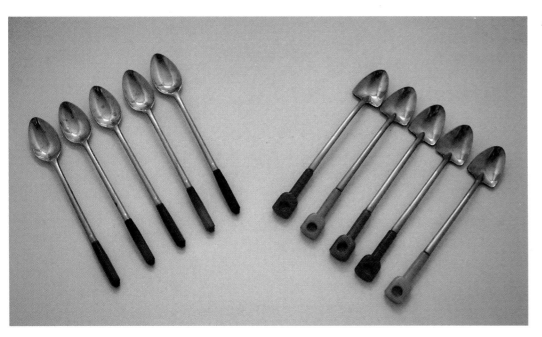

Accessories

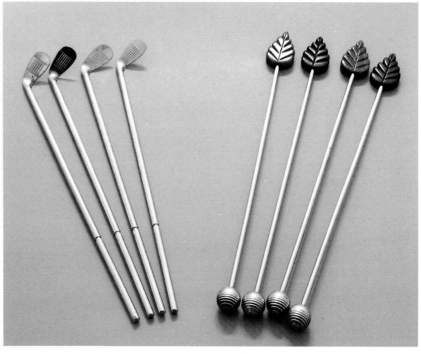

Above left: Stainless steel iced drink spoons with colorful bakelite handles. Left: Spoons with stepped motif on handles, 7-1/4" l. $4-7 each. Right: Spoons with shovel design bowl and handle, 7-1/4" l. $5-10 each.

Above right: Polished chromium iced drink mixers from Chase.
Left: "Nibblick Swizzlers" (No. 90037), Lurelle Guild-designed stirrers in the shape of golf clubs, 7-1/4" l., $85-105, set of four.
Right: Harry Laylon-designed "Iced Drink Mixers" (No. 90090) with jade green and lapis blue catalin leaves. Over time, the catalin has changed colors to where the green and blue are barely discernible. The tips of the mixers are step-down spheres. $105-125.

Left: A "muddled" picture. Both Manning-Bowman (No. 299), left, and Chase (No. 90065), right, added "Old-Fashioned Cocktail Muddlers" to their giftware line in 1936. The muddlers were the same size, 4" l., had the same concentric circle motif on the bottom, and had colored tops, Manning-Bowman using enameled bands of red, yellow, blue and green and Chase bakelite knobs of red, black, green, and ivory. Even the companies' prices were the same—$.75 for a boxed set of four. Although the muddlers first appeared in the 1936 Chase catalog, the May 1935 *House Beautiful* announced their introduction. Current values are comparable at $75-95. Although the Manning-Bowman version is considerably harder to find, Chase is currently more collectable.

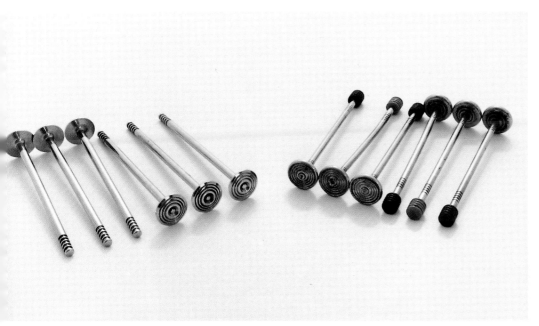

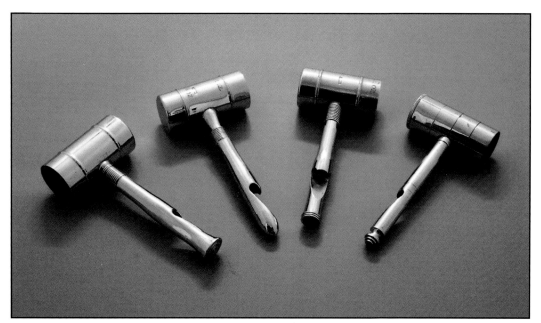

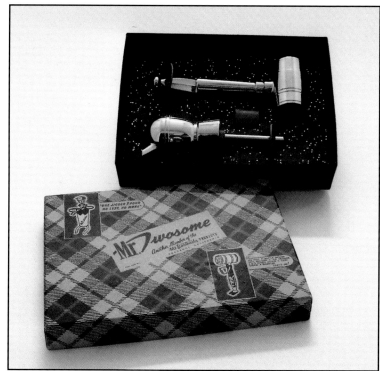

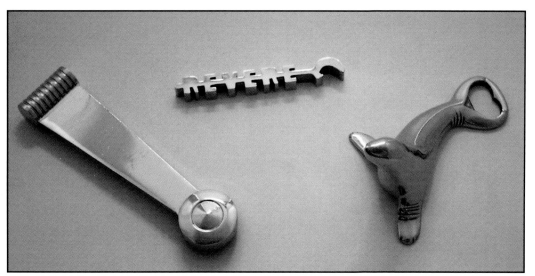

Unusual bottle openers. Left: Polished chromium opener stamped "Magnacap," 7" l. The quality of this piece is obvious from it heavy weight and the fact that the base metal is nonmetallic. $45-55. Center: Although Revere was not very good about marking many of its items, there is no doubt about the origin of this 4-1/2" l. opener. Rare $95-115. Right: The tail of this unmarked silver-plated seal, 5-1/2" l., forms a bottle cap remover while the underside conceals an opener to loosen the lids of screw-on liquor bottles. The opener was purchased in Australia, but its country of origin is unknown. A variation of this opener with a paper sticker marked "Made in China" is currently marketed. The quality is inferior, but with the sticker removed, some unscrupulous dealers may pass the item off as being original. $55-65.

Above left: Variations of a combination bar tool, all polished chromium. The two tools on the left are variations of the Chase "Bar Caddy" (No. 90141). The tool on the far left, which I was unable to find in Chase catalogs, has a blunt ended handle with concentric circles embossed in the end. I found a picture of what appears to be this version of the Chase bar tool in the December 1945 *House Beautiful*. Second from the left is the Chase "Bar Caddy" as it appeared in the 1940 through 1942 catalogs. It is slightly longer than the postwar version, 6-1/8" vs. 5-3/4", has a pointed rather than blunt end, does not have embossed rings on the bottom of the jigger, and has embossed rings located further down the handle than the postwar version. The blunt ended version is harder to find, making it slightly more valuable. Both versions sold well, limiting their current value. $35-50. To the right of the Chase bar tools is a bar tool marked "Cavalier by National Silver." Its dimensions and appearance are almost identical to the postwar Chase design. The only discernible difference is a change in the design at the end of the handle. Where the Chase tool had embossed circles on the blunt end, the Cavalier has a smooth end with embossed rings on the side. National Silver even retained the style and size of lettering on the Chase jigger. $25-35. On the right is the "Bar Aide," 5-3/4" l., with a nice stepped tip on the handle. This tool appears to be post war as I found it advertised in the November 1948 *House Beautiful*. Although it matches the Chase bar tools in design and quality, it commands a slightly lower price because it is anonymous. $30-40.

Above right: Mint-in-box "Mr. Twosome" by Mr. Bartender Products, Torrance, California, probably from the 1950s judging from the package graphics. The box reads "One jigger I pour, no less, no more," and "Ice Pick. Bottle Opener. Seal Breaker. Ice Crusher. 1 & 2 Ounce Jigger. Cork Screw. Muddler.—That's Me." $55-65.

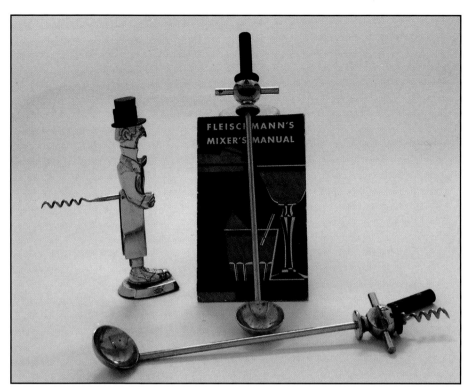

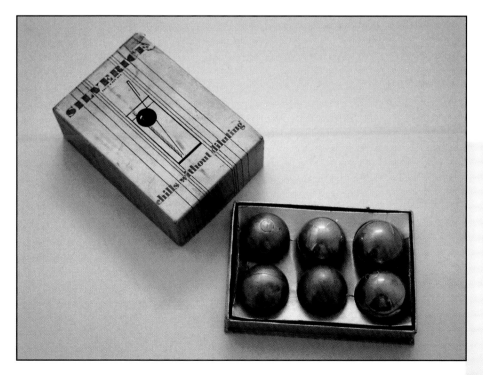

Above left: Whimsical corkscrews of polished chromium and black enamel. Left: Demity "Old Sniffer" corkscrew, 6-3/4" h. $35-45. Right: Combination bar tool, 11" l., with a corkscrew hidden under the exaggerated top hat. The nose and mouth form a bottle cap remover. $45-55.

Above right: Polished chromium jiggers.
Left: Chase "High Hat" jigger (No. 28014) designed by Lurelle Guild, 1-3/4" h. $75-90.
Right: "Jigger" by Reynolds Products, Detroit, Michigan, 2-1/2" h. x 1-3/4" d. $45-55.

Left: Boxed set of "Silverice" that "chills without diluting." A mechanical patent (No. 1,641,139) was awarded to William Glennan of Norfolk, Virginia, on August 30, 1927. $35-45.

Build a Better Mousetrap and...

"It is well known that in household refrigeration apparatuses of the present day, provision is made for manufacturing small cubes of ice for table use. The drawers which are usually provided for this purpose have partitions which form a plurality of compartments in which the ice is made. These small blocks of ice are removed and placed in liquids, or otherwise used, for the purpose of cooling. The pan, in which the compartments are located, must be provided with water to be frozen. This entails labor, in removing the ice blocks, and also the danger of spilling water from the pan while replacing the same in the refrigerator.

"The purpose of the present invention is to eliminate the objectionable feature of spilling water, and the other objectionable features that are present when the substance to be frozen is placed directly in the pan." (Patent application for Silverice, filed July 12, 1927)

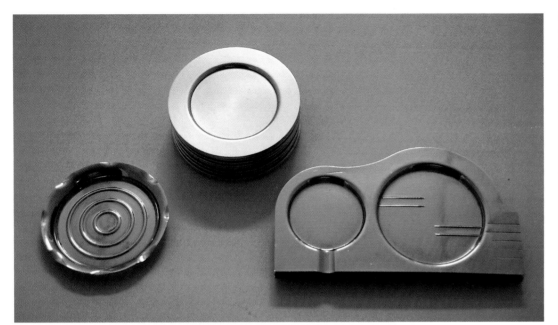

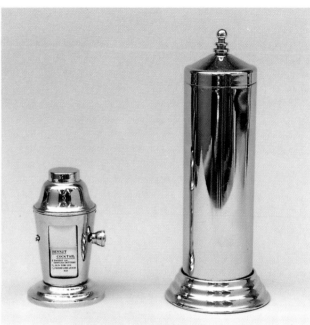

Left: Unmarked cocktail recipe shaker in polished chromium, 5-3/4" h., 3-1/4" d. A simple turn of the dial shows your favorite recipe. $65-80. Right: Unmarked straw dispenser, 11-1/2" h. x 4-1/2" d. The moderne design of the knob and the step-down base add to the value. $95-115.

Left: Chase polished chromium "Coaster" No. (11261), 3-3/4" d. The "coasters" were also included in the "Assembly Smokers' Set" (No. 850) as nested ash receivers. $8-12 each. Center: Kensington aluminum alloy coasters, 4" d. $5-10 each. Right: Revere polished chromium "Coastray" (No. 317) designed by Norman Bel Geddes, 7" l. x 4" w. When introduced, the coastray was offered only in satin chromium. $20-30 each.

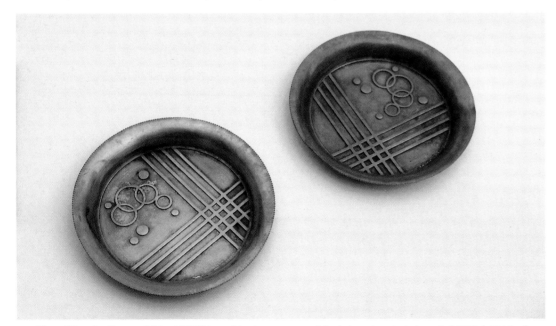

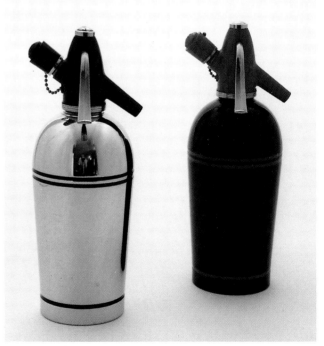

Soda siphons in two of a wide variety of available finishes, 11-1/2" h., by Sparklets Corp., New York. Designed by Lawrence T. Ward in 1935 for Sparklets Limited, London.

Chase "Danube Coasters" (No. 17072) in polished copper or polished chromium (not shown), 3-3/4" d. Originally sold for $.75 for a set of four, or $2.00 for a boxed set of 12 (No. 08006), they have a current value of $8-12 each.

Beldenette—Combine one-half jigger raspberry syrup, one-half jigger pineapple syrup, and the juice of one-half lemon in a tall shell glass with a small portion of crushed ice. Fill with syphon water, stir, and serve garnished with fruit.

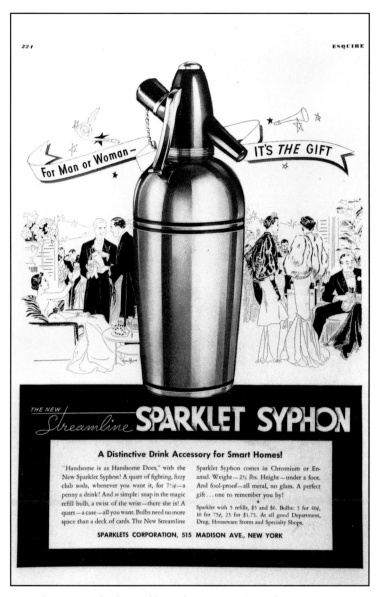

Advertisement for the Sparklet Syphon (*Esquire*, December 1936).

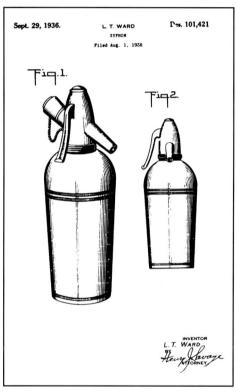

Design patent awarded to Lawrence T. Ward, September 28, 1936, for a syphon.

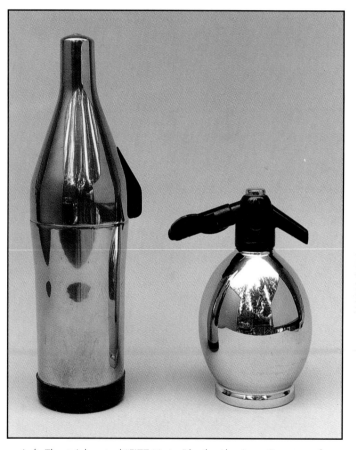

Left: The stainless steel "FIZZ Master" by the Aluminum Company of America, better known as Alcoa, 15-1/4" h., has a black rubberized base and is marked "Patent Pending." $55-65. Right: "Soda King" syphon in polished chromium and black enamel, 9" h. $45-55.

White Wax—Combine an ice cube and a wine glass full of White Menthe in a small tumbler. Fill the tumbler with syphon water and mix well. (Source: *The Barkeeper's Manual of 1910*)

"OYOUKID"—In a mixing glass combine one-half teaspoon lemon, one teaspoon Grenadine, two teaspoons Raspberry Syrup, and one sherry glass of Gin. Pour the mixture over a small stein filled with ice. (Source: *The Barkeeper's Manual of 1910*)

Chapter 12
Buffet Service

The generation of today—and its influence upon tomorrow—turns thumbs down upon the whole formal dinner picture. Today's younger hostesses find no allure in a vast expanse of white damask on a table set with sparse magnificence, with places for twenty-four or more, a footman behind every third chair, the company walking in two by two and at the dining room door the butler with table list in his hand saying, "At the right, sir" or "At the left, sir" to each approaching gentleman. (Emily Post in *How to Give Buffet Suppers*, 1933.)

Emily Post attributed the surging popularity of informal dining to the hard times brought on by the Depression but predicted that the buffet supper was too much in accord with the spirit of the times to go out of fashion with a return to prosperity. Although the picnic is the simplest form of informal "buffet" dining, buffet parties range from cocktail parties with little or no food service, to afternoon teas with accompanying sweets, to stand-up breakfasts, luncheons, and suppers.

Interspersed throughout this chapter are some of Emily Post's tips from *How to Give Buffet Suppers*.

Candy and Nut Dishes

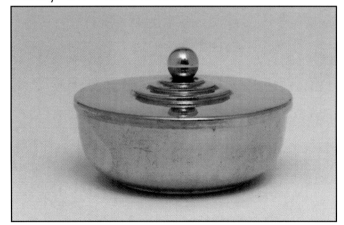

Early Chase polished copper candy jar (NS-316) designed by Walter von Nessen, 4" d., 1-3/4" h. $90-110.

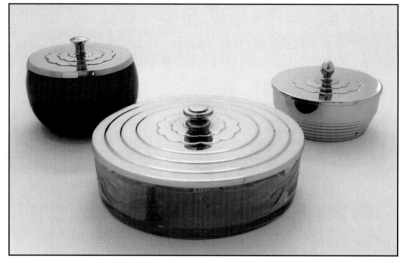

Occasional boxes designed by Jay Ackerman for Manning-Bowman. Left: "Incidental Jar" (No. 151/6), 4" d., 3-3/4" h., ruby glass with polished chromium top. The jar was also available with blue glass (No. 151/10) and cut crystal (No. 151/5) and sold for $1.50. The catalog notes that the "design on the chromium plated cover harmonizes with rings on the lower half of the jar itself…" $45-55. Center: "Confection Dish" (No. 152/5), 6-1/4" d., 2-1/2" h., polished chromium top with cut crystal base ($3.00 retail). The dish was also available with a blue (No. 152/10) or ruby (No. 152/6) base ($2.50 retail). $65-75. Right: "Milady's" Powder Jar (No. K158), 4-1/2" d., 3" h., polished chromium with a pale blue glass lining. The catalog notes that the jar has the "step-down design so much in vogue at the present time." $55-65.

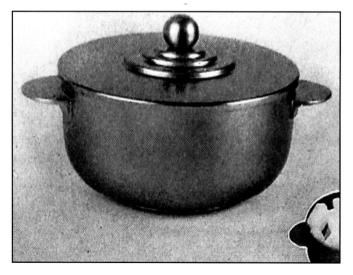

Early Chase sugar bowl (No. 17025), designed by Walter von Nessen, 3-1/2" h. "An attractive little sugar bowl in polished copper, with handles and ball on cover of polished brass." Rare. $125-150.

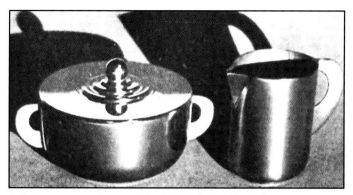

Early Chase sugar and creamer (No. 17028), designed by Walter von Nessen. Finished in polished copper with polished brass handles, the sugar measures 3-1/2" h., 3-7/8" d., the creamer, 3-1/4" h., 2-1/4" d. Rare. $150-175 a set.

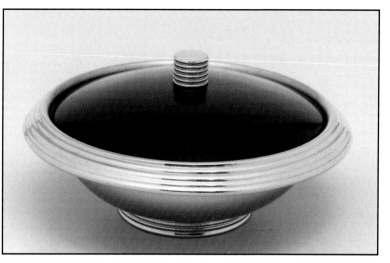

Chase "Delta Bon Bon Dish" (No. 28010), polished chromium with black enameled top, 7" d. (top), 3-1/4" h. One of the rarest and most attractive Chase designs, the Delta exhibits many of the classic art deco motifs, such as the step-down edge, smooth lines, and ribbed knob. Other available finishes were combinations of satin copper and white and satin copper and green. $150-175.

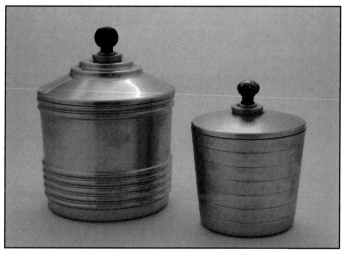

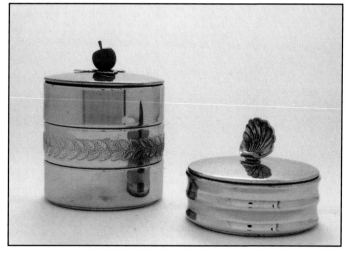

Two versions of Chase stacking candy boxes, both designed by Harry Laylon. Left: "Three Layer Candy Box" (No. 90104), polished chromium with bakelite apple knob, 4-3/4" d., 5-5/8" h. With the center section removed, it was sold as the "Two-Layer Candy Box" (No. 90117). With only the middle section with a running border of leaves and cover, it was the "Eden Candy Box" (No. 90116). All three variations were also available in polished copper. $75-85 (three-layer), $50-60 (two-layer), $35-45 (Eden). Right: "One-Tray Box" (No. 17107) in polished chromium, 4-3/4" d., 3-5/8"h. The box, also available in polished copper, becomes the "Two-Tray Box" (No. 17106) and "Three-Tray Box" (No. 17105) when second and third layers, respectively are added. One of the more popular Chase designs, it can still be found at bargain prices. $25-30 (one-tray), $40-50 (two-tray), $50-60 (three-tray).

Above: Lurelle Guild designed these aluminum alloy covered containers by Kensington, both with brass knobs. Left: The "Snack Cracker Jar" (No. 7470), 8-3/4" h., 6-3/4" d. $70-90. Right: "Sussex Tobacco Jar" (No. 7471), 6-3/4" h. x 5-1/4" d. $45-55.

Right: Three variations of the Gerth and Gerth-designed Chase "Candy Dish" (No. 90011), 7" d. x 3-1/8" h. Left and center: The original design with a metal fruit cluster knob shown in combinations of satin and black nickel (center) and polished brass and copper (left). Right: The redesigned candy dish in satin copper with white bakelite knob. The redesign replaced the original metal knob with a harder to grip bakelite knob, and the original three-section glass dish with an undivided dish. The design of the fruit cluster was also changed. The redesigned dish was also available in satin brass, a combination of satin brass and copper, and a combination of satin nickel and black. Because the "Candy Dish" sold so well, it is readily available and is one of the most affordable Chase pieces. $25-40.

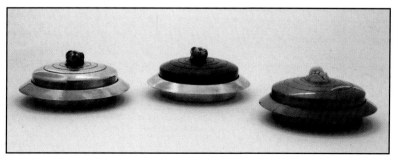

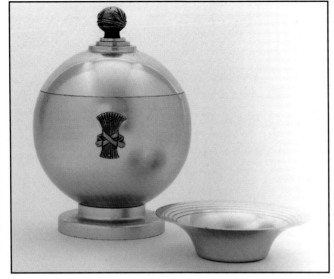

Left: Kensington round covered container designed by Lurelle Guild, aluminum alloy with brass knob and adornment, 6-1/2" d., 8-1/4" h. $85-100. Right: Kensington "Devonshire" candy dish (No. 7422), aluminum alloy, 5-1/2" d. $15-20.

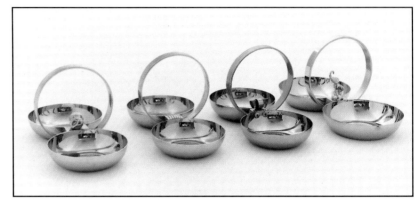

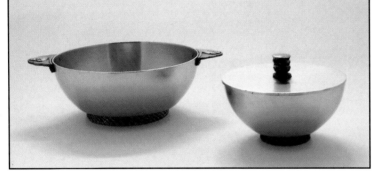

Left: Kensington "Briar" bon-bon dish (No.7419), designed by Lurelle Guild, aluminum alloy with brass handles and base. $25-35. Right: Kensington "Briarton" covered bowl designed by Lurelle Guild, aluminum alloy with brass knob and base, 5" d. $40-50.

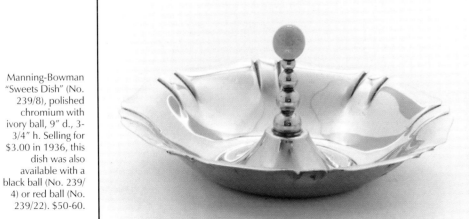

Manning-Bowman "Sweets Dish" (No. 239/8), polished chromium with ivory ball, 9" d., 3-3/4" h. Selling for $3.00 in 1936, this dish was also available with a black ball (No. 239/4) or red ball (No. 239/22). $50-60.

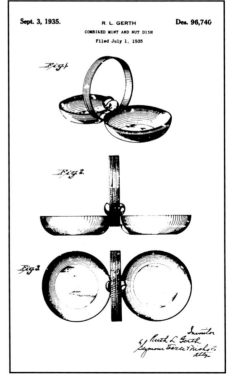

A design patent for the "Mint and Nut" dish was awarded to Ruth L. Gerth on September 3, 1935.

Above: Left: The original Chase "Mint and Nut" dish (No. 29003) designed by Ruth Gerth in polished chromium, with a baby whale sitting between two 4" d. trays. Next to it is the redesigned Chase "Mint and Nut Dish" with the baby whale removed. A third variation (not pictured) was shown in the 1941 catalog, when the hoop handle was ribbed on both sides rather than just the outside as shown in the above examples. All variations were also available in polished brass and copper. $25-35. Second from right: Polished bronze mint and nut dish stamped "Emerald Glo by National Silver Co.," with 4" d. trays. Almost identical in design to the later versions of the Chase Mint and Nut dish, the Emerald Glo dish has wider ribbing on the hoop handle and a translucent emerald green plastic rod between the trays. In addition, the trays are riveted rather than soldered to the stand. $25-35. Right: Polished chromium mint and nut dish stamped "Keystonewear" 4-1/2" d. trays, 5" h. Slightly larger than the Chase dish, it also has a smooth hoop handle and an elephant between the trays. $25-35.

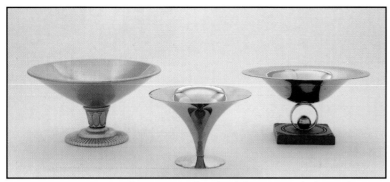

Left: Manning-Bowman "Lustralite" compote of anodized aluminum, 3-3/4" h. x 7" d. Manning-Bowman was awarded a trademark for Lustralite in 1937. Lustralite is an early example of an anodized aluminum finish. Manning-Bowman is believed to have been the first to produce colored aluminum giftware. Such colored aluminum ware became popular in the 1950s, but Manning-Bowman appears to have had little success with it in the 1930s. Although reference to the new line, designed by Oscar Bach, was found in the *Gift and Art Buyer*, I was unable to find the line in Manning-Bowman catalogs or in advertisements. $55-70. Center: Candy dish by A. S. Solingen, polished nickel silver, 5" d., 3-3/8" h. $45-55. Right: Unmarked polished chromium compote on a wooden base, 3-1/2" h. x 6-3/4" d. $45-55.

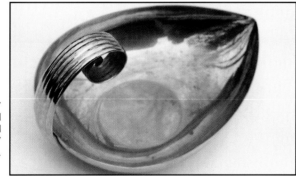

Chase "Tulip Serving Dish" (No. 90095) in polished chromium or polished copper (not shown), 7-5/8" x 4-1/4" x 5-1/2". $30-40.

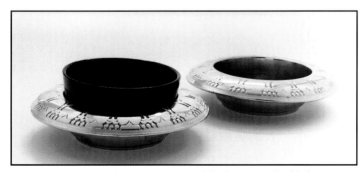

Chase "Confection Bowls" (No. 90027) in polished copper with a black glass insert (left) and polished chromium (right) missing its black glass insert. The base is 6-1/2" d., 1-1/2" h.; the bowl, 4" d., 2" h. $85-95 (with glass insert), $45-55 (without glass insert).

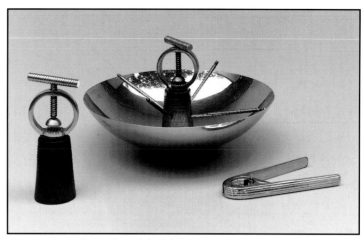

Goin' nuts over Chase, all in polished chromium. Left: The "Nut Cracker" (No. 90082) with walnut base, 5-1/2" h. $45-55. Center: The "Nut Bowl" (No. 90084) designed by Harry Laylon with walnut trim, 10" d., 6-3/4" h. $75-85. Right: The "Big 'n Small" nutcracker (No. 90150) designed by Harry Laylon, 5-7/8" l. $70-80.

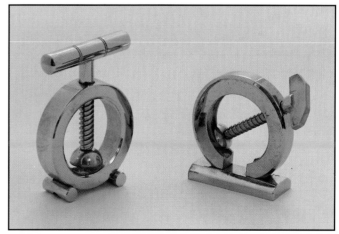

Two unmarked polished chromium nutcrackers of exceptional moderne design. Left: 3-1/2" h., 2-5/8" w. $45-60. Right: 3" h., 3-1/4" w. $45-60.

Hor D'oeuvres

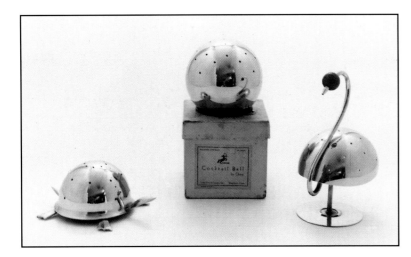

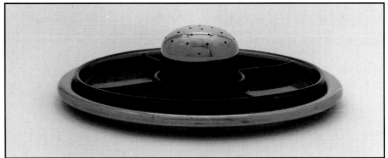

Relish tray stamped "Emerald Glo by National Silver Co.," consisting of a polished bronze version of the popular Chase "Ring" tray, an Hor d'oeuvres server, and an emerald green glass insert, 11-3/4" d., 3" h. $55-65.

Above: A trio of Hor d'oeuvres servers.
Left: Polished chromium "Mock Turtle" Hor d'oeuvres server by Irvinware, 5-1/2" l., 2" h. $30-40. Center: Chase polished chromium "Cocktail Ball" (No. 90071), designed by Russel Wright, 3-3/8" d. This boxed example has its original maroon rubber base. $80-90 with box, $65-75 without box. Right: Napier Hor d'oeuvres swan, designed by E. A. Schuelke, polished chromium with red catalin head, 6-1/4" h. $55-65.

Right: Patent issued to Emil A. Schuelke October 22, 1935, for the Hor d'oeuvres swan. The patent was assigned to The Napier Co.

"There should be about half as many tables as expected guests—so that within reach of every two chairs there will be a table on which people can put down glasses and cups and saucers." (Emily Post in *How to Give Buffet Suppers*, 1933)

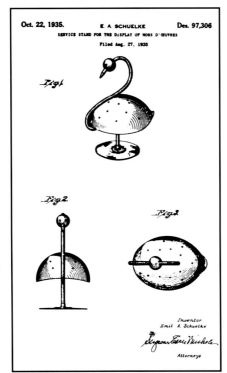

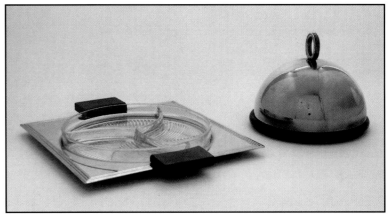

Left: Manning-Bowman "The Party Pal" relish dish (No. 337), 9-1/2" sq., in polished chromium with walnut handles and a three-section crystal insert. The tray, minus the glass insert, was offered as the "Criterion" (No. 341) in the 1941 catalog. $45-55. Right: Unmarked polished copper cheese server with oak base, 6-1/2" d., 5-1/2" h. $55-65.

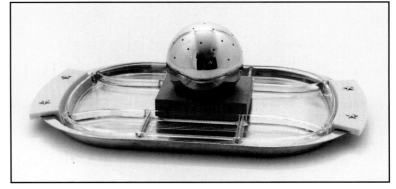

Chase "Star Time Relish Dish" (No. 90155A), polished chromium with white plastic handles, 15-1/2" l., 9-7/16" w., shown with the Cocktail Ball (No. 90071). Designed by Harry Laylon, the tray, introduced in 1942, is fitted with an eight-compartment glass tray and a maple cheese board that, when reversed, is cut out to hold the cocktail ball. $200-225 (with ball), $125-150 (without ball).

Three polished chromium serving accessories by Chase. Left: The Walter von Nessen-designed "Olympia Dessert Dish" with ivory composition knob, 3-7/8" d. "We've never seen a dessert dish as handy as this one for formal meals or buffet parties. Its scroll handle makes it easy to hold at a sit-down-or-wander-about meal" reads the 1937 catalog. $60-75. Center: The "Fairfax Relish Dish" (No. 90128), with three-section glass insert, 8-1/2" d. The white plastic handles were designed by Walter von Nessen. $65-80. Right: The base to the Chase "Cruet Set" (No. 26009) retains some of its value even though the glass cruets are long gone because the piece is functional as a mint and nut dish. $45-55 (without cruets), $85-95 (with cruets).

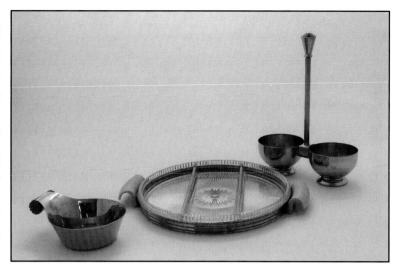

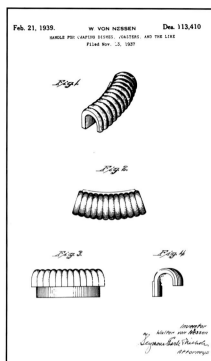

Design patent awarded to Walter von Nessen on February 21, 1939, for the handles used on a variety of Chase serving items such as the Fairfax Relish Tray, the Electric Table Butler, Electric Table Chef, and the Coronet Coffee Urn.

Park Sherman lazy susan relish tray, polished chromium with 5-piece fitted glass inserts, 11-1/8" d., 2-3/4" h. A nice design with four ribbed handles for easy turning. $55-65.

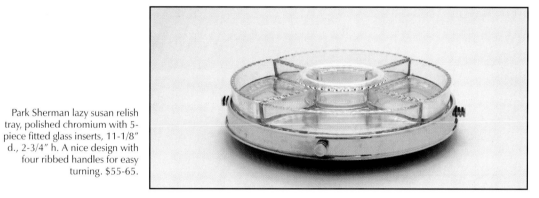

Chase polished chromium "Individual Canapé Plates" (No. 27001) designed by Lurelle Guild, 6-1/4" d. The display rack is vintage but not believed to be Chase. The 1937 catalog notes that "with this smart-looking canapé plate, you can hold a cocktail, a canapé and a cigarette in one hand and shake hands with the other." The November 1933 *House Beautiful* notes that "[i]f you have ever struggled yourself or have watched your guests struggling for nourishment with a cup and saucer balanced precariously in one hand and a plate of sandwiches clutched in the other, you will appreciate this new individual canapé plate originated by a Boston silversmith and now being manufactured very inexpensively." The article does not, unfortunately, identify the Boston silversmith that originated the canapé plate. Shown with the canapé plate is the Chase "Cocktail Cup" (No. 26002) designed by Harry Laylon. Trays: $20-25 each. Cocktail cups: $5-10 each.

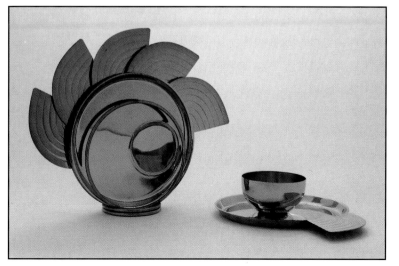

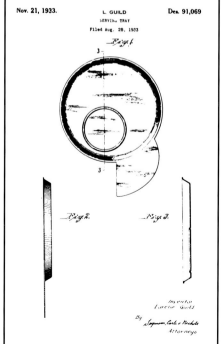

Design patent for the individual canapé plate awarded to Lurelle Guild on November 21, 1933. The patent was assigned to Chase.

"Don't feed hungry men on bouillon, sar-
dines, samples of fruit salad and meringues."
(Emily Post in *How to Give Buffet Suppers*, 1933)

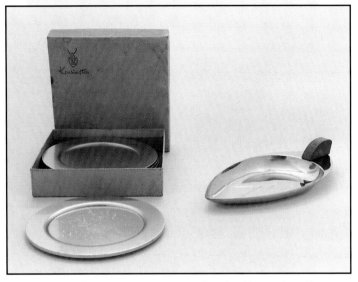

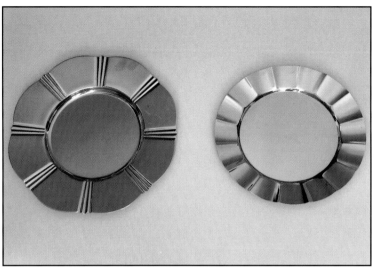

Two polished chromium trays by Revere. Left: The "Trio Tray," 11" d. The 1937 catalog offered the "Trio Tray" only in a 10" d. either with (No. 7503) or without (No. 7502) a three-section glass insert, 7-3/8" d. $35-45 (as shown), $45-55 (with glass insert).Right: The "Relish Dish," 9-1/4" d. The 1937 catalog offered the "Relish Dish" only in a 10" d. either with (No. 7501) or without (No. 7500) a three-section glass insert, 7-3/8". $35-45 (as pictured); $45-55 with glass insert.

Left: Boxed set of six Kensington "Vanity Fair" bread and butter plates (No. 7301), 5-1/2" d. $35-45. The plate shown in the foreground is badly scratched and has little value. Right: Unmarked polished chromium mint or nut dish with walnut handle, 8" l. x 4-1/4" w. This popular dish, probably post war, is plated over metallic base metal and has limited value. $5-10.

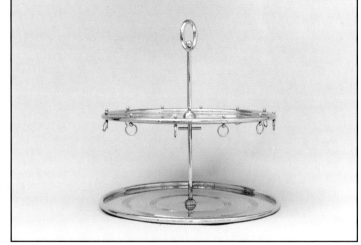

Chase polished chromium "Cocktail Canapé Server" (No. 28001), 13-3/4" d., 13-3/4" h. The rings hanging from the upper tray are used for cocktail napkins. $125-150.

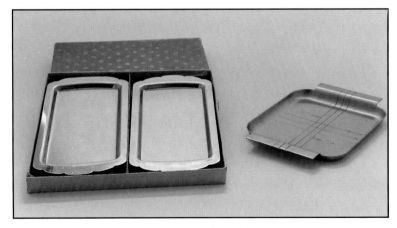

Left: Boxed set of 12 Manning-Bowman "Individual Canapé Trays" (No. 261) in polished chromium, 7-1/2" x 3-7/8". $85-100. Individual trays should sell for $4-8. Right: Norman Bel Geddes-designed Revere "Five O'clock Tray" (No. 813) in satin chromium, 6-3/4" x 4-5/8". The 1937 catalog notes that "Simple and distinctive in form, this individual canapé tray adds a modern note to any cocktail set and has been designed to nest conveniently. $20-25 each.

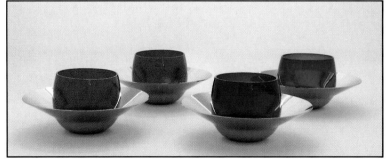

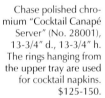

Revere polished chromium "Service Cups" with blue cups (No. 802) and red cups (No. 805), 5-1/4" d. Designed by Fred Farr, "Service Cups" were also available in bronze with either red (No. 803) or crystal (No. 806) tumblers. The 1937 catalog describes the cups as being "[n]ew and colorful for serving fruit, sherbets, custards, fruit and vegetable juices, oyster or crabmeat cocktails." $30-40 each.

Serving Bowls

Manning-Bowman "Cape Cod" Baker and Server (No. 260/8), polished chromium tray, 14.5" d., with spherical white oven-proof ceramic bean pot, 7"d. Also available with a brown pot (No. 260/7), the 1936 catalog boasted that the Cape Cod "…may be placed directly in the oven, of course, and then inserted in the beautifully chromium plated server which accommodates breads, crackers, celery, and other essentials so handily on its wide flared edge." Rare. $225-275.

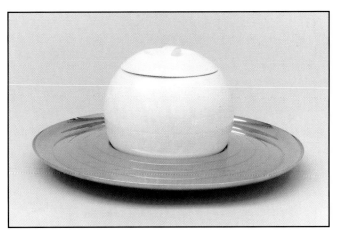

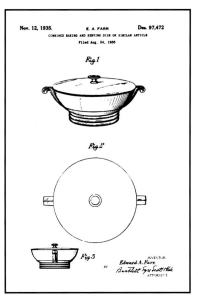

Edward A. Farr was awarded a design patent for the "Baker's Man" on November 12, 1935.

"'Complete' buffet service means that the table is set with all sorts of good things to eat; people go to the table, help themselves to whatever they like, choose where to sit and whom they like to sit with, and it is all friendly, simple, informal, and perfect!" (Emily Post in *How to Give Buffet Suppers*, 1933)

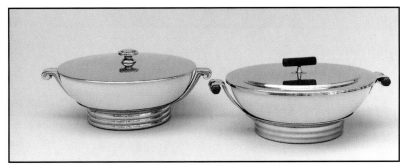

Manning-Bowman "Means Best." Left: "The Baker's Man" (No. 3032) designed by Edward A. Farr, 11-3/4" w. x 4-3/4" h. The copy in the 1941 catalog reads "It is a baking dish…serving dish…salad bowl. The lining of ovenproof china and the metal cover may be placed directly in the oven for baking and returned to the chromium-plated frame for serving on the table. Then again, by removing the cover it becomes a graceful salad bowl." $135-160. Right: A similarly designed casserole with a ceramic bowl marked "Hall." On this example, however, the chromium-plated frame and cover are lighter and plated over a metallic base metal." $75-90.

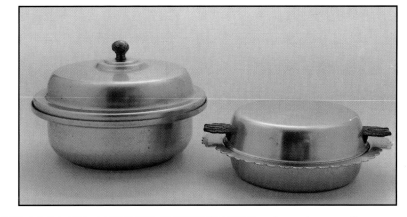

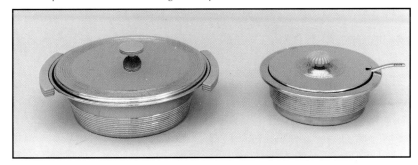

Chase polished chromium and bakelite serving dishes. Left: The "Aurora Service Dish" (No. 17061), 8" d. x 2-3/8" h. The 1937 catalog reads "Here is a vegetable dish by Walter von Nessen that is as serviceable as it is good looking. It can also be used without the cover for flowers, fruit, desserts, nuts or popcorn, potato chips or candy. Simple lines carry out the modern feeling of design." $125-160. Right: The "Butter Dish" (No. 17067), 6" d. x 2-5/8" h. The "Butter Dish" includes a three-pronged fork and a removable strainer to keep the butter away from the ice. The "Butter Dish" is prone to stress cracks around the sides where ribbing has been embossed in the thin metal. It should be carefully examined before purchase. $75-90.

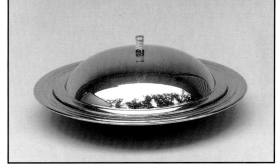

Manning-Bowman polished chromium covered serving dish with four-section glass insert and white cordex knob, 12-1/2" d. x 5-1/2" h. Rare. $150-175.

Above: Aluminum alloy covered casseroles by Kensington. Left: The "Canterbury" (No. 7384), 6-3/4" h. x 10" d. $50-60. Right: The Lurelle Guild-designed "Dorchester Double Serving Dish" (No. 7381) with brass handles, 3-1/8" h. x 10" d. $55-65.

Trays and Platters

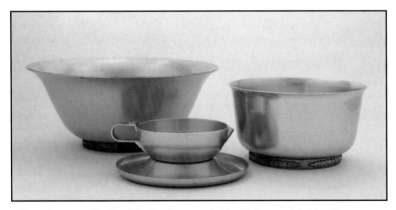

Three Kensington aluminum alloy serving bowls. Left: "Ship's Galley Bowl" (No. 7427), designed by Lurelle Guild, 9-1/4" d. x 1-3/4" h. $20-30. Center: "Lotus" bowl (No. 7424), 5" d. x 1-3/4" h. $10-20. Right: "Wiltshire" bowl (No. 7410), 9" d. x 3" h. $25-35.

Three aluminum alloy bowls by Kensington. Left: The "Epicurean Salad Bowl" (No. 7259), 11-5/8" d. x 5" h., with a brass base. $80-110. Center: The "Southhampton" sauce bowl (No. 7320), designed by Lurelle Guild, 7" d. (saucer), 4-3/4" d. x 2-3/4" h. (bowl). $35-45. Right: The "Coldchester" (No. 7246), 7-7/8" d. x 4-1/4" h., with a brass base. $50-60.

"Every dish at a buffet without set tables must be chosen to eat easily with a fork held in one hand while holding the plate in the other." (Emily Post in *How to Give Buffet Suppers*, 1933)

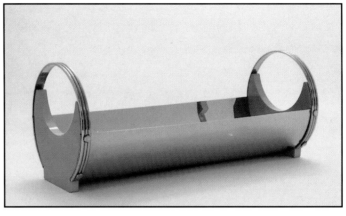

Manning-Bowman's "The Bread Basket" (No. 353), polished chromium with ivory catalin ends, 11-1/2" l. x 4-1/2" w. "'Different' is the word used to describe this new bread or roll tray…" reads the 1941 Manning-Bowman catalog, and different it is. One of the most striking designs produced by any of the major giftware manufacturers, the "Bread Basket" is right at home in contemporary kitchens as a bagel server. $175-225.

"An attractive woman can even escape a tiresome talker by going to the table and then joining whomever she chooses." (Emily Post in *How to Give Buffet Suppers*, 1933) (Author's comment: It is not clear why this option was offered only to attractive women.)

Kensington "Zodiac Platter" (No. 7100), design patented by Lurelle Guild in 1936, 18" d. $115-130.

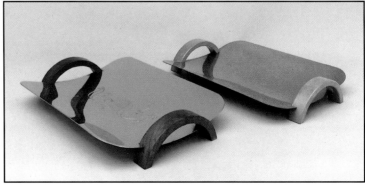

A popular tray by Revere with arched wooden handles, shown in polished chromium (left) and polished copper (right), 13" l. x 9" w. $65-80.

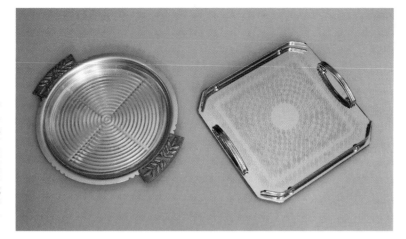

Left: Kensington "Laurel" tray (No. 7108), aluminum alloy with brass handles and clear glass insert, 12" d. $75-90. Right: Polished chromium tray stamped "Regency" with an etched design of overlapping circles, 11-3/4" x 11-3/4" x 1-7/8". $45-55.

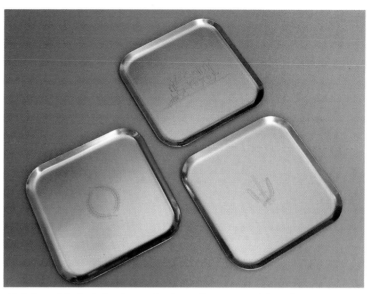

Variations of the basic Kensington aluminum alloy tray, 10-3/4" sq. The trays, left to right, "Dorchester" (No. 7162), "Pioneer" (No. 7160), and "Savoy" differ only in their etched designs. $20-25.

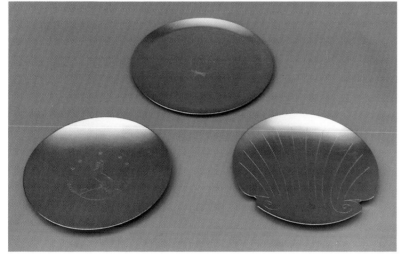

Three aluminum alloy trays by Kensington. Left: "Havana" Canapé plate (No. 7321), 10" d. $15-20. Right: "Shell" Canapé Plate (No. 7331), designed by Lurelle Guild, 10" d. $25-30. Top: "Savoy" Round Tray (No. 7159), 12-1/4" d. $30-40.

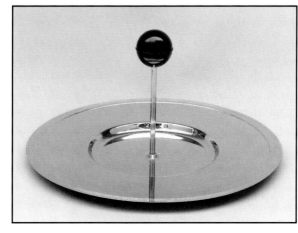

Bruce Hunt, Chicago, Illinois, handled serving dish in polished chromium with black bakelite handle, 11-1/2" d., 6" h. $45-60.

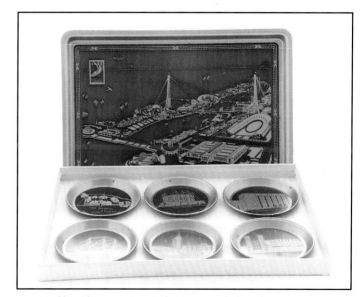

Mint and boxed tray, 10" x 7", and coasters, 3" d., from the 1933 Chicago "A Century of Progress" World's Fair. Each coaster has a different scene from the fair. The tray has an aerial view of the fair complete with sailing ships, airplanes, and an airship. Because both art deco and World's Fair collectors seek them, souvenirs of both the 1933-34 Chicago fair, and the 1939-40 New York fair command high prices. $65-85.

113

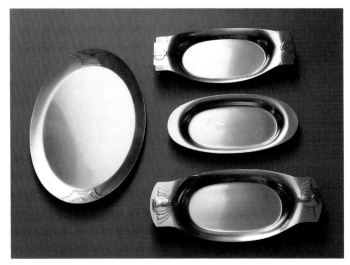

Four Kensington aluminum alloy service dishes designed by Lurelle Guild. Left: "Hampton" oval platter (No. 7332), 10-3/4" x 15-3/8". $30-40. Top right: "Irvington" tray (No. 7158), 13" x 6". $15-25. Right center: "Clifton Celery Dish" (No. 7314), 11-1/4" x 5-3/4". $15-25. Bottom right: "Dover" tray (No. 7155), 13-3/4" x 6". $15-20.

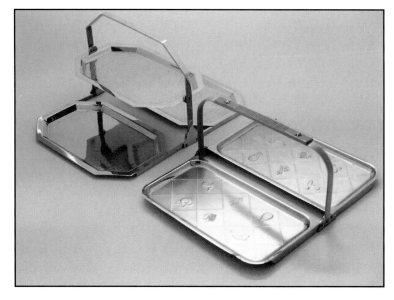

Chase folding trays. Left: The original design of the Chase "Triple Tray" (No. 09001) in polished chromium, 11" l. x 7-1/2" w. (closed). This was among the most popular Chase designs, making it readily available. $55-65. Right: Chase "Double Tray" (No. 09025), in satin chromium with white bakelite handle decorated with stars, 13" l. x 11" w. x 5-3/8" h. (open). Embossed designs set in a diamond motif decorate the trays. $55-70. Harry Laylon designed the version of the "Double Tray" shown as well as the later version of the "Triple Tray" using the same embossed designs. A third variation of the triple tray has the same rounded-edge trays shown in the double tray but is finished in polished chromium with no embossed decoration. The later versions of the triple tray are harder to find and command a higher price.

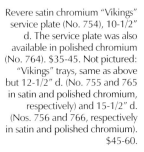

Revere satin chromium "Vikings" service plate (No. 754), 10-1/2" d. The service plate was also available in polished chromium (No. 764). $35-45. Not pictured: "Vikings" trays, same as above but 12-1/2" d. (No. 755 and 765 in satin and polished chromium, respectively) and 15-1/2" d. (Nos. 756 and 766, respectively in satin and polished chromium). $45-60.

Kensington aluminum alloy service plates designed by Lurelle Guild. Back: The "Cortex Footed Platter" (No. 7106) with brass feet, 16" d. $70-85. Front: "Zodiac Sandwich Plate" (No. 7315-D), with brass Sagittarius symbol, 10" d. $25-35.

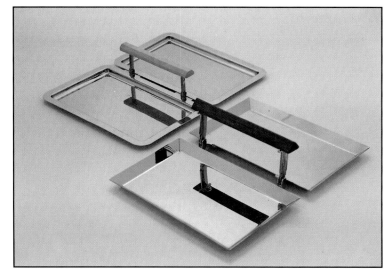

Manning-Bowman polished chromium folding trays designed by E. A. (Bert) Farr. Foreground: The 1934 "Stowaway" tray (No. K186) with triangular shaped walnut handle, 11-1/2" x 8-1/4" x 2" (closed), and 11-1/2" x 14-3/4" x 4" (open). The tray was also available in a finish Manning-Bowman referred to as "Butler Chromium." $65-80. Rear: A later variation of the "Stowaway," (No. 442) featuring rounded edges on the trays and a catalin handle, 15-1/2" x 11-3/4" x 2-7/8" (open). $70-85.

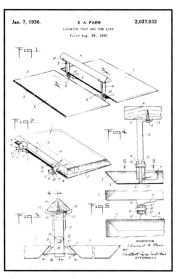

Patent awarded to Edward A. Farr on January 7, 1936 for the "Stowaway" tray.

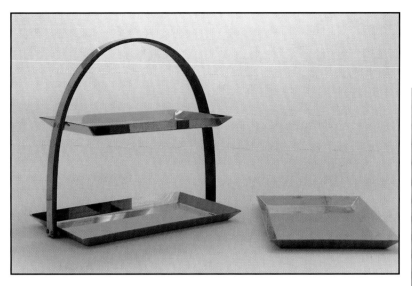

Left: Manning-Bowman "Tasty Bite" tray (No. K161), designed by Jay Ackerman, in polished chromium with a bent walnut handle, 11" x 7" x 11-1/2". $75-90. Right: A simple polished chromium tray included in many of Manning-Bowman's Carafon sets, 11" l. x 7" w. $35-45.

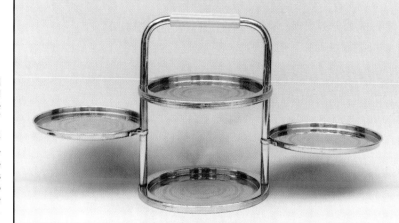

Chase polished chromium and white bakelite "Four-In-Hand" tray (No. 17074), 10-1/4" h., 8-3/8" d. Designed by Harry Laylon, the two center trays swing inward to reduce storage space. $105-125.

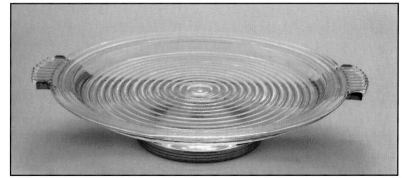

Unmarked polished chromium lazy susan cake stand, 15-1/2" d., 3-1/8" h. The glass cake plate is fairly common but the stand is hard to find. $45-60.

Condiments

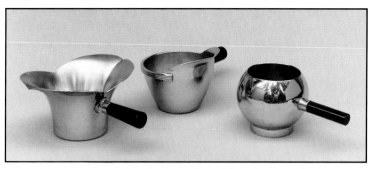

Polished chromium sauce pitchers by Chase, all with bakelite handles. Left: The "Lotus Sauce Bowl" (No. 17045), designed by Walter von Nessen, 6-1/2" x 6" x 3". $75-90. Center: The "Viking Sauce Bowl" (No. 17046), 6-1/2" x 4-1/2" x 3-1/4". $70-90. Both the Lotus and Viking bowls came with a polished chromium saucer, 6-1/2" d. $20-30. Right: The "Sphere Pitcher" (No. 90079), designed by Russel Wright, 2-1/2" l. marble-ized green bakelite handle, 2-5/8" d. sphere, 3" h. This is an early version of the "Sphere;" later versions came with a ribbed white handle. $65-80

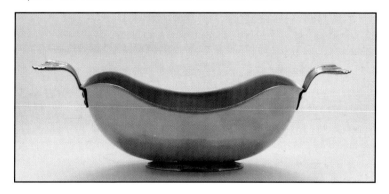

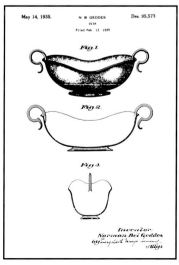

Above: Revere "Vestal" sauce bowl (No. 108) designed by Norman Bel Geddes, polished chromium with bronze handles, 9-1/16" x 2-3/4" x 2-3/8". When introduced in 1935, the Vestal had different handles and had a satin silver finish. The version shown here was introduced in 1937. The original handles are shown in the patent drawing. $75-90.

Left: Patent awarded to Norman Bel Geddes on May 14, 1935, for the Vestal sauce bowl. The pictured handles were used for only the first 2 years of production.

115

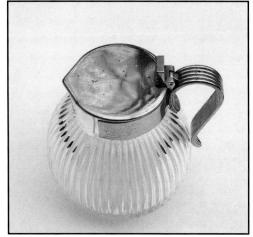

Chase "Jubilee Syrup Jug" (No. 26004) in polished chromium with clear ribbed glass, 4-1/4" h., 3-1/2" d. Not shown is the matching saucer, 5-5/8"d. $35-50. Add $10 with the saucer.

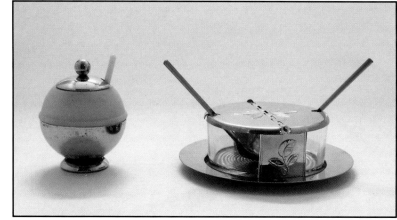

Two polished chromium condiment servers from Chase. Left: "Mustard Jar" (No. 90070), 4" h., with white frosted glass insert. $30-45. Right: "Double Condiment Server" (No. 26006), 4-9/16" d. (dish), 6-9/16" d. (saucer), 2" h. The spoons shown are not original. $45-60.

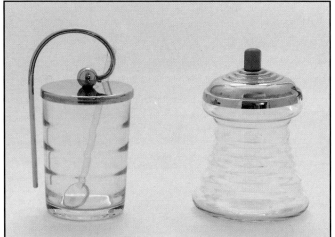

Left: Jam jar with the Heisey trademark, 5-1/2" h., glass with polished chromium lid/handle. This jar is very similar to the Manning-Bowman "Turn Top" jam jar (No. 336) shown in the 1941 catalog. It appears likely that Heisey and Manning-Bowman collaborated, each producing a variation of the basic design. $45-60. Right: Unmarked jam jar with polished chromium top and bakelite knob, 5" h. $35-45.

The Manning-Bowman "Turn-Top" jam jar (No. 336), 5-1/2" d., 5-3/4" h. as shown in the 1941 catalog. The catalog copy reads "Lift top, turn it aside, let it down and lo, the cover is suspended in air…out of the way while you scoop up jam with the neat glass ladle." $60-75.

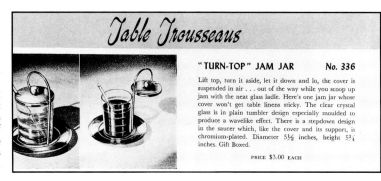

Table Trousseaus

"TURN-TOP" JAM JAR **No. 336**

Lift top, turn it aside, let it down and lo, the cover is suspended in air . . . out of the way while you scoop up jam with the neat glass ladle. Here's one jam jar whose cover won't get table linens sticky. The clear crystal glass is in plain tumbler design especially moulded to produce a wavelike effect. There is a stepdown design in the saucer which, like the cover and its support, is chromium-plated. Diameter 5½ inches, height 5¾ inches. Gift Boxed.

PRICE $3.00 EACH

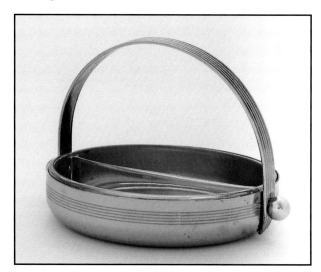

Chase polished chromium "Duplex Jelly Dish" (No. 90062), 5-1/2" d., 4-1/2" h., with 2-section glass liner. Designed by Harry Laylon, this was a big seller for Chase both as shown and in polished copper, limiting its current value. $25-35.

The "Wright" stuff. Russel Wright designs for Chase in polished chromium. Left: "Pancake and Corn Set" (No. 28003), consisting of the "Syrup Pitcher" (No. 28005), 5-1/4" h; "Coaster Tray" (No. 09014) with cobalt blue glass bottom, 6" d.; and "Salt and Pepper Spheres" (No. 28004), 1-3/4" d. (salt), 1-1/8" d. (pepper). Selling in 1937 for $4, the current value is $325-400. Right: "Sugar Spheres" (No. 90078), 2-5/8" d., $55-70 each, and "Salt and Pepper Spheres," $50-80 per pair.

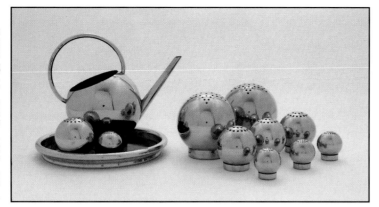

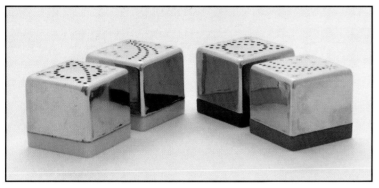

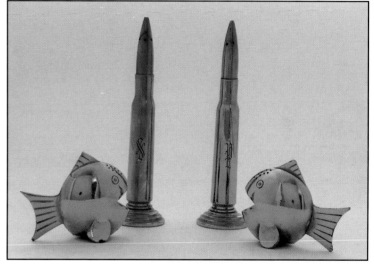

Front: Unmarked polished chromium salt and peppers in the shape of fish, 2-1/2" h. $35-45. Rear: Unmarked polished chromium salt and peppers made of shell casings, 6" h. The set has a nice stepped base but the moderne look is spoiled by the gothic looking "S" and "P" etched into the sides. $25-35.

Chase polished chromium "Skyway" salt and pepper shakers, 1-3/8" x 1-3/8" x 1-1/4". The pair on the right (No. 17095) was released to commemorate the 1939 New York World's Fair and have blue and orange bases, the official color scheme of the fair. The pair on the left (No. 17104) has the usual white bases. $55-70 with white bases; $70-90 in the World's Fair colors.

Left: Kensington "Raleigh" salt and pepper shakers (No. 7697), 2-7/8" h. $15-25. Center: Unmarked polished aluminum "personal" salt and pepper shakers, 2" h., in original box. These shakers were advertised in the March 1950 House and Garden by Park Products of Cincinnati, Ohio. Four sets were offered for $3.95. Current value is $45-60. Right: Unmarked aluminum alloy salt and pepper dispensers, 3-1/4" h. Salt and pepper are dispensed from the bottom by pushing the button on the top. $25-35.

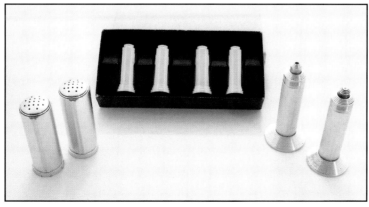

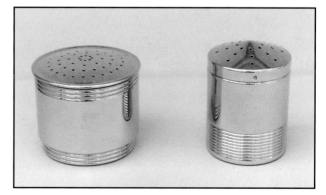

Polished chromium sugar shakers. Left: Manning-Bowman, 2-3/4" h. $30-40 Right: Chase (No. 90057), 3-3/8" h. $45-60.

Chase polished chromium and black composition "Diplomat Coffee Set" (No. 17029) designed by Walter von Nessen. The set, which was also available in polished copper, consists of the pot, 8" h., sugar bowl, 4" h., and cream pitcher, 2-3/4" h. $325-375. With the matching 10" d. "Diplomat Tray" (No. 17030) the value increases to $450-500. The tray pictured is similar in style to the Diplomat tray but is not Chase.

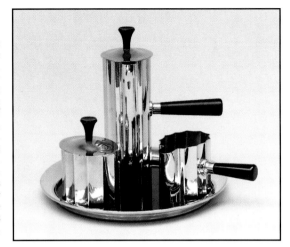

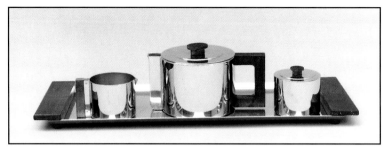

Manning-Bowman polished chromium "Geniality" coffee or tea service (No. 2190) with solid walnut "trimmings." The set consists of a coffee or teapot (No. 219), 7-1/4" x 4-1/2" x 4", sugar and creamer (No. 220), 2-3/4" x 2", and "Precedence" tray (No. 221/7), 19" x 6-3/4". Without the tray, the set, which sold for $7 in 1936, has a current value of $150-200. With the tray, the value increases to $225-275.

Coffee and Tea Sets

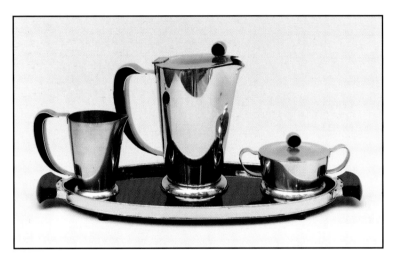

Gense (Sweden) stainless steel coffee service with black bakelite trim, consisting of pot, 8" h., creamer, 4" h., and sugar, 3" h. $125-175. The set is shown with a Manning-Bowman tray (K15615) of polished chromium and ebony catalin, 17" x 7-1/8". $80-110.

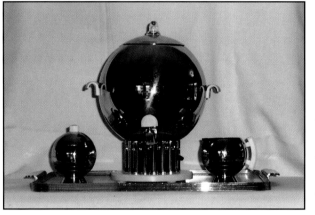

Chase polished chromium "Coronet Coffee Urn Service" (No. 90121), introduced in 1938. Designed by Walter von Nessen, the set includes the "Coronet Coffee Urn" (No. 17088), 12" h., sugar and creamer (No. 17089), 4-1/2" h. and 3-1/2" h., respectively, and "Festivity" tray (No. 09018), 16-11/16" x 12-1/8". The set sold for $28.95 in 1941, but now has a value of $700-800. Values for individual components are $350-425 for the urn, $55-70 for the cream and sugar, and $150-175 for the tray. The handles on the Festivity tray shown in the 1941 catalog have been redesigned to better harmonize with the von Nessen-designed handles on the urn. (Photo by Rick Inserra.)

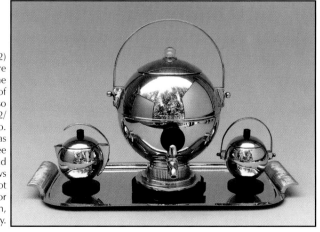

Manning-Bowman polished chromium "Harmony" (No. 4920/12) coffee set with black trimmings. Appearing at least one year before Chase introduced its famous spherical "Coronet" coffee service, the 1937 Manning-Bowman catalog notes that the "...spherical design of the 'Harmony' sets it apart as the smartest coffee service." The set, also available with crystal catalin trimmings, consisted of the urn (No. 492/12), 13" h., gold-lined sugar and creamer (No. 1152), and tray (No. 5120), 20" x 10". In the 1934 "Gifts" catalog, the tray was offered as the "Bacchanalian" (No. 289). Unlike the Chase "Coronet" coffee service that combines the stunning "Coronet" urn with a sugar and creamer and tray with different handle designs, the Harmony shows particularly well as a coordinated set. Because Manning-Bowman is not as collectible as Chase, this set is a bargain at $250-350. Prices for individual components are also reasonable at $125-175 for the urn, $45-60 for the creamer and sugar, and $60-80 for the tray.

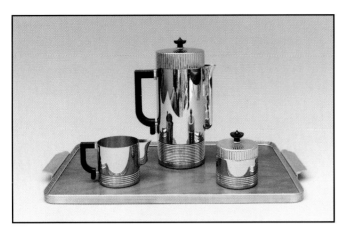

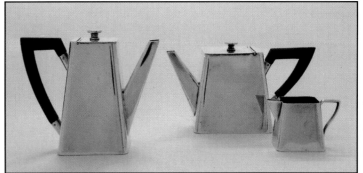

Individual silver-plated coffee and tea service with ebony wood handles. The set, of European origin, consists of the coffeepot (4-1/2" h.), teapot (3-1/2" h.), and creamer (1-7/8" h.). $450-550.

Chase polished chromium and black bakelite "Continental Coffee Making Service" (No. 17054) designed by Walter von Nessen. The set includes the No. 17051 "Continental Coffee Pot" (9-3/8" h. , 3-3/4" d.); a sugar bowl (3-5/8" h., 3" d.); and a creamer (2-7/8" h., 3" d.). The three-piece set sold in 1937 for $11.00 or, when combined with the "Festivity Tray" (No. 09018), 17-3/4" x 12-1/4", for $17.00. Current values are $125-150 (pot), $200-250 (three-piece set); and $325-375 (with tray).

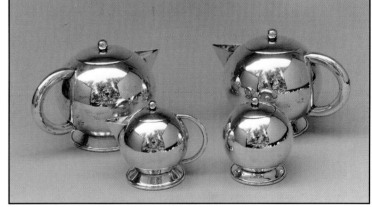

Silver-plated coffee and tea service marked "Made in England." The coffee and teapots are 4-1/2" d.; the cream and sugar, 3-1/4" d. This design sold well in England and is readily available at flea markets and antique shops throughout England. $115-145.

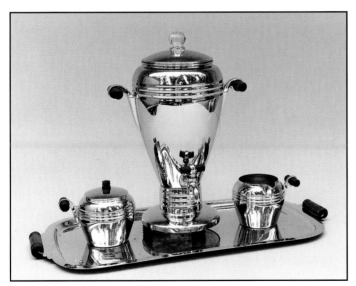

Early General Electric "Hotpoint" polished chromium coffee urn set (No. 119P85) with walnut trim. The set consists of an urn, 13" h., sugar, 4" h., creamer, 3-1/4" h., and tray, 9-3/4" x 20". This set retains some traditional styling, but makes effective use of fluting to give it a "moderne" look. $95-135.

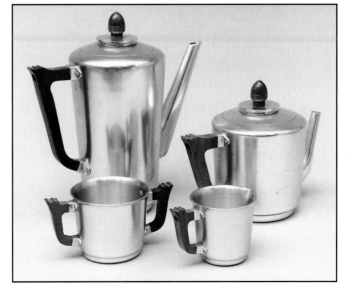

Lurelle Guild-designed Kensington "Mayfair" coffee and tea set of aluminum alloy with cherry wood handles and knobs. The set consists of the coffee server (No. 7200), 10" h., $50-60; tea server (No. 7201), 7" h., $60-70; sugar bowl (No. 7203), 3-1/4" h., $10-20; and creamer (No. 7202), 3-1/8" h., $10-20. Not pictured is the matching "Mayfair" tray, 15" d. $45-60.

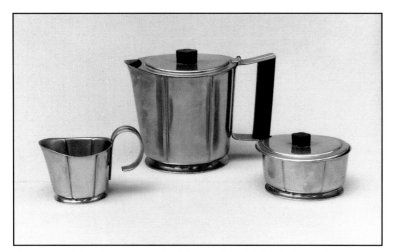

Gense (Sweden) coffee or tea set of stainless steel with black bakelite handles and knobs. The set consists of the pot, 5-3/4" h., sugar bowl, 2-3/4" h., and cream pitcher, 3-1/8" h. $125-150.

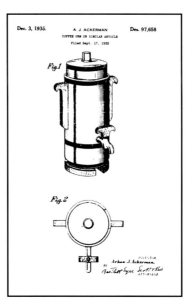

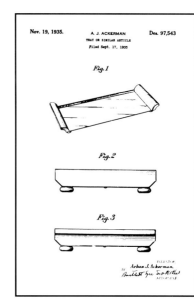

Far left: Design patent awarded to Jay Ackerman for the Pioneer coffee urn, December 3, 1935.

Left: A design patent for the tray used with the Pioneer coffee set was awarded to Jay Ackerman on November 19, 1935.

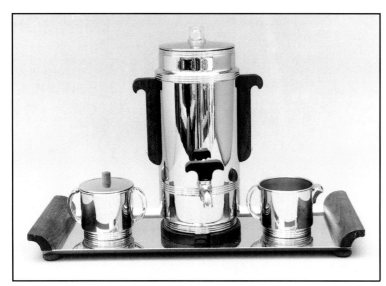

Manning-Bowman "Pioneer" coffee service (No. 4830/9) designed by Jay Ackerman. "Straight lines subtly relieved by narrow circular bands is the Pioneer design which has been so enthusiastically approved by the most fastidious…" reads the 1937 catalog. The set, finished in polished chromium with solid walnut trimmings, consists of the urn (No. 483/9), 12-3/4" h., the sugar and creamer (No. 146), 4" h. and 3" h., respectively, and the tray (No. 4819), 19-1/4" x 7-3/4". $160-200. Component values are $55-70 for the urn, $45-60 for the cream and sugar, and $60-70 for the tray.

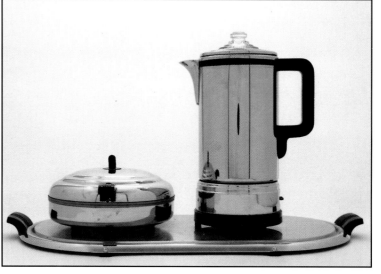

Polished chromium "Breakfast Set" by Westinghouse Electric & Manufacturing Co., Mansfield, Ohio. The set consists of a waffle iron (No. WK4) attached to a polished chromium tray with satin chromium surface, 21" l. x 10-3/4" w., and percolator (No. PTC4), 11-1/2" h. $95-115.

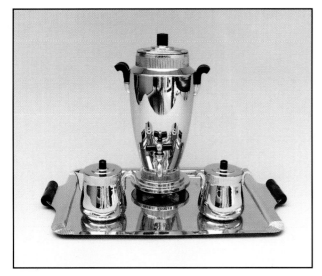

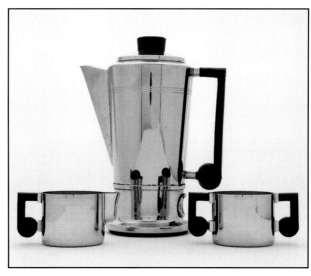

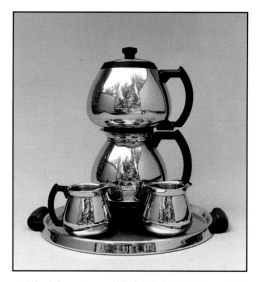

Manning-Bowman polished chromium coffee set (No. 4860/9) designed by Jay Ackerman in the "Harmony" pattern. The set consists of the urn (No. 486/9), 12-1/2" h., sugar and creamer (No. 148), 4" h., and tray (No. 4616), 19" x 12". The trimmings are black catalin and the inside surfaces of the sugar and creamer are finished in a gold wash. The set has a current value of $160-200. Component values are $75-90 for the urn, $35-50 for the sugar and creamer, and $40-60 for the tray. A hard to find set sure to increase in value.

Collaboration across the seas? The polished chromium and black bakelite "Swan Brand" percolator (No. CH-480), made by Bulpitt & Sons, LTD. of Birmingham, England, 10-1/2" h. A big seller in England, the coffeepot is readily available at British antique shops. $65-90. The creamer and sugar, 2-3/8" h., have handles of identical design but were made by Bruce Hunt of Chicago, Illinois. $45-55.

Polished chromium and black bakelite "Coffeemaster" set (No. C30A) produced by the Sunbeam Corporation, Chicago, Illinois. The set consists of the coffee maker, 12-1/2" h.; creamer and sugar, 3" h.; and tray, 12-1/2" d. The top to the sugar bowl is missing from this example. Alphonso Iannelli patented the design in 1939. The set sold extremely well and remained in production with some modifications into the 1950s. $95-125.

Right: Design patent for a coffee urn awarded to Jay Ackerman on December 31, 1935. Separate patents were awarded for the creamer (D97,978), sugar (D97,977), and tray (D97,662).

Center right: Design patent for a tray awarded to Jay Ackerman on December 3, 1935.

Far right: Design patent for the Sunbeam "Coffeemaster" awarded to Alfonso Iannelli on February 28, 1939.

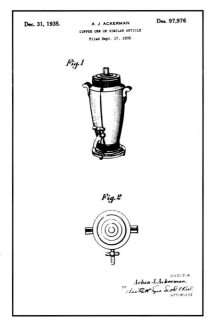

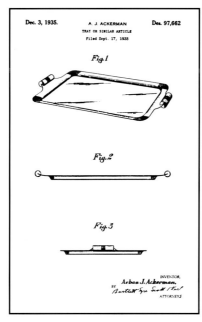

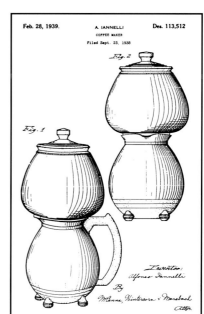

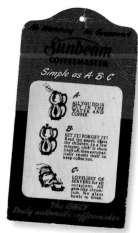

Hangtag from the Sunbeam Coffeemaster.

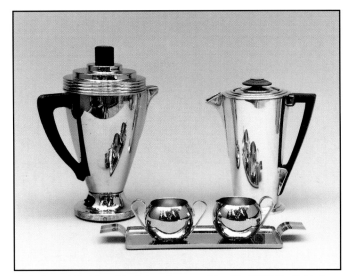

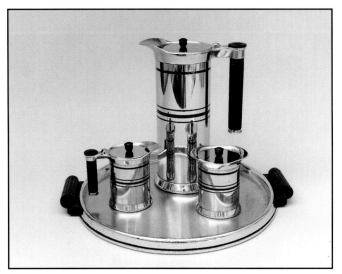

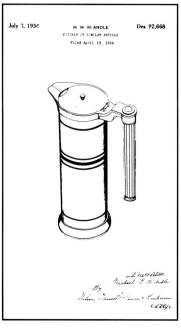

Left: General Electric polished chromium percolator (No. 119PS2) with black enameled wood handle and knob, 11" h. A nice combination of stepped design with a more traditional base and handle. $80-95. Foreground: Revere polished chromium "Sugar and Creamer" (No. 788) designed by Frederick Priess, 2-3/4" h., with matching "Cordiality" Tray (No. 789), 12-1/4" x 4-1/4". $50-65. Right: "Ile de France" coffeepot by Meriden Silver Plate Co., a division of International Silver. Marked on the bottom "Patented Jan. 11, 1927," the pot is silver plated with wood handles and knob and stands 9" h. An exceptional example of early American art deco, the pot has clean lines and a stepped base and top. $400-550.

Polished chromium "Sunbeam" coffee set by the Chicago Flexible Shaft Co., which later became the Sunbeam Corporation. The pot was designed by Michael W. McArdle in 1934; the tray 2 years later by John W. Lynch. The pot, 9-1/4" h., the creamer and sugar, 3-1/2" h., and the tray, 12" d., have decorative black enameled bands and black bakelite handles. $60-75 (pot); $35-50 (creamer and sugar); $25-35 (tray) $125-175 (set).

Design patent awarded to Michael W. McArdle on July 3, 1934, for the "Sunbeam" coffeepot.

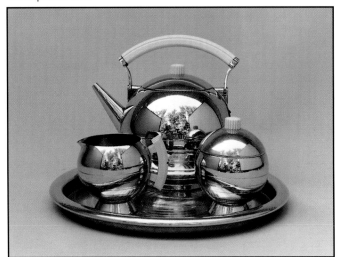

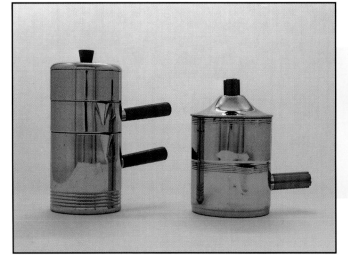

Chase polished chromium and white plastic "Tea Service" (No. 90119). The set consists of the "Electric Tea Kettle" (No. 17083), 7-9/16" h. x 6" d., the "Sugar and Creamer" (No. 17089), 3-3/8" d., and the "Ring" tray (No. 90058), 12" d. Selling as a set for $13.50 in 1941, the set now sells for $300-375. Individual component values: kettle, $150-200; creamer and sugar, $50-65; and tray, $75-90.

Two designs that really stack up. Left: the Russel Wright-designed Chase "Individual Coffee Set" (No. 90073), in polished chromium and ivory bakelite, 6-1/4" h. x 3" d. $125-160. Right: Farberware polished chromium stacking cream and sugar with ribbed bakelite handle and knob, 5-1/2" h. x 3-1/4" d. $40-55.

"In setting a buffet table the important dishes of food are placed down the length of the table as close to the centerpiece as possible....A large tea or coffee set on its tray...is balanced by platters of hot food at the other." Emily Post in *How to Give Buffet Suppers*, 1933.

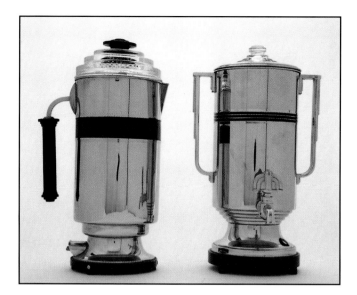

Exceptional "Royal Rochester" percolator designs by Howard H. Schott in polished chromium for the Robeson Rochester Corp., Rochester, New York. Left: The "Extraculator" (No. 16058), described in the December 1933 *Home & Field* as a new principle in coffee making. It features black enameled trimmings and a unique stepped glass top, 12-1/2" h. $115-140. Right: Coffee urn (No. 11368) with great stepped design on handles, top, and spigot, 12-3/4" h. $110-135.

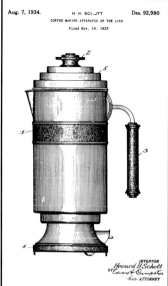

Design patent 92,980 awarded to Howard H. Schott on August 7, 1934. The patent was assigned to the Robeson-Rochester Corporation.

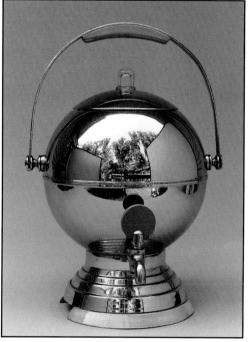

Manning-Bowman polished chromium and white catalin "Party Urn" (No. 488/20), 14" h. Although generally found in the finish shown, the urn was also available with a walnut base and walnut-colored "Cordex" handle. As a leader in the development of thermostatic controls, Manning-Bowman also produced separate versions of the urn for houses with direct and alternating current. The version for direct current included a protective fuse-link device to shut the pot off if it overheated while the alternating current version had an automatic thermostatic control to maintain the proper temperature. $175-250.

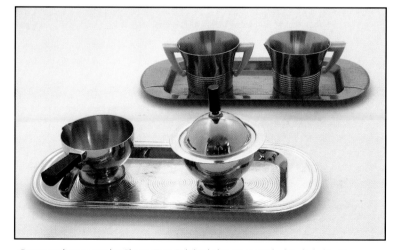

Cream and sugar sets by Chase. Top: Polished chromium and white bakelite "Savoy Cream and Sugar" (No. 26007), design attributed to Harry Laylon, 2-1/4" h., $65-80. Shown with the polished copper version of the "Savoy" tray (No. 26008), 11-3/8" x 5", $25-35. Bottom: Polished chromium and black bakelite "Breakfast Set" (No. 26003) designed by Gerth and Gerth, consisting of sugar bowl, 4-1/4" h. x 3-3/4" d.; creamer, 3-1/8" h. x 4-7/8" l.; and tray, 11-3/8" l. x 5" w. $100-125.

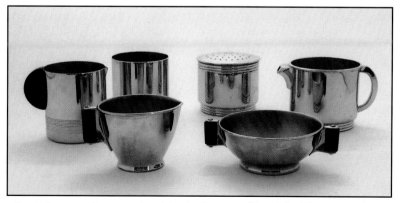

Assorted cream and sugar sets from Manning-Bowman, all in polished chromium. Left rear: The "Puritan" cream and sugar (No. 147) available with either black ebonized wood (shown) or walnut trim, 3" h. x 2-3/4" d. $35-45. Center: Cream, 3" d. x 2-1/2" h., and sugar, 4-1/4" d. x 1-3/4" h., probably from the late 1920s, with gold wash interior and black enameled wood handles. $30-45. Right rear: Creamer, 2-7/8" h. x 3-1/4" d., and sugar shaker, 3-1/4" d. x 2-3/4" h. $50-65.

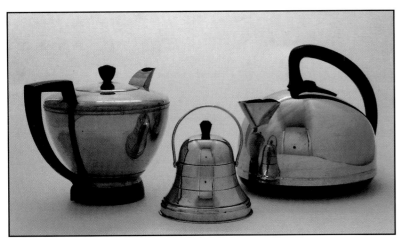

Left: Manning-Bowman "Water Server" (No. 190), polished copper with brown catalin trimmings, 7" h. x 7-1/2" d. $65-80. Center: Unmarked polished chromium tea caddy with brown bakelite knob, 5-3/4" h. $35-50. Right: Polished chromium Electric Kettle (No. K-51A) by the Canadian General Electric Co. Limited, 11" x 7-1/4" x 8-1/2". $40-55.

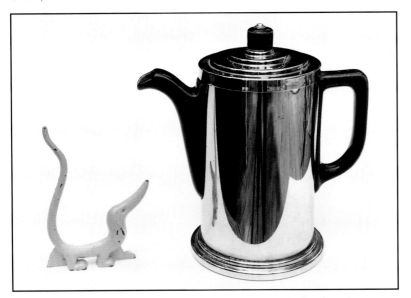

Manning-Bowman "Keephot" Tea or Coffee Pot (No. 800/30), 7-1/4" h. A hinged insulated chromium cover keeps coffee or tea hot in the four-cup china pot. The 1934 catalog notes that it "is ideal for late arrivals, out-of-door serving, after dinner coffee, et cetera." $50-65. Shown to the left of the coffeepot is a green enameled "wiener" dog by the Revere Manufacturing Company. $30-40.

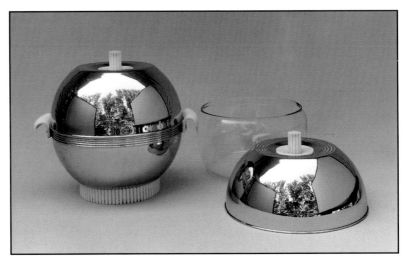

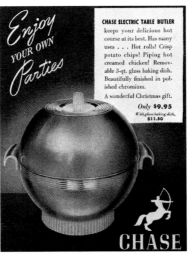

Table Electrics

Above: Chase polished chromium "Electric Table Butler" (No. 17100 w glass dish), (No. 17093 w/o glass) with plastic handles designed by Walter von Nessen, 8-7/8" h. x 8-5/8" d. $150-175. Chase also sold the cover separately as the "Piping Hot Dish Cover" (No. 17099). $75-90.

Left: Advertisement for the Chase Electric Table Butler (*House & Garden*, November 1938).

Below: Chase polished chromium and walnut "Electric Buffet Warming Oven" (No. 90096), designed by Charles Arcularius, 10-1/4" l. x 7-1/8" d. $150-200.

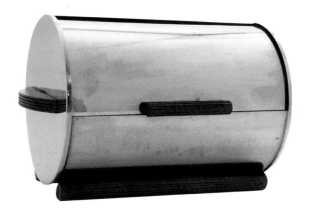

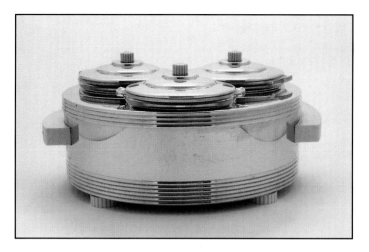

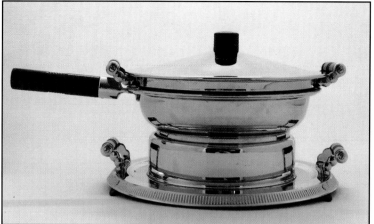

Manning-Bowman "Harmony Chafing Dish" (No. 601), polished chromium with black catalin trimmings, 11-1/4" d. x 7-3/4" h. This is a 1936 variation of a Jay Ackerman-designed chafing dish introduced in late 1933. It has two heating elements, high for cooking and low for simmering, and separate water and cooking pans. $95-125.

Above: Chase polished chromium "Electric Snack Server" (No. 90093 (110 v), No. 90110 (220 v)), designed by Howard Reichenbach (D94,568 awarded February 12, 1935), 13" d. x 6" h. The pictured snack server has plastic knobs, handles, and feet. The original snack server had walnut trimmings and was available with either a single (No. 90048) or double heating element (No. 90069). $110-135.

Right: Advertisement for the Chase "Electric Snack Server" (*New Yorker*, December 8, 1934).

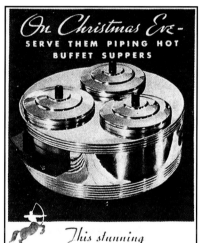

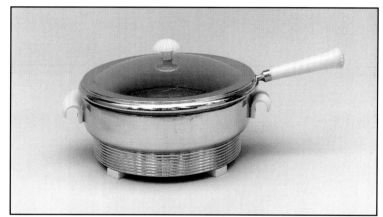

Chase "Electric Table Chef" (No. 17087), polished chromium with white plastic handles designed by Walter von Nessen, 10" d. x 6-1/4" h. $125-175.

"...there is now the very last word in buffet equipment—the debutante daughter as it were, of the chef's *bain-marie*, or a four-compartment chafing dish." (Emily Post in *How to Give Buffet Suppers*, 1933)

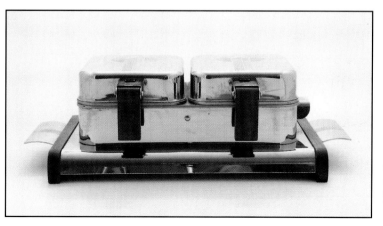

Westinghouse waffle iron (No. WFT-4) in polished chromium and walnut, 8" x 15" x 5". $50-65.

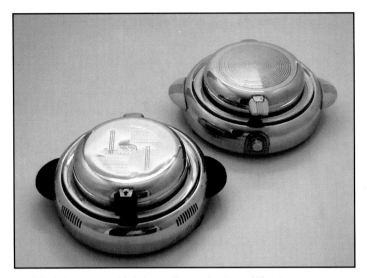

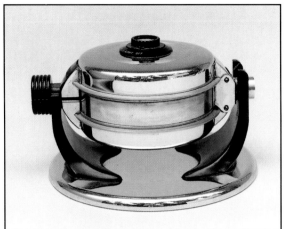

Polished chromium and bakelite waffle irons by General Electric, 13" d. x 4-1/2" h. Left: Model 119W4. Right: Model 129W9 with thermostatic control. A design patent was awarded to August A. Propernick on May 9, 1939. $50-65.

Above: Manning-Bowman polished chromium "Twin Reversible Waffle Iron" (No. 5050), 11" d. x 7" h. The waffle iron bakes two waffles in the space of one. Batter is poured onto the top griddle and then the unit is rotated using its bakelite handles and batter poured onto the second griddle. The 1937 catalog notes that "The Twin Reversible overcomes once and for all the inconvenience of trying to satisfy hungry appetites with inadequate waffle servings." By 1941, the unit was given a new name, the "Twin-O-Matic™" and catalog number (No. 6060). $125-175.

Right: Manning-Bowman Twin-O-Matic™ waffle iron advertisement (*House Beautiful's Guide for the Bride*, 1939-40 Winter)

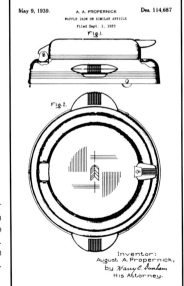

Design patent for a waffle iron awarded to August A. Propernick on May 9, 1939.

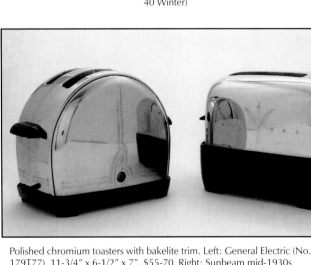

Polished chromium toasters with bakelite trim. Left: General Electric (No. 179T77), 11-3/4" x 6-1/2" x 7". $55-70. Right: Sunbeam mid-1930s Model T-9 "Half-Round" toaster designed by George Scharfenberg, 6" x 10-1/2" x 8". The "Half-Round" recently launched a successful new career in advertising, selling Kellogg's Pop-Tarts™. $85-105.

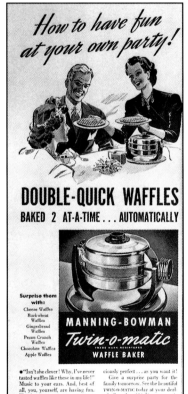

126

Manning Bowman Introduces Matched Patterns

Manning Bowman was among the first companies to manufacture and market electric appliances and developed many of the appliances that are now household by-words. Shortly after being elected president of Manning Bowman in 1932, Benjamin Tassie directed the design and introduction of matched patterns of household appliances. The 1937 electric appliances catalog describes three patterns of matched appliances—Puritan, Pioneer, and Harmony. Appliances available in the Puritan pattern included a glass coffeemaker, a coffee service, waffle irons, a toaster, and a percolator. The trim was available in either black ebonized wood or walnut. Offered in the Pioneer pattern were a glass coffeemaker, coffee services, a chafing dish, a toaster, a toaster service, an egg cooker, a breakfast service, waffle irons, a cooker, a cooker service, and a series of percolators. Trimmings on Pioneer pattern appliances were solid walnut. Finally, the Harmony pattern included a glass coffeemaker, coffee services, toasters, toaster services, waffle irons, a cooker, a chafing dish, a buffet server, and a series of percolators. Trimmings were available in either black or crystal "Arinite," Manning Bowman's trade name for bakelite. Earlier versions of Harmony appliances have walnut or black ebonized wood trim.

Table Accessories

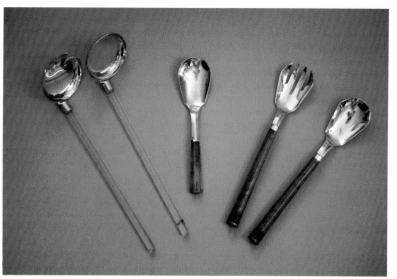

Left: Unmarked salad servers of polished chromium and clear glass, 12-1/2" l. $45-60. Center: Unidentifiable polished chromium serving spoon with catalin handle, 7-1/4" l. $5-10. This spoon was offered for sale as Chase and has a bowl identical to that of the Chase spoon to its right, but the trademark on the back of the spoon is clearly not that of Chase. It is possible, however, that Chase, which was not a flatware producer, bought the bowl from another manufacturer and designed its own handle. Right: Chase polished chromium "Serving Fork and Spoon" (No. 90076) with dark walnut handles, designed by Harry Laylon, 10-3/4" l. $60-85.

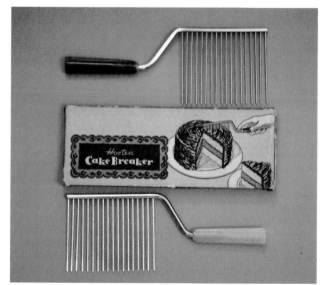

Polished chromium and catalin "Hostess Cake Breakers" by Langner Manufacturing Co., New York, 10-1/2" l. The box reads "You'll LOVE the way it breaks cake into perfect portions. NO MESSY CRUMBLING OF FROSTING OR FILLING." $10-15 without box; $25-30 with box.

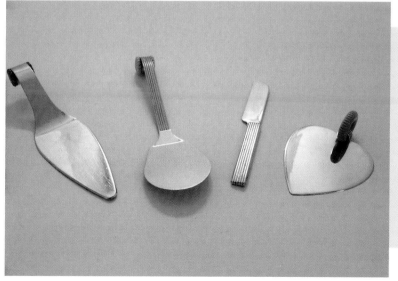

Polished chromium and white plastic serving utensils by Chase. Walter von Nessen designed all but the Valentine Server. Left: "Cake and Sandwich Trowel" (No. 17060), 8-1/4" l. $65-80. Second from left: "Tomato and Egg Server" (No. 17080), 8-3/4" l. $70-90. Second from right: "Cheese Knife" (No. 17062), 7" l. $55-70. Right: "Valentine Server" (No. 90094), 4-3/8" x 3-5/8" x 1-5/8". $40-55.

"One of the advantages of the buffet table is that it can be set with anything you have. No stack of plates need match any other stack, each fork or spoon need only match the others in its own row..." (Emily Post in *How to Give Buffet Suppers*, 1933)

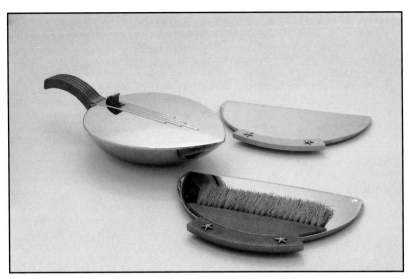

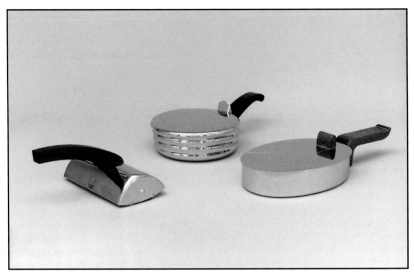

Left: Harry Laylon-designed Chase "Silent Butler" (No. 17111) with bakelite handle, 11-3/8" x 5-5/8" x 1-1/2". $65-80. Foreground: Chase polished chromium and catalin "Tidy Crumber" (No. 90147), 8" x 5-3/8" (tray), 5-3/4" x 3-1/8" (brush). This is the redesigned version of the Tidy Crumber. The original, which had the same name but a different catalog number (No. 90092) utilized two trays, the smaller tray serving as a scraper. The original handle, shown on the tray in the rear, was also redesigned to replace the grooved outer edge of the bakelite handle with the smooth edge on the redesigned tray. $45-60.

Silents please! Three variations of polished chromium silent butlers. Left: Manning-Bowman polished chromium and walnut "Crumb Sweeper" (No. 272), 5-1/4" x 6-1/4". One of the best selling Manning-Bowman products, the 1934 catalog notes that "With a few deft strokes this amazing miniature sweeper crumbs the table clean as a whistle. Its operation is essentially the same as a room sweeper and the efficient rotating brush is mounted with non-scratching noiseless rubber rollers on each end." $35-50. Center: Park Sherman silent butler with black enameled wood handle, 10" x 5-3/4" x 1-7/8". The fluted sides add a nice design touch and the felt bottom prevented marring of the dining table. $40-55. Right: Revere "Silent Butler" (No. 140) with walnut handle, 10-5/8" x 4-3/4" x 2-1/4". $40-55.

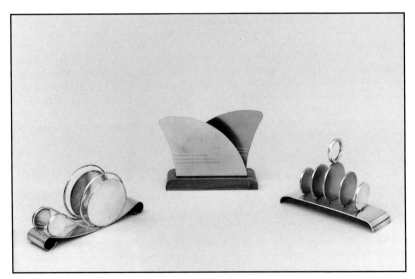

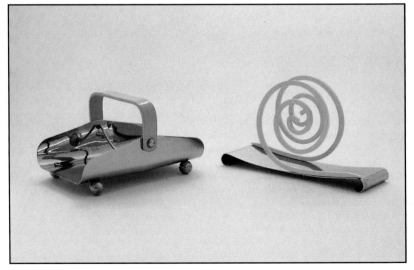

Three unusual napkin holders. Left: A moderne design in silver-plate stamped "WMF," 5-1/8" x 1-1/4" x 2-1/2". $100-125. Center: Unmarked polished chromium and walnut napkin or letter holder, 5" x 1-1/2" x 3-3/4". $35-50. Right: An exceptional design stamped "Waterhouse Plate," 4-3/4" x 1-1/2" x 3-1/2". $85-105.

Chase polished chromium napkin holders designed by Harry Laylon. Left: The "Napkin Holder" (No. 90148) with bakelite handle, 6-1/16" x 4-1/8" x 3-3/8". $65-80. Right: The "Napkin or Stationary Holder" (No. 90087), 6-7/8" x 2-1/4" x 3-7/8". $40-60.

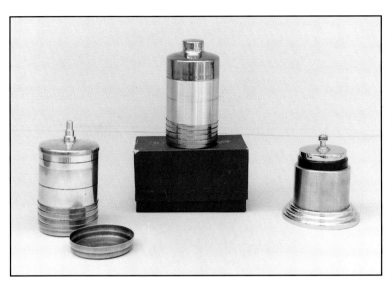

Chapter 13
Smokers' Articles

Sets and Multipurpose Items

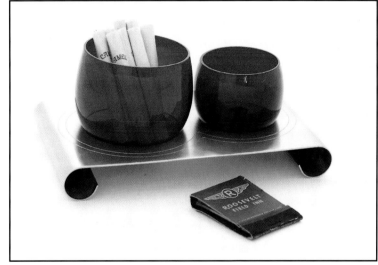

Revere "Smokette" (No. 801) designed by Fred Farr, satin chromium with ruby red glass containers for cigarettes and ashes, 6-1/2" x 4". Introduced in 1936, the "Smokette" was also available with cobalt blue glass (No. 800). Undervalued at $75-90.

Above: Left: Nu-Mador stacking cigarette box and four ashtrays of polished brass and white metal, 3" d., 6" h. $40-60. Center: Mint-in-box "Nu-Mador" cigarette humidor that rests on four stacking ashtrays, 5-3/4" h. x 3" d. The top and ashtrays were available in polished brass or copper while the body was of spun white metal. The interior is lined with mahogany. Neither the humidor nor the ashtrays are marked so identification was made through the paper insert. $50-70. Right: Unmarked cigarette holder of polished chromium, satin brass, and black enamel, 4-1/8" d. (base), 4-1/2" h. A handsome design with stepped base and knob. $55-65.

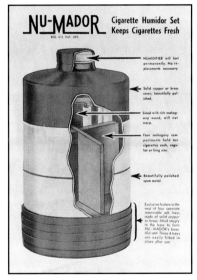

NU-MADOR *Cigarette Humidor Set*
Keeps Cigarettes Fresh
REG. US. PAT. OFF.

HUMIDIFIER will last permanently. No replacements necessary.

Solid copper or brass cover, beautifully polished.

Lined with rich mahogany wood, will not warp.

Four mahogany compartments hold ten cigarettes each, regular or king size.

Beautifully polished spun metal.

Exclusive feature is the nest of four separate removable ash trays made of solid copper or brass, fitted snugly to the base to form NU-MADOR's beautiful unit. These 4 trays are easily fitted in place after use.

Package insert for the Nu-Mador cigarette humidor. Another insert contains directions for using the permanent clay moistener contained in the cap. The user is instructed to pour cold water on the clay every other week and, after letting it soak 5 minutes, wipe it dry. It suggests that "smokers desirous of flavoring tobacco merely pour rum, brandy, wine, menthol, or perfume into the moistener instead of water."

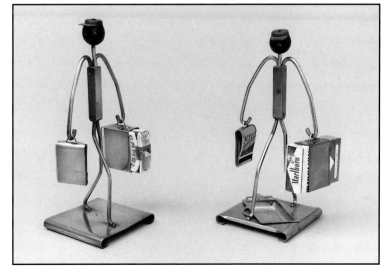

Two versions of the "Red Cap" Cigarette Porter by Guild International, Providence, Rhode Island. The version on the right includes a removable ashtray in the shape of a suitcase. The porter's bags are holders for book matches and a pack of cigarettes. Both stand 9-3/4" tall with 4" square bases and are made of polished brass with a black enameled head and red cap. Values drop significantly if a piece of luggage is missing. The "Red Cap" is collectible primarily as a novelty. The holders and ashtray in later versions of the "Red Cap" have a decidedly "cheap" appearance. $125-175.

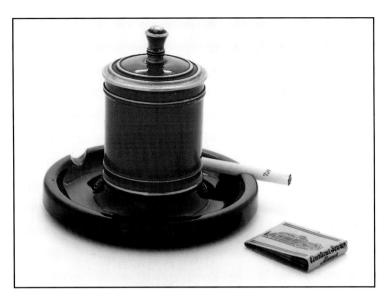

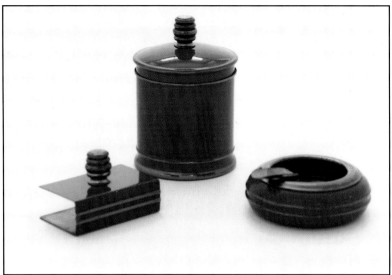

Unmarked smoker's set, probably Park Sherman, resembling the Chase "Smokers Set" (No. 560) but with a different knob. The set consists of a match holder (2-3/8" x 1-1/2"), ashtray (2" d.) and cigarette container (3-3/4" h., 2-5/8" d.). The Chase set is among the Park Sherman smoking items distributed by Chase prior to 1933 and given a Chase catalog number. The knob is the same as that on the Chase "Cigarette Container" (No. 541), also listed as among the Park Sherman items distributed by Chase. $125-145.

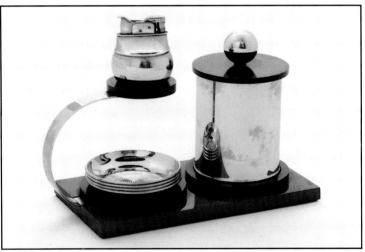

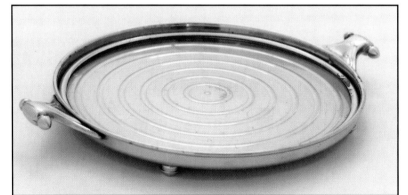

Park Sherman polished chromium tray with glass bottom, 7-1/4" d. Marked "Made of Chase brass," this tray appears identical in design to the tray in the Chase "Deluxe Cigarette Set" (No. 815). Many Park Sherman smoking accessories were given Chase catalog numbers and distributed by Chase prior to 1933. Chase continued to carry many Park Sherman designs after 1933 but it is not clear whether they were serving as distributors or manufacturers or both. $30-35.

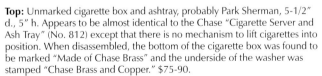

Top: Unmarked cigarette box and ashtray, probably Park Sherman, 5-1/2" d., 5" h. Appears to be almost identical to the Chase "Cigarette Server and Ash Tray" (No. 812) except that there is no mechanism to lift cigarettes into position. When disassembled, the bottom of the cigarette box was found to be marked "Made of Chase Brass" and the underside of the washer was stamped "Chase Brass and Copper." $75-90.

Above: Unmarked cigarette set of polished chromium and plastic, including cigarette box, lighter, and four individual ashtrays, overall dimensions 7-3/4" x 3-5/8" x 5-3/4". $125-150.

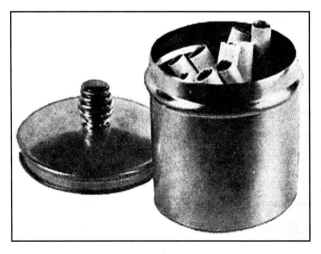

The "Cigarette Container" (No. 541) was identified in a Chase advertising flyer as one of the Park Sherman line of smoking articles distributed by Chase. It was available in polished nickel or polished brass. $60-70.

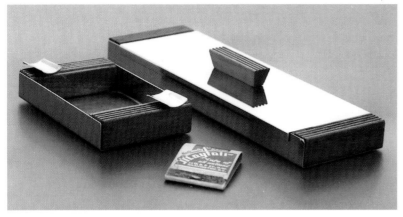

Unmarked polished chromium and walnut smoking set consisting of a cigarette box, 9-1/2" x 3", and ashtray, 5" x 2-15/16". $65-75.

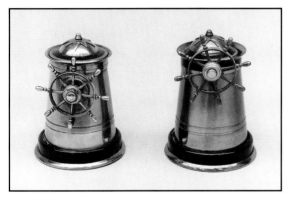

Unmarked nautical ash receiver and cigarette dispenser of polished bronze and bakelite, 6" h. Turning the pilot's wheel on the example on the left displays/dumps the ash receiver. Turning the wheel on the right raises the pop-up cigarette dispenser. $45-60 each.

Left: Chase "Globe" ash receiver (No. 17068), designed by Walter von Nessen, polished chromium with blue "chromatic" knob and base, 3" x 3" x 4". Also available with white knob and base. $85-100. Right: Chase "Bubble Cigarette Server" (No. 860), polished chromium with blue "Chromatic" base. $40-50.

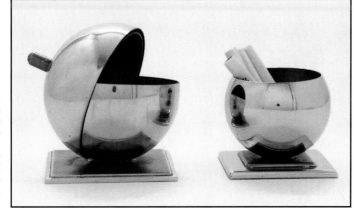

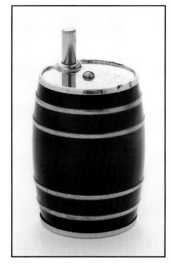

Chicago Flexible Shaft Co. "Sunbeam™" electric cigarette dispenser/lighter in black enamel and polished chromium, 3" d., 5" h. The Chicago Flexible Shaft Co. later became the Sunbeam Corporation. Pushing the button on the top dispenses a lit cigarette. The lighter/dispenser sold for $1.75 when introduced in 1934. $95-$110 if still working, otherwise $50-75.

Ashtrays

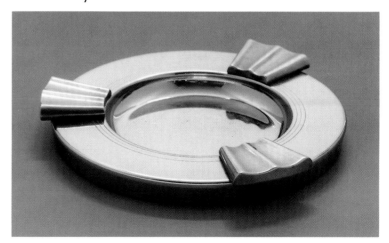

The Revere "Commodore" ashtray (No. 118), 6-1/2" d., in polished chromium with polished bronze rests. Designed by Norman Bel Geddes and introduced in 1935, the "Commodore" was initially available only in satin chromium (No. 117); a second version—satin chromium with polished copper rests (No. 118)—was added in 1936. In 1937, the satin chromium versions were replaced by the polished chromium version. The 1935 Revere Gifts catalog notes that "A decorative wave motif has been ingeniously used to provide a rest for cigarettes or cigars." $85-100.

Unmarked ashtray of exceptional design, satin chromium with black enameled center and polished chromium sphere rests, 7-5/8" d. The date of manufacture is uncertain, but I have seen versions of this ashtray with commercial advertising in the center from the 1950s. $50-65.

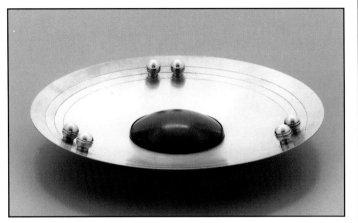

Smith Metal Arts, Buffalo, New York, antique bronze ash tray with polished bronze accents, 6" x 6" x 1-3/4". $35-50.

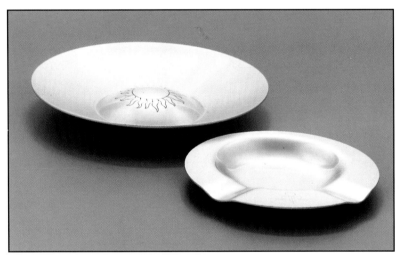

Revere "Stadium" ashtrays designed by Leslie Beaton, 7"d. Left: polished chromium with polished copper rests (No. 267). This version of the "Stadium" has double rather than triple rests and was not found in Revere catalogs. Right: polished bronze with polished copper rests (No. 1267). When introduced in 1935, the "Stadium" was available only in satin chromium with copper rests. The bronze version was added in 1937. $75-95.

Above: Kensington aluminum alloy ashtrays. Left: The "Corona" (No. 7416), designed by Lurelle Guild, 7" d. $20-25. Right: The "Mall" (No. 7609), designed by Donald G. Wharton, 5" d. $8-10.

Right: Left: An unmarked polished chromium seaplane ashtray, 6" d. x 3-1/2" h., $50-60. Right: The polished chromium "Airtray" produced by V. F. Patuskin Co., Santa Monica, California, has an 8-1/4" wingspan. An Eastern AirLines emblem adorns the edge. $65-75 in excellent condition. The value of this example, $35-45, is reduced because of pitting of the chromium.

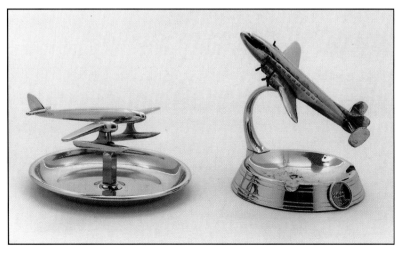

Left: Chase "Aristocrat" ash tray (No. 835), designed by John W. Schulze, "makes use of some of the striking motifs of modern architecture." In addition to the pictured version in polished copper with brass rests, the "Aristocrat," 4" d., 5-1/2" w., was available in polished chromium and English bronze in 1937 and sold for $1.00. By 1941, the metal rests had been replaced with plastic; available finishes were polished chromium with black rests; polished chromium with tortoise rests; English bronze with brown rests, and satin brass with black rests. $75-90. Right: Chase satin brass "Individual Ash Tray" (No. 883), 3-1/3" d. These ashtrays, also available in polished chromium, polished copper, and English bronze, sold in 1941 for $.50 for a set of four, but are now worth $8-10 each.

"Saturn" ashtray of polished chromium sitting on a black bakelite base with a bronze ring and raised copper stars, 4-1/2" d., 4" h. It has stamped on the bottom the letters NOR and LOC, intersecting to form a cross. This ashtray is virtually identical to the "Saturn" ashtray (No. 711) introduced by Revere in its 1937 catalog, except that the inner ring is of chromium rather than black as listed in the Revere catalog. Because Revere was not very good about marking its products, this ashtray is likely a later variation of the original Revere design. $55-70.

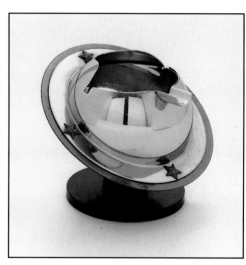

Unmarked polished chromium ashtray with black enameled rim and red enameled spherical handle, 6-1/2" d. $30-45.

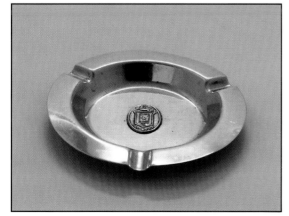

Polished copper ashtray, 6" d., marked "Rolls Royce Patent 1927," $75-100. Although this ashtray is not of exceptional design, it has a high value because it is also sought by automotive collectors.

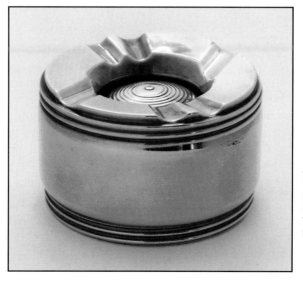

Chase polished copper "Sextette" ash receiver (No. 848), 3-9/16" d., 2-1/16" h. The Sextette was also available in polished nickel. $65-80.

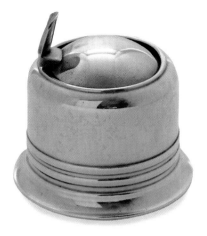

Park Sherman polished brass "Flip-Top" ash receiver stamped "Made of Chase Brass," 3-5/8" d., 3-1/2" h. Chase sold the same ashtray as the "Eclipse" (No. 809). $70-80.

Revere "Pick-Me-Up" ash tray (No. 712), polished chromium and black bakelite, 3" d., 3-1/4" h. Designed by W. Archibald Welden and introduced in the 1937 catalog, the ash receiver was also available in polished copper (No. 713). The catalog notes that "When you pick it up the valve head drops down carrying with it ashes or burning cigarettes and immediately extinguishing them." $50-65.

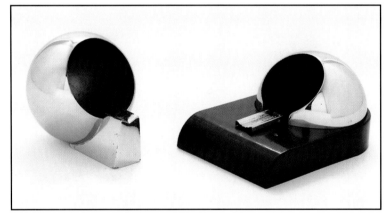

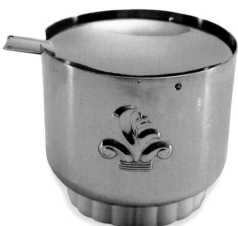

Chase "Flip-Top" ash receiver (No. 871) in polished chromium with a white bakelite base, 2-7/8" h., 3-1/4" d. Designed by Harry Laylon, the "Flip-Top" was also available in polished copper with a white base and English bronze with an English brown base. $90-110.

Above: Left: Manning-Bowman polished chromium "Gypsy" ashtray (No. 319) designed by Jay Ackerman, 3" d. sphere with chromium rest. The 1941 catalog notes "A masterpiece in modern metal art, the "Gypsy" is particularly entrancing...." Also available in polished chromium with a black bakelite cigarette rest. $50-65.
Right: Revere spherical chromium ashtray with black bakelite base, 5-1/2" x 3-1/2" x 2-1/2". The cigarette rest has a patented (No. 2,034,710, awarded March 24, 1936) spring-loaded mechanism to dump the ashes. $40-50.

Right: A design patent for the "Gypsy" ashtray was awarded to Jay Ackerman on January 21, 1936.

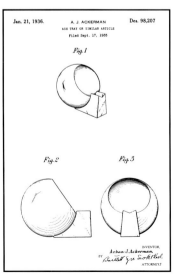

Jan. 21, 1936. A. J. ACKERMAN Des. 98,207
ASH TRAY OR SIMILAR ARTICLE
Filed Sept. 17, 1935

Fig. 1

Fig. 2 *Fig. 3*

INVENTOR.
Arban J. Ackerman
BY
ATTORNEYS

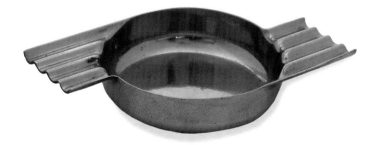

Revere polished copper "Streamline" ashtray (No. 635) designed by Leslie Beaton, 5-1/2" w. The Streamline, introduced in 1935, was also available in polished chromium (No. 7635). The 1935 catalog noted that the Streamline is an "...ash tray that is modern in design and conception and above all practicable." $75-90.

134

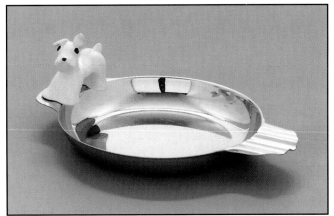

Manning-Bowman "Scottie" ash tray (No. 183/8), in polished chromium with white enameled dog, 5-1/4" d., 2-3/4" h. The 1934 catalog states "As pert and defiant as his prototype, the Scottie stands with legs braced and ears cocked attentively forward." Also available with a black enameled Scottie (No. 183/4). Selling for $1.75 in 1934, the current value is $40-50.

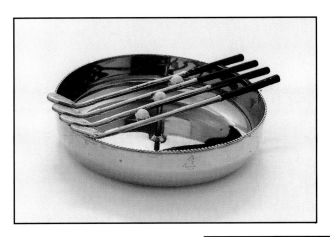

Above: Chase "Golfer's" ashtray (No. 890) of polished copper with polished chromium and black enameled clubs and white enameled golf balls, 4" d., 1" h. Designed by Howard Reichenbach, the ash tray was also available in polished copper and sold for $1.00 in 1941. $55-65.

Right: A design patent for the "Golfer's" ashtray was awarded to Howard Reichenbach on December 31, 1940.

Dec. 31, 1940. H. F. REICHENBACH Des. 124,409
 ASH RECEIVER
 Filed July 1, 1940

 Inventor
 Howard F. Reichenbach

 Attorneys

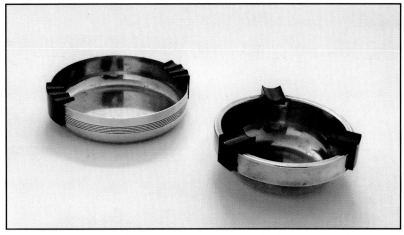

Two more of Chase's vast selection of ashtrays. Left: The "Utility" (No. 855), polished brass with brown bakelite rests, 5-5/8" d., 1-1/4" h. Designed by Harry Laylon, this ash tray was also available in English bronze with brown plastic rests, and polished chromium with either black or red rests. $35-45. Right: The "Delphic Ash Receiver" (No. 28008) in polished copper with black bakelite rests, 5-1/8" d., 1-7/8" h. Also available in polished chromium and black. $35-45.

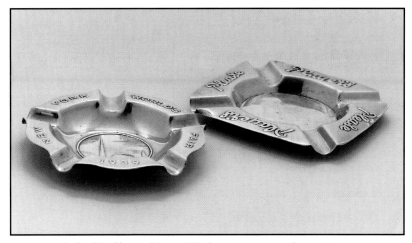

Left: Unmarked polished brass ashtray, 4-3/4" d., commemorating the 1939 New York World's Fair. Although both art deco and world's fair collectors seek this ashtray, it sold well and is easily found. $55-70. Right: "Player's Please" pub ashtray of polished brass stamped "Made in England," 4-5/8" x 4-5/8". $25-35.

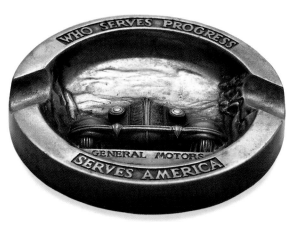

Bronze ashtray, 4" d., stamped "Designed and Produced by Ternstedt Div. General Motors Corp." The ashtray, sought by both art deco and automotive collectors, features a sculpted image of the 1937 Buick. $125-175.

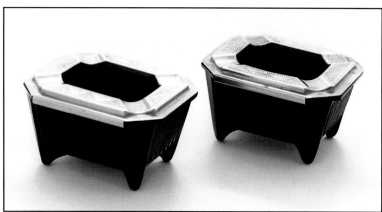

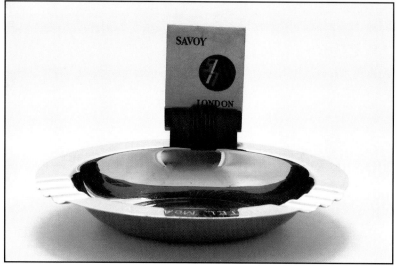

Chase "Match Holder Ash Tray" (No. 863) in polished chromium with black bakelite match holder, 5-7/8" d. This example is engraved "Hotel McAlpin." Also available in English bronze, it was sold for $.50 in 1937, but is now valued at $60-75.

Above: Chase "Slide-Top" ash trays (No. 804A), black glass base with combination polished nickel and polished brass top, 3-5/16" x 2-7/8" x 1-7/8". The "Slide-Top" was also available with a green glass bowl and polished brass top. The Slide-Top appears to be one of the Park Sherman smoking articles sold by Chase. A design patent was awarded to Jacob Sherman. A set of four originally sold for $.50 but the "Slide-Top" is now valued at $25-35 each.

Right: Design patent awarded to Jacob Sherman for what appears to be the Chase "Slide Top Ash Receiver." The patent was assigned to the Universal Lamp Company, predecessor of Park Sherman.

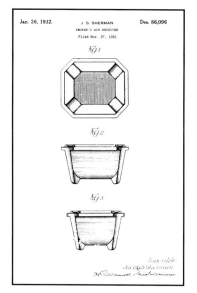

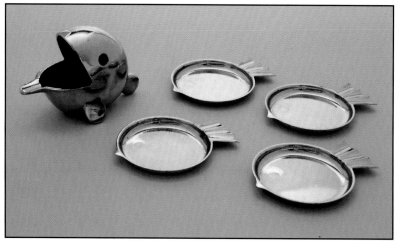

Something fishy. Left: Unmarked ashtray of polished nickel silver, 5" x 2-1/4" x 3-1/4", $35-45. Right: Set of four Manning-Bowman polished chromium stacking "Aquarium" ash trays, 4-1/4" l., 3-1/8" d. The 1936 catalog reads "Here are individual ash trays in the form of fishes with soulful little eyes and fan-like tails that serve as cigarette rests. Then, too, they make dandy coasters." $10-15 each.

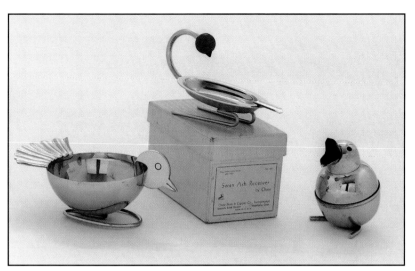

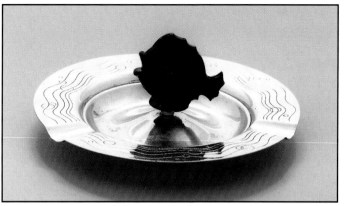

Chase "Snuffer" ash tray (No. 845) in polished chromium with black enameled fish, 6-1/2" d., 2-1/4" h. A cigarette is extinguished by placing it under the spring-loaded fish and pressing down. The edge of the tray has etchings representing ocean waves and air bubbles. $75-85.

Birds of a feather ash together. Left: Napier polished chromium bird whose body forms the receptacle and tail feathers serve as cigarette rests, 6" x 3-1/2" x 2-3/4". $25-35. Center: Mint-in-box Chase "Swan" ashtray, polished chromium with red enameled head. Designed by Walter von Nessen, it measures 5-1/2" x 2" x 3", and was also available with a black head. Initially selling for $1.00, the mint-in-box version is now valued at $100-125. Without the box, it is worth $65-80. Right: Napier polished chromium chick, 3-1/2" h., whose gaping mouth serves as the cigarette rest and whose cut out eyes allow smoke to escape. $40-55.

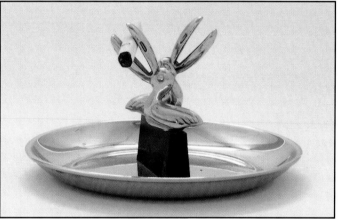

Pelican ashtray (6" d., 3-1/4" h.) in polished chromium and black plastic, designed in 1949 by Eric Wedemeyer. This and similar ashtrays with other animals were widely sold to commercial concerns and are frequently found engraved with company names, addresses, and telephone numbers. Because they were so widely distributed, they, like the Penguin™ ice bucket, have limited value, and should be available for $10-20.

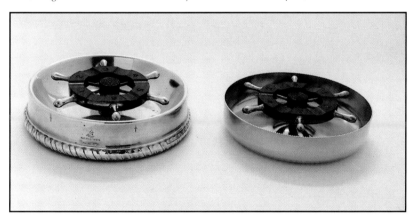

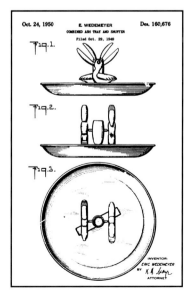

Above: Chase ship's wheel ashtrays designed by Howard Reichenbach in polished brass and brown bakelite. Left: The "Riviera" (No. 885), 6-1/4" d., 1-3/8" h. $40-50. Right: The "Whirligig" (No. 884), 5-1/2" d. This early example, marked "Pat. Appld. For," lacks the etched bands shown in the 1941 Chase catalog. $45-55

Right: A design patent for the "Riviera" ashtray was awarded to Howard Reichenbach on October 3, 1939.

A design patent for the pelican ashtray was awarded to Eric Wedemeyer on October 24, 1950.

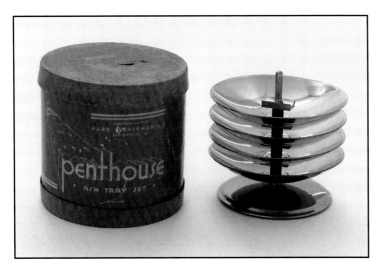

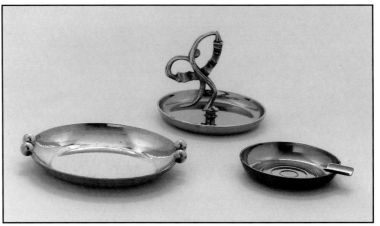

Three unmarked ashtrays of exceptional design. Left: Simple polished copper ashtray, 4-1/8" d., with rests formed of polished brass spheres. $30-45. Center: A polished chromium ashtray with stylized figure of a man playing a music box, 3-1/4" d., 2-1/2" h. $45-60. Right: An individual polished copper ashtray of simple design, adorned only by three concentric circles, 2-3/4" d. Although unmarked, the thickness of the copper indicates the exceptional quality of this ashtray. $25-30.

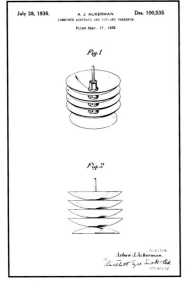

Above: Park Sherman mint-in-box "Penthouse™" ashtray set in polished brass, 4" d. x 3-1/2" h. Only the box is marked. The exceptional graphics on the box add significantly to the value of this set, which should sell for about $30-45 without the box but $75-90 with the box. In its 1936 catalog, Manning-Bowman shows a similar set, the "Smoke Tower" (No. 224). The Manning-Bowman set came in polished chromium and was 3" in diameter and 3-1/4" high.

Right: A design patent for the "Smoke Tower" awarded to Jay Ackerman on July 28, 1936.

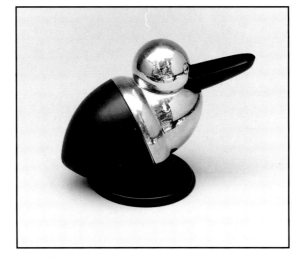

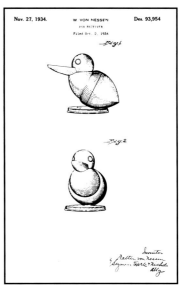

Chase "Pelican" Ash Receiver (No. 17050) in matte black enamel and polished chromium. The chromium plating is not original. An art deco dealer had the ashtray plated because the original enamel was badly worn. Designed by Walter von Nessen, the 1937 Chase catalog shows the following available finishes: black and white, black and yellow, and rose and gray. In one of the original finishes, the Pelican in mint condition should bring $200-250, but significant scratching or flaking of the enamel drops the value significantly. As pictured, the "Pelican" should have a value of about $150 unless the availability of an original Chase chromium finish can be documented.

A design patent for the Chase "Pelican" Ash Receiver was awarded to Walter von Nessen on November 27, 1934.

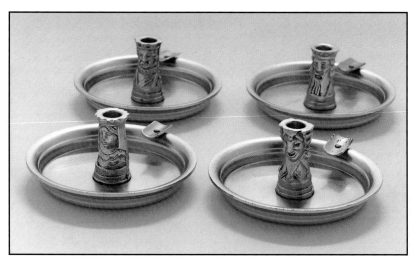

Kensington "Royal Family" aluminum alloy ashtrays with snuffers shaped as a king, queen, jack, and joker (Nos. 7612-A, B, C, D, respectively), 4-1/4" d., 2" h. $35-50 a set.

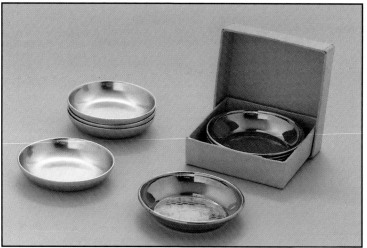

Left: Kensington aluminum alloy "Hostess" ashtrays (No. 7607), 2-5/8"d. $2-4 each. Right: Mint-in-box Chase "Individual Ash Trays" (No. 839), polished chromium with moderne etched design, 2-3/4" d., $50-65; without the box, $35-45.

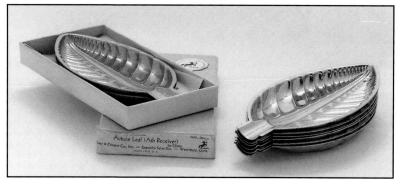

Chase "Autumn Leaf" ash receivers (No. 28009) in polished copper (left) and polished chromium (right), 5-7/8" l., 2-3/4" w. The boxed set of four, complete with National Recovery Act (NRA) emblem, should sell for $125-150. Individual ash receivers in either finish should bring $20-30.

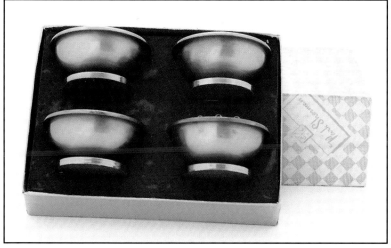

Mint-in-box set of four Park Sherman ash receivers in a combination of satin and polished brass, each 3" d. x 1-3/4" h. Because the box is decorative, it adds more to the value of this otherwise quite mundane design than would a plain white box such as those normally used by Chase. $50-65.

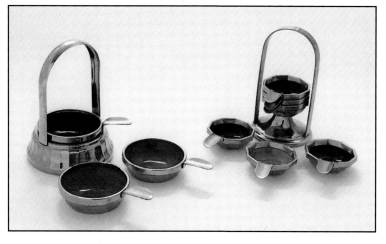

Two sets of stacking ashtrays with enameled bowls. Left: Unmarked set engraved "H. M. S. Scythia" consisting of a polished chromium stand and ashtrays with colorful enameled bowls, 3-1/2" d., 4-3/4" h. $50-65. Right: S. W. Farber Co., "Farberware," nickel silver stand with six stacking ashtrays with enameled bowls, 2-3/4" d., 4-1/2" h. $55-60.

139

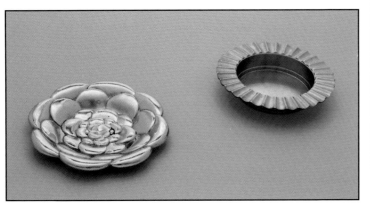

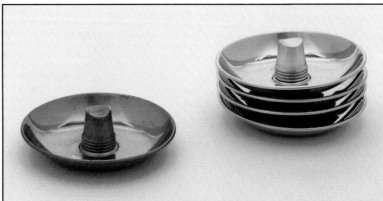

Left: Chase polished chromium "Summer Rose" Ash Receiver (No. 28010), 4-1/4" d. Also available in polished copper. $45-60. Right: Chase satin chromium "Fluted" ashtray (No. 17040), 4" d. Other available finishes were black nickel and English bronze. Originally sold as a set of four for $1.00. $15-25 each.

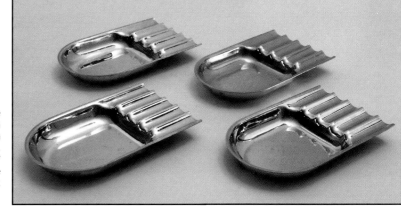

Set of four Chase polished chromium "Pentad" Ash Receivers (No. 840), 4" l., 2-1/2" w. $60-75 for the set of four.

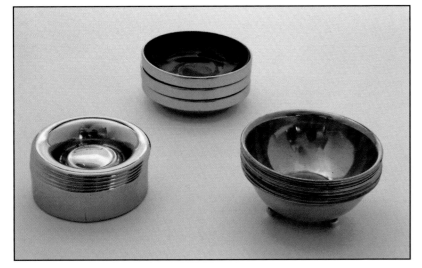

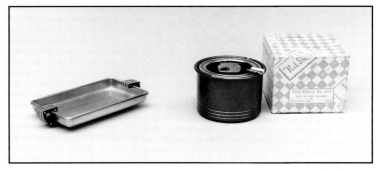

Three examples of Chase stacking ashtrays. Left: Polished chromium stacking ashtrays, 2-3/4" d. These appear to be part of the "Compact Cigarette Server" (No. 822) but do not have the engraving on the bottom of the trays described in the 1937 Chase catalog. Because they are still functional without the cigarette box, they have a value of $25-30. Center: Polished chromium "Bridged Ash Receivers" (No. 849), 3-3/8" d., missing the arched holder, 3-1/4" h. The ash receivers are lined with glass enameled black on the underside. The "Bridged Ash Receivers" are hard to find and have a reasonable value even without the stand and with the paint cracking under the glass. $25-30 as shown, $75-100 in mint condition with stand. Right: Polished copper "Stayright Set" (No. 302) of eight stacking ashtrays, 3-1/4" d. Only the bottom tray, which has spherical brass feet, is marked. The "Stayright Set" is among the Park Sherman smoking articles sold by Chase. $75-90.

Left: Revere "Quadrille" ashtray (No. 132) in satin chromium with ebony black bakelite handles into which are inserted bands of white metal, 5-3/4" x 3" x 7/8". The "Quadrille," designed by Norman Bel Geddes, was introduced in 1935. It was redesigned in 1937 and the bakelite handles were replaced with bronze handles like those used on the "Vestal" sauce bowl. The 1937 version was given a new catalog number (1132). $85-105. Right: Mint-in-box Park Sherman "Tip-It Ash Tray" (No. 1423), antique satin bronze base with amber glass bowl set in polished brass and red enamel frame, 2-1/2" h., 3-1/4" d. $40-50.

Smoking Stands

Examples of smoking stands designed by Wolfgang Hoffmann for the Howell Manufacturing Co., St. Charles, Illinois. These stands are made of a metallic base metal and are often found pitted or rusted. Such items have little resale value unless replated. Left: Polished chromium with black enameled tray and ash tube, 24" h. x 15-1/2" d. A quick push of the button dumps the ashes into the center tube which removes for emptying. The broad area around the ashtray accommodates drink glasses. $125-150. Right: A simple stand supported by three chromium rods, 24-1/2" h. x 8" d. $75-90.

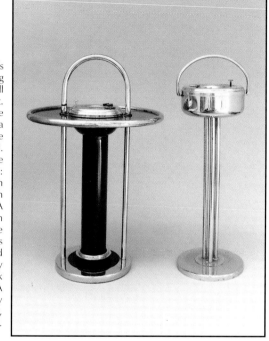

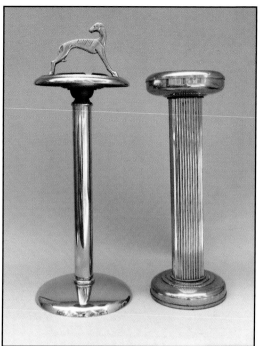

Left: Unmarked polished chromium (over metallic base metal) smoking stand with removable amber glass ashtray and a handle in the form of a dog, 28" h. $45-60.
Right: Polished copper smoking stand stamped "Greene of Racine," 23-1/4" h. x 8-1/2" d. $45-55.

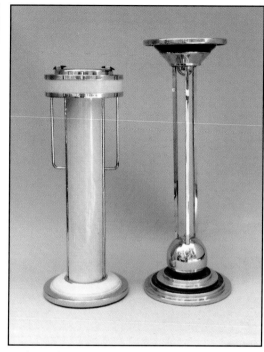

Left: Nagel-Chase "Ash Away" smoking stand of polished chromium and ivory enamel designed by Edward Schultz of Chicago, 21-1/2" h. x 8" d. at base. $70-85. Right: An exceptional moderne smoking stand of polished chromium with black enamel trim, 23" h. Unlike most smoking stands, the base metal is nonmetallic, indicating that this stand was probably made for home rather than commercial use. $150-200.

Right: Design patent 98,648 awarded to Wolfgang Hoffmann on February 18, 1936.

Center: Design patent 98,594 awarded to Wolfgang Hoffmann on February 18, 1936.

Far right: Design patent 105,810 awarded to Edward Schultz on April 14, 1937. Schultz assigned the patent to the Nagel-Chase Manufacturing Co. of Chicago.

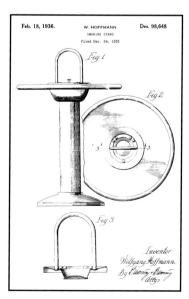

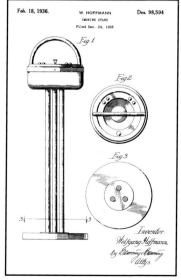

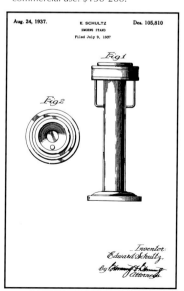

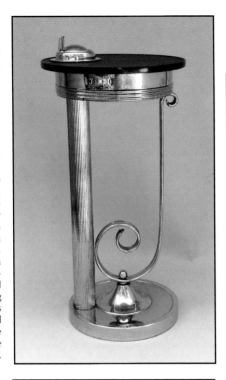

Chase "Lazy Boy" Smoker's Stand (No. 17031), designed by Walter von Nessen, 22" h., 14" d. The 1937 Chase catalog notes: "It has a roomy compartment for pipes, tobacco, cigars, cigarettes, and matches, which is easily accessible by sliding open the top which pivots around the ash tray. The special composition top is stainproof to insure a permanently neat and trim appearance." The "Lazy Boy" was available in polished chromium with a black (shown) or red top, English bronze with a matching top, or a combination of black and satin nickel with a black top. The swing out tray is prone to stress cracks and buyers should carefully examine the smoking stand before purchase. $450-600.

Cigarette Servers

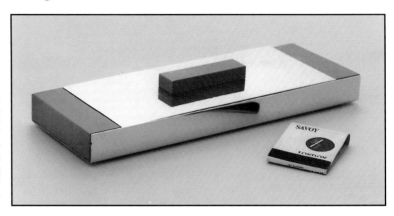

Chase polished chromium and bakelite "Piccadilly" cigarette box (No. 867), 8-3/4" l., 3" w. Designed by Harry Laylon, the Piccadilly was also available in polished copper. $75-90.

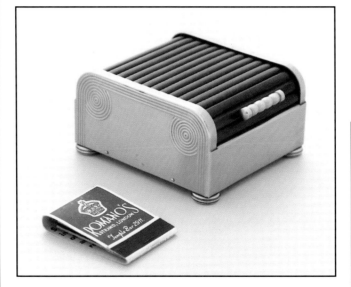

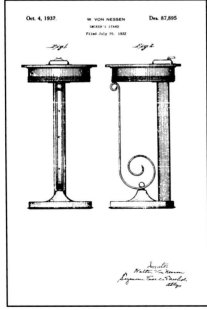

A design patent for the "Lazy Boy" smoker's stand was awarded to Walter von Nessen on October 4, 1932.

Above: Roll-top cigarette box stamped "Precision Made by Shanklin, Springfield, Illinois," 3-3/8" x 3-3/4" x 2". One of a series of roll top cigarette boxes patented by J. H. Horsley in 1935, it is finished in satin chromium with a black bakelite top. An excellent design, these boxes sold well, reducing somewhat their current values. The boxes are sometimes marked Park Sherman rather than Shanklin. Park Sherman bought Shanklin in 1932, but continued to used both trade names. $45-55.

Right: Design patent 98,000 issued to James H. Horsley on December 31, 1935.

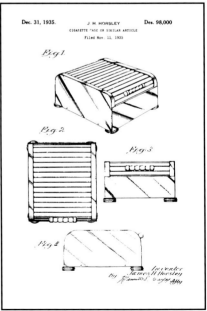

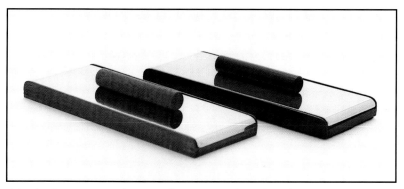

Manning-Bowman "Arsenal" cigarette boxes (No. 225/7), 8" l., 3-1/4" w. The 1934 catalog notes that the "Arsenal" "is a beautifully grained solid walnut cigarette box with a lustrous chromium plated cover surmounted by a convenient solid walnut knob." $65-75.

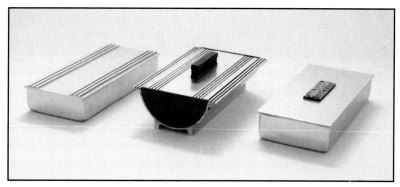

Three cigarette boxes by Kensington, all of aluminum alloy. Left: "Manor" (No. 7548), designed by William C. White, 9-3/8" l., 3-1/4" w. $35-45. Center: The walnut-trimmed "Penthouse" (No. 7542), designed by Lurelle Guild, 6-5/8" l., 4-1/8" w. $50-60. Right: The "Carolinian" (No. 7547), designed by Lurelle Guild, 7-3/8" l., 3-5/16" w. $40-50.

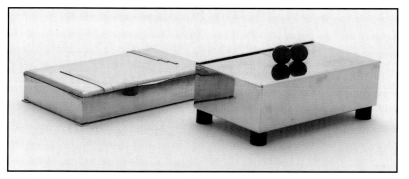

Left: Cigarette box of nickel silver and polished chromium, stamped "Made in Germany," 6-1/2" x 3-1/2" x 1". The interior is divided into two wood-lined sections. $60-70. Right: Sliding top cigarette box in polished chromium with red catalin knobs and feet, stamped "Foreign," 6" x 3-1/2" x 2-5/8". $55-60.

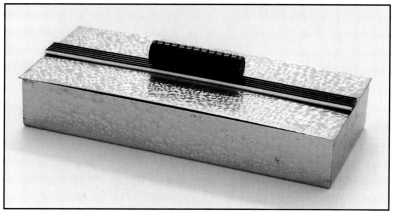

Marked Chase, "The Band Box" (No. 852) in a finish that appears to be Manning-Bowman's "Peacock Plate," 7-1/8" l., 3-1/8" w. Chase was never known to have a finish similar to Peacock Plate and this may be an experimental or prototype piece. "The Band Box" normally came in polished chromium with the grooves of the band in black, red, or ivory with a matching composition handle and in polished copper with white grooves and handles. $125-150. Because it is not known to be a production finish, the example shown might bring a significantly higher price at a well-attended auction of art deco items.

Chase "The Rollaround" cigarette box (No. 841) in satin nickel with a black plastic knob set on a blue disk. Designed by Gerth and Gerth, the box is lined in wood and mounted on four ball bearings so that it can be rolled across the table. $135-150.

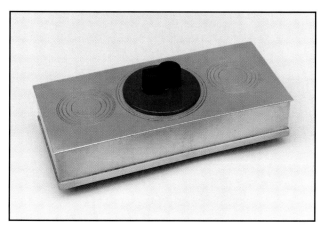

"Smoked" Turkey—Tobacco companies did not always hide the health effects of smoking. In the 1930s, their advertisements touted the beneficial effects of cigarettes. The R. J. Reynolds Tobacco Company described its idea of a perfect Thanksgiving Dinner in a 1936 ad for Camel™. The ad suggests smoking a Camel "for digestion's sake" after starting the meal with hot tomato soup. Moving on to the main course, the ad suggests a pause to smoke a Camel between helpings because "Camels ease tension. Speed up the flow of digestive fluids. Increase alkalinity. Help your digestion to run smoothly." Another Camel is recommended with the salad to "clear the palate." Having Camels with dessert adds a final touch of comfort and good cheer for "when digestion proceeds smoothly, you experience a sense of ease and well-being." Thanksgiving would not be complete without after-dinner Camels with coffee to make you feel "on top of the world."

Recycling, 1930s style. Hickok and other belt makers packaged their products in decorated boxes that could be reused as smart cigarette boxes. Left: Hickok belt box finished in satin nickel with an ivory enameled lid and black bakelite base, 3-5/8" x 3-5/8" x 1-3/4". $45-60. Center: Hickok bakelite belt box with gold enameled top, 5" x 3-1/2" x 1-3/4". $60-75. Right: Unmarked bakelite belt box with polished chromium lid, 3-5/8" x 3-5/8" x 1-3/8". $55-70.

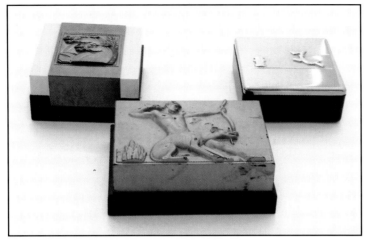

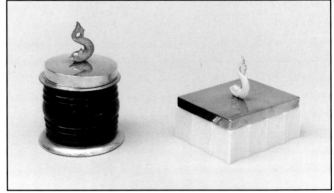

Two Chase cigarette boxes designed by Helen Bishop Dennis. Left: The "Brigantine" cigarette server (No. 887), 4-7/8" h., 3-1/2" d. The "Brigantine" came in polished brass with red (pictured) or green glass. The 1941 catalog suggests "Display this with the Chase nautical ashtrays, book-ends, and lamps, for one nautical item suggests another, and your sales can be increased." $60-70. Right: The "Dolphin Box" (No. 856) in polished copper with white bakelite base and white enameled dolphin, 3-3/4" x 3" x 1-5/8". The box was also available in polished chromium with red or black base and dolphin and satin brass with ivory-colored base and dolphin. $80-90.

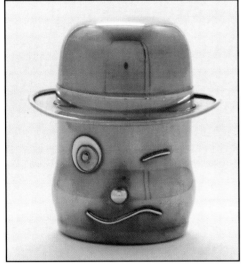

Stamped "Higgins California" polished copper humidor/cigarette box with brass facial features, 4-1/2" d., 4-1/2" h. $110-125.

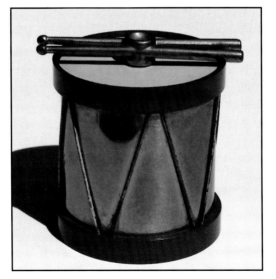

Chase "Drum" cigarette server (No. 894B) in polished brass and red plastic, 3-1/16" d., 3-3/8" h. The "Drum" was also available in polished chromium with red plastic and colored wire cord. $85-95.

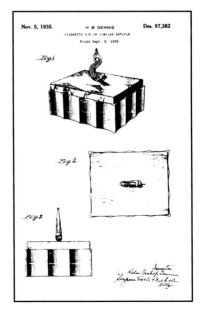

Design patent 97,382 issued to Helen Bishop Dennis on November 5, 1935, for the "Dolphin" cigarette box.

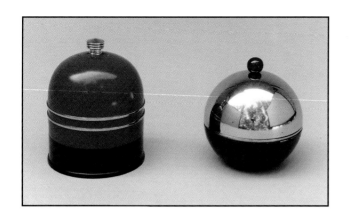

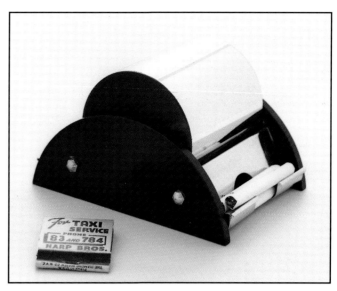

Cigarette dispenser of polished chromium and black bakelite stamped "Tallent" and "Made in England," 5-1/2" x 4" x 3-1/2". Cigarettes loaded in the chromium drum are dispensed onto the holders by rotating the drum in either direction. $90-110.

Above: Left: Unmarked cigarette container, red enamel with chromium rings and knob, 3-1/2" d., 4-1/2" h. The design of this container features a built in humidor patented by Solomon Shapiro. $50-65. Right: The Harry Laylon-designed Chase "Ball Cigarette Server" (No. 853) in polished chromium with a tortoise enamel base and catalin knob, 3-5/8" d., 3-3/4" h. The "Ball" also came with a polished chromium top, a red, black, or ivory enamel base, and a color coordinated knob. In addition, it was available with a polished copper top and white base and knob. $60-75.

Right: Drawing of U.S. patent issued to Solomon Shapiro on January 8, 1935, for a cigarette humidor. The patent is a mechanical rather than a design patent.

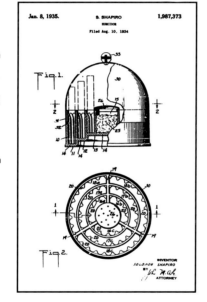

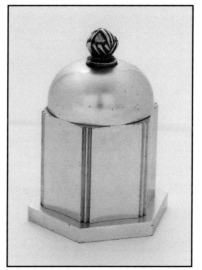

Kensington aluminum alloy "Hexagon" cigarette box (No. 7541), with brass knob, 4-3/4" h. Designed by Lurelle Guild (Patent D94,300, January 8, 1935). $50-60.

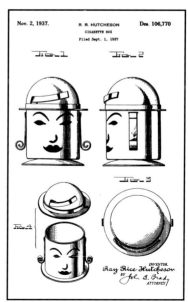

Example of a cigarette container designed by Ray Rice Hutcheson for the Everedy Company.

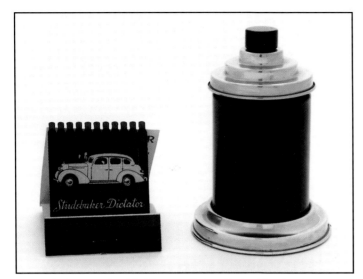

Unmarked cigarette humidor/dispenser designed by David W. Dunberg, polished chromium top and base with black bakelite body, 4-3/8" d., 6" h. There are many variations of this dispenser, most of which have floral or other designs, which decrease their value. This example is a good art deco design because of its simplicity and stepped top. $70-80.

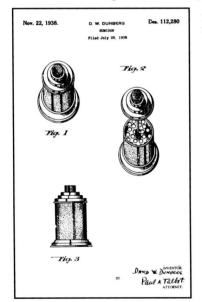

Left: Design patent for a cigarette humidor issued to David W. Dunberg November 22, 1938.

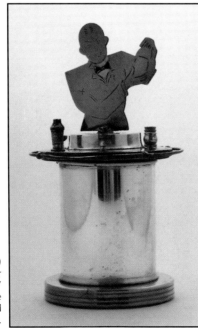

Unmarked (bought in England) silver-plate and brass bartender cigarette dispenser, 7-3/4" h., 5" d. Works on the same principle as the Dunberg-designed dispenser. $600-700.

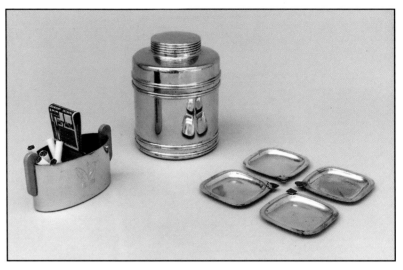

Left: Chase polished chromium and white bakelite "Oval Cigarette Holder" (No. 17073), 4-1/2" x 1-7/8" x 2-1/8". It has two compartments separated by a holder for book matches. $65-80. Center: Polished chromium "Rumidor™" humidor, 5-1/2" h., 4-1/4" d. $25-35. Right: Napier silver-plated bridge ashtrays with red and black enameled suits, 2-3/4" sq. $55-70.

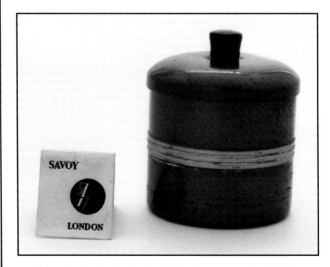

"Duk-It" cigarette box by McDonald Products Corporation, Buffalo, New York, antique bronze with polished bronze ribbing around the middle and a translucent plastic knob, 3-3/4" h. $30-40.

Left: Park Sherman polished brass cigarette dispenser, 6-1/2" h., 3-1/8" d. $45-55. Center: Revere "Miniature Wood Basket" (No. 169) cigarette server, solid bronze with polished brass hoops, 3-1/4" l., 2-5/8" w., 3" h. Introduced in the 1937 catalog, this cigarette server is a miniature version of the Fireside Wood Basket (No. 7055), designed by Leslie Beaton. $25-35.Right: West Bend cigarette container, polished copper with polished brass base and knob, 3-1/2" deep, 2-3/4" w., 3-3/4" h. $35-40.

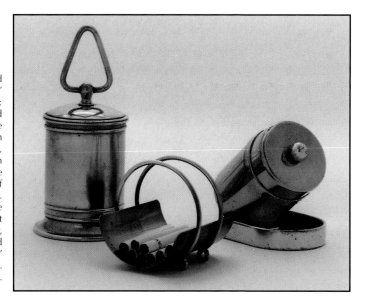

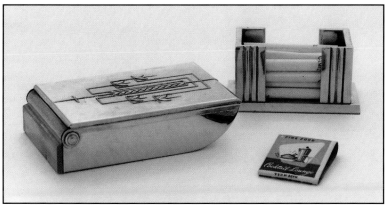

Left: Chase polished chromium and white bakelite "Cosmopolitan" cigarette box (No. 17075), 4-7/8" x 3-1/8" x 1-5/16". The hinged cover of this box, which was also available in polished copper, has a moderne stamped design. $65-80. Right: Chase polished chromium "Smokestack" cigarette holder (No. 831), 3-3/4" x 2-1/4" x 2". Perfect for business cards! The other finishes, English bronze, polished copper, and black nickel are harder to find. $75-85.

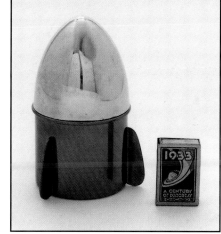

Chase "Bubble Cigarette Servers" (No. 860), left: 2-1/4" h., right: 2-3/8" h. Available in polished chromium with a blue "chromatic" base and polished copper with a white base. Although the catalog dimensions never changed, the chromium server shown is slightly shorter and has a wider opening, giving it a distinctly different appearance. $40-50. Because the wider opening is rare, it is likely to command a slightly higher price among advanced collectors.

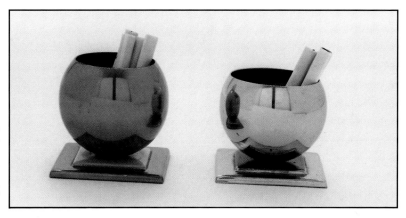

Left: Bronze rocket ship cigarette box with chromium top, stamped "W-B Mfg. Co." (No. 178), 4-1/2" h. The glass insert bears the Anchor Hocking trademark. $55-65. Right: Souvenir matchbox holder with etched design from the 1933 Chicago "A Century of Progress" World's Fair, polished brass and brown, 1-5/8" x 1-1/8" x 1/2". The overlap between art deco collectors and collectors of world's fair memorabilia makes such items sought after. $30-40

Humidors/Pipes

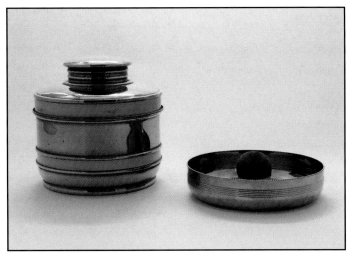

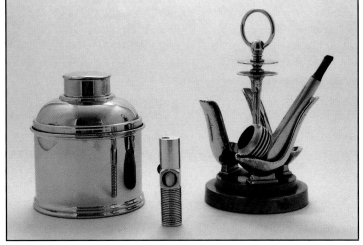

Above: Left: Chase polished coppe and white enamel "Tobacco Humidor" (No. 857), 6" h. x 5-1/2" d. The humidor appears to have been designed by Jacob S. Sherman. At the time the design patent was awarded, Sherman was president of the Universal Lamp Co., Chicago, the predecessor of Park Sherman. Other finishes include polished chromium with black bands and English bronze. $65-80. Right: Chase polished chromium "Pipe Smokers' Ash Tray" (No. 865), 5-1/2" d. Other finishes included polished copper and English bronze. $55-70.

Right: Design patent for a tobacco humidor awarded to Jacob S. Sherman, president of the Universal Lamp Company of Chicago, on September 16, 1930.

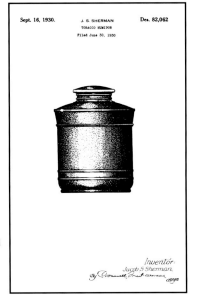

Above: Left: Revere polished chromium "Humidor for Cigarettes" (No. 7461-P), 5" h. x 4-1/2" d. $45-60. Center: The polished aluminum "Nimrod Pipeliter™" produced by the Ward-Nimrod Company of Cincinnati, Ohio, during the late 1940s, 3-1/8" h. $30-40. Right: Unmarked pipe rack with solid copper base and polished chromium handle and pipe rests, 7-1/4" h. x 4-1/4" d. $110-125. Sitting in the pipe rack is an unmarked polished aluminum pipe with wooden bowl. $45-60.

Right: Mechanical patent awarded to Ashley F. Ward for the Nimrod Pipeliter.

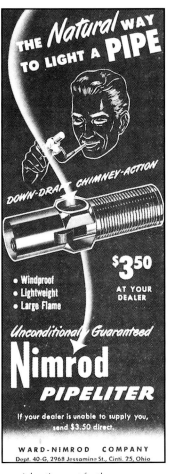

Advertisement for the "Nimrod Pipeliter."

Lighters and Match Holders

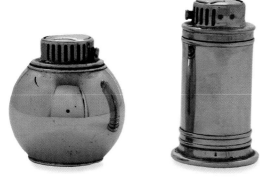

Chase polished chromium table lighters credited to John W. Schulze. It is not clear whether Schulze designed the mechanics of the lighters or the cases, or both. Left: "Fire Ball Lighter" (No. 851), 2-3/8" d. The lighter was also available with black or tortoise enamel. $65-80. Right: "Automatic Table Lighter" (No. 825), 3-1/4" h. $55-70.

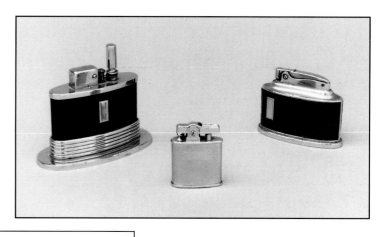

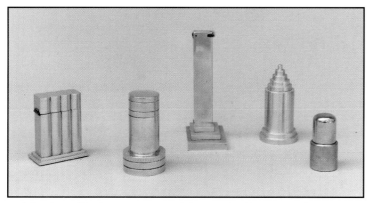

A skyline formed by skyscraper cigarette lighters. Left: White metal table lighter by Branston Co., Inc., New York, New York, 2-1/2" x 1-1/2" x 3-1/8". $40-55. Second from left: Polished chromium "Paxton" cigarette lighter produced by the Mitchell Co., Omaha, Nebraska, 2-1/2" h. The only decoration on this simple lighter is the use of embossed bands. $35-50. Center: An unmarked white metal skyscraper lighter with offset stepped base, 5-3/4" h. $45-60. Second from right: The ultimate skyscraper design in white metal with a stepped base and top, unmarked, 4" h. $55-70. Far right: unmarked polished chromium lighter with removable top that hides the mechanism, 3-3/4" h. Embossed bands around the sides add to the sleekness. $45-60.

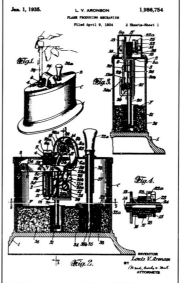

Above: A trio of Ronson™ lighters produced by the Art Metal Works, Newark, New Jersey. Left: A polished chromium and black enamel "Touch Tip™" table lighter, 3-5/8" h. The mechanism which enables the "torch" to be lit by pulling it out of the container was invented by Louis V. Aronson. $95-125. Center: The "Triumph," 2-1/8" h. $45-60. Right: The polished chromium and leather "Senator" table lighter from the late 1940s/early 1950s. $55-70.

Left: Mechanical patent awarded to Louis V. Aronson, January 1, 1935, for invention of the "Touch Tip" lighter.

Below: Left: Unmarked ashtray of black bakelite and polished chromium, 6" x 4-1/2". Although unmarked, the quality and exceptional design of this ashtray add to its value. $55-75. Right: Pewter matchbox holder stamped "Pairpoint" and "No. P4992," 2-1/4" x 1-1/2" x 2-3/8". $90-125.

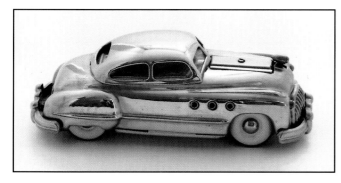

Postwar Buick polished chromium cigarette lighter made in occupied Japan. The lighter is stamped "Freedom." Pulling the hood ornament opens the lighter. The car has a friction motor. Because it crosses over multiple types of collectibles—occupied Japan, tobacciana, automotive, and art deco—the lighter commands a high price. $300-400.

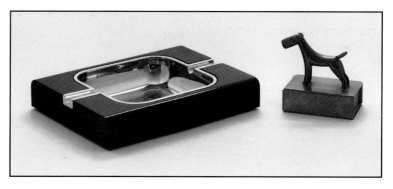

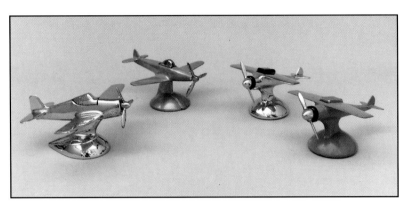

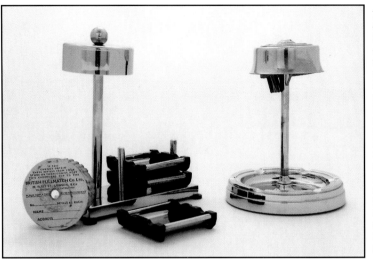

Two examples of Pullmatch™ dispensers. Pullmatch ads indicate that Lurelle Guild designed their products, but I was unable to identify design patents for the pictured examples. The mechanical patent for the pullmatch package and holder was awarded to Oskar Koehler on September 10, 1935. Left: Polished chromium and black bakelite match dispenser and stacking ashtrays by the British Pullmatch Co., 6-1/2" x 7-1/8" x 3-1/4". $95-115. Right: Polished chromium ashtray and match dispenser by the American Pullmatch Corporation, Piqua, Ohio, 7-1/2" h., 5-5/8" d. $75-90.

Fueled and ready for take off. Airplane lighters were popular from the 1930s through the 1950s. Left: Unmarked polished chromium airplane lighter, 7-1/4" wingspan, 3-3/4" h. $105-130. Second from left: Polished nickel lighter with copper propeller and cockpit produced by Negbaur, New York, New York, 6-1/2" x 6-1/4" x 4". $105-130. Second from right: Polished chromium and black enamel lighter marked "A Hamilton Product," 5" wingspan, 3" h. Planes made by Hamilton are often unmarked. The Hamilton lighter is by far the most common of the airplane lighters and therefore has the lowest value. $75-90. Right: A variation of the Hamilton lighter finished in greenish-gray enamel and polished chromium. $90-115. Condition is especially important in setting values for airplane lighters; they frequently have broken or missing propellers or cockpits and heavy corrosion of their metallic base metal. Lighters with missing parts or heavy corrosion have minimal value. $20-30.

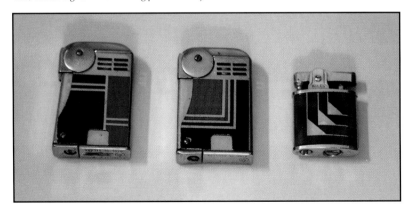

Pocket cigarette lighters. Left: Two variations of enameled lighters stamped "Made in Austria," 2-3/8" h. $55-60. Right: Polished chromium and enamel "Wales" cigarette lighter marked "Japan," 1-5/8" h. $20-30.

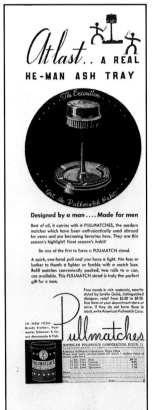

Advertisement for Pullmatch ashtrays. The ad notes that the four stands were "styled by Lurelle Guild, distinguished designer." (*Esquire*, December 1936)

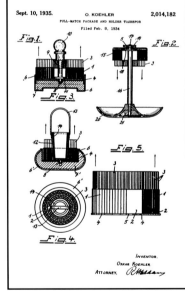

Oskar Koehler was awarded a mechanical patent for design of the pullmatch package and holder.

Chapter 14
Lighting

The garish colored glass of 1910 is still with us. Pink roses with polychrome gold leaves still disfigure some commercial lighting fixtures. Many a wall bracket that started out to be a simple design ends up daubed with gilt and chocolate paint with pink and green glass inserts. It is a fair criticism to say that at least among low-priced fixtures the lack of good taste is apparent to all. In fact the intelligent man who goes to buy moderately priced fixtures of good design for his living room is hard put to find them. In this statement every architect and decorator will agree. (F. S. Chase, 1934)

The President of Chase Brass & Copper wrote the above words in introducing Chase's new 1934 line of lighting fixtures featuring designs by Lurelle Guild. He expressed similar, but more reserved criticism, in the companion catalog introducing Chase Lamps, also featuring designs by Lurelle Guild. Unlike the giftware line, which was predominantly modern, the Chase lamps and lighting fixtures catalogs gave customers six or more period collections from which to choose. Lamps were divided into Early American, Georgian, Federal, Empire, Classic Modern, and American Adaptations collections. An additional collection—Early English—was available in the fixtures catalog. The "American Adaptations" collections consisted of lamps and lighting fixtures designed by other designers, excluding Guild, such as the Gerth and Gerth-designed "Glow Lamp."

Although Chase was the only one of the four major giftware manufacturers to market a line of lamps and lighting fixtures, there were many other companies producing lamps in the art deco style. Unfortunately, most lamps and lighting fixtures are unmarked, making identification of manufacturers very difficult.

Table Lamps

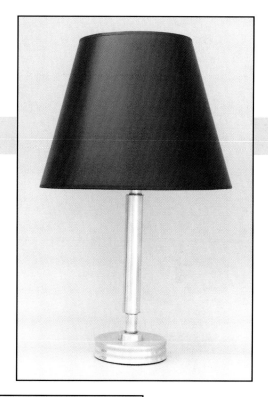

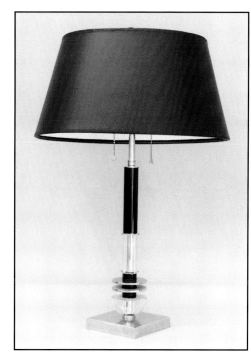

Polished chromium, black lacquer, and clear glass table lamp stamped "MSLC" and "3732," 22" h. The exceptional moderne design of this lamp adds to its value. $250-325.

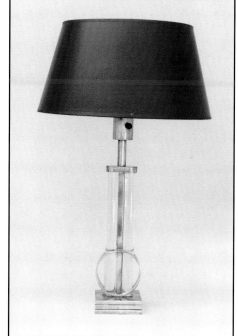

Above: Unmarked white metal table lamp with fluted base, 25" h. $80-110.

Left: Unmarked polished copper table lamp, 24" h., with clear glass rods. Although both the maker and designer are unknown, the exceptional style and quality of this lamp are readily apparent. $175-225.

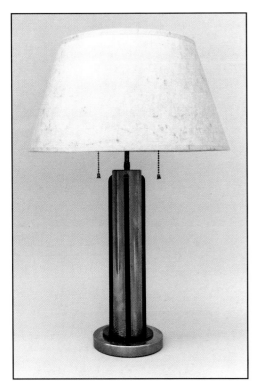

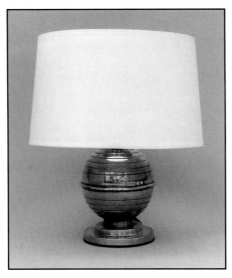

Chase "Ball Table Lamp" designed by Gerth and Gerth, 15" h. In addition to the brass and copper version pictured, the lamp was available in polished chromium. The heavy weight and fine finish on the Ball lamp is quite a contrast to the light weight, cheap looking former Steele and Johnson lamps included in the 1940 Chase catalog. This lamp reflects Chase at its best. $300-350.

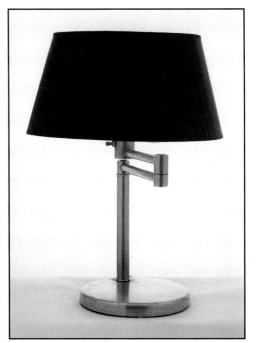

Marked "Nessen Studio, New York," swing arm lamp, 16" h. This is the most famous of the von Nessen designs and versions of this lamp are still being manufactured, reducing the value of the originals. $200-300.

Unmarked table lamp believed to be the "Ambassador" (No. 6300) included in the 1940 Chase catalog. It is the same height as the "Ambassador," 23-1/2", and the same "coppertone" finish with tortoise shell plastic trim. $135-160.

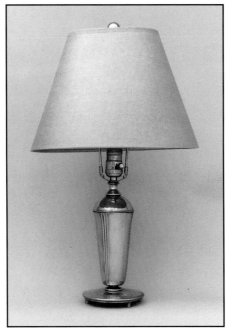

Chase amber bronze "Parthenon" Lamp (No. 6318), 18-1/4" h. The original lamp, which was also available in white enamel with polished brass trim, had a pleated clair-de-lune shade. $75-90.

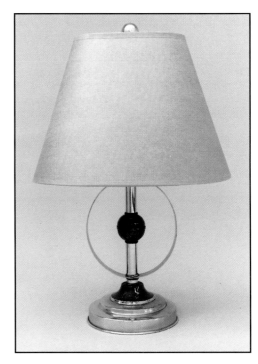

Unmarked table lamp finished in polished chromium and antique bronze enamel, 18" h. $125-175.

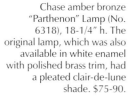

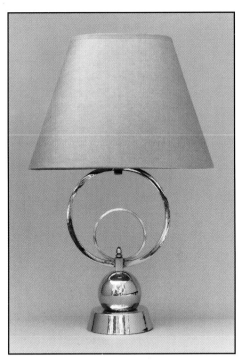

Unmarked polished chromium lamp of exceptional design, 18"h. $225-275.

Desk, Dresser, and Accent Lamps

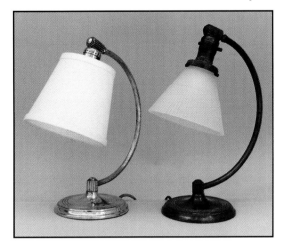

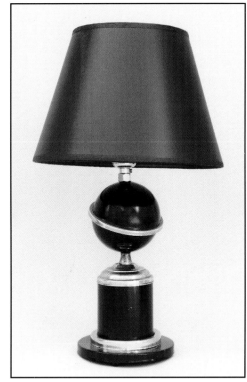

Far left: Chase "The Desk Lamp" (No. 01003) in English bronze (right) and polished chromium (left), 14-1/2" h. Although Chase catalogs only list this lamp with a parchment shade, I have seen many of the lamps fitted with glass shades like the one on the right. The lamp was one of Chase's best sellers and is easy to find, reducing its current value. $65-80.

Left: Unmarked "Saturn" lamp of polished chromium and black enamel, 16" h. Although an attractive design, this lamp is made of a metallic base metal and lacks the overall quality needed to command a premium price. $40-55.

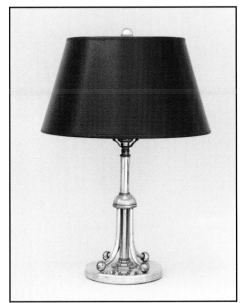

Unmarked table lamp of polished chromium and copper, 17-1/2" h. $150-200.

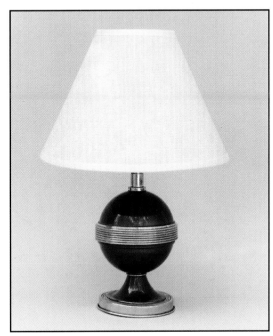

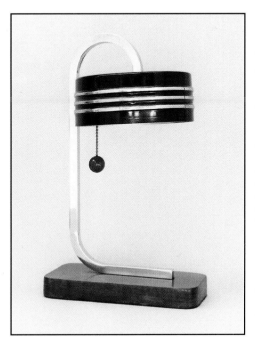

Far left: Occasional Lamp, 13-3/4" h., marked with the Steele and Johnson diamond trademark. After Chase acquired Steele and Johnson, this lamp was included in the 1940 Chase catalog as the "Westbrook" (No. 6146). The Chase catalog calls it "an inexpensive lamp with smart lines." In my opinion, this lamp looks and feels too "inexpensive" with its painted on antique bronze finish and paper thin brass base. $45-55.

Left: Unmarked desk lamp of exceptional design, in walnut, polished chromium, black enamel, and red catalin, 14-1/2" h. $135-160.

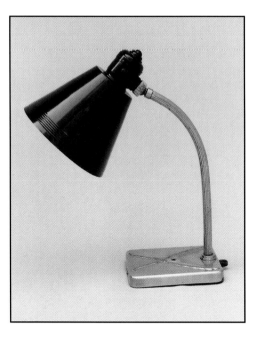

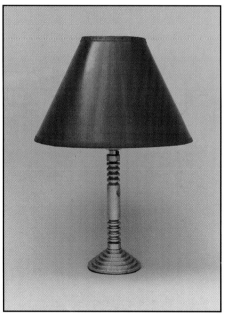

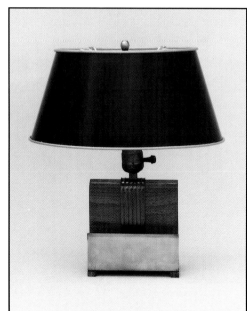

Far left: Chase "Quill Lamp" (No. 01011), satin nickel with black enameled shade, 10" h. $85-115.

Center left: Unmarked dresser lamp with white metal stem and polished chromium step-down base, 14" h. $50-65.

Left: Chase "Writing Paper Lamp" (No. 01014) of English bronze and walnut, 13" h. The original shade was ivory parchment decorated with crossed quills, 4-3/4" x 10-1/2" x 6". $110-130.

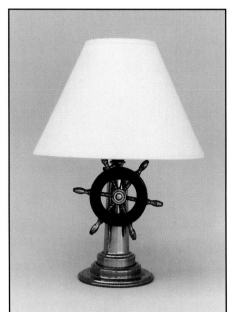

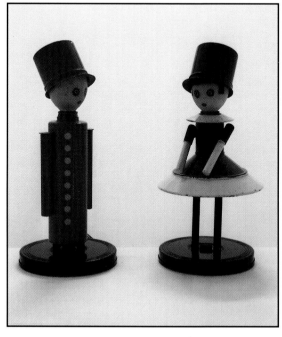

Chase polished brass "Wheel" lamp (No. 6305), 16-1/4" h. Rotating the bakelite wheel turns the lamp on and off. The original shade had a full color picture of a sailboat. $85-115.

Above: Unmarked "Saturn" lamps, black enamel and polished chromium base with frosted glass globe, 7" h., 7-3/8" d. shade. $350-450.

Right: Lurelle Guild-designed Chase "Colonel Light" (No. 27013) and "Colonel's Lady Light" (No. 27014), 9-3/8" h. In addition to the combination of red and white enamel shown, the Colonel was available in combinations of green and white and red and white. His lady was available in green and white in addition to the pictured blue and white. All color combinations came with black enameled bases. The face is painted on a frosted light bulb and the hat forms a tilting shade. The right arm of the lady has been repaired, decreasing the value. $125-150 each.

Right: Chase polished brass "Sentinel Lamp" (No. 17112) with original shade, 15-7/8" h. In addition to red plastic with a black cap, the lamp was available with a blue plastic body. With the original shade, the lamp has a value of $350-450. Without the shade, the value drops to $175-250.

Center right: This decorative satin brass lamp is unmarked, but appears in the 1940 Chase catalog as the "Winthrop" (No. 6155), 11" h. The original lamp had a 5" rectangular parchment shade. It is not clear whether this lamp was made by Chase or by Steele and Johnson before it was acquired by Chase. $75-90.

Far right: Marked Steele and Johnson lamp finished in coppertone with white (now yellow) trim, 13" h. with the shade. This lamp appears in the 1940 Chase catalog as the "Sutton" (No. 6176) and was also available with rose and green trim. The original shade on the Chase version was covered with ribbed silk. This is one of the more attractive and higher quality lamps produced by Steele and Johnson. $85-100.

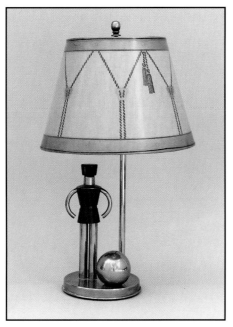

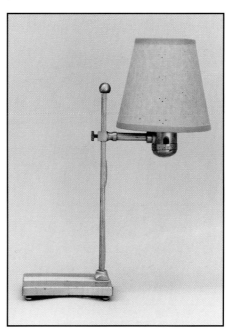

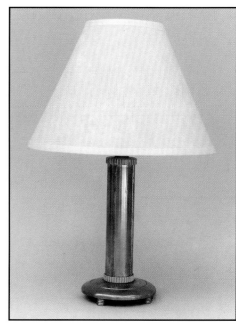

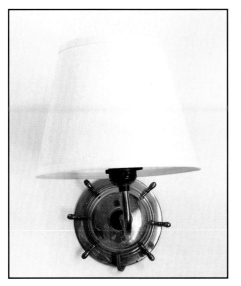

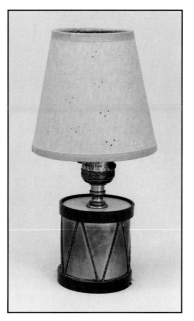

Far left: Unmarked polished brass nautical wall lamp, extending 7-1/2" from the wall. $35-45.

Center left: Stamped "Westinghouse Odorout Lamp Fixture" (No. 1595), manufactured by the Handy-Hannah Company, Whitman, Massachusetts. Made of polished copper and white metal, this fixture appears to be an early attempt to eliminate odors through the use of ultraviolet radiation. The owner is cautioned to "HANG ABOVE EYE LEVEL" and "Protect eyes and plants from direct ultra violet rays." $20-30.

Left: Chase polished brass and red plastic "Drum" occasional lamp (No. 6324), 10" h. The lamp originally came with a parchment shade, 7" d. $125-150.

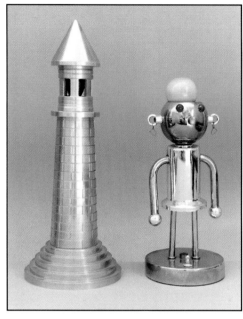

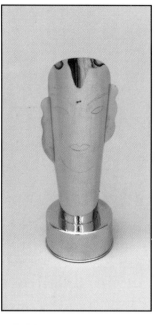

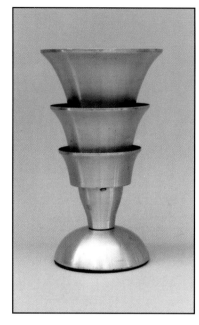

Far left: Left: Unmarked lighthouse lamp of unidentified white metal (nonmetallic), 15-1/2" h. This lamp has a great step-down base. $125-150. Right: Polished chromium "Robot" Lamp (No. E-53565) by Torino Lamps, 12" h., marked patent pending. The date of manufacture of this lamp is uncertain, but it is probably 1950s. $125-155.

Center left: Revere polished chromium "Masque" occasional lamp (No. 126) designed by Helen Dryden. 10" h. $175-250.

Left: Decorative lamp marked "H. Karish, Los Angeles, California," 10" h. Made of brushed aluminum, the inside of the cones are painted red and green. $80-120.

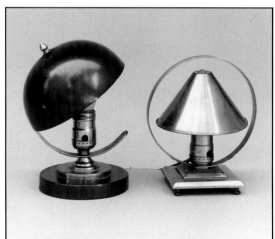

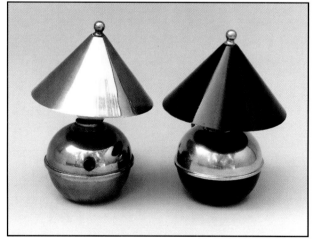

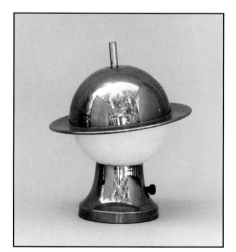

Left: Unmarked accent lamp with English bronze finished shade and base and polished chromium trim. All parts of this lamp, 8-1/2" h., are metallic, decreasing its value. $25-35. Right: Unmarked accent lamp of satin copper and brass, 6-1/2" x 4-1/4" x 7-1/2". $35-55.

Chase "Glow" lamps (No. 01001) designed by Gerth and Gerth, 8-1/4" h. One of the more popular Chase designs, the Glow lamps were included in Chase catalogs from 1933 through 1941. In addition to the polished copper and polished chromium and black versions shown, the Glow lamp was available in polished copper and white. Because they sold so well, these lamps are still readily available. $55-75.

Chase polished copper "Constellation" lamp (No. 17048), 8-1/2" h. The Constellation, designed by Walter von Nessen, was also available in polished chromium and English bronze. $250-300.

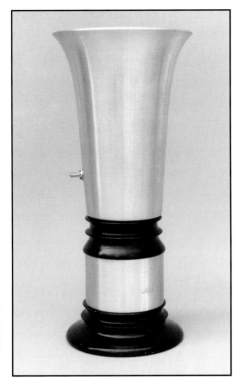

Unmarked torch lamp of spun aluminum with black enameled wood base, 14-3/4" h. $155-200.

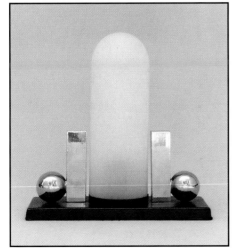

Unmarked accent lamp of polished chromium and matte black enamel with a frosted glass shade, 9" l. x 3-1/4" w. x 8-3/4" h. $225-300.

Dual-Purpose Lamps

In the late 1930s, Chase designed a series of "dual-purpose" lamps that could be used on either a table or the wall. At least a dozen different styles were offered, of which three are illustrated below.

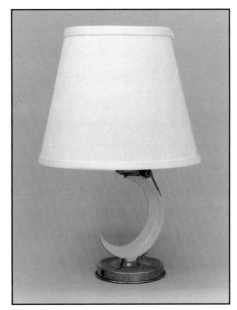

Chase satin brass "Crescent" dual-purpose lamp (No. 6156) with white plastic crescent moon, 11-1/2" h. The original parchment shade would have been decorated with star clusters. $75-90.

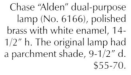

Chase "Alden" dual-purpose lamp (No. 6166), polished brass with white enamel, 14-1/2" h. The original lamp had a parchment shade, 9-1/2" d. $55-70.

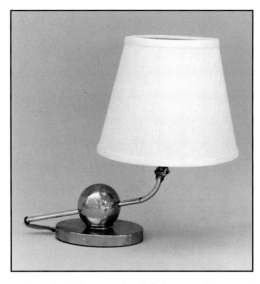

Chase polished brass "Lexicon" dual-purpose lamp (No. 6322), 11-5/8" h. The original shade was decorated parchment, 7-3/4" d. The diagonal bracket of the lamp adjusts by pushing it thorough the ball on the base. $65-80.

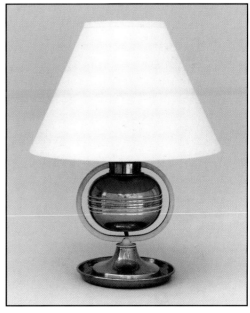

Floor Lamps

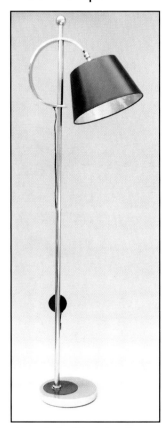

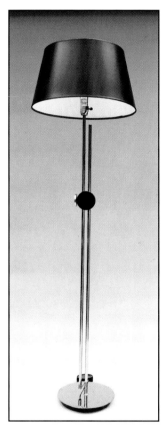

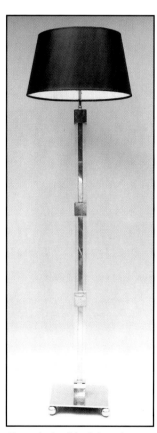

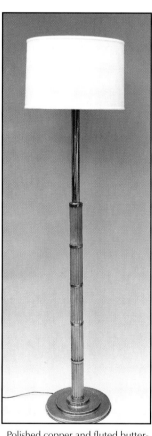

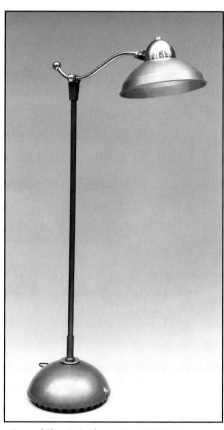

Unmarked polished chromium floor lamp, 63" h. The height of the lamp adjusts by sliding the arc up and down the stationary shaft. The use of an off-center black bakelite disc on the base adds to the moderne design. $350-450.

Unmarked polished chromium floor lamp of exceptional design. The height of the lamp adjusts by sliding the rod through the black enameled disk and then locking it in place by tightening the chromium disk. The height adjusts from 57" to 84". $375-475.

Unmarked polished chromium floor lamp with translucent plastic tubes, 54" h. This lamp is hard to date and may have been produced anywhere from the late 1930s to the 1950s. $115-145.

Polished copper and fluted butterscotch catalin floor lamp believed to be British, 60" h. $350-450.

General Electric Sunlamp (No. 4170417-1, Style No. LM4), 51" h. $75-90.

Flashlights and Battery-Operated Candles

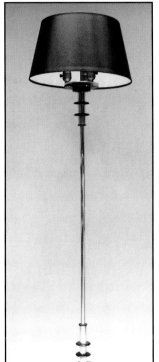

Unmarked polished chromium floor lamp with decorative black enameled discs near the top and bottom, 56" h. $195-245.

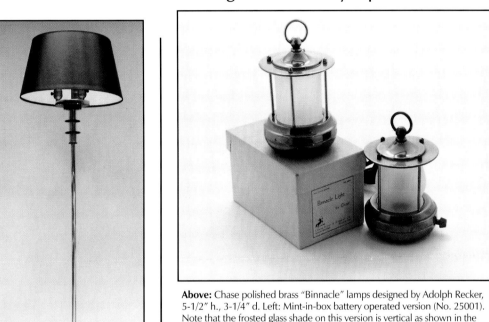

Above: Chase polished brass "Binnacle" lamps designed by Adolph Recker, 5-1/2" h., 3-1/4" d. Left: Mint-in-box battery operated version (No. 25001). Note that the frosted glass shade on this version is vertical as shown in the 1937 Chase catalog. Right: Wired version (No. 25002) with more traditional hurricane shaped shade. The "Binnacle" light has also been found with a shade decorated with scenes from the 1933 Chicago "A Century of Progress" World's Fair. Not pictured: I recently purchased a battery-operated Binnacle lamp marked "Bond" and "Made in USA" rather than Chase. It bears the same design patent number as the Chase version. I believe Chase may have designed and manufactured the lamp for Bond before adding it to the Chase catalog. Binnacle lights sold well and can be found fairly easily. Without the box, they should sell for $35-45. Mint-in-box versions should bring $50-65, with the World's Fair edition being the most desirable because it is sought by both Chase and world's fair collectors.

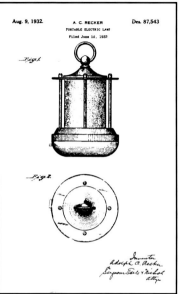

A design patent for the "Binnacle" lamp was awarded to Adolph C. Recker on August 9, 1932.

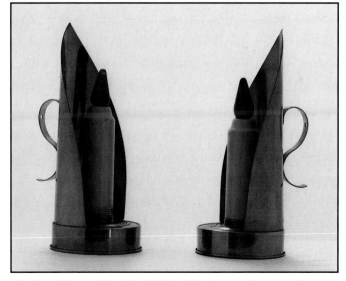

The Chase "Sconce" light (No. 16004), polished brass and copper with a white candle, 7-7/8" h. Wired (No. 16005) and candle (No. 16003) versions were also available. The "Sconce" candles were added to the Chase line after 1938. $35-50.

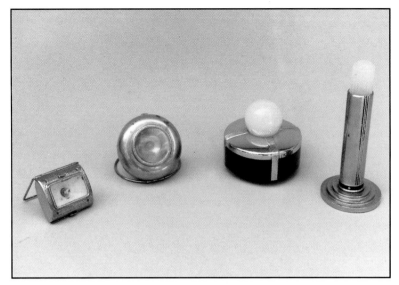

The two flashlights on the left were designed for Chase by August Mitchell. Far left: The "Airalite" (No. 22003) finished in polished nickel with green enamel inlays, 2-1/2" l. x 2" w. $55-70. Second from left: The polished nickel "Bomb" (No. 22001), 3-1/2" d. x 1-3/4" thick. $50-65. Second from right: the Eveready™ (Union Carbide) "Masterlite" flashlight of polished chromium and black enamel, 3-3/4 d, 3-1/2" h. It works both as a flashlight and as a nightlight. $55-70. Far right: Eveready battery-operated candle of satin nickel, 6-1/2" h. Both the base and top of the plastic lens utilize the popular stepped motif. $55-70.

Light Fixtures

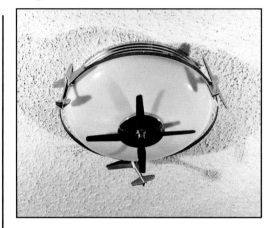

Ceiling fixture by Moe Brothers, Chicago, Illinois, 11" d. Three chromium-plated airplanes circle the white glass globe on a red enameled band. A chromium propeller spins below the globe and the base is fluted chromium. $300-400.

Right: A design patent for the "Airalite" was awarded to August Mitchell on May 23, 1933.

Far right: Design patent for a flashlight awarded to Herman G. Graubner. The patent was assigned to the Union Carbide and Carbon Corporation.

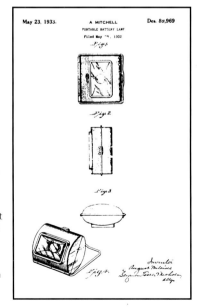

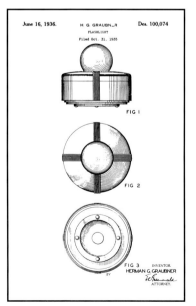

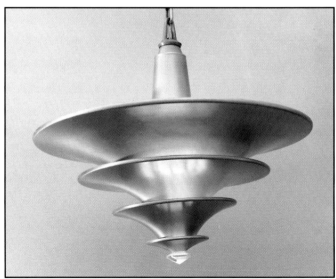

Unmarked polished aluminum ceiling fixture, 20" d. x 18" h. excluding the chain. The tiered shade is painted blue and yellow on the inside to cast colored shadows. $350-500.

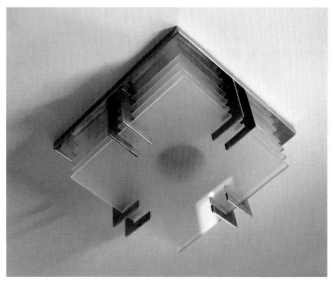

Unmarked polished chromium ceiling fixture with frosted glass panels, 14" x 14" x 5-1/2". The fixture is partially recessed into the ceiling. $250-325.

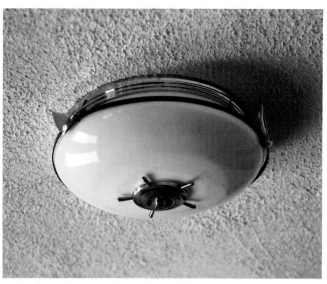

Ceiling fixture by Moe Brothers, Chicago, Illinois, 13" d. Three polished brass ships sail around the white glass globe on a red enameled band. A fluted base completes this exceptional design. $300-400.

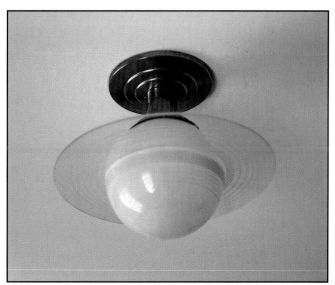

Unmarked polished brass "Saturn" ceiling fixture with stepped base, 12-1/2" d., 10" h. A clear glass ring with etched bands rests on a white glass globe. $300-375.

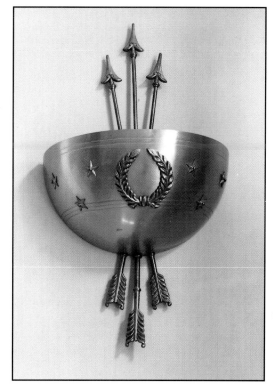

Satin chromium wall sconce decorated with brass stars and arrows and marked "After Daylight Levolite," 5" x 9" x 16". $150-225.

Chapter 15
Miscellaneous

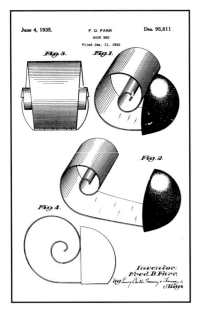

Fred D. Farr was awarded a design patent for the scroll bookend on June 4, 1935. He received several additional design patents for variations of the book scroll.

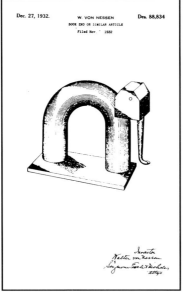

Walter von Nessen was awarded a design patent for elephant bookends in 1932. Richard Kilbride's second Chase book pictures "Elephant Book Ends" under Model No. 17043 that appear to have the thin base pictured in the design patent. This original design apparently was not sold after 1932. The bookends reappeared in the Chase catalog in 1941 as the "Jumbo Book Ends" (No. 17113).

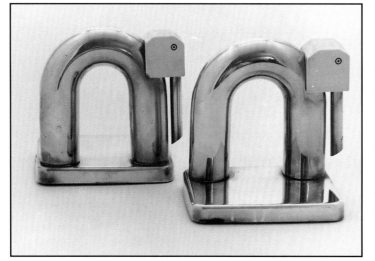

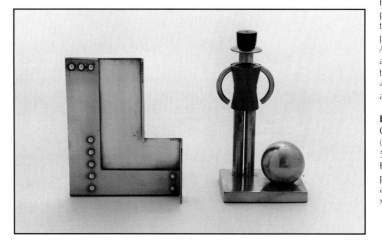

Top: Book scrolls designed for Revere by Fred Farr. Left: Polished chromium scroll with butterscotch bakelite end containing the "Graphic" thermometer and humidistat made by Middleburg, Macomb, Illinois, 4-1/2" x 4-1/2" x 4-1/2". The dial reads "Healthful conditions of temperature and humidity exist when hands cross within GREEN AREA." $55-70. Center: "Twin Scroll" (No. 297), polished chromium disc base and scrolls separated by black enameled wood center, 6" d. base, 5" h. The "Twin" was also available with a red divider and chromium band (No. 295) and white divider with copper band (No. 296). $45-60. Right: Red lacquered wood with polished chromium scroll, 6" x 3" x 4-1/2". $55-70.

Center: Chase polished brass and white plastic "Jumbo Book Ends" (No. 17113) designed by Walter von Nessen, 4-3/4" x 4-5/8" x 3-5/8". The examples pictured in Chase catalogs and the design patent show white bakelite trunks to match the heads. These bookends are hard to find and frequently have the trunks missing. The example shown was purchased with brass trunks, but I have found no evidence that Chase produced such a variation. It is likely that they were professionally repaired with newly fashioned trunks. As shown, the bookends are valued at $300-375. With intact bakelite trunks the value increases to $400-475. Even without trunks, they have a value of $150-200.

Bottom: Two more bookends by Chase. Left: "Book End Moderne" (No. 11246), satin brass and copper, 5-1/2" w. x 6-1/2" h. $125-175 each. Right: "Sentinel" (No. 17109), polished brass with a red plastic body and black plastic hat, 3-3/4" x 3-1/16" x 7-1/4". $125-175 each.

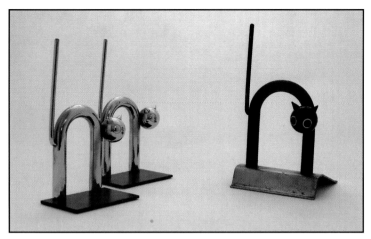

The ultimate book ends and doorstop designed by Walter von Nessen. Left: "Cat Book Ends" (No. 17042) in polished chromium with a black nickel base, 4" w. x 7-3/8" h. $450-550. Right: "Cat Door Stop" (No. 90035) in combination of satin and black nickel, 4-3/4" x 4-1/2" x 8-1/2". $200-275.

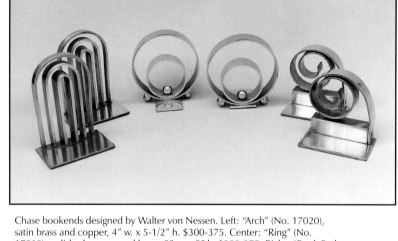

Chase bookends designed by Walter von Nessen. Left: "Arch" (No. 17020), satin brass and copper, 4" w. x 5-1/2" h. $300-375. Center: "Ring" (No. 17019), polished copper and brass, 5" w. x 5" h. $300-375. Right: "Book Ends Spiral" (No. 17018), satin brass and copper, 4" w. x 4-1/2" h. $275-350.

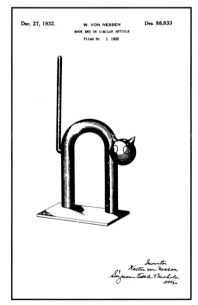

Design patent awarded to Walter von Nessen on December 27, 1932, for the cat bookends and doorstop.

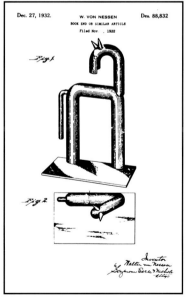

Design patent for the Horse bookends awarded to Walter von Nessen on December 27, 1932. The rarest of the Chase animal bookends, expect to pay $500-700.

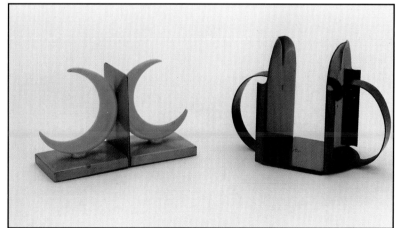

More traditional bookends by Chase. Left: "Crescent" (No. 90137), satin brass and white plastic, 3" w. x 4-5/8" h. $110-130 pr. Right: "Colonial" (No. 11248), English bronze, 4-1/2" x 5-1/4". $110-140.

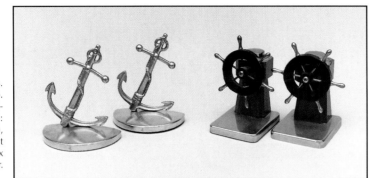

Chase nautical bookends. Left: "Davey Jones" (No. 90142), polished brass, 5-1/4" x 6". $55-70 pr. Right: "Pilot" (No. 90138), polished brass with walnut and brown plastic, 4-3/8" x 3-1/2" x 6-3/8". $50-70 pr.

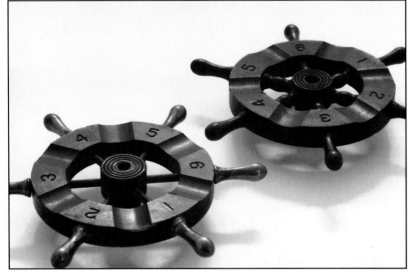

Changes in Chase designs are not always reflected in the catalogs. Close up of ship's wheels on two Chase "Pilot" bookends to show the change in design from brass to plastic spokes. I was unable to find the variation with plastic spokes in the catalogs.

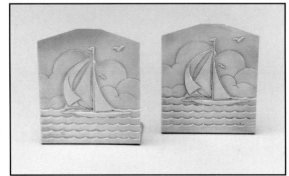

An attractive but inexpensive pair of aluminum bookends, 3-7/8" w. x 4-1/2" h. The bookends feature a moderne embossed design of a sailing ship with rippling waves and stylized clouds. $25-40.

Newspaper and Magazine Racks

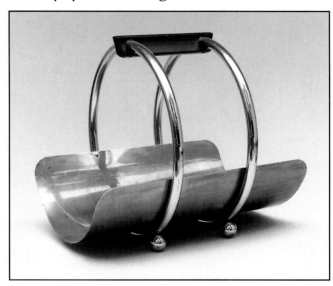

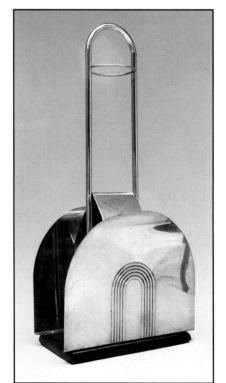

Above: Revere "Fireside" log holder/magazine rack (No. 7055) designed by Leslie Beaton, 18" x 15" x 15-1/2". A bronze tray is gently curved to conform to the continuous chromium circles that form the handles. The handle is ebony finished wood and the floor rests are chromium spheres. Selling for $10.00 in 1937, the Fireside now has a value of $175-225.

Left: Revere bronze and polished chromium "Magazine Holder" (No. 304) designed by W. Archibald Welden, 25-1/2" x 11" x 6". The base is matte black enameled wood. Missing from this example is the bronze ashtray that should rest in the ring at the top of the handle, placing it at the lower end of the price range. $175-225

Unmarked polished chromium and glass magazine rack, 17" x 12" x 16-3/4". This rack is hard to date, but is probably from the late 1940s or 1950s. $55-80.

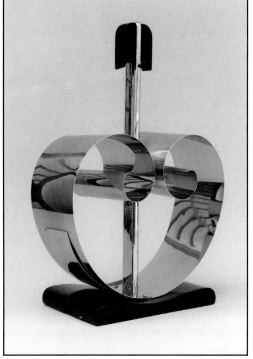

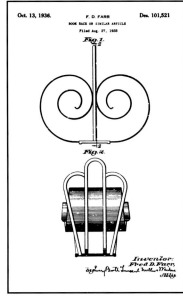

Center left: Revere "Magazine Scroll" designed by Fred Farr in polished chromium with a black enameled wood base and handle, 17-1/2" x 12" x 5-1/2". There are several variations of this basic design. $150-225.

Left: Design patent for a magazine scroll awarded to Fred Farr on October 13, 1936. He was awarded several other patents for variations of the magazine scroll.

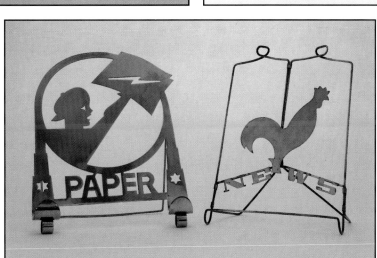

Left: Unmarked newspaper holder in polished chromium, 9-1/2" w. x 10-1/2" h. The holder is fairly common but is typically found in copper. $65-80 Right: Chase brass and copper "Newspaper Rack" (No. 27027) designed by Lurelle Guild, 11-3/8" x 8-3/8" x 5-1/8". $90-125.

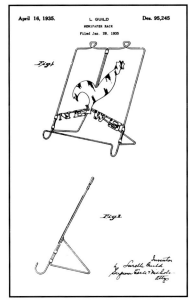

A design patent for a "Newspaper Rack" was awarded to Lurelle Guild on April 16, 1935.

Andirons

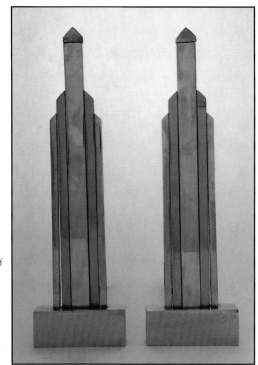

Right: Unmarked skyscraper andirons of polished chromium and copper, 5" w. x 16" h. $350-450.

Below: Unmarked polished brass andirons, 17" x 11-3/4" x 8-1/4". $125-150.

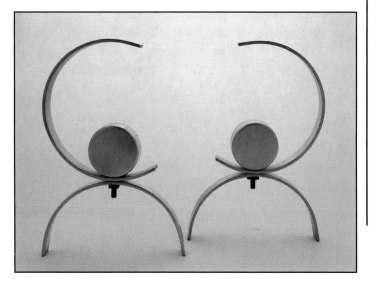

Banks

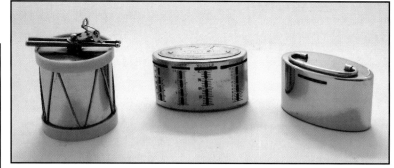

A penny saved is a penny earned. Left: Chase "Drum Bank" (No. 90156) in polished chromium and white bakelite, 3-11/16" d. x 3-1/2" h. This bank is more commonly found in polished brass with red plastic or polished chromium with red plastic. $105-135. Center: The original "Clearvue Registering Bank" by Earl Service for Banks, Melrose, Massachusetts. It is stamped "Owners of Clearvue Registering Bank Original Patent No. 1,703,994." Donald F. Earl holds the patent on this bank, which later appeared in the Chase catalog. The bank is marked "Made of Chase Brass" and Chase may have made the bank for Earl Service before adding it to their line under the same name (No. 405002). $90-115 for the original Earl Service bank; $80-95 for the Chase version. Right: Chase polished chromium "Oval Handle Bank" (No. 405004), 4" x 2" x 2". It is not clear whether this bank was designed by Donald F. Earl or by Chase designers. $65-80.

Patent awarded to Donald F. Earl on March 5, 1929, for the Clearvue Registering Bank. The patent application was filed in July 1927.

Picture Frames

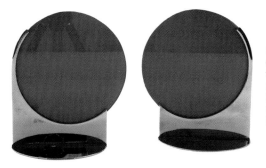

Unmarked polished chromium combination picture frame and mirror, 4-1/4" d. x 5-3/4" h. An extraordinary moderne design. $65-80.

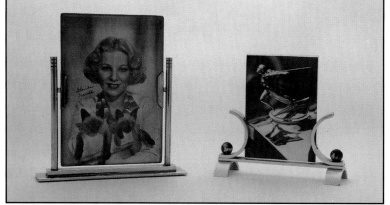

Left: Unmarked polished chromium picture frame/mirror, 7-1/4" x 1-1/2" x 7-1/2". The picture is film star Glenda Farrell. $45-60. Right: Aluminum and brass picture frame stamped "Brevete," 6" x 2" x 5-3/4". $35-50.

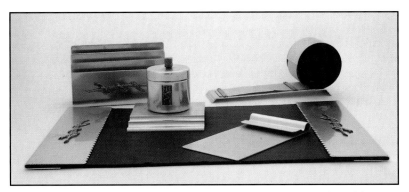

Desk accessories by Kensington, all designed by Lurelle Guild in aluminum alloy with brass trim. Center: "Waverly" Blotter (No. 7000), 20" x 12-1/2". $40-60. Rear left: "Waverly" Correspondence Rack (No. 7002), 2-5/8" x 7" x 4". $50-65. Rear center: "Waverly" Ink and Penholder (No. 7003), 5-1/2" x 4-3/4" x 4". $50-65. Rear right: "Oxford" Memo Roll (No. 7013), 9-1/4" l. $75-90. Front right: "Jot-It" Memorandum Pad Holder (No. 7007), 7" x 4". $15-25.

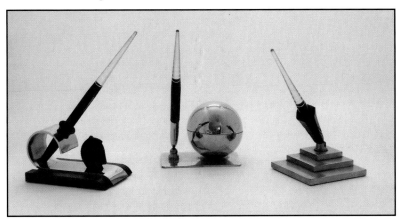

Above: Pen pals. Left: "Aimes" pen holder of polished chromium, black enamel, and bakelite, 4" x 2-1/2" x 6-1/2". $40-55. Right: Unmarked white metal Pen holder with stepped base, 3" x 3" x 6". $35-50. Center: Unmarked polished chromium Pen holder and inkwell, 3-3/4" x 2-3/8" x 7". $60-75.

Right: Design patent for a pen and pencil holder awarded to Francis M. Aimes on November 2, 1937.

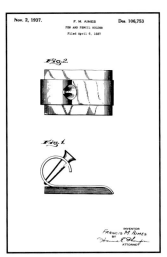

Desk Accessories

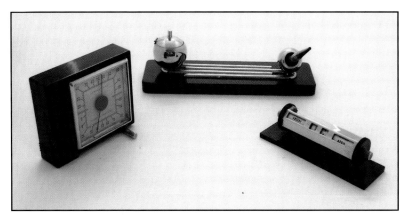

Left: A smart Airguide™ thermometer and humidistat by Fee and Stemwedel, Inc., Chicago, Illinois. Black bakelite with polished chromium trim, 4-7/8" x 4-1/8" x 2-3/8". $45-60. Center: Manning-Bowman "Executive" Penholder and Inkwell of black catalin and polished chromium, 10" x 3" x 3". The "Executive" was offered in 1936 as a complete desk set consisting of a blotter, letter holder, Pen holder and inkwell, letter opener, and desk pad. It was offered with walnut rather than black bakelite trim and sold for $20.00. Today, the Pen holder and inkwell is valued at $95-125. Right: Unmarked perpetual desk calendar of polished chromium and black plastic, 5-7/8" x 1-7/8" x 1-3/8". $25-35.

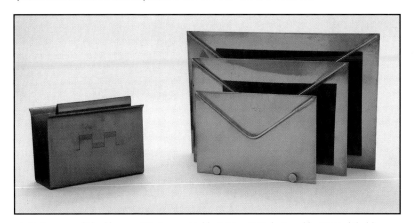

Left: Revere polished bronze "Stationary Holder" (No. 418) designed by W. Archibald Welden, 3-3/4" l. x 2-3/4" h. Selling in 1937 for $1.00, it has a current value of $65-80. Right: Unmarked nickel silver correspondence holder, 3" x 8" x 5". $80-105.

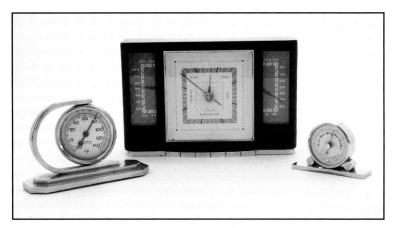

The temperature's rising. Left: "Rototherm" polished chromium desk thermometer, 5-1/2" x 1-3/4" x 3". $65-80. Center: The Airguide™ "Argyle" combination thermometer, barometer, and humidistat of black bakelite and polished chromium, manufactured by Fee and Stemwedel, Chicago, Illinois, 8-1/2" x 2" x 5-1/2". $65-80. Right: Polished chromium barometer stamped "Lufft" and "Made in Germany," 3-3/8" x 1" x 1-1/8". $35-50.

Dresser Accessories

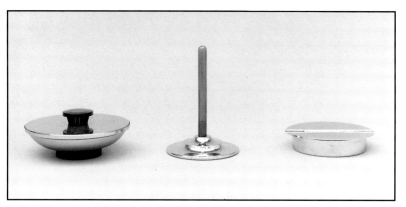

Left: Revere polished chromium "Vanitie" powder box (No. 710) with black enameled base, 5-3/8" d. x 2-1/2" h. There is a glass mirror on the underside of the top. $50-65. Center: Manning-Bowman "Yarn Holder" (No. K188/39), polished chromium base with green catalin rod, 4" d. x 5-3/4" h. The Yarn Holder was also available with an ivory rod (No. K188/8), a blue rod (K188/10) or a red rod (K188/22). The 1934 catalog notes "That elusive and tangled ball of knitting yarn or crochet cotton can now be controlled by slipping it on one of these colorful yarn holders that can easily be carried from place to place." $65-80. Right: Unmarked polished chromium hinged top box, 5" d. x 7/8" h. $40-55.

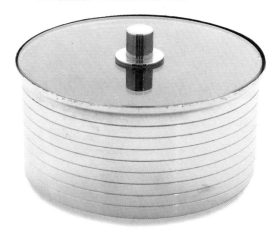

Above: Manning-Bowman "Miramar" candy/powder box (No. 232), polished chromium with clear glass top, 4-3/4" d., 3" h. $40-50.

Right: Chase "Iris Box" (No. 90074), brushed nickel top with fluted black composition base, 5-1/2" d., 3-1/2" h. Other available finishes included brushed nickel with rose or blue base and satin brass with ivory or green base. One of the harder to find Chase pieces and one of the better designs. $90-115.

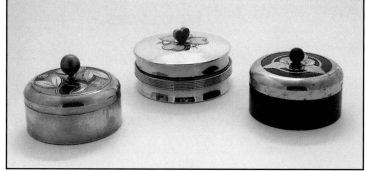

Chase "Occasional" boxes. Right: Black enameled brass with polished nickel trim and catalin ball knob, frosted glass liner, 4-1/2" d. This variation of the Gerth-designed Occasional box (No. 90002) was also available with white, red, blue, green, or rose enamel. Early versions had a ribbed metal knob. $55-65. Left: The same box in satin brass with a leaf design highlighted by dark and light green enamel and brass knob, 4-1/2" d. $55-65. Center: The 1942 "Occasional" box (No. 90144) in polished copper with white enameled hearts and bakelite heart knob, clear glass liner, 5-1/4". Other finishes include polished triangle brass with white trim and polished chromium with black trim. Earlier versions of this box had a ribbed copper knob. $35-50.

Left: Kensington aluminum alloy brushes. In the rear is the "Hatmaster" hat brush (No. 7692), 5-1/2" l. $30-$45. In the foreground is the "Clothmaster" clothes brush (No. 7693), 6-1/2" l. $30-45. Right: Chase polished chromium "Hair Brush" (No. 90140) designed by Harry Laylon, 4-1/2" x 2-1/8" x 1-1/4". $45-60.

Unmarked dresser box of polished chromium and black plastic, 10-5/8" x 5-3/4" x 3-1/2". $50-65.

Bridge Accessories

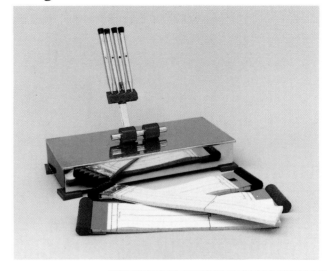

Unmarked bridge set with a nickel silver top, polished chromium sides, and red and black catalin trim, 10" x 4-1/2" x 2-1/2". The set includes four score pads with catalin tops, and four mechanical pencils, each marked with a different suit. $250-325.

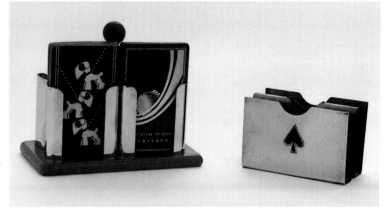

Bridge anyone? Left: Unmarked polished chromium cardholder with base and handle of red enamel, 5-1/2" x 4" x 4-1/2". $55-70. Right: Revere solid bronze "Double Deck" cardholder (No. 416), 3-9/16" l. x 2-1/4" h. $55-70.

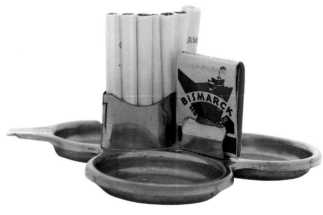

Polished copper bridge coasters/ashtrays by Saxon, Toledo, Ohio, 6" x 6" x 1-3/4". The trays also hold cigarettes and book matches. $25-35 each.

Part Three

Advertisements and Catalog Reprints

Chapter 16
Advertisements

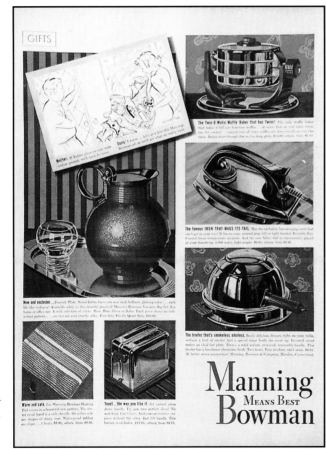

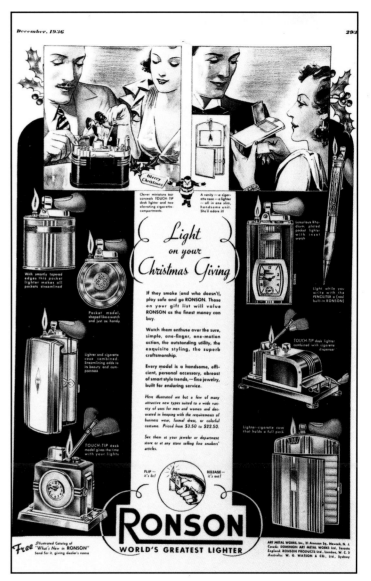

Esquire, December 1936.

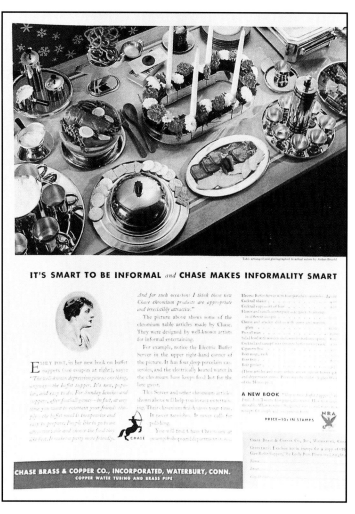

Home & Field, December 1933.

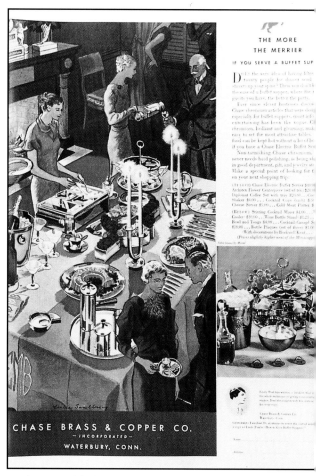

House Beautiful, May 1934.

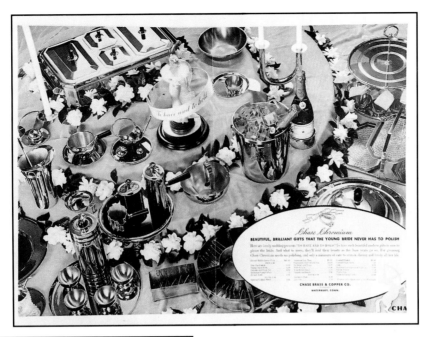

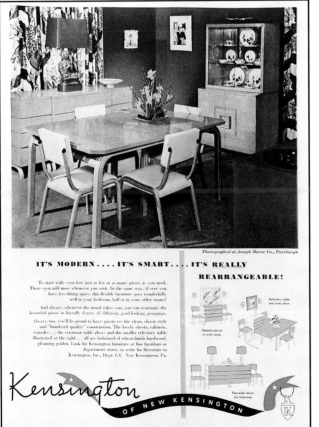

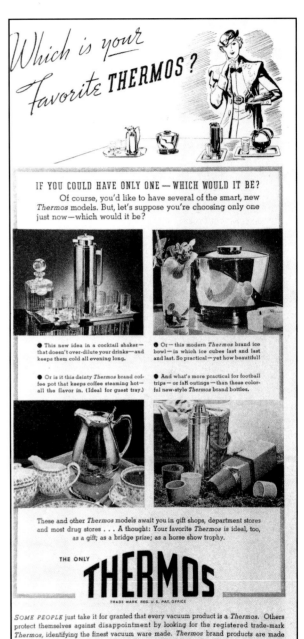

Above: *New Yorker,* June 2, 1934.

Left: *House & Garden,* August 1948.

Right: *New Yorker,* September 12, 1936.

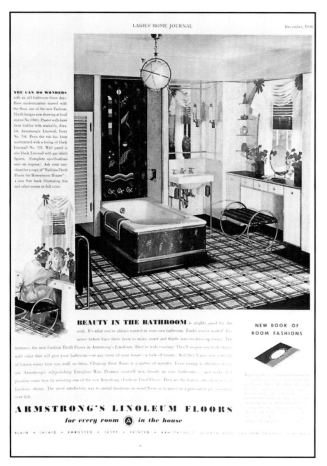

Chase products were often featured in other companies' ads. Here, the Chase "Planetarium" ceiling fixture is shown in an ad for Armstrong tile. (*Ladies Home Journal*, December 1936).

You now have the finest coffee-maker made!

The art of making perfect coffee is dependent solely upon these things

The coffee itself must be good. The water must be at the correct high temperature when it rises up and mixes with the coffee. All the water must rise to the brew-top, vigorously agitate with the coffee and then brew for the correct period of time. If all these three conditions are correct and uniform every time—then you'll get a perfect cup of coffee every time. Sunbeam Coffeemaster controls these things automatically and gives you the same delicious cup of coffee every time, 365 days of the year.

Coffeemaster removes the "human element" from coffee making—"thinks of everything" and "does everything" by itself. You simply set it and *forget it*. You can't miss.

Why is correct water temperature so important?

To make perfect coffee the water should be at the correct high heat—above 200°, but not boiling, which is 212°. The water must be over 200° to completely draw out the aromatic flavor oils in the ground coffee, and release them into the beverage. The ideal temperature, tests prove, is 205°.

You might say—"Why not boil the water at 212° and be done with it?" Boiling not only releases the flavor oils, but goes a step further. It breaks down the fibre *holding the oils*. This fibre contains the caffetannic acid that gives coffee a bitter, sourish taste. Boiling releases that acid. You don't want it. All you want is the rich aromatic flavor of the oils, which is released at 205°.

Your Sunbeam gives you this perfect brewing temperature automatically. Coffeemaster's 1000-watt, built-in heating element comes in direct over-all contact with the base of the brewing vessel. It is sealed between heavy copper plates, and copper is a fast heat-conductor. Glass, on the other hand, is an insulator. To insure the water's reaching 205° before rising, the Sunbeam has a little hole in the brew-tube that allows some of the vapor pressure to escape until the water reaches 205°. The resulting agitation is vigorous, and always at the correct high heat. The bubbling you see in the upper vessel is the steam agitating through the mixture. It never boils.

Why is correct brewing time so important?

If you brew coffee too long, you release the bitter, caffetannic acid, just as you do when you boil it. When you brew for too short a period, you fail to extract true coffee goodness of the flavor oils. In your Sunbeam you get that perfect timing automatically—one cup or eight. It shuts off by itself and the brew goes down into the lower vessel by itself. No watching. No worry. Regardless of how many cups you make, the actual brewing period of the coffee and water is always the same.

Coffeemaster not only makes from ONE to EIGHT cups of coffee, but all of the water rises to the brew-top and comes in contact with the coffee

Here's another big advantage you have in your Sunbeam—another reason why it makes better coffee, time after time, year-in, year-out. Whether you make one cup or eight, all the water rises to the brew-top to agitate vigorously with the ground coffee, extracting every bit of its rich, native goodness. Not a drop ever remains in the lower vessel to dilute the coffee when it comes down. In all other vacuum-type coffeemakers a cup or more of water remains in the lower vessel. There is always *dilution*, and "dilution" is exactly what Webster says: "To dilute is to reduce or diminish the flavor by thinning." You'll never get that in your Sunbeam Coffeemaster. You get the same taste-tempting perfection every time, one cup to eight.

Above & right: Instructions for the Sunbeam *Coffeemaster.*

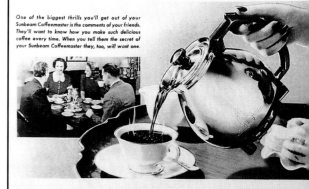

One of the biggest thrills you'll get out of your Sunbeam Coffeemaster is the comments of your friends. They'll want to know how you make such delicious coffee every time. When you tell them the secret of your Sunbeam Coffeemaster they, too, will want one.

Good coffee means HOT coffee—so the Sunbeam keeps it piping hot after it's made.

The service of your Coffeemaster doesn't even end after "the perfect cup" is made. It automatically re-sets itself to keep the coffee at perfect drinking temperature in the lower vessel. The coffee never has a chance to cool before you serve it. It will never have that flat, warmed-over taste you get in coffee that has been re-heated.

You can make the same strength of coffee every time with Coffeemaster—and without guesswork

A level or rounded tablespoonful of ground coffee for each cup of water is the usual amount used in making coffee. This amount can be varied to suit your taste, depending on how strong or weak you like your coffee. Once you determine the exact amount of coffee per cup of water it takes to make the exact strength of coffee you like, there is absolutely no guesswork. You make your idea of perfect coffee every time, continuously, from then on.

New Seat Ring and New Convenient Handle on upper vessel

This new Seat Ring has a stainless steel inner spring which prevents the Brew-top from popping out while the coffee is being made. No other coffeemaker has this exclusive construction.

A thing of beauty is a joy forever

Last but not least, the enduring beauty of your Sunbeam is a joy forever. The design is classic in its lovely simplicity. And this beauty is not skin-deep. It goes all the way through. It "Quality for keeps."

Both bowls, upper and lower, are of copper. Sunbeam uses copper not only because it is the best heat conductor, but because it is best for long life and lasting appearance. There probably no finer ware in the world than the Sheffield silver ware of England. Copper has been used as a base in the famous ware for centuries. Naturally, it is the most expensive but since it is the best, you have it in your Sunbeam.

Quality has been the slogan of Sunbeam craftsmen from the beginning. You'll find it in the flawless surface of the nickel plating, and you don't even see that. It is nickel-plated before being chrome-plated, and that's why Sunbeam chrome is a gem-like and lasting. This chrome-plating, on top of the nickel gives your Sunbeam a hard, sparkling finish. These are the surfaces that assure you of true coffee flavor every time. And not just the *lower* bowl—but *both* bowls—top and bottom, inside and out.

And not only that—they will give you freedom from glass bowl breakage. What is more irritating or inconvenient than the bowl breakage that is inevitable with glass and half-glass coffeemakers? Over a period of time it's a real item of expense, too. You'll have none of that with your Sunbeam, and you also have the most beautiful coffeemaker in America.

That is what you have in your Sunbeam Coffeemaster—the finest coffee maker money can buy. We know you are going to find it the "last word" in service—just as you do your Sunbeam Mixmaster, Ironmaster, Toaster, Waffle Baker, if you happen to own them. Sunbeam believes its most valuable possession is the enthusiasm of people who use our appliances.

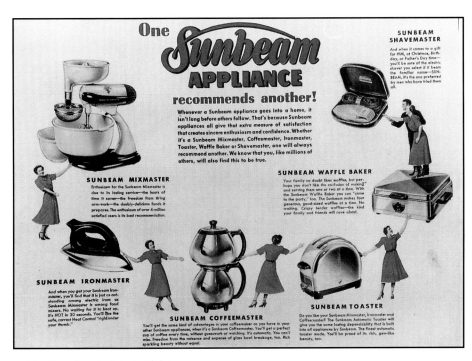

Advertising flyer included with late
1940s/early 1950s Sunbeam products.

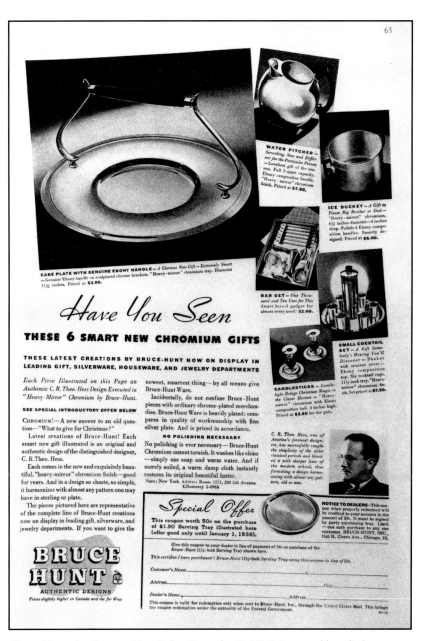

Bruce Hunt advertisement (*New Yorker*, December 7, 1935). I was unable to find any
record of the company at the Chicago Historical Society or Chicago Public Library.

Chapter 17
Reprint of 1934 Chase Modern Fixtures Pamphlet

The following is a reprint of a 1934 Chase foldout pamphlet for art deco ceiling fixtures, wall sconces, and bathroom fixtures. The folded pamphlet measured 6" x 3-1/4". The pamphlet is reprinted through the courtesy of the Mattatuck Historical Society.

Designed for Lighting — Chase Classic Modern Fixtures contribute the charm of diffused light and the brilliant style of contemporary decoration to homes done in the CLASSIC MODERN MANNER.

The chief characteristic of the Classic Modern school is the use of classical decorations in conjunction with designs whose simple lines and proportions show their modern purpose.

The rapidly growing demand for Classic Modern furniture, interior architecture and lighting fixtures, is due to the fact that it is an exquisite style that may be used successfully with modernized period decoration. It is not extreme modernism—but a blending of classical forms with the newer ideas of design.

In the decorations employed in Chase Classic Modern fixtures you will recognize modernized versions of the urn, arrow, laurel spray, drapery swag, banded reeds and stars which glorified the classical art of ancient Greece and Rome — effectively adapted to lend stately beauty to Chase Classic Modern Lighting.

In all Classic Modern fixtures Chase makes use of only the finest glass and employs only lasting brass as a basic metal, finishing it in lustrous, non-tarnishing chromium.

Included in the Chase Classic Modern group are a number of distinctive bathroom and dressing room brackets which are ideal for use in any home.

Many of these smart and exquisite fixtures can be used with excellent taste in homes employing modernized versions of Empire, Directoire and Federal decorations. Ask your local dealer for the folders which illustrate Chase Federal and Empire fixtures, for certain of these fixtures may be used in Classic Modern interiors.

Beautiful table and floor lamps related in design to Chase Classic Modern fixtures are also made by Chase. They are sold by Chase lighting fixture dealers, leading department stores and gift shops and are most reasonable in price.

With the introduction of Chase Classic Modern Lighting it is now possible to select fixtures and lamps of such excellent taste, fine design and low cost, that they will not only add to the comfort and beauty of your home but will be one of the most effective and inexpensive home improvements you can make.

1934 Chase Modern Fixtures Pamphlet.

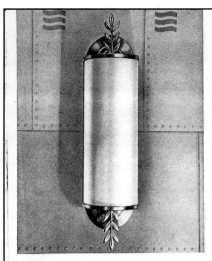

The OLYMPIA

Extreme simplicity marks the design of this bracket, with its modern purity of line enhanced by the classic laurel spray. Whether placed vertically or horizontally, it offers unusual lighting possibilities in any classic-modern setting. Wrought of Chase Brass, with finish of polished chromium the half column of frosted glass insuring abundant light without glare. Height, 13 inches. Width, 3½ inches. Projection, 4 inches. $10.00

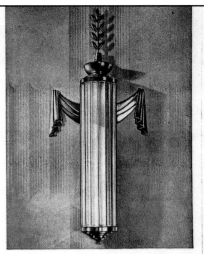

The ATHENA

In this exquisite adaptation of classical decorative forms, Chase has created a bracket that embodies the very essence of Classic-Modern design. The stately, frosted-glass column is relieved with clear glass flutings—the swag, urn and laurel decorations being finished in polished chromium. A tubular lamp contributes the mellow light so sought in modern decoration. Height, 23 inches. Width, 10 inches. Projection, 2½ inches. $17.50

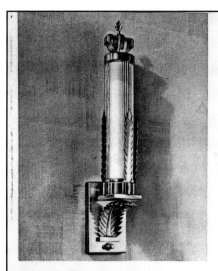

The IMPERATOR

The happy conjunction of classic and modern influence is perfectly illustrated in the beauty of this impressive bracket, with its polished chromium back plate and etched glass column accented by modern adaptations of leaf, crown and reed motifs. A truly superb fixture for the more formal rooms of homes done in the Classic Modern manner. Height, 13½ inches. Width, 3¼ inches. Projection, 3¼ inches. $10.00

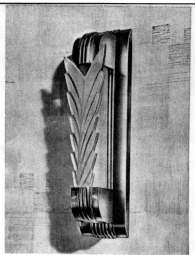

The TROY

The versatility of Chase Lighting is well illustrated by this superbly designed bracket scaled for smaller rooms, in the Classic Modern manner. Truly modern in its finish of polished chromium, the classic influence is seen in the reeded pattern of the metal and in the imperial leaf design of frosted glass which insures generous but glareless light. Height, 11½ inches. Width, 3¼ inches. Projection, 3 inches. $12.00

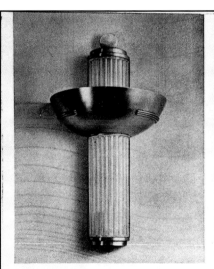

The MINERVA

The spirit and purity of Greek forms are revived in this graceful wall light which contains two light-sources—one within the classic column of frosted glass to give softly diffused illumination, the other shielded by the polished chromium bowl to cast indirect light against the wall and ceiling. Both lights can be used independently, or together. Height, 17 inches. Width, 10 inches. Projection, 5½ inches. $18.50

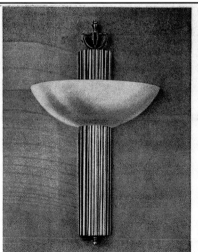

The COLONNADE

Classic in design, modern in its method of illumination, The Colonade's indirect light is thrown upward from the crystal glass bowl of this brilliantly designed bracket, the eye-level light being diffused to scientifically shaded softness. The classic influence is evident in the stately, fluted column and graceful finial in lustrous polished chromium. Height, 16½ inches. Width, 10 inches. Projection, 5½ inches. $15.00

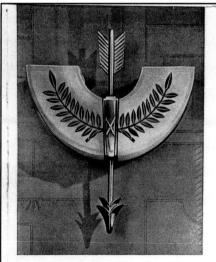

The DIANA

An effect altogether unique is created in this Classic Modern fixture by the polished chromium arrow bisecting a graceful laurel spray which is etched in burnished silver on the crystal frosted glass. The light, properly diffused outward into the room, is also thrown boldly upward to give an effect as dramatic as the design of the bracket itself. Height, 12 inches. Width, 10 inches. Projection, 3½ inches. $10.00

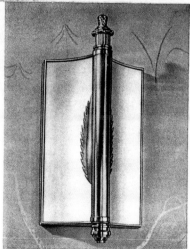

The VESTA

The simple dignity of this bracket is due to its design being influenced by the classic column-and-capital and executed in the rich lustre of polished chromium. The beauty of its classical treatment is enhanced by silhouetting a modernized leaf decoration against its two frosted glass panels which insure a maximum of even and properly diffused light. Height, 9 inches. Width, 6 inches. Projection, 3¼ inches. $13.50

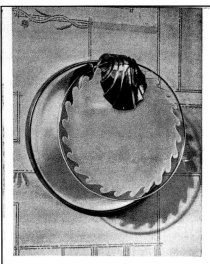

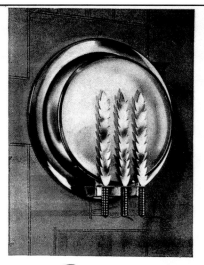

The THESSALY

The merit of adapting classical decorations to dynamic modern design is notably apparent in this distinctive bracket, with its utilization of the Greek wave design etched on the circular disc of plate glass, and the "shell", forged of Chase Brass and finished in polished chromium. These sea symbols render The Thessaly particularly harmonious for use in the bath. Height, 7 inches. Width, 7 inches. Projection, 3¼ inches. $12.00

The ROMA

In this pleasing bracket, the circular reflector plate and convex crystal-glass disc are given classical significance by conventionalized laurel leaves. The metal parts are of Chase Brass, finished in polished chromium and the glass is frosted. In rooms of Classic Modern influence the Roma is admirably suited in its design no less than its modern illumination. Height, 8½ inches. Width, 8½ inches. Projection, 3½ inches. $10.00

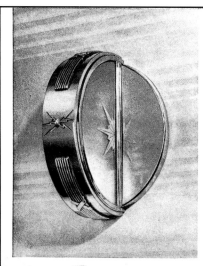

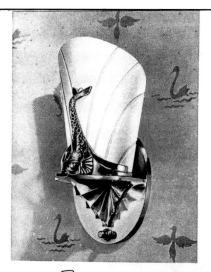

The THOR

As interesting as its decorations of cross-ribboned bands, imprisoned lighting and stars, is the half-disc and circle form of this effective bracket. The light, diffused through frosted glass, is reflected by the chromium circular back plate insuring correct diffused lighting. Whether hung vertically or horizontally it is a truly individual fixture. Height, 7¼ inches. Width, 7¼ inches. Projection, 4½ inches. $15.00

The DOLPHIN

The dolphin, fantastic creature of the sea, gave inspiration for many an ancient maritime design. One such design, on an old sea chart, in turn gave inspiration for this bracket, wherein the shell-and-dolphin motif is handled with all the simplicity and grace of the classic-modern manner. Chromium finished with frosted glass, The Dolphin makes an ideal bathroom light. Height, 8½ inches. Width, 4¼ inches. Projection, 4¼ inches. $7.50

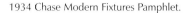

1934 Chase Modern Fixtures Pamphlet.

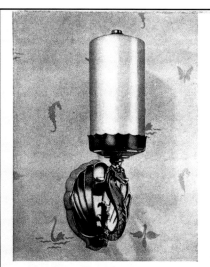

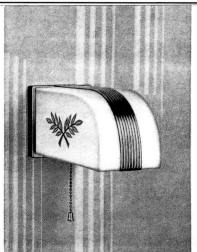

The SEA HORSE

This interesting yet highly efficient and decorative bracket is, in its design, a modern adaptation of the sea-symbols of classic antiquity. Carefully cast in Chase brass and finished in satin chromium, this lovely wall light is altogether in harmony with the fittings of the modern bath and thus is perfectly suited to such use in homes of all periods. Height, 11 inches. Width, 4½ inches. Projection, 4 inches. $7.50

The JUPITER

While it may be used with excellent taste in hallways, closets and bedrooms, this simple bracket was created as an ideal bath and dressing room light. The frosted glass shade, decorated with a reeded band of polished chromium and sprays of burnished silver, slips into the chromium back plate. A fine example of a utility light made beautiful by intelligent designing. Height, 3½ inches. Width, 3½ inches. Projection, 5½ inches. $5.50

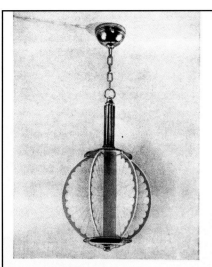

The AURORA

While dynamically modern in its execution, the exquisite decorative beauty of this classical ceiling fixture, is reminiscent of the gracious forms of Georgian design. Six half circles of plate glass etched with a modernized version of the lotus design are arranged around a center column of illumination producing a lighting effect that must be seen to be appreciated. Height, 45 inches. Width, 14 inches. $40.00

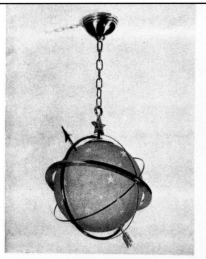

The PLANETARIUM

While modern in its design this beautiful and symbolic fixture is thoroughly appropriate for Empire, Federal and even Colonial homes, if antique brass finish is chosen. For modern homes it comes in polished chromium. The idea and design were inspired by an old astrolabe of about 1750. The globe is of frosted glass sprinkled with clear glass stars. Height, 45 inches. Width, 13 inches. Chromium finish, $32.00. Brass finish, $27.50

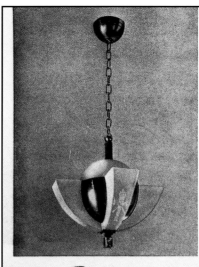

The ZEUS

While the classic decorations of this unusual fixture are 18th Century in origin, only the 20th Century could have produced its dynamic design and scientific illumination. Providing indirect light from the glass top of the polished chromium sphere and diffused light from the four frosted glass pockets surrounding its base, it casts the glareless illumination that is the triumph of modern lighting. Height, 45 inches. Width, 16 inches. $37.50

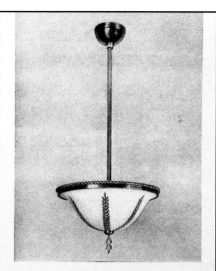

The SYBIL

The grace apparent in this fixture is illustrative of the way in which Classic Modern design can achieve pure beauty without sacrificing scientific illumination. The symmetrical curve of the bowl, the burnished silver laurel sprays, the slender satin chromium stem—all contribute great charm to a ceiling fixture that gives the shadowless glow of perfect indirect lighting. Height, 45 inches. Width, 14 inches. $20.00

1934 Chase Modern Fixtures Pamphlet.

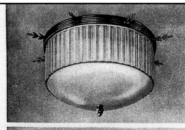

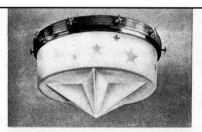

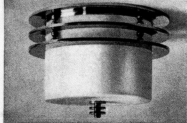

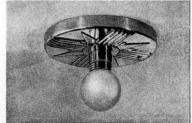

THE PARIS Inspired by the glittering splendor of the crystal chandeliers of the Empire Era. The Paris, with polished chromium topplate, interspersed with laurel sprays, is thoroughly Classic Modern. Height, 12 inches. Width, 18 inches. $25.00

THE APOLLO With its repetition of polished chromium rings and its severely simple frosted glass bowl, this fixture verges toward the pure modern. Made of lasting Chase Brass, it is finished in polished chromium. Height, 9 inches. Width, 13 inches. $22.50

THE CYPRUS Exceptional decorative value is achieved in the Cyprus by a star design carried out either in polished chromium or antique brass at the top and in clear glass star-shapes on the frosted glass. Height, 5½ inches. Width, 11 inches. Chromium, $12.50. Brass, $10.00

THE AUGUSTA Because of the simplicity of its decoration The Augusta can be properly used in rooms and periods other than Classic Modern. Height, ¾ inch. Width, 6½ inches. Polished chromium, $3.25. Antique brass, $2.75

Chapter 18
Excerpts from the 1941 Chase Lighting Fixtures Catalog

By 1941, Chase's variety of art deco fixtures had narrowed significantly. The following excerpts from Chase Residential Lighting Catalog No. 15 show some of the more modern designs. The most "moderne" designs, however, were limited to one page in the catalog.

Chase Manufacturing Plant and Rolling Mills

WATERBURY • CONNECTICUT

EVERY Chase lighting fixture you buy comes from this large Chase plant. Chase Rolling Mills produce sheet brass and copper which are the basic materials for all Chase fixtures. And the manufacturing plant, one of the largest fabrication plants in the country, is well equipped to do all the intricate stamping, knurling, forging, finishing and assembling required for Chase fixtures. That means you can buy Chase fixtures with the assurance that they are well-made and are backed by a responsible company.

Excerpts from the 1941 Chase Lighting Fixtures Catalog.

CHASE *Residential* LIGHTING FIXTURES

IN this catalog, we show a wide variety of styles in Chase Lighting Fixtures for "light conditioning" the home. Chase Lighting Fixtures are made to give more uniform illumination to a room, to eliminate glare from electric light bulbs, and to use the amount of light necessary for comfortable seeing. These lighting fixtures also eliminate dark shadows, and in general give the kind of light that is restful to the eyes.

The first consideration in lighting equipment today is given to eye comfort rather than to eye appeal, but you will find a good combination of both in Chase Lighting Fixtures, and to keep up a high standard of design and construction, we have our own designers and engineers.

We use only brass or copper for the basic metal of Chase Lighting Fixtures because only brass and copper have the lasting quality which preserves good finishes.

While glass and plastic bowls, crystal and other such ornamental materials are made for us by other companies, all the important brass and copper parts, and finishing and assembling of Chase Lighting Fixtures are done in our own plant under our own supervision. (See picture on opposite page.)

And for your protection, every Chase Lighting Fixture in this catalog bears the label of approval of the Board of Fire Underwriters.

This Chase tag identifies Chase Lighting Fixtures and is attached to Chase fixtures before they are shipped from our plant.

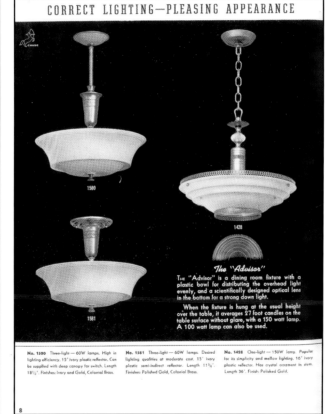

1580

1428

1581

The "Advisor"

T**HE** "Advisor" is a dining room fixture with a plastic bowl for distributing the overhead light evenly, and a scientifically designed optical lens in the bottom for a strong down light.

When the fixture is hung at the usual height over the table, it averages 27 foot candles on the table surface without glare, with a 150 watt lamp. A 100 watt lamp can also be used.

No. 1580 Three-light — 60W lamps. High in lighting efficiency. 15" ivory plastic reflector. Can be supplied with deep canopy for switch. Length 18½". Finishes: Ivory and Gold, Colonial Brass.

No. 1581 Three-light — 60W lamps. Desired lighting qualities at moderate cost. 15" ivory plastic semi-indirect reflector. Length 11⅝". Finishes: Polished Gold, Colonial Brass.

No. 1428 One-light — 150W lamp. Popular for its simplicity and mellow lighting. 16" ivory plastic reflector. Has crystal ornament in stem. Length 36". Finish: Polished Gold.

8

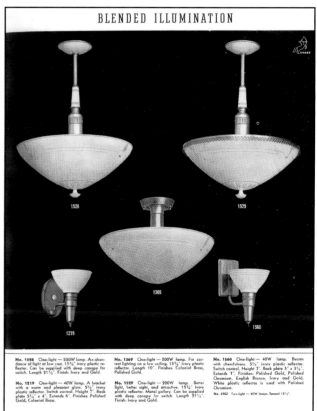

1528

1529

1389

1219

1560

No. 1528 One-light — 200W lamp. An abundance of light at low cost. 15¾" ivory plastic reflector. Can be supplied with deep canopy for switch. Length 21½". Finish: Ivory and Gold.

No. 1219 One-light — 40W lamp. A bracket with a warm and pleasant glow. 5½" ivory plastic reflector. Switch control. Height 7". Back plate 5¼" x 4". Extends 6". Finishes: Polished Gold, Colonial Brass.

No. 1389 One-light — 200W lamp. For correct lighting on a low ceiling. 15¾" ivory plastic reflector. Length 10". Finishes: Colonial Brass, Polished Gold.

No. 1529 One-light — 200W lamp. Better light, better sight, and attractive. 15¾" ivory plastic reflector. Metal gallery. Can be supplied with deep canopy for switch. Length 21½". Finish: Ivory and Gold.

No. 1560 One-light — 40W lamp. Beams with cheerfulness. 5½" ivory plastic reflector. Switch control. Height 7". Back plate 5" x 3¼". Extends 7". Finishes: Polished Gold, Polished Chromium, English Bronze, Ivory and Gold. White plastic reflector is used with Polished Chromium.

No. 1562 Two-light — 40W lamps. Spread 13½".

9

Excerpts from the 1941 Chase Lighting Fixtures Catalog.

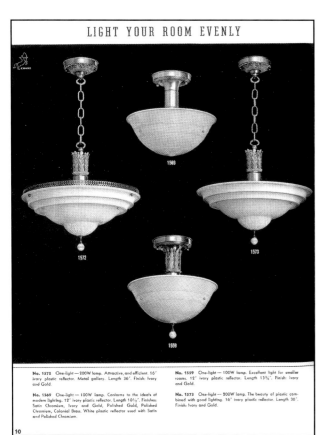

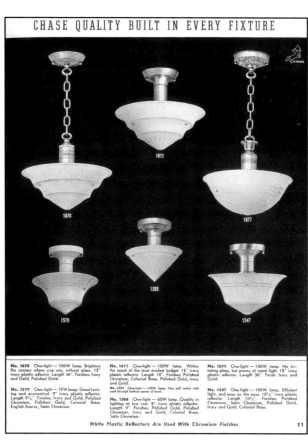

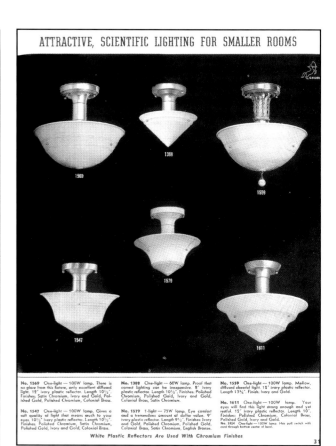

No. 1572 One-light — 200W lamp. Attractive, and efficient. 16" ivory plastic reflector. Metal gallery. Length 36". Finish: Ivory and Gold.

No. 1569 One-light — 100W lamp. Conforms to the ideals of modern lighting. 12" ivory plastic reflector. Length 10½". Finishes: Satin Chromium, Ivory and Gold, Polished Chromium, Colonial Brass. White plastic reflector used with Satin and Polished Chromium.

No. 1559 One-light — 100W lamp. Excellent light for smaller rooms. 12" ivory plastic reflector. Length 13¾". Finish: Ivory and Gold.

No. 1573 One-light — 200W lamp. The beauty of plastic combined with good lighting. 16" ivory plastic reflector. Length 36". Finish: Ivory and Gold.

10

No. 1678 One-light — 100W lamp. Brightens the corners where you are, without glare. 12" ivory plastic reflector. Length 36". Finishes: Ivory and Gold, Polished Gold.

No. 1579 One-light — 75W lamp. Good looking and economical. 9" ivory plastic reflector. Length 9½". Finishes: Ivory and Gold, Polished Chromium, Polished Gold, Colonial Brass, English Bronze, Satin Chromium.

No. 1611 One-light — 100W lamp. Within the reach of the most modest budget. 12" ivory plastic reflector. Length 10". Finishes: Polished Chromium, Colonial Brass, Polished Gold, Ivory and Gold.

No. 1524 One-light — 100W lamp. Has pull switch with cord through bottom center of bowl.

No. 1388 One-light — 60W lamp. Quality in lighting at low cost. 8" ivory plastic reflector. Length 9". Finishes: Polished Gold, Polished Chromium, Ivory and Gold, Colonial Brass, Satin Chromium.

No. 1677 One-light — 100W lamp. No irritating glare, but plenty of warm light. 12" ivory plastic reflector. Length 36". Finish: Ivory and Gold.

No. 1547 One-light — 100W lamp. Efficient light, and easy on the eyes. 10½" ivory plastic reflector. Length 10½". Finishes: Polished Chromium, Satin Chromium, Polished Gold, Ivory and Gold, Colonial Brass.

White Plastic Reflectors Are Used With Chromium Finishes 11

No. 1369 One-light — 100W lamp. There is no glare from this fixture, only excellent diffused light. 12" ivory plastic reflector. Length 10½". Finishes: Satin Chromium, Ivory and Gold, Polished Gold, Polished Chromium, Colonial Brass.

No. 1547 One-light — 100W lamp. Gives a soft quality of light that means much to your eyes. 10½" ivory plastic reflector. Length 10½". Finishes: Polished Chromium, Satin Chromium, Polished Gold, Ivory and Gold, Colonial Brass.

No. 1388 One-light — 60W lamp. Proof that correct lighting can be inexpensive. 8" ivory plastic reflector. Length 10½". Finishes: Polished Chromium, Polished Gold, Ivory and Gold, Colonial Brass, Satin Chromium.

No. 1579 1-light — 75W lamp. Eye comfort and a tremendous amount of dollar value. 9" ivory plastic reflector. Length 9½". Finishes: Ivory and Gold, Polished Chromium, Polished Gold, Colonial Brass, Satin Chromium, English Bronze.

No. 3524 One-light — 100W lamp. Has pull switch with cord through bottom center of bowl.

No. 1559 One-light — 100W lamp. Mellow, diffused cheerful light. 12" ivory plastic reflector. Length 13¾". Finish: Ivory and Gold.

No. 1611 One-light — 100W lamp. Your eyes will find this light strong enough and yet restful. 12" ivory plastic reflector. Length 10". Finishes: Polished Chromium, Colonial Brass, Polished Gold, Ivory and Gold.

White Plastic Reflectors Are Used With Chromium Finishes 3

Excerpts from the 1941 Chase Lighting Fixtures Catalog.

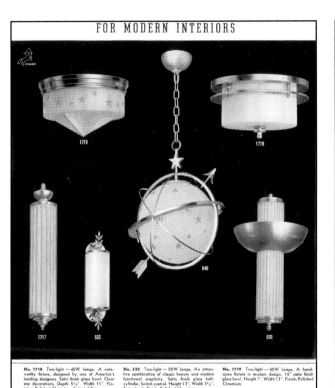

FOR MODERN INTERIORS

No. 1718 Two-light — 40W lamps. A noteworthy fixture, designed by one of America's leading designers. Satin finish glass bowl. Clear star decorations. Depth 5½". Width 11". Finishes: Polished Chromium, Colonial Brass.

No. 1717 One-light. An exclusive Chase adaptation of classical decorative forms. Use 40W tubular lamp. Satin finish fluted glass column. Switch control. Height 19". Width 3¾". Extends 2½". Finish: Polished Chromium.

No. 532 Two-light — 25W lamps. An attractive combination of classic beauty and modern functional simplicity. Satin finish glass half-cylinder. Switch control. Height 13". Width 13½". Extends 4". Finish: Polished Chromium.

No. 646 One-light — 100W lamp. Equally appropriate for Empire, Federal, and even Colonial homes. 10⅝" satin finish glass globe. Clear star decorations. Length 36". Width 13". Finish: Polished Chromium.

No. 1719 Two-light — 60W lamps. A handsome fixture in modern design. 10" satin finish glass half-cylinder. Switch control. Height 7". Width 13". Finish: Polished Chromium.

No. 526 Two-light. Striking in design, and modern in its method of illumination. Use 40W tubular bulb in glass column and 40W standard bulb in indirect metal reflector. 3¾" wide fluted satin finish glass column. Has 3-way switch. Height 17". Width 10". Extends 5½". Finish: Satin Chromium.

40

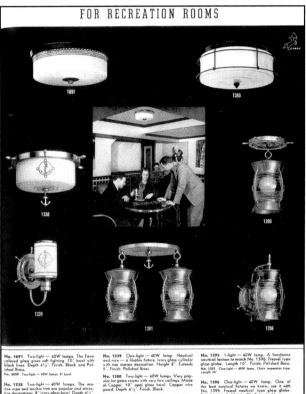

FOR RECREATION ROOMS

No. 1691 Two-light — 40W lamps. The Fawn colored glass gives soft lighting. 10" bowl with black lines. Depth 4½". Finish: Black and Polished Brass.

No. 1690 Two-light — 40W lamps 8" bowl.

No. 1338 Two-light — 40W lamps. The marine rope and anchor trim are popular and attractive decorations. 8" ivory glass bowl. Depth 4½". Finish: Polished Brass.

No. 1339 One-light — 40W lamp. Nautical and nice — a likeable fixture. Ivory glass cylinder with tan marine decoration. Height 8". Extends 5". Finish: Polished Brass.

No. 1391 Two-light — 40W lamps. The Fresnel nautical type glass globe gives this fixture a seagoing touch. Length 10". Width 12". Finish: Polished Brass.

No. 1395 1-light — 40W lamp. A handsome nautical lantern to match No. 1396. Fresnel type glass globe. Length 10". Finish: Polished Brass.

No. 1392 One-light — 40W lamp. Chain suspension type. Length 36".

No. 1396 One-light — 40W lamp. One of the best nautical fixtures we know, use it with No. 1395. Fresnel nautical type glass globe. Switch control. Height 9". Extends 6". Finish: Polished Brass.

41

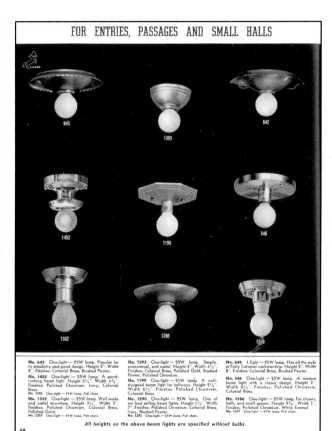

FOR ENTRIES, PASSAGES AND SMALL HALLS

No. 643 One-light — 25W lamp. Popular for its simplicity and good design. Height 2". Width 8". Finishes: Colonial Brass, Brushed Pewter.

No. 1452 One-light — 25W lamp. A good-looking beam light. Height 3½". Width 4⅜". Finishes: Polished Chromium, Ivory, Colonial Brass.

No. 1352 One-light — 25W lamp. Well made and useful anywhere. Height 3½". Width 5". Finishes: Polished Chromium, Colonial Brass, Polished Gold.

No. 2353 One-light — 25W lamp. Pull chain.

No. 1393 One-light — 25W lamp. Simple, economical, and useful. Height 2". Width 4½". Finishes: Colonial Brass, Polished Gold, Brushed Pewter, Polished Chromium.

No. 1199 One-light — 25W lamp. A well-designed beam light for hallways. Height 2¼". Width 6½". Finishes: Polished Chromium, Colonial Brass.

No. 1290 One-light — 25W lamp. One of our best selling beam lights. Height 1½". Width 7". Finishes: Polished Chromium, Colonial Brass, Ivory, Brushed Pewter.

No. 642 1-light — 25W lamp. Has all the style of Early Colonial workmanship. Height 2". Width 8". Finishes: Colonial Brass, Brushed Pewter.

No. 546 One-light — 25W lamp. A modern beam light with a classic design. Height 2". Width 6½". Finishes: Polished Chromium, Colonial Brass.

No. 1286 One-light — 25W lamp. For closets, halls, and small spaces. Height 2⅜". Width 5". Finishes: Polished Chromium, White Enamel.

No. 1287 One-light — 25W lamp. Pull chain.

All heights on the above beam lights are specified without bulbs

42

Excerpts from the 1941 Chase Lighting Fixtures Catalog.

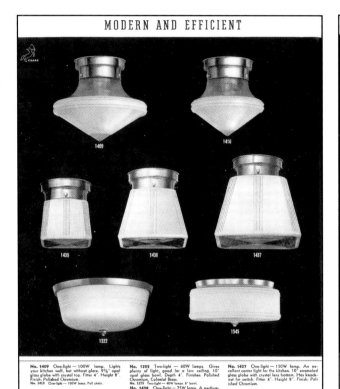

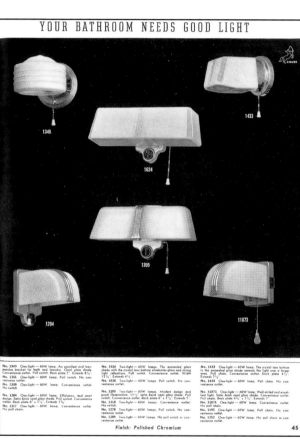

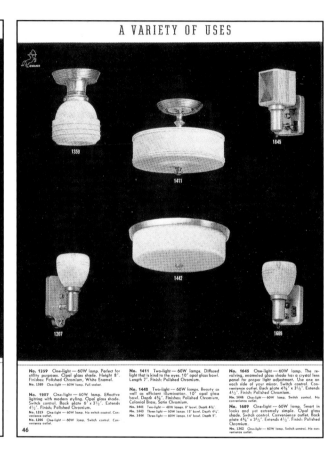

No. 1409 One-light — 100W lamp. Lights your kitchen well, but without glare. 9¾" opal glass globe with crystal top. Fitter 4". Height 8". Finish: Polished Chromium.
No. 1415 One-light — 100W lamp. Pull chain.

No. 1439 One-light — 60W lamp. A small, efficient light to use over the kitchen sink. 6" enameled glass globe with crystal lens bottom. Has knock-out for switch. Fitter 4". Height 6". Finish: Polished Chromium.

No. 1410 One-light — 60W lamp. Scientific lighting for a small space. 7⅝" opal glass bowl with crystal top. Fitter 4". Height 7¼". Finish: Polished Chromium.
No. 1420 One-light — 60W lamp.

No. 1392 Two-light — 60W lamps. Gives plenty of light, good for a low ceiling. 10" opal glass bowl. Depth 4". Finishes: Polished Chromium, Colonial Brass.
No. 1275 Two-light — 60W lamps. 8" bowl.

No. 1438 One-light — 75W lamp. A medium-size fixture to match fixtures to the left and right. 9" enamel glass globe with crystal lens bottom. Has knock-out for switch. Fitter 4". Height 7". Finish: Polished Chromium.

No. 1437 One-light — 150W lamp. An excellent center light for the kitchen. 10" enameled glass globe with crystal lens bottom. Has knock-out for switch. Fitter 4". Height 8". Finish: Polished Chromium.

No. 1545 Two-light — 60W lamps. Fulfills the requirements for modern kitchen lighting. 10" opal glass globe. Depth 4½". Finishes: Polished Chromium, Colonial Brass, Satin Chromium.
No. 1548 Two-light — 60W lamps. 12" bowl. Depth 4¾".

No. 1349 One-light — 60W lamp. An excellent and inexpensive bracket for bath and laundry. Opal glass shade. Convenience outlet. Pull switch. Back plate 5". Extends 8½".
No. 1351 One-light — 60W lamp. Pull switch. No convenience outlet.
No. 1350 One-light — 60W lamp. Pull switch. No switch.

No. 1204 One-light — 60W lamp. Efficiency, and smart design. Satin finish opal glass shade. Pull socket. Convenience outlet. Back plate 6" x 3½". Extends 5".
No. 1317 One-light — 60W lamp. Convenience outlet. No pull chain.

No. 1624 Two-light — 60W lamps. The enameled glass shade with the crystal lens bottom eliminates glare and strong light reflections. Pull switch. Convenience outlet. Width 11¼". Extends 7½".
No. 1626 Two-light — 90W lamp. Pull switch. No convenience outlet.

No. 1205 Two-light — 60W lamps. Modern design and good illumination. 11½" satin finish opal glass shade. Pull switch. Convenience outlet. Back plate 6" x 3½". Extends 5".
No. 1318 Two-light — 60W lamps. Convenience outlet. No pull chain.
No. 1278 Two-light — 60W lamps. Pull switch. No convenience outlet.
No. 1289 Two-light — 60W lamps. No pull switch or convenience outlet.

No. 1433 One-light — 60W lamp. The crystal lens bottom in the enameled glass shade sends the light over a larger area. Pull chain. Convenience outlet. Back plate 4½". Extends 7½".
No. 1434 One-light — 60W lamp. Pull chain. No convenience outlet.

No. 11073 One-light — 60W lamp. Well-styled and excellent light. Satin finish opal glass shade. Pull chain. Back plate 4½" x 3½". Extends 7".
No. 11674 One-light — 60W lamp. Convenience outlet. No pull chain.
No. 1193 One-light — 60W lamp. Pull chain. No convenience outlet.
No. 1252 One-light — 60W lamp. No pull chain or convenience outlet.

No. 1359 One-light — 60W lamp. Perfect for utility purposes. Opal glass shade. Height 8". Finishes: Polished Chromium, White Enamel.
No. 1369 One-light — 60W lamp. Pull socket.

No. 1907 One-light — 60W lamp. Effective lighting with modern styling. Opal glass shade. Switch control. Back plate 6" x 3½". Extends 4½". Finish: Polished Chromium.
No. 1319 One-light — 60W lamp. No switch control. Convenience outlet.
No. 1206 One-light — 60W lamp. Switch control. Convenience outlet.

No. 1411 Two-light — 60W lamps. Diffused light that is kind to the eyes. 10" opal glass bowl. Length 7". Finish: Polished Chromium.

No. 1442 Two-light — 60W lamps. Beauty as well as efficient illumination. 10" opal glass bowl. Depth 4⅝". Finishes: Polished Chromium, Colonial Brass, Satin Chromium.
No. 1443 Two-light — 40W lamps. 8" bowl. Depth 4⅛".
No. 1443 Three-light — 60W lamps. 12" bowl. Depth 4½".
No. 1444 Three-light — 60W lamps. 14" bowl. Depth 5".

No. 1645 One-light — 60W lamp. The revolving, enameled glass shade has a crystal lens panel for proper light adjustment. Use one on each side of your mirror. Switch control. Convenience outlet. Back plate 4½" x 3½". Extends 4½". Finish: Polished Chromium.
No. 1646 One-light — 60W lamp. Switch control. No convenience outlet.

No. 1689 One-light — 60W lamp. Smart in looks and yet extremely simple. Opal glass shade. Switch control. Convenience outlet. Back plate 4½" x 3½". Extends 4½". Finish: Polished Chromium.
No. 1362 One-light — 60W lamp. Switch control. No convenience outlet.

44 45 46

Excerpts from the 1941 Chase Lighting Fixtures Catalog.

Chapter 19
Reprint of a 1937 Revere Gifts Brochure

Following is a reprint of a 1937 Revere Gifts Brochure. The original measured 3-1/2" x 5-1/2".

Pages from Revere 1937 "Gifts" brochure.

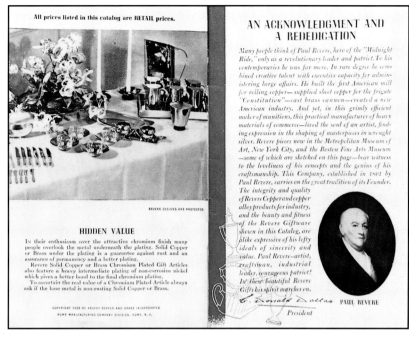

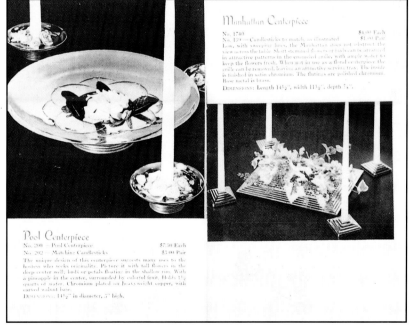

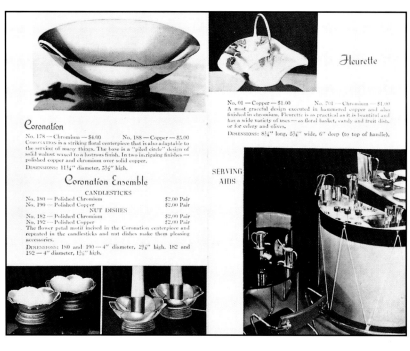

Coronation

No. 178 — Chromium — $4.00 No. 188 — Copper — $5.00

Coronation is a striking floral centerpiece that is also adaptable to the serving of many things. The base is a "piled circle" design of solid walnut waxed to a lustrous finish. In two intriguing finishes — polished copper and chromium over solid copper.

Dimensions: 11¼" diameter, 3½" high.

Coronation Ensemble

CANDLESTICKS

No. 180 — Polished Chromium $2.00 Pair
No. 190 — Polished Copper $2.00 Pair

NUT DISHES

No. 182 — Polished Chromium $2.00 Pair
No. 192 — Polished Copper $2.00 Pair

The flower petal motif incised in the Coronation centerpiece and repeated in the candlesticks and nut dishes make them pleasing accessories.

Dimensions: 180 and 190 — 4" diameter, 2⅜" high. 182 and 192 — 4" diameter, 1⅝" high.

Fleurette

No. 01 — Copper — $1.00 No. 701 — Chromium — $1.00

A most graceful design executed in hammered copper and also finished in chromium. Fleurette is as practical as it is beautiful and has a wide variety of uses — as floral basket, candy and fruit dish, or for celery and olives.

Dimensions: 8¼" long, 5¾" wide, 6" deep (to top of handle).

SERVING AIDS

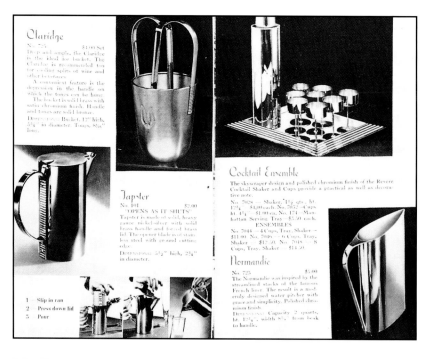

Claridge

No. 725 $3.00 Set

Deep and ample, the Claridge is the ideal ice bucket. The Claridge is recommended too for cooling splits of wine and other beverages.

A convenient feature is the depression in the handle on which the tongs can be hung.

The bucket is solid brass with satin chromium finish. Handle and tongs are solid bronze.

Dimensions: Bucket, 12" high, 5¾" in diameter. Tongs, 8½" long.

Tapster

No. 191 $2.00

"OPENS AS IT SHUTS"

Tapster is made of solid, heavy gauge nickel-silver with solid brass handle and forced brass lid. The opener blade is stainless steel with ground cutting edge.

Dimensions: 5½" high, 2¾" in diameter.

1 Slip in can
2 Press down lid
3 Pour

Cocktail Ensemble

The skyscraper design and polished chromium finish of the Revere Cocktail Shaker and Cups provide a practical as well as decorative note.

No. 7028 — Shaker, 1½ qts., ht. 12¾ — $4.00 each. No. 7052 — Cups, ht. 4¼ — $1.00 each. No. 174 — Manhattan Serving Tray — $5.50 each.

ENSEMBLES

No. 7044 — 4 Cups, Tray, Shaker — $11.00. No. 7046 — 6 Cups, Tray, Shaker — $12.50. No. 7048 — 8 Cups, Tray, Shaker — $14.00.

Normandie

No. 725 $5.00

The Normandie was inspired by the streamlined stacks of the famous French liner. The result is a most truly designed water pitcher with grace and simplicity. Polished chromium finish.

Dimensions: Capacity 2 quarts, ht. 12¾", width 8½" from beak to handle.

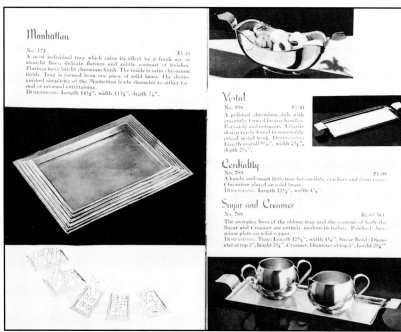

Manhattan

No. 174 $5.50

A most individual tray which gains its effect by a frank use of straight lines, delicate flutings and subtle contrast of finishes. Flutings have bright chromium finish. The inside is satin chromium finish. Tray is formed from one piece of solid brass. The distinguished simplicity of the Manhattan lends character to either formal or informal entertaining.

Dimensions: Length 14½", width 11½", depth ⅝".

Vestal

No. 198 $5.00

A polished chromium dish with gracefully formed bronze handles. For candy and nutmeats. A classic design rarely found in reasonably priced metal work. Dimensions: Length overall 9⅝", width 2¾", depth 2⅜".

Cordiality

No. 789 $1.00

A handy and smart little tray for cordials, crackers and demi-tasse. Chromium plated on solid brass.

Dimensions: Length 12½", width 4¼".

Sugar and Creamer

No. 788 $2.50 Set.

The sweeping lines of the oblong tray and the contour of both the Sugar and Creamer are entirely modern in feeling. Polished chromium plate on solid copper.

Dimensions: Tray: Length 12½", width 4¼". Sugar Bowl: Diameter at top 3", height 2¾". Creamer: Diameter at top 3", height 2¾".

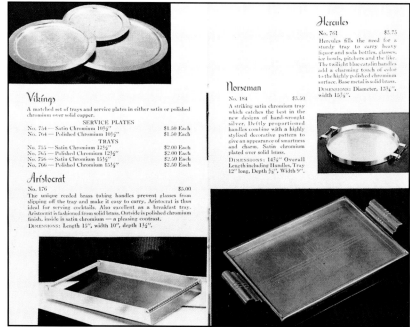

Vikings

A matched set of trays and service plates in either satin or polished chromium over solid copper.

SERVICE PLATES

No. 754 — Satin Chromium 10½" $1.50 Each
No. 764 — Polished Chromium 10½" $1.50 Each

TRAYS

No. 755 — Satin Chromium 12½" $2.00 Each
No. 765 — Polished Chromium 12½" $2.00 Each
No. 756 — Satin Chromium 15½" $2.50 Each
No. 766 — Polished Chromium 15½" $2.50 Each

Aristocrat

No. 176 $5.00

The unique reeded brass tubing handles prevent glasses from slipping off the tray and make it easy to carry. Aristocrat is thus ideal for serving cocktails. Also excellent as a breakfast tray. Aristocrat is fashioned from solid brass. Outside is polished chromium finish, inside is satin chromium — a pleasing contrast.

Dimensions: Length 15", width 10", depth 1½".

Hercules

No. 761 $5.75

Hercules fills the need for a sturdy tray to carry heavy liquor and soda bottles, glasses, ice bowls, pitchers and the like. The twilight blue catalin handles add a charming touch of color to the highly polished chromium surface. Base metal is solid brass.

Dimensions: Diameter, 13¾", width 15⅜".

Norseman

No. 184 $5.50

A striking satin chromium tray which catches the best in the new designs of hand-wrought silver. Deftly proportioned handles combine with a highly stylized decorative pattern to give an appearance of smartness and charm. Satin chromium plated over solid brass.

Dimensions: 14¾" Overall Length including Handles, Tray 12" long, Depth ⅝", Width 9".

Pages from Revere 1937 "Gifts" brochure.

Service Cup

New and colorful for serving fruit, sherbets, custards, fruit and vegetable juices, oyster or crabmeat cocktails. Ice can be packed around the glass tumblers.

No. 802 — Chromium bowl, blue tumblers $1.00 Pair
No. 803 — Bronze bowl, red tumblers $1.00 Pair
No. 805 — Chromium bowl, crystal tumblers $1.00 Pair
No. 806 — Bronze bowl, crystal tumblers $1.00 Pair

DIMENSIONS: Diameter of bowl 5¼", depth 1⅜". Diameter of cup 2⅜", capacity 5 ounces.

Hampshire Bread Tray *(Lower Left)*

No. 7024 $1.00
In an all-over hand-hammered effect in satin chromium, Hampshire has many incidental uses in addition to its primary function as a tray.

Norseman Bread Tray *(Lower Right)*

No. 7026 $1.00
In satin chromium with the Norseman motif stamped in the center, this tray matches the Norseman Serving Tray and the Vikings.

DIMENSIONS: The Hampshire and Norseman Bread Trays are 14½" in length, 7½" in width. Base metal of both trays is solid brass.

Coastray

No. 517 $1.00 Pair
A coaster and ash tray combined which conserves space on the bridge table. The raised straight line decorative motif on the coaster prevents it from being picked up with the glass. Made of solid brass and finished in satin chromium.

DIMENSIONS: Length 7", width 4".

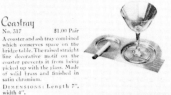

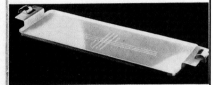

Cocktail Hour

No. 185 $2.50
"Long as an hour" itself, the Cocktail Hour Tray will accommodate at least 12 cocktail or highball glasses. A note of color is introduced by the beautiful twilight blue catalin decorations on the handles. They serve as firm grips too.
The Cocktail Hour Tray is satin chromium plated over solid brass.

DIMENSIONS: Length 20¼" long, width 6".

Bon Bon Dish

No. 186 — Polished Chromium over Solid Brass. $1.00
No. 1186 — Polished Bronze $1.00
The Bon-Bon Dish with its highly polished surface is an individual piece that can be used for candies, nut meats, mints, calling cards or for floating flower buds. In two beautiful finishes.

DIMENSIONS: 7" in diameter.

Relish Dish

No. 7501 $1.00 Set
No. 7500 — Tray only $.75
The Relish Dish Set is an attractive and practical accessory for the Sunday evening buffet supper. The tray of many uses is chromium plated over solid copper and is 10" in diameter. The glass inset is 7⅜" in diameter.

Five O'Clock

No. 813 $1.00 Pair
Simple and distinctive in form, this individual canape tray adds a modern note to any cocktail set and has been designed to nest conveniently. Finished in Satin chromium over solid brass.

DIMENSIONS: Length 6¾", width 4⅝".

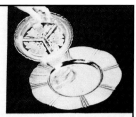

Trio Tray Set

No. 7503 — Trio Tray Set — $1.50 No. 7502 — Tray only — $1.00
A decorated glass compartment dish and heavy chromium plated 10-inch tray. The Trio Tray Set serves the hostess in so many ways — a needed relish dish, casserole tray, cake, cookie or muffin tray and numerous other uses.

DIMENSIONS: Diameter of tray 10". Diameter of glass dish, 7⅜".

Condiment Set

No. 804 $2.50
A set with many uses for daintily serving assortments of condiments, jellies, jams and relishes. There are three twilight blue glasses on an attractive tray in polished chromium finish. Covers for the glasses are also chromium plated and knobs are white catalin. Spoons are blue glass to match jars. All metal is solid brass with high chromium finish.

DIMENSIONS: Tray length 12¼", width 4⅝". Large jar: diameter 2½". Small jar: diameter 1¾".

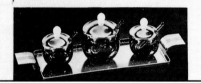

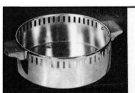

Casserole Frame

No. 565 $2.00
An attractive casserole frame for baking dishes. Made of solid brass with polished chromium finish, it withstands the moisture from foods, is rust-proof, non-tarnishing and stain-proof. It enhances the appearance of foods served on the table. The handles of solid walnut are waxed to a lustrous finish and have the advantage of keeping cool.

DIMENSIONS: Inside diameter 7⅜", depth 2¾". Holds a 1½ quart Pyrex type casserole.

Candy Caddy

No. 105 — Copper $2.50
No. 115 — Chrome $5.50
A candy or nut meat holder with classic lines. Furnished either in polished copper or bright chromium finish. The unusual cover knob and base are turned solid walnut waxed to a lustrous finish. The lining in both numbers is chromium plate.

DIMENSIONS: Overall height 6", diameter at top 4½".

Pie Plate Frame

No. 561 $2.00
A chromium plated brass frame for glass or metal pie plates. The streamline handles are solid walnut waxed to a lustrous finish.

DIMENSIONS: Inside diameter 9½" to take a standard 9½" pie plate, depth 1½".

Casserole-Tray *(Lower Left)*

No. 150 $1.50
For the baking and serving of individual or small family casserole treats. Made of solid copper, food cooks evenly and quickly. From the oven it goes right to the table — its cheerful color adding to the appetizing appearance of the food.
Formed from one piece of solid copper and chromium lined for easy cleaning.

DIMENSIONS: Width 9¾", diameter of bowl 7½", depth 1¾".

Duet

No. 272 $1.00 Set
A modern salt and pepper set which gains distinction from its simplicity. Easily filled through a slide bottom. A perforated "S" and "P" tells Who's Who.

DIMENSIONS: Width 2", depth ⅝", height 1¾".

Crescent *(Upper Left)*

No. 160 $2.00 Each
For "U" candles. Incised lines give a feeling of lightness and delicacy. Semi-circle contrasts with rectangular forms. Satin chrome finish with base of satin black nickel.

Pool *(Upper Right)*

No. 202 $3.00 Pair
Designed to match the Pool Centerpiece No. 200 (Page 4). Not only do they carry the extremely tall or medium sized candles but they hold water in which petals or buds may be floated. Bright chromium plated with walnut bases.

Manhattan *(Lower Left)*

No. 159 $1.00 Pair
To match the Manhattan Centerpiece (Page 5) and to create striking table settings. The Manhattan Candlesticks in polished chromium finish over solid brass, the best in modern classic design.

Candlesphere *(Lower Right)*

No. 162 $3.00 Each
Overlapping polished chromium circles with polished brass holders. The Candlesphere radiates cheerfulness. 8¾" long, 2½" wide.

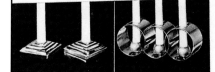

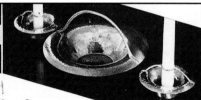

Revere

No. 7012 — Chromium Candlesticks $1.00 Pair
No. 708 — Centerpiece in chromium, 8¾" dia. $1.00 Each
No. 011 — Hammered Copper Candlesticks $1.00 Pair
No. 07 — Centerpiece in copper, 8¾" dia. $1.00 Each

Coronation

These beautiful candlesticks match the Coronation Centerpiece Nos. 178 and 188.
No. 180 — Polished Chromium $2.00 Pair
No. 190 — Polished Copper $2.00 Pair

Tuxedo

No. 155 $3.00 Pair
Used singly or in pairs, in both modern and period interiors. Chromium plate with satin finish.

Regency

No. 154 $3.50 Pair
This candlestick embodies a charm that adapts itself to any period or setting. Satin chromium Bow, plate glass base.

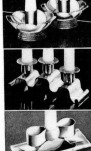

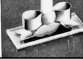

Pages from Revere 1937 "Gifts" brochure.

Masque

No. 126 $2.00

"Discreetness" is a feature of this engagingly modern bedside reading lamp.

It shades the light from the sleeper while reflecting good light in the direction of the reader. An excellent hall lamp, distinctly smart, in polished chromium over brass.
DIMENSIONS: Height 10", diameter of base 5⅝".

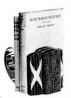

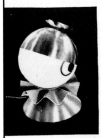

Coquette

No. 127 — Satin Copper — green ruffle $5.00
No. 727 — Satin Chromium — black ruffle $5.50
A chic boudoir lamp.
DIMENSIONS: Diameter of globe is 4½". Height of lamp is 6¾".

Vanitie

No. 710 $2.00

Chromium streamlined powder vanity box with a convenient glass mirror on reverse side of the cover.
DIMENSIONS: 5⅜" in diameter, 2½" in height.

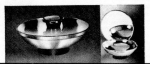

Scroll

THE MODERN SUCCESSOR TO BULKY BOOK ENDS

Holds one book perfectly firm. Expands to hold many volumes. No tumbling — no more marred table and desk tops from cumbersome book ends.

Streamline—light, yet stronger than massive book ends.

All Revere Book Scrolls and Magazine Scrolls designed by Fred Farr, and protected by U. S. Design Patent No. 95811, and other patents pending and applied for.

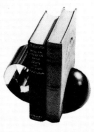

Romans

No. 282 —Ebony and green $1.50
No. 283 —Mandarin red $1.50
No. 284 — Old Ivory $1.50
No. 287 — Ivory, motif gold $2.00
No. 288 — Ebony, motif gold $2.00

A classic model that widens the assortment of Revere Book Scrolls, to include a design and color to harmonize with almost any decorative scheme.

Laurels

No. 276 — Ebony and verdis green $1.50
No. 277 — Mandarin Red $1.50
No. 278 — Old Ivory $1.56
No. 285 — Old Ivory and gold $2.00
No. 286 — Ebony and gold $2.00

No. 275 — Black Ball, and Chromium Scroll $1.00
No. 289 — White Ball, and Chromium Scroll $1.00
No. 290 — Red Ball, and Chromium Scroll $1.00

Twin Scroll

No. 295 — Red divider — chromium band $2.50
No. 296 — White divider copper band $2.50
No. 297 — Black divider chromium band $2.50
The spring coils are chromium plated.

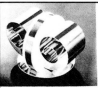

New Natural Woods

TWIN SCROLL

The Twins with natural wood dividers, and spring coils of solid brass, add a note of richness and conservative beauty.
No. 298 — Solid Mahogany divider — brass coils $5.50
No. 299 — Solid Walnut divider — brass coils $5.50

SINGLE SCROLL

No. 291 — Solid Walnut $2.00
No. 292 — Solid Mahogany $2.00
No. 293 —Solid Maple $2.00
The natural beauty of the woods has been further enhanced by the use of highly polished golden brass, doubly lacquered.

Sea Shells

No. 279 — Ebony with Green $1.50
No. 280 — Mandarin Red $1.50
No. 281 — Old Ivory $1.50
These designs will prove popular for game rooms and rooms decorated in the Marine manner.

Magazine Holder

No. 504 $10.00

A magazine rack in bronze and polished chromium equipped with ash receiver. The chromium "V" spring in the center holds magazines and newspapers upright against the bronze shields. The removable bronze ash receiver is fitted near the top of the chromium tubular handle. The base is hard wood with a black mat finish.
DIMENSIONS: Over-all height 25½", base is 11" long, width 6".

Magazine Scroll

No. 500 —Red Catalin Handle $7.50
No. 501 —Blue Catalin Handle $7.50
No. 505 —Chromium Handle $7.50

Employs the Book Scroll principle. Will accommodate up to 50 magazines of all sizes, in the self-expanding scroll springs. Periodicals and newspapers can be slipped in and taken out easily. Polished chromium with solid ball floor rests, handles of chromium or colorful catalin.
DIMENSIONS: Height 17½", length 11½", width 8".

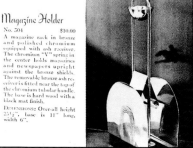

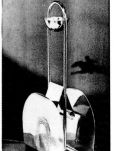

Fireside

No. 7055 $10.00

A beautiful chromium and bronze Wood Basket. The handle is ebony finish and the floor rests are chromium balls.
DIMENSIONS: Length 18", width 15", height 15½".

Stationery Holder *(Lower Left)*

No. 418 $1.00

A heavy bronze stationery holder with a bronze spring divider that keeps envelopes and letterheads separate.
DIMENSIONS: Length 5¾", height 2¾".

Double Deck *(Lower Right)*

No. 416 $1.00

Gracefully formed from one piece of solid bronze. It keeps two decks of cards from becoming "dog eared".
DIMENSIONS: Length 5⅜", height 2¾".

Pages from Revere 1937 "Gifts" brochure.

188

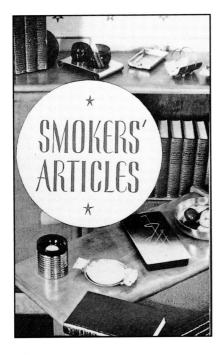

SMOKERS' ARTICLES

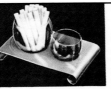

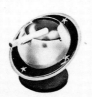

Smokette

No. 800 — Cobalt Blue Glass Containers $1.00
No. 801 — Ruby Red Glass Containers $1.00
DIMENSIONS: The base is 6½" in length, width 4", height ¾".

Saturn

No. 711 $2.00
The globe is polished chromium while the band around it is bronze with a night black inner ring, studded with raised copper stars. Flip the removable holder and the ashes disappear — the smouldering cigarette drops out of sight, is extinguished and all odor is prevented.
DIMENSIONS: Over-all width 4", height 4".

Pick-Me-Up

No. 712 — Chromium $1.00
No. 715 — Polished Copper $1.00
A most unusual ash receiver with a cylinder valve feature. When you pick it up the valve head drops down carrying with it ashes or burning cigarettes and immediately extinguishing them. Black bakelite rim is easily removed when the ash receiver is to be emptied.
DIMENSIONS: Diameter 5", height 5¼".

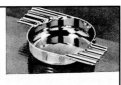

Streamline

No. 7655 — Chromium $1.00
No. 655 — Copper $.75
Modern in design and conception and practical. Graduated grooved wings hold any length of cigarette and prevent burning of furniture.
DIMENSIONS: Over-all width 5½".

Discus

No. 155 $2.00
An ash tray of remarkable charm and distinction. The wide rim and the notches of the removable center cup are for resting cigarettes. In satin chromium finish. The band around the outer edge and the cup are of brass.
DIMENSIONS: Diameter 6⅝".

Stadium

No. 267 — Chromium $2.00
No. 1267 — Bronze $2.00
A man-sized tray for the heavy smoker. The bowl is 7 inches in diameter and is furnished in chromium or polished bronze. The holders are forged copper.

Chanticleer

No. 111 — Chromium $1.00
No. 1111 — Bronze $1.00
DIMENSIONS: Length 6¾", width 4⅝", depth ¾".

Pipe Smokers Tray

No. 134 $1.00
Clicks with pipe smokers. It's spacious with a cork center stem for tapping pipes. It can pinch-hit as a cigar ash tray too. Polished solid copper, heavily lacquered.
DIMENSIONS: Diameter 7", depth 1⅜".

Penthouse

A smart cigarette box with three compartments for different brands.
No. 165 — Black nickel box, satin chromium top $5.00
No. 1650 — Satin chromium box, satin copper top $5.00
No. 1165 — Satin chromium box, polished bronze cover $5.00
DIMENSIONS: Length 9½", width 4⅜", depth 1".

Humidors

Equipped with a new clay moistener that keeps all tobacco products at perfect humidity, and maintains the original fragrance. Felt padded bottoms prevent scratching and marring of furniture and desks.
FOR CIGARETTES AND PIPE TOBACCO
No. 462-H — Hammered copper finish, 5" high $1.60
No. 7461-P — Smooth chromium, 5" high $2.00
No. 7461-H — Hammered chromium finish, 5" high $2.00
FOR CIGARS AND PIPE TOBACCO
No. 466-H — Hammered copper finish, 7¾" high $2.25
No. 7465-H — Hammered chromium finish, 7¾" high $3.00
No. 7465-P — Smooth chromium finish, 7¾" high $3.00

Miniature Wood Basket (Lower Left)

No. 169 CIGARETTE SERVER $.50
An attractive cigarette server which is a miniature model of our No. 7055 Fireside Wood Basket. Something new for the bridge table, dining room or office. The tray is solid bronze and the hoops are solid brass.
DIMENSIONS: Length 5¼", height 3", width 2⅝".

Quadrille (Lower Right)

No. 1152 $1.00
A gracefully designed modern small tray for ashes, calling cards and other uses. Rich bronze handles combine with the satin chromium finish of the tray for a pleasing effect.
DIMENSIONS: Over-all length 5", width 3".

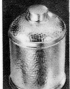

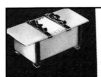

Pandora

No. 164 $3.50
A cigarette box of unusual charm with a very practical smoothly sliding top. In satin chromium finish with contrasting bands of satin black nickel finish.
DIMENSIONS: Length 5", width 2⅝", depth 3¼".

Incense Burner

No. 187 $1.00
Graceful polished brass handles, wide and deep compartment and white catalin knob, contrasting favorably with the all-over polished copper finish.
The ventilators are spaced accurately so that the incense burns slowly and the odor is given off readily.
DIMENSIONS: Length 5⅝", height 5".

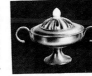

Commodore

No. 118 $2.00
Appealing to both men and women, this striking ash tray in polished chromium with polished bronze rests is especially suited to a man's desk or table.
DIMENSIONS: Diameter 6½".

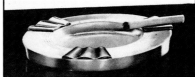

Pages from Revere 1937 "Gifts" brochure.

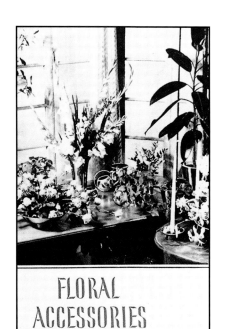

FLORAL ACCESSORIES

Copper Aids Plant Growth

An outstanding reason why many plants tend to thrive better in Revere Copper Floral Containers is the fact that copper is vitally essential to cell-life processes in many plants.

Experiments show definitely that copper salts, in proper strength, destroy bacteria and protozoa harmful to plant life.

In Revere copper and brass Vases and Plant Containers, the plants get the copper salts they need directly from the metal. The amount absorbed is, of course, very minute. Yet it is extremely important to the plant.

AN INTERESTING SCIENTIFIC DEMONSTRATION

Since 1933, the University of Delaware has been experimenting with copper salts as an aid to plant growth. Here are some facts about these experiments. Copper sulphate, in proper quantity, mixed with fertilizer, produced 16,555 pounds of beets per acre, as compared with 14,025 pounds yielded with fertilizer alone. Of cabbages, 25,960 pounds per acre were produced with copper sulphate and fertilizer, compared with 14,025 pounds with the fertilizer only. Of potatoes the copper sulphate, with manganese sulphate, added to the fertilizer, yielded 17,405 pounds per acre as against 10,261 pounds with the fertilizer only.

COPPER REVIVES "DEAD" ORCHID

Here is another amazing instance of the importance of copper to plant life, reported in a recent issue of the "Reader's Digest." The article tells the experience of those who witnessed a demonstration in which a solution of colloidal copper was added to water in which an apparently dead purple orchid had been placed. The flower was described as "a withered, yellowed thing, dead. It had been taken a short time before from a pile of debris." The article related how a famous bacteriologist added a teaspoonful of an amber-colored solution of colloidal copper to the water containing the orchid. Before the astounded eyes of the onlookers, the orchid revived. Its petals became crisp, its color vivid. It bloomed with new life, and would, the witnesses were assured, continue to do so for 16 or 17 days.

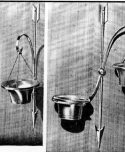
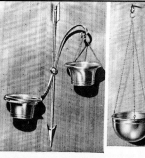

Hamilton *(Upper Left)*

No. 7051 — $3.00 No. 17051 — $5.00

Slightly reminiscent of Federal Period Design, yet it combines the modern feeling with a happy result. The arrow and the extending arm of No. 7051 are polished chromium plated brass, as are the chains. The floral basket is satin copper. The arrow of No. 17051 is solid polished bronze.

DIMENSIONS: Length of arrow is 18⅝", diameter of basket is 5¼"

Jefferson *(Center)*

No. 7052 — $4.00 No. 17052 — $4.00

The Jefferson is practical for vines and plants and enhances their natural loveliness.

In the No. 7052 the arrow and brackets are polished chromium and the bowls are satin copper — a striking combination.

In the No. 17052 the arm and cross scroll are rich bronze.

DIMENSIONS: Length, 18⅝", width 12". The baskets are 5¼" in diameter.

Madison *(Upper Right)*

No. 729 $2.00

Polished chromium, finely designed and executed with an attractive chromium bracket and chain; also two eye bolts for fastening conveniently to any wall.

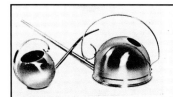

Large Watering Pot *(Upper Right)*

No. WP-42 $2.00

Practical for both indoor and outdoor use. Body and spout are made of solid copper and handle of brass. Cannot rust. Capacity, 2 qts.

DIMENSIONS: 17" from handle to tip of spout, and 7¾" in height.

Junior Watering Pot *(Upper Left)*

No. WP-41 $1.50

A handy and decorative one pint watering pot. Body and long seamless spout are of highly polished copper, and handle of brass.

DIMENSIONS: 12¾" from handle to tip of spout. Height 5".

Bulb Bowl *(Lower Left)*

No. F-15 — Copper — $1.00 No. F-715 — Chromium — $1.25

Ideal for bulbs and flowers and can also be used for candy or fruit.

DIMENSIONS: Diameter 7", height 3". Two distinctive finishes.

Bubble Bowl *(Lower Right)*

Shimmering spheres for single bulbs or short stemmed flowers.

No. F-17 — Copper — $.75 No. F-717 — Chromium — $1.00

DIMENSIONS: Diameter 4½", height 3".

No. F-18 — Copper — $.70 No. F-718 — Chromium — $.90

DIMENSIONS: Diameter 3½", height 2⅜".

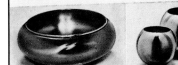

Reflector Wall Bracket

F-26 (left) and F-16 (right) — Polished copper reflector and bowl, brass ring $2.00

F-726 (left) and F-716 (right) — Polished chromium reflector, bowl and ring $2.50

A circular, highly polished reflector, 11¼" in diameter, catches the myriad lights and colors in a room. And a removable ivy or flower bowl, 4½" in diameter.

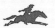

Venetian Wall Piece

No. F-22 — Brass brackets and copper bowls $5.00

No. F-722 — Chromium brackets and bowls $5.50

Interesting in design, decorative and useful.

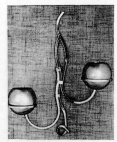

Babylon

No. F-12 $1.00

An attractive hanging basket for ferns, ivy and other plants. Being made of solid polished copper, it is rust-proof. Holds the moisture longer and really aids plants to thrive. The Babylon is furnished with three chains attached. Basket 7" in diameter, 5" deep.

A solid brass Bracket for attaching the Babylon to any wall is sold separately.

No. F-52 $.50 Each

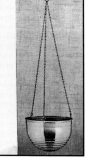

La Fleur

These ultra smart flower pots in rich red-copper and golden-yellow brass provide a new decorative treatment for house plants. Made in four sizes to accommodate standard size clay pots. If desired plants may be grown directly in these unbreakable rust-proof and leak-proof containers.

La Fleur Jardinieres also make attractive vases for cut flowers. The Jardinieres are available with and without motif decoration as pictured.

WITH MOTIF				WITHOUT MOTIF			
Copper	Brass	Size	Retail	Copper	Brass	Size	Retail
No. 263	½ No. 243	½ 3½"	$1.00	No. 253	½ No. 253	½ 3½"	$.75
No. 264	No. 244	4"	$1.25	No. 254	No. 254	4"	$1.00
No. 265	No. 245	5"	$1.75	No. 255	No. 255	5"	$1.50
No. 266	No. 246	6"	$2.25	No. 256	No. 256	6"	$2.00

APPROX. WEIGHT: No. 3½, ¾ lb. No. 4, ⅞ lb. No. 5, 1¼ lb. No. 6, 1½ lb.

Grecian Vases

5½" TALL

No. 5-Copper Plain $1.50
No. 52-Copper, brassrings $1.75
No. 75-Chromium Plain $2.00

7" TALL

No. 7-Copper Plain $1.75
No. 72-Copper, brassrings $2.00
No. 77-Chromium Plain $2.25

8" TALL

No. 9-Copper Plain $2.00
No. 92-Copper, brassrings $2.25
No. 79-Chromium Plain $2.50

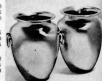

Pages from Revere 1937 "Gifts" brochure.

Selected Bibliography

Acton, Marilyn C. *Fifty Golden Years*. Norwich, Connecticut: The American Thermos Products Company, 1957.

Albrecht, Donald. *Designing Dreams: Modern Architecture in the Movies*. New York: Harper & Row, 1986.

Baer, J. E. *History of the Eveready Company*. Unpublished speech before the Frederick County, Maryland Historical Society, 1943.

Ball, Charlotte, ed. *Who's Who in American Art: Vol. III For the Years 1940-1941*. Washington, D.C.: The American Federation of Arts, 1940.

Bassett, Homer F. *Waterbury and Her Industries*. Gardner, Massachusetts: Lithotype Printing and Publishing Co., 1887.

Brecher, Jeremy, Jerry Lombardi, and Jan Stackhouse. *Brass Valley: The Story of Working People's Lives and Struggles in an American Industrial Region*. Philadelphia, Pennsylvania: Temple University Press, 1982.

Bucki, Cecelia and others. *Metal, Minds, and Machines: Waterbury at Work*. Waterbury, Connecticut: Mattatuck Historical Society, 1980.

Byars, Mel. *The Design Encyclopedia*. New York: John Wiley & Sons, Inc., 1994.

Chase Dictionary of Brass and Copper Terms. Waterbury, Connecticut: Chase Brass & Copper Co., Inc., 1937.

Chronological History of Revere Copper and Brass Incorporated: 1801-1970. New York: New York: Revere Copper and Brass Incorporated, 1970.

Darling, Sharon. *Chicago Furniture: Art, Craft, and Industry 1833-1983*. New York: W. W. Norton & Co., 1984.

Davis, Watson. *The Story of Copper*. New York: The Century Company, 1924.

Connecticut Circle. Vol. VIII, No. IV, April 1945.

DiNoto, Andrea. *Art Plastic: Designed for Living*. New York: Abbeville Press, 1984.

Fowler, Herbert E. *A History of New Britain*. New Britain, Connecticut: New Britain Historical Society, Inc., 1960.

Fusco, Tony. *The Official Identification and Price Guide to Art Deco*. New York, New York: House of Collectibles, 1988.

Genauer, Emily. *Modern Interiors: Today and Tomorrow*. New York: Illustrated Editions Company, Inc., 1939.

Grief, Martin. *Depression Modern: The Thirties Style in America*. New York, New York: Universe Books, 1975.

Kery, Patricia Frantz. *Art Deco Graphics*. New York: Harry N. Abrams, Inc., 1986.

Kilbride, Richard J. *Art Deco Chrome: The Chase Era*. Stamford, Connecticut: JO-D Books, 1988.

Kilbride, Richard J. *Art Deco Chrome Book Z: A Collector's Guide Industrial Design in the Chase Era*. Stamford, Connecticut: JO-D Books, 1992.

Koch, Robert, ed. *Chase Chrome*. Stamford, Connecticut: privately printed, 1978.

Lyman, Taylor, editor. *Metals Handbook, Eighth Edition*. Metals Park, Ohio: American Society for Metals, 1964.

Mandelbaum, Howard and Eric Myers. Screen Deco: A Celebration of High Style in Hollywood. New York: St. Martin's Press, 1985.

Marcosson, Isaac F. *Copper Heritage: The Story of Revere Copper and Brass Incorporated*. New York, New York: Dodd, Mead & Company, 1955.

Marcosson, Isaac F. *Industrial Mainstreet: The Story of Rome—The Copper City*. New York, New York: Dodd, Mead & Company, 1953.

May, Earl Chapin. *Century of Silver: 1847-1947*. New York, New York: Robert M. McBride & Company, 1947.

Meikle, Jeffrey L. *Twentieth Century Limited: Industrial Design in America, 1925-1939*. Philadelphia, Pennsylvania: Temple University Press, 1979.

My Trip Through the Chase Metal Works (Souvenir Book). Waterbury, Connecticut: Chase Brass & Copper Co., Inc., 1951.

Myers, Howard, ed. *Architectural Forum* vol. 73, no. 4. New York: Time, Inc. October 1940.

Ockner, Paula and Leslie Piña. *Art Deco Aluminum: Kensington*. Atglen, Pennsylvania: Schiffer Publishing Ltd., 1997.

Packer, William. *The Art of Vogue: Covers 1909-1940*. New York, New York: Bonanza Books, 1984.

Pile, John. *Dictionary of 20th Century Design*. New York, New York: Facts on File, A Roundtable Press Book, 1990.

Post, Emily. *How to Give Buffet Suppers*. New York: Chase Brass & Copper Co., 1933.

Rainwater, Dorothy T. *Encyclopedia of American Silver Manufacturers*. New York, New York: Crown Publishers, Inc., 1975.

Roth, David M. *Connecticut: A History*. New York, New York: W. W. Norton & Co., 1979.

Sferrazza, Julie. *Farber Brothers Krome-Kraft: A Guide for Collectors*. Marietta, Ohio: Antique Publications, 1988.

"The Story of Waterbury—1917-1938." *Waterbury Sunday Republican*, August 16, 1953.

Thibodeau, Patrick. *New Britain: The City of Invention*. Chatsworth, California: Windsor Publications, Inc., 1989.

Visakay, Stephen. *Vintage Bar Ware: Identification & Value Guide*. Paducah, Kentucky: Collector Books, 1997.

Waterbury Tercentennial: 1674-1974. Program. Waterbury, Connecticut, 1974.

Young, A. M. *The History of Manning Bowman & Co. Which Had For Many Years Added to the Importance of Meriden As An Industrial Center*. Unpublished.

Appendix A
Listing of Chase Giftware Items
Designed By Harry Laylon

The following list of Chase giftware items designed or redesigned by Harry Laylon was developed based on a listing prepared and signed by Harry Laylon on June 24, 1997. The only changes I have made to his listing are to correct a few catalog numbers that did not agree with the item description because numbers had been transposed. It should be noted that a couple of the items Mr. Laylon identified as his designs were in production before he began working at Chase. Presumably, he was responsible for the redesign rather than the original design of such items. In addition, some items were added to Chase catalogs after his departure. This is not surprising, however, as the items may have been designed before his departure. In addition, Laylon continued to submit designs to Chase as a freelance designer.

Catalog Number	Name
00853	Ball Cigarette Server
00855	Utility Ash Tray
00864	Cone Ash Tray
00865	Pipe Smokers Ash Tray
00867	Piccadilly Cigarette Box
00871	Flip-Top Ash Receiver
00873	Tamaris Cigarette Box
00879	Ribbed Ash Receiver
00880	Plaza Cigarette Box
00888	Tournament Cigarette Box
00889	Three Anchors Ash Tray
04004	Pendant Plant Bowl
04005	Chase Circular Wall Bracket
04006	Chase Diamond Wall Bracket
04007	Rippled Flower Pot
04008	Tri-Plant Bracket
04009	Tri-Plant Stand
04010	Tom Thumb Plant Pot
05006	Rain Beau Watering Can (Redesign)
09001	Triple Tray
09013	Cocktail tray
09015	Incidental Tray
09018	Festivity Tray
09024	Savoy Tray
09026	Star-Time Tray
13008	Canterbury Bell
15005	Diana Bowl
15006	Clipper Bowl
15007	Compton Console Bowl
16007	Mt. Vernon Hurricane Lamp
16008	Salem Candlesticks
17074	Four-In-Hand Serving Tray
17098	Steeplechase Cigarette Box
17099	Piping Hot Dish Cover
17105	Three-Tray Box
17106	Two-Tray Box
17107	One-Tray Box
17111	Silent Butler
24009	Diana Candlestick
24010	Hurricane Wall Bracket
25008	Masthead Lantern
26004	Jubilee Syrup Jug
26005	Jubilee Jam Jar
26006	Double Condiment Server
26007	Savoy Sugar and Creamer Set
26008	Savoy Sugar and Creamer Set with Tray
26009	Cruet Set
90018	Jam Set
90029	Round Rod Wall Bracket
90058	Ring Tray
90060	Circlet Tray
90061	Syrup and Sugar Service
90062	Duplex Jelly Dish
90063	Old Fashioned Cocktail Cup
90067	Blue Moon Cocktail Cup
90068	Marmalade and Jam Globes (Based on an idea by Helen Bishop Dennis)
90075	Skewers
90076	Serving Fork and Spoon
90083	Berry Bowl and Spoon
90084	Nut Bowl
90085	Iced Drink Cups
90086	"Squeezit" Opener
90087	Paper Napkin or Stationary Holder
90090	Iced Drink Mixers
90092	Tidy Crumber
90104	Three-Layer Candy Box
90105	Animal Napkin Clips (Elephant)
90106	Animal Napkin Clips (Duck)
90107	Animal Napkin Clips (Squirrel)
90108	Animal Napkin Clips (Bunny)
90116	Eden Candy Box
90117	Two-Layer Candy Box
90118	Tea Ball
90128	Fairfax Dish
90129	Target Cocktail Set
90130	Cocktail Glass
90133	Whisk Broom
90135	Ice Crusher
90138	Pilot Bookends
90139	Clothes Brush
90140	Hair Brush
90141	Bar Caddy
90142	Davey Jones Book Ends
90145	Military Brush Set
90147	Tidy Crumber
90148	Napkin Holder
90149	Mt. Vernon Candle Snuffer
90150	Nut Cracker
90151	Puritan Candle Snuffer